KUNA ART AND SHAMANISM

KUNA Art and Shamanism

An Ethnographic Approach

BY PAOLO FORTIS

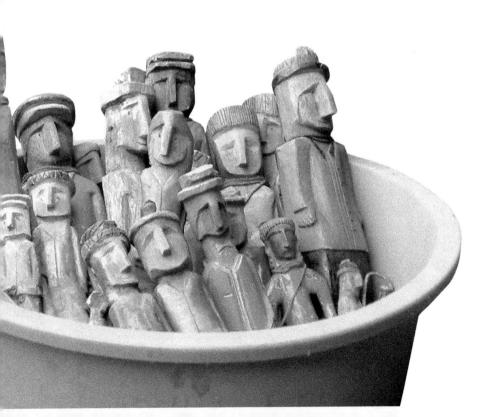

Copyright © 2012 by the University of Texas Press All rights reserved Printed in the United States of America First edition, 2012 First paperback edition, 2013

Requests for permission to reproduce material from this work should be sent to:

Permissions
University of Texas Press
P.O. Box 7819
Austin, TX 78713-7819
utpress.utexas.edu/index.php/rp-form

LIBRARY OF CONGRESS CATALOGING-IN-PUBLICATION DATA Fortis, Paolo.

Kuna art and shamanism : an ethnographic approach / Paolo Fortis.

p. cm. Includes bibliographical references and index. ISBN 978-0-292-75686-1

1. Cuna art. 2. Cuna mythology. 3. Cuna Indians— Religion. 4. Shamanism—Panama. I. Title.

F1565.2.C8F67 2012 704.03'9783—dc23

2012013280

doi:10.7560/743533

Silky anteater (*Cyclopes didactylus*). Drawing by Patrick Fortis.

To Giulia and Luigi My little treasures

Everyone will have their own zoo in paradise.

JUAN MENDOZA, 2004

CONTENTS

Acknowledgments ix

Note on Orthography xiii

Introduction 1

- 1. Island, Gardens, and Ancient Trees 23
- 2. Alterity and the Populated Forest 40
- 3. Carving and the Transformation of Male Fertility 67
- 4. Amniotic Designs 93
- 5. From the Perspective of the Mother 110
- 6. Tarpa, or What Lies between Us 133
- 7. Images of Alterity 152
- 8. Sculptural Forms 175

Conclusion 193

Notes 209

Glossary 239

References 241

Index 253

ACKNOWLEDGMENTS

This book is based on ethnographic research conducted among Kuna people of Panamá in 2003 and 2004. It is the outcome of a long, fascinating trip that started in Italy and reached Scotland via Panamá. Research and writing have been funded by various bodies and individuals throughout the years. Fieldwork and the initial stage of writing was funded by a doctoral scholarship granted by the University of Siena (2002-2005). Additional funding for fieldwork in 2004 was provided by a Short Term Fellowship from the Smithsonian Tropical Research Institute of Panamá (STRI). The School of Philosophical, Anthropological, and Film Studies at the University of St. Andrews funded one year of my fees. Subsequent funding was provided by the Royal Anthropological Institute, through a Radcliffe-Brown Trust Fund/Sutasoma Award (2007), and by the Sainsbury Research Units for the Arts of Africa, Oceania and the Americas at the University of East Anglia, which granted me a Visiting Research Fellowship (2010). This book would have not been completed without the financial support of my parents, Dario Fortis and Clara Rocco, and my parents-in-law, Giampiero Margiotti and Daniella Casarini.

I came to know about Kuna people in Siena during my undergraduate studies. I thank for their guidance and encouragement Massimo Squillacciotti, Fabio Mugnaini, Luciano Li Causi, Luciano Giannelli, Pier Giorgio Solinas, Francesco Zanotelli, Simona de Bravo, Sara Tagliacozzo, Giovanni Burali, Valentina Lusini, Fabio Malfatti, Alessandra Pugliese, Cinzia Fia, Tommaso Vianello, and Maria Marchitiello.

When I first went to Panama City Kuna friends helped me to settle in and begin my research. My deep gratitude goes to Loys Paniza and José Colman who have been good friends and intellectual companions throughout fieldwork. Marden Paniza, Egnis Paniza, Abuelo Paniza, Blas Lopez, Reina, Natta, and Lola were delightful company during my early days in Panama. I thank Flor Denis and the Kuna women of the Cooperativa Productores de Mola de Panamá, who embraced my project and introduced me to Kuna Congresses. I wish also to thank the Instituto de Investigación Koskun Kalu, the Congreso General Kuna, and the Congreso General de la Cultura Kuna, which gave me permission to conduct fieldwork in Kuna Yala.

In Okopsukkun I wish to thank all the men, women, and children who provided me with their help, support, and friendship and who taught me about themselves as well as asked me about myself. I was welcomed with smiles, and the doors of people's houses were always open to me. Kuna friends fed me, made me laugh, and taught me the importance and pleasures of living in many. Nixia Pérez has been a strong support throughout my residence in Okopsukkun. Without her much of my research would not have been possible. I thank all her family for their help and support: Nikanor Pérez, Raquel Morris, Olopayti, Nepa, Kanek, Liz, Jaison, Paolo Pippi, Enriqueta and Milciades. Juan Mendoza helped me to translate Kuna into Spanish during the first months and taught me much of what I know about the Kuna language. My profound gratitude goes to the late Aurelio Pérez, who first welcomed me into his home. Rotalio and Alejandrina Pérez and their daughters, Nistilisop, Natisop, Tirwikili, and Muu Wakala, have been joyful friends. Isaias Garcia, who died in late 2007, was a wonderful and patient informant. I remember the afternoons speaking with him and his kind way of explaining things to me. Garibaldo del Vasto has been a wise teacher and an invaluable source of information; he decided when it was time to start his teachings and left me with a lesson to be continued. I wish also to thank Héctor Garcia, Leopoldo Smith, Meliña Smith, Mikita Smith, Teobaldo Lopez, Leobijilda Smith, Marciales Davis, Nekartyli, Reinaldo Tuny, Aurora Diaz, Papa Rey, Aurolina Tuny, Alejandrino, Inaekikinya, Mario Pérez, Muu, Remigio Lopez, Beatriz Alba, Justino Lopez, and Lucrezia Morales.

In Panamá, at STRI, I thank Olga Linares for her encouragement and important suggestions, and Fernando Santos-Granero, who provided invaluable feedback and precious advice during my fieldwork and communicated to me the passion for ethnography; for this I owe him a lot. I am also grateful to Adriana Bilgray, Maria Leone, Jorge Ventocilla, and Monica Martínez.

In St. Andrews and in the United Kingdom I wish to thank Mhairi Aikenhead, Giovanna Bacchiddu, Eleni Bizas, Peter Clark, Marco Cremonese, Lorenzo Cremonese, Luca Cremonese, Tony Crook, Elizabeth Ewart, Conrad Feather, Emilia Ferraro, Stan Frankland, Paloma Gay y Blasco, Suzanne Grant, Veronika Groke, Mark Harris, Stacy Hope, Stephen Hugh-Jones, Margaret Hutcheson, Yannis Kallianos, Craig Lind, Lisa Neilson, Efpraxia Pollatou, Tristan Platt, Adam Reed, Napier Russell, Juan Pablo Sarmiento, Jacob Scott, Leah Scott, Micah Scott, Juan Serrano, Mattia Serrano, Samuel Serrano, Christina Toren, Rodrigo Villagra, and Huon Wardle. Linda Scott and Dawn Cremonese

polished my English and gave me tremendous help rendering my writ-

ing comprehensible.

I am grateful to Joanna Overing, who asked me challenging questions, opened my mind to anthropological theory, and gave me invaluable advice about how to combine academic work with a good life. When I was an undergraduate student in Siena an article by Peter Gow set me on my way. Years later, he himself helped me along the path.

James Howe, Margherita Margiotti, Anne-Christine Taylor, Christina Toren, and two anonymous reviewers read different versions of this work at different stages. I thank them for their comments and suggestions. I also wish to thank Theresa May for her friendly help throughout the editorial process.

I thank Patrick Fortis for drawing the silky anteater, Ariel Beraha for making the maps, and Martin Evans for his help with photographs.

My family has been a continuous support throughout the years. I thank my mother, Clara; my father, Dario; and Myriam, Mattia, Ariel, Patrick, Sofia, Martino, and Tommaso. I thank also Daniela and Giampiero, my parents—in—law. Giovanni, Lorenzo, and Biagio have been good friends.

Giulia and Luigi made me discover a new level of happiness in life and gave me new strength. Margherita Margiotti, partner and fellow anthropologist, brought me to the Kuna for the first time and since then has been a constant source of intellectual stimulation. She gave me invaluable insights and precious feedback. This work would not exist without her contribution. To her goes my most sincere love.

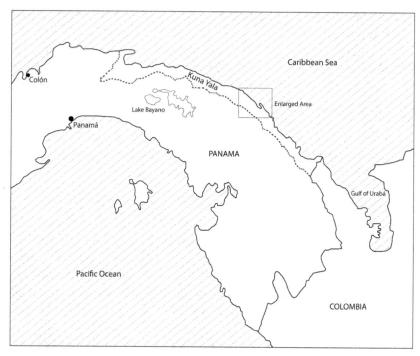

MAP 1: Eastern Panamá. Map by Ariel Beraha.

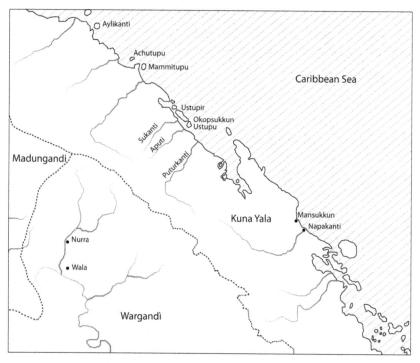

MAP 2: Enlarged area, Kuna Yala. Map by Ariel Beraha.

NOTE ON ORTHOGRAPHY

The Kuna language has been transcribed in several different alphabets. The system developed by Holmer (1947) has been used by academic scholars (Sherzer 2001 [1983], 1990; Howe 2002 [1986]; Salvador 1997). Another system of transcription is that of the missionary Jesus Erice (1980). In June 2004 the Kuna General Congress started a series of seminars in order to form the basis for establishing a common orthography for transcribing the Kuna language (see Price 2005; Orán and Wagua 2011). In this work I use the system of transcription adopted by Sherzer (2003).

All words in the Kuna language, *tule kaya*, are italicized throughout the text. Kuna personal names and names of places are not italicized. Singular and plural forms are transcribed according to the way Kuna people utter them. The suffixes -kana and -mala are used to pluralize nouns and adjectives. Some nouns take one form but not the other; other nouns can take either form. The main difference is that the form -mala is used to pluralize both nouns and verbs.

There are five vowels, which can be short or long (single or double), and the stress is usually on the penultimate syllable:

```
a: tala 'sight'; kaa 'hot pepper'
e: eye 'yes'; seet 'to lead'
i: mimmi 'little one'; tii 'water'
o: koe 'deer,' 'baby'; oo 'cough'
u: ua 'fish'; muu 'grandmother'
```

There are four voiced stop consonants:

```
p (pronounced b): ape 'blood'
t (pronounced d): tule 'people'
k (pronounced g): kurkin 'brain,' 'hat'
kw (pronounced gw): kwallu 'grease'
```

There are four voiceless stop consonants, which occur only in the middle of words, represented as long (doubled) versions of the voiceless consonants: pp (pronounced p): sappi 'tree' tt (pronounced t): satte 'not at all' kk (pronounced k): takket 'to see' kkw (pronounced kw): walikkwa 'close'

Nasals, liquids, and the r can also be short or long (doubled):

m: ome 'woman'; mimmi 'little one' n: nuu 'bird'; sunna 'real' l: sulu 'monkey'; pollekwa 'far' r: tarkwa 'taro'; serreti 'old,' strong'

There is a sibilant s and an affricate ch:

s: misi 'cat' ch: macheret 'man'

There are two semivowels:

w: war 'tobacco' y: maysa 'made'

Introduction

his book is an ethnography of wood carving and shamanism among Kuna people living on an island of the San Blas Archipelago, off the Atlantic coast of Panamá. By describing the relationship between shamans and their auxiliary spirits, represented by carved wooden

anthropomorphic figures, it explores the link between art and ontology. The main argument is that by inquiring into the visual system of a society, into the way people perceive the world and make sense of it in their daily life, we can gain better insight into their ideas about the social, the cosmological, and the person. This has two main implications: first, visual art is treated in this work more as a category of experience, a way of knowing, than as an aesthetic category. Second, visual art is examined through the category of the people who create it. By asking what it means to carve the figure of a person for Kuna people, different fields of experience of their lived world are explored. It is argued that Kuna categories of design and image are central to their conceptualization of the human person and to how they perceive the world. This work explores these categories through an ethnography of the everyday that focuses on Kuna discourses about what it means to be human.

Birth and death are the limits of human life. By considering how the person is constituted and how illnesses and death are conceived, it is possible to understand how Kuna people see the world and experience the immanent relationships binding together the beings living in it. These relationships are conceptualized and acted on through designs and sculptural forms, among other media. It is my aim here to show that the category of the visual and the capacity to see are key to the

process of becoming human among the Kuna. In order to properly understand what Kuna people mean by "visible" and "invisible" we need to unfold the experiential fields in which visual capacity has a prominent role. For this reason, in exploring the production and meaningfulness of Kuna ritual wooden statues, I place them at the center of the network of social relationships among people between themselves as well as with nonhuman entities. Carving wooden statues is an activity carried out by skilled elderly men. As I argue, it is through their embodied knowledge and lifelong experience of transformations that they mediate between mortal human beings and immortal primordial spirits, in order to cure and protect people from illness and death.

Kuna wooden sculptures, *nuchukana*, are protectors and helpers of Kuna people. They aid shamans in curing and diagnostic rituals and protect households against the penetration of malevolent spirits. They are powerful coresidents of Kuna people. They nonetheless differ substantially from human beings, primarily in that they do not have bodies. Although they can be met in dreams and engage in conversations with shamans, and sometimes even with nonshamans, their material form, visible to everyone in waking life, is only a temporary abode for the immortal soul that inhabits each of them.

This book argues that in order to talk about the visual experience that surrounds Kuna wooden figures and makes them meaningful for Kuna people, we have to explore their ontology; we have to look at the wider context in which the human person is considered to be constituted and within which people come to acquire their own knowledge of the world. In doing so, the ethnographic focus of this work is on the lived experience of people who engage in wood carving and shamanic initiation, which I chose as privileged roads leading to the understanding of the Kuna visual system. It is by focusing on the embodied lived experience of those who produce specific art objects that the meaning of those objects becomes known to the anthropologist. For Kuna people, as for most people who do not wish to develop an internal market for art objects, the meaning of art is intimately linked to the everyday experience of their lived world (Overing and Gow 1996).

Unlike the conception of Westerners, for the Kuna being invisible is not an intrinsic quality of any subject or object endowed with subjectivity; it is rather a quality of a relation between two subjects (Viveiros de Castro 2004). That which sees and that which is seen engage in a relation in which predation and reciprocity often modulate the encounter (Descola 1992). Similar to other Amerindians, Kuna people contend

that seeing what lies beyond the limits of normal visual experience is the field of what anthropologists call shamanism.² In the case of Kuna wooden statues, it is the visual capacity of 'seers,' nelekana, that enables them to see nuchukana in their real appearance as people, to converse with them and learn from them, whereas others are able to see only the carved wooden figure that hosts a primordial soul. Wooden statues act therefore as a boundary to human visual perception. In a similar way, bodies act as limits between the internal images of souls and external visual appearances. Human souls can be perceived detached from their bodies only in dreams, when they float free and meet with other souls.

The relationship between the visual appearance of wooden statues and bodies and their internal images stands at the core of the analysis carried out in the present work. This gives rise to a series of questions concerning the Kuna visual system. First, if the "invisible" internal form of a nuchu (pl. nuchukana) is what counts in the relationship with ritual specialists, why do Kuna people bother carving anthropomorphic figures at all? This process seems redundant if seen from the outside, especially since Kuna people, along with most Amerindians, think that objects (not to mention animals and plants) possess souls, which, regardless of their external appearance—be it stone, tree, or animal—is that of a person. My argument is that the effort of carving a human form for hosting a primordial soul has to be seen as a generative act, which, despite the impossibility of creating a human body out of a part of a tree, bears a resemblance to human gestation and birth. Similar to the birth of a human being, carving a nuchu is about giving an individual form to a generic soul, allowing it to acquire a personality through establishing relationships with other human beings.

The second question is, what is the relationship between designs and images? This question is a leitmotif throughout this book. Although it is indeed not fully answered, it opens a very interesting path of research that, as I shall suggest in the conclusion, points to a wider comparative field of research on Amerindian art. Let us now begin with a discussion of how this question arose during my fieldwork.

THE ETHNOGRAPHIC RIDDLE

Initially, I went into the field with the idea of studying the Kuna women's diverse cloth designs of their colorful blouses, *molakana*, sewn in a rather complicated reverse-appliqué technique. ³ *Molakana* are known worldwide and sold internationally. I became interested in *mola*

designs before commencing my fieldwork and dedicated my undergraduate thesis to the creation of analytical models for interpreting the cognitive processes followed by Kuna women when sewing their molakana (Fortis 2002). Then, once I started my Ph.D. studies, I decided to go to the field to observe what Kuna women actually do and say about their creative process. Unsurprisingly, I found myself in the awkward situation of not really knowing how to formulate my questions to Kuna women, most of whom did not understand what I was interested in. In fact, I slowly became aware that I was less and less confident about the nature of my interest. Sitting on the patios of their homes observing women sewing their mola, I often wondered how I had gotten myself in that embarrassing situation. Insisting on asking about the meaning of designs, I was clinging to my common understanding and sociohistorically informed ideas of art. My questions appeared to be meaningless to Kuna women, though were keen to show me their beautiful molakana and soon suggested that I find an elder man knowledgeable in Kuna ancient history and able to teach me about the origin of mola, about which the women seemed quite uninterested.

My frustration about not knowing what direction my research should go kept growing, until one day in May 2003, after three months of living in Okopsukkun, I gathered my courage and went to speak with Héctor Garcia, one of the 'chiefs,' saylakana, of the village. Despite my hesitance to interview one of the village elders, whom I pictured as reluctant to speak with foreigners, Héctor received me with an encouraging kindness. He actually proved to be a loquacious speaker. That day, while he listened to my questions about the meanings and origins of mola designs, he sat on his stool near the kitchen fire carving a small wooden stick, stopping at times to examine his work and to look at me. He was surrounded by baskets containing woods of various shapes, roots and vines, which he explained he used for the preparation of medicines. He patiently waited for me to finish formulating my questions, then took a nuchu from a basket and told me:

I've carved it. This is a *nuchu*. It's like a house. Now I'm going to explain to you. If, for example, gringo soldiers wanted to come here, first of all they'd need a house to stay in. They'd need a house to be built for them before coming here. Otherwise where would they stay? It's the same for the souls of trees. If I carve a *nuchu* they can come here from the fourth layer under the world. They come to help us, to protect us against illnesses.

Walking home after my conversation with Héctor, I kept thinking about what he had told me and about his nuchu. Although I could not make sense of his words, I felt a genuine interest in what appeared to me a completely different vision of the world. What is a nuchu? I asked myself. Why did Héctor describe it as a house? Thinking about these questions during my stay in Okopsukkun led me deep into the exploration of Kuna cosmology and specialist knowledge, which provides the ethnographic material on which the present analysis is based. What I did not realize then were the theoretical implications of Héctor's switch of topic from mola designs to nuchu figures. I now find it fascinating how he turned the topic so swiftly to his own familiar domain, that of wood carving, while I was asking him about the female activity of making designs. In addition to the gendered dimension of creating figures and designs, which is indeed relevant, Héctor's shift is a poignant example of the crucial importance of the relation between designs and plastic images, which is foundational to the Kuna visual system. This relation is so deeply embedded in Kuna ontology that I dare say that no shift of topic had been made at all from Héctor's perspective. All he did was to point at a solution for my problems. Héctor did not change the topic of discourse but its object.

Talking about images and designs is talking about two inseparable aspects of the same problem, like talking about the internal appearance of a *nuchu* and its external form. Images and designs are intimately interconnected aspects of Kuna experience, and they are constitutive of the human person itself. I argue that, far from only being visual categories, designs and images are existential categories for Kuna people. They refer to how the human person is constituted and how the world is perceived by Kuna people. It is to the analysis of these Kuna categories that this book is dedicated.⁴

IMAGES AND DESIGNS IN AMERINDIAN WORLDS

This is therefore not yet another study of *mola* designs, nor one on the aesthetic value of sculptural forms among the Kuna. It is rather a study of designs and images in Kuna ontology. The difference is radical, in that I do not aim here to give an outline of Kuna visual art, positing its de facto existence. On the contrary, I actively avoid circumscribing art within a specific domain of Kuna life, although I am forced by language exigencies and issues of comprehensibility to use such terms as *visual art* and sometimes even *aesthetics*. What I aim to do is to make

sense of the Kuna concepts 'design,' narmakkalet, and 'image,' the latter intended both in its tangible, concrete form, sopalet, and in its immaterial form, as 'soul,' purpa. Furthermore, the particular relation between the concrete image, nuchukana, and the immaterial image, purpakana, is the key to understanding wood carving without appealing to Western theories of representation.

The riddle that Héctor posed to me is not a simple one. However, I can appeal to earlier anthropologists who noted the same problem when they tried to describe the art of American Indians. That these scholars, some many years ago, noted something that still preoccupies people like Héctor today is proof of their research acumen and points to a wider and yet little explored problem concerning Amerindian ontologies.

Franz Boas (1955 [1927]) first addressed the problem of the relation between plastic figures and graphic designs in his famous study of the art of the Northwest Coast of America. He argued that figuration was not independent from the restraints of decorative art in the carving of totem poles:

When making simple totemic figures, the artist is free to shape its subjects without adapting them to the forms of utensils, but owing to their large size, he is limited by the cylindrical form of the trunk of the tree from which they are carved. The native artist is almost always restrained by the shape of the object to which the decoration is applied. (183)

When the artist desires realistic truth he is quite able to attain it. This is not often the case; generally the object of artistic work is decorative and the representation follows the principles developed in decorative art. (185)

For Boas decorative and figurative art were defined following the Western canon and therefore considered two hierarchically separate techniques. Figuration was the highest form of art. Nonetheless, he was able to observe ethnographically the irreducibility of Northwest Coast art to either figurative or decorative art, a problem that was later addressed by Claude Lévi-Strauss (1972 [1963]).

Alfred Kroeber (1949) elaborated this relation in his comparative study of South American art. Although his tendency was to project Western aesthetic values onto Amerindian cultures, he nonetheless noted a very interesting aspect of South American art:

Within the range of the merely decorative, and sometimes of the symbolic as well, the arts of South America frequently evince originality and fantasy. They are feeble in adding interest and skill in representation, which would have led to products like those of the Maya—or Egyptian and Chinese—in which lifelikeness, an approach to the realities of nature, is attained along with the successful retention of both decorative and religious expression. (411)

Besides the evidence of the absence of anything like the Northwest Coast totem poles in South America, what is remarkable is the coincidence of both Boas's and Kroeber's statements with respect to the prominence of decorative over figurative art. I wish to extend Boas's remark that "when the artist desires realistic truth he is quite able to attain it" to South American art, inasmuch as I reject the idea that Kuna people, and other Amerindians, are not able to attain figuration. What is interesting, in my view, is focusing on what Kuna people actually do instead of what they apparently do not do. Therefore, what Kroeber described as "feebleness in representation" could well be the clue to the distinctiveness of Amerindian art.

Lévi-Strauss demonstrated that the Amerindian aversion to figuration is in fact a nonproblem. In his seminal study of face painting among the Brazilian Caduveo (1989 [1955]) he showed that the opposition between the plastic form of the face and the designs painted on it, which are defined as "geometric" in the Western aesthetic tradition, is a powerful analytical perspective through which to look at Amerindian art. Lévi-Strauss cogently argued that face and design are inseparable aspects of the person, and each one cannot be conceived as separated from the other: "In native thought . . . the design is the face, or rather it creates it" (1972 [1958]: 259; original emphasis). In the same essay, "Split Representation in the Art of Asia and America" (245–268), he showed that the opposition between graphic and plastic is a much wider problem, and it is key to understanding Amerindian art.

Following the lead of Lévi-Strauss, Gow (1989) showed that the opposition between designs and images is widespread among Amazonians, although it still needs to be addressed ethnographically. The recent work of Lagrou (2007) on the Cashinahua is one of the most complete analyses focusing on an Amerindian design system. The richness of her ethnography is key to her exploration of the Cashinahua visual system, where designs are the main medium for communicating with nonhuman agencies and fabricating beautiful human bodies. La-

grou also demonstrates how the categories 'design,' kene, 'figure,' dami, and 'image,' yuxin, are central to Cashinahua experience of the world. As a Cashinahua woman cogently explained to Lagrou, "Designs are the language of yuxin" (2007: 119). Although Amerindian concepts of designs have been richly explored (Reichel-Dolmatoff 1978; Gebhart-Sayer 1984; Guss 1989; Gow 1999; Lagrou 2007; Fortis 2010), indigenous conceptualizations of plastic forms remain little studied. Barcelos Neto's fine work (2002, 2008), on "plastic cosmology" and the rituals of masks among the Wauja from the Upper Xingu (central Brazil), is a rare exception.

Another exception is Eduardo Viveiros de Castro's work on the Yawalapíti (1977, 2002). Much of his ethnographic analysis of the experiential categories of the Yawalapíti is devoted to the relationship between what he defines as the archetypical model of each living being and its actual form in the everyday life. The Yawalapíti experience this relationship as a series of differences hierarchically organized along a continuum, which ranges from the archetypal mythic beings, living a separate life and unreachable by human beings, to their earthy, and inescapably imperfect, actualization. Each species, including human beings, has a prototype that was created in mythic time and that stands for the species in general. Individual living beings are the actualization of such prototypes. This is also illustrated in myths, which describe how Kwamuty, the creator, fabricated the first human beings using the wood of a tree. In so doing, Kwamuty made, as it were, the first replica from the original, creating an "actual" being, inutaya, from the "original" model, umañi. "As a matter of fact, Kwamuty made the prototype of 'making': he transformed tree trunks into the first human beings" (Viveiros de Castro 1977: 123; my translation). Viveiros de Castro suggests that the slippage between symbol and referent is a pervasive feature of Yawalapíti thought and is subsumed to the relation between archetype and actualization (122). Any actualization, he argues, is always a weaker replica of the original for the Yawalapíti. Similarly, for the Cashinahua, a drawn 'figure,' dami, looks less like its model than a real 'image,' yuxin, which is intended as the immaterial double that each living being possesses (Lagrou 2007: 116).

It seems to me that the Yawalapíti idea of the original act of creation as an act of replication—defined by an incommensurability between original and replica—is a suggestive description of what is a sculpture for Amerindians, which helps us to understand Kuna ideas about the nature of images and figuration. I argue that the non-iconic nature of images lies at the core of the Kuna visual system, as well as that of other

Amerindians (cf. Viveiros de Castro 2009). Although this may seem a bold statement, I endeavor to demonstrate its validity in the course of this work. I will refer to the case of mortuary rituals and the use of wooden logs to represent deceased people in the Upper Xingu region of central Brazil, where the Yawalapíti and other indigenous people live. Through this comparison I will argue that the carving of nuchukana is linked to the idea of the irreversibility of death. In carving images of a person, Kuna people rehearse the incommensurability between the living and forms of alterity. It is by acknowledging this ontological distance, at the core of Kuna sociocosmological theory, that we can make sense of their visual art. By mastering the process of giving shape and transformation, Kuna carvers and ritual specialists become able to establish power relations with immortal beings, seeking their help to cure illnesses and prevent death.

The difference between an image and what it is an image of is at the core of Kuna ontology, similar to saying that for the Yawalapíti a symbol is always different from its referent (Viveiros de Castro 1977: 122). This, I suspect, is not caused by an ambivalence intrinsic to the cognitive process of representation, as Goody (1997) would have it (see also Gell 1998: 97–98), but it has its roots in the reflection of Kuna people on life and on the irreversibility of death. My point is that carving images of a person for Kuna people is an act that instantiates a reflection on the human condition, which is defined by birth and death and by the interaction with forms of nonhuman alterity. By the same token, carving a nuchu is a declaration of alterity from death and the establishment of identity for the living. By replicating the original act of creation, through which immortal tree beings were created, wood carving establishes the difference between mortal and immortal beings.⁵

This artful process is aimed among Kuna people at curing illnesses, which is the opposite of dying. Curing is in fact a process through which the person has to be recomposed in its unity. It is the unity of the human person, achieved through the fabrication and maintenance of proper human bodies (cf. Seeger et al. 1979; Vilaça 2005), that requires a skilful balance between soul and body, between internal forms and external appearances, in other words, between image and design.

IMAGES, DESIGNS, AND THE KUNA PERSON

This book argues that the relation between designs and images lies at the core of the Kuna theory of personhood. Kuna people consider persons as formed by elements that have their own independent life in the universe, which are then transformed and molded into human bodies by adult people. The Kuna theory of visual art is therefore identical to their ontology; it provides people with categories to know the world. Concepts such as image and design are embedded in social praxis and not just abstract ones. Images and designs are not categories of the aesthetic; they are category of praxis (Fortis 2010).

For this reason I frame my analysis around the Kuna concepts of image and design as minimal categories of Kuna visual art.⁶ Although in this book I focus on Kuna wooden figures, with some attention to canoe making and design, there are other forms of visual art in the Kuna lived world. Basket weaving, carving of stools and other objects, clay molding, and beadwork are important activities in the everyday life of the Kuna. The Kuna people I met directed me to those forms that seem to concern them the most and thus provide the best objects for an analysis of their visual system. Kuna verbal art has been studied extensively by Sherzer, who has produced illuminating analyses of the integration of verbal forms and social life (1990, 2001 [1983]). In this work I deal exclusively with those categories of human experience that inform Kuna ideas about visual capacity. For this reason I do not endeavor to integrate visual and verbal art into a wider field of aesthetics, which would require further ethnographic research.⁷

Similar to Munn's discussion of the Walbiri, Kuna women's designs, molakana, are the objectification of the subjective experience of Kuna women (1973: 94).8 Nuchukana are instead the outcome of the male equivalent of female fertility. In each of these two activities-sewing designs and carving figures—one category is concretized at the expense of the other: carving the figure of a person means to produce the generic representation of a gendered person; sewing designs manifests the individual praxis of each woman. Male and female nuchukana are carved to represent their general gendered attributes but without any of the specific features that would render them similar to an individual living being. Carving a nuchu points to the basic principle that each living being shares the same original, or true, form, which is that of a person. By the same token, a nuchu is the instantiation of an impossible form, at least from the perspective of human beings. It instantiates the immortal dead that are ever different from the living, for they lack the basic attribute of the latter: the human body. Nuchukana are self-different figures; they are different from themselves, insofar as they lack external features by means of which to abduct their internal forms. Like Yanomamy xapiripë spirits, they are not iconic images, although, unlike

them, they are visible in normal waking experience (Viveiros de Castro 2009).

The realization of designs by Kuna women is part of the wider process of making oneself visible within the network of social relations.9 Making mola designs and carving nuchukana are aspects of the life trajectory of a Kuna person who develops his or her own praxis during the course of a lifetime. In this work, I do not focus on mola as such but instead on designs, of which molakana are an instantiation (cf. Lagrou 2007: 81). To this end I explore the category 'design,' narmakkalet, and the concept 'beautiful,' yer tayleke, which tend to coincide for Kuna people, insofar as what is beautiful is compellingly decorated with designs and attracts the gaze of humans and nonhumans alike (cf. Gell 1998: 83-90). On the other hand, what is 'ugly,' kachar tayleke, has the effect of repelling the onlooker. Seeing means to get close and grasp one's inner self, as composed by a self and an Other, the human and the nonhuman, animal, component of the person. It is by appreciating the mixed composition of newborns that adult kinspeople are able to create new human people through the transformation and neutralization of the nonhuman side. Becoming visible is thus coextensive with becoming human, that is, being visually available to establish social relationships with other human beings. According to the Kuna, it is by reaching a balance between the internal and the external form that real human persons are created.

ON THE KUNA

The curiosity of Baron Erlan Nordenskiöld was attracted by Kuna wooden statues during his expedition in Panamá in 1927. His descriptions of *nuchukana* are accurate and reliable and give details on the rituals in which they are involved (Nordenskiöld 1929, 1938). He returned to Sweden with a few exemplars, which are now kept in the archives of the Museum of World Culture (Världskultur Museet) in Göteborg. Nordenskiöld considered the possibility that *nuchukana* were the representation of Christian saints, and with this idea in mind he compared Kuna wooden figures with the ones created by their neighbors, the Emberà, living between Panamá and Colombia (1938: 423–426). However, his analysis remains conjectural, and he did not develop it further, nor did he visit the Kuna again after his first trip. On *nelekana*, or seers, Nordenskiöld received reliable information from his Kuna informant, Ruben Pérez, who was secretary to the Kuna chief and seer Nele Kan-

tule, political leader of all the Kuna during the first half of the twentieth century.

Another invaluable source of comparison for the present work is the ethnography of Chapin (1983, 1997), which provides a wealth of detailed information on Kuna cosmology, personhood, and rituals. Moreover, I use some versions of Kuna myths that Chapin collected and translated into Spanish during the late 1960s when he was living in Kuna Yala as a Peace Corps volunteer (1970, 1989).

Severi (1981a, 1981b, 1987, 1993, 1997, 2000), in his extensive study of Kuna conceptions of suffering and memory and of the pictographic representation of curing chants, often describes *nuchukana* and *nelekana*. Moreover, Severi provides useful insights on the concepts of *purpa* (soul, image) and *kurkin* (brain, intelligence), which I focus on in the course of this work, through my own ethnography (see especially chaps. 4 and 5).¹⁰

Taussig (1993) focuses on *nuchukana* as the privileged object of his inquiry on the mimetic faculty. His study concentrates on the way Western imagery is perceived by Kuna people—and, he argues, by colonized people in general—by focusing on one aspect of *nuchukana* previously noted by Nordenskiöld (1938) and later by Chapin (1983), namely, the representation of European types in Kuna wooden figures. Taussig argues that Kuna people aim to abduct the power of white people by representing their image in their wooden statues. He reaches the conclusion that the power of *nuchukana* resides in the fact that they are copies of white people. Although Taussig addresses the interesting problem of the representation of white people in Kuna sculptures, he fails to address the two main issues arising from it: What do white people represent for the Kuna? What is an image for them?

As for the first question, this has been already addressed in part by Severi (1993), who studied the healing song for madness, *nia ikar*, and argued that for the Kuna the evil spirit that causes people to become ill, Nia, is associated with the historical figure of white people and their disastrous encounter with Kuna people. Severi thus argues that madness, the most dangerous form of other-becoming, is conceived today by the Kuna as a transformation of the self. I wish to suggest that white people should be understood as one, perhaps the most distant, form of alterity for the Kuna, although this does not constitute directly the topic of the present work. This of course poses problems for Taussig's thesis on the mimetic faculty applied to Kuna ontology. Although his argument is an interesting digression on Benjamin's reassessment of mimesis, I suggest it does not shed much light on the Kuna theory of images.

As might already be evident, the position that I adopt in this work is to follow Kuna categories as closely as possible, using only them to understand the world as they see it. In so doing, I come to a different conclusion from that reached by Taussig. It is not by looking at what they allegedly represent (although I maintain that the "white people problem" is an interesting one) that we might be able to understand Kuna wooden sculptures11 but by looking at what they are not, or what they are the transformation of. As I noted above, by being an instantiation of human mortality, Kuna wooden statues are a representation of absence. It is by being the negation of the very possibility of representation that nuchukana establish their own agency in the world. It is therefore by focusing on the fullness of human life that I will carry out my ethnographic analysis of Kuna wood carving. I consider birth and the coming into being in the world as key moments to understanding Kuna concepts of the visual. I also argue that the concept of humanity must be the focus of any study that chooses art as its object—a far cry indeed from mimesis.

In addition, I find it more appealing and realistic to think that Kuna people themselves chose what they found appealing about foreign colonialists. I do not think that the Kuna consider white people appealing tout court, even less that they want to become white (cf. Taylor 2007). I rather think that it is analytically significant to start from the idea that Amerindian cosmologies were already open to alterity when Europeans so abruptly appeared on the scene (Lévi-Strauss 1995). It is exactly the transformability of Amerindian lived words (cf. Gow 2001) that so easily tricks the observer into recognizing some familiar aspect. By the same token, I find, and I am not alone, that it is important to explore what indigenous people do and say, as their own personal and distinctive point of view on life, and to focus the attention "from start to finish" on indigenous voices (Overing and Passes 2000: 2). This has powerful implications, which, if we refrain from seeing fake reflected images of ourselves where they do not exist, might provide new insights into the variability of human nature.

SEERS

A few Kuna villages are located on the mainland; the majority are on small islands close to the coast, each with a population ranging from a few hundred to four thousand individuals. Other villages are situated in the interior of the region and in the Darién forest, and there are two villages in the Colombian territory on the Gulf of Urabá. About

35,000 Kuna live in the Comarca Kuna Yala, which comprises the San Blas islands and a narrow strip of coastal land stretching westward for more than two hundred kilometers from the Colombian border. Another 25,000 Kuna live between Panama City and Colón. The language of the Kuna, *tule kaya*, although still a matter of debate, is considered affiliated with the Chibcha family (Constenla Umaña 1991; Holmer 1947; Sherzer 1997).

When entering a Kuna house, one is struck by the strong contrast between the bright sunlight outside and the darkness inside. The eyes slowly become accustomed to the dim light of the interior and begin to discern the shapes of the objects and persons. Hammocks hang between the main horizontal poles; one bed is positioned in one sector of the house separated by a cane wall. A wooden trunk supported by four legs is along the cane wall; wooden stools and plastic chairs are scattered around. A small table, used by children for their homework, is in a corner. Plastic buckets used to preserve various kinds of objects from the dust and the saline air line the walls. Clothes hang from cane sticks attached to the roof with lines that can be pulled down when necessary. A Singer pedal sewing machine is positioned close to the door, where some light comes in. During the day the house is relatively calm and silent as the members of the extended family spend most of their time in the kitchen, a separate hut, and on the patio.

At the foot of one of two main posts, one can distinguish, with some difficulty, a plastic box containing a tight group of small, carved wooden statues standing upright one beside the other. They are the *nuchukana*, the anthropomorphic figures carved by elderly Kuna men, used in healing rituals and kept in each house as protection against evil spirits. These small wooden statues measure between five and thirty centimeters and represent both males and females. On the occasion of the celebration of village-wide healing rituals special statues more than a meter tall, called *ukkurwalakana*, are carved in balsawood. These lose their vitality at the completion of the ritual and are either discarded or, more rarely, kept on house patios as decorative items.

Despite their difference in size, nuchukana and ukkurwalakana are similar in appearance; they are standardized representations of the human figure with few details to represent their gender. In general they are quite roughly made, with scant attention to details. Indeed, depending on the type of wood used for carving and its hardness, different levels of detail can be achieved. However, as I discuss in chapter 3, Kuna people value the properties of each tree more for their spiritual

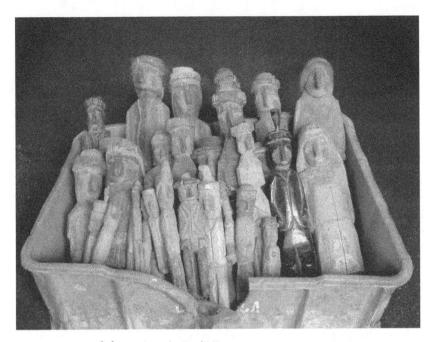

FIGURE 0.1: Nuchukana. Photo by Paolo Fortis.

impact on curing processes than for their material properties. Characteristically, almost all statues are upright figures, standing with arms stretched along the torso, slightly bent legs, and looking forward. This straight posture is likely to be connected to the shape of the wooden stick from which the figures are carved. Similar to the Northwest Coast totem poles, the cylindrical shape and the size of each wooden log poses the external limits of the carved figure. No external parts are attached to the branch or root used for the carving, in order to make limbs or items of clothing. Figures with spread legs or arms are rare, but these are made using already bifurcated branches (like a reverse Y shape) that lend themselves to this particular posture. Sometimes *nuchukana* might in fact be referred as *suarkana*, 'sticks,' or *mimmisuarkana*, 'little sticks.'

The features of the face are sketchy. A prominent straight nose is the hallmark of every *nuchu*, and it is attained by carving out the rest of the face, which results in a flat surface where sometimes little holes are incised to host the glass beads that represent the eyes; the mouth is almost never represented. Male figures are normally carved wearing a flat-topped hat, a shirt, sometimes with a tie, and trousers. Fe-

male figures are made wearing a headscarf going down to the shoulders, a shirt, and a long skirt. The shape of the breasts is often visible. Sometimes the clothes are painted with artificial colors and the cheeks colored with makep (Bixa orellana). A few of the figures also wear bead necklaces across the neck and torso, similar to those worn by Kuna curing specialists symbolizing their healing capacities. All the nuchukana in each house are kept together in the same box, called ulu, meaning "canoe." Together they form a quite homogeneous ensemble, regardless of differences in size and style of carving, with some being older and more deteriorated than others. Despite or perhaps because of their importance in Kuna daily life, nuchukana are kept relatively out of sight, and it took me a few months to notice their presence in almost every household.

One of the first definitions of nuchukana that I received was that they are nelekana, or seers. They are powerful, knowledgeable beings, able to cure illnesses by confronting the pathogenic entities of animal beings, ponikana, and demons, niakana. Despite their nonhuman nature, they might be valiant helpers of Kuna people. To this aim ritual specialists have to befriend them, and members of the family have to establish commensal relationships with them. Literally each nuchu, after having been carved by an elder specialist, has to be incorporated in the household by the people who will look after it and seek its protection. Normally it is the 'grandfather,' tata, who sings chants during the night to speak with his nuchukana and greet them, or who calls them in the afternoon when he sits at the table, inviting them to join the meal. The 'grandmother,' muu, puffs tobacco smoke from a pipe or a cigarette on nuchukana to refresh and strengthen them. All these quotidian acts show nuchukana that the people living in the household "remember" them and think of them.

We can therefore say that human beings and nuchukana are effectively coresidents. Despite the ontological alterity of nuchukana, their power and agency might be harnessed for the sake of humans' protection against forms of predator alterity, such as that of ponikana. Crucial in the process of mediation between people and nuchukana is the figure of the nele proper, the human seer, who by virtue of his capacity to see is able to establish direct relationships with nuchukana. In this work I therefore focus on the relationship between nuchu and nele, which I argue is vital in shedding light on Kuna sociocosmological preoccupations and understanding the interplay between the visible and the invisible in Kuna ontology.

Nelekana are born shamans who are able to see animal and tree en-

tities in dreams. In developing their capacity to see through initiation ceremonies, nelekana become able to see illnesses within the human body. Among the Kuna ritual specialists, they are the diagnosticians of illness. The curing of illnesses, on the other hand, is then performed either by a 'medicine man,' ina tuleti, who is expert in the preparation of plant medicines, or by a 'ritual chanter,' api sua, who knows the healing 'chants,' ikarkana. The major skill of nelekana is therefore that of seeing beyond the limits of the visible, to which normal people, including the other categories of specialists, are bound. They learn to see and to control their dreams in order to interact with supernatural entities and to learn their ancestral knowledge. This knowledge may then be transmitted to other curing specialists or directly used by nelekana to cure ill persons. A nele may be consulted when a person becomes ill, to discover the cause of the illness, or when epidemics spread in a village. In the latter case, once the nele has discovered the cause that afflicts the entire village, he helps the api sua in the performance of an eight-daylong collective healing ritual, called nek apsoket, to rid the village of the presence of malevolent entities (cf. Howe 1976a).

Kuna people are clear in saying that *nelekana* are different from other ritual specialists because they are born with a particular gift that renders them able to see nonhuman entities in dreams as people. This distinction by birth is manifested by the fact that *nelekana*, different from other babies, have no designs on the remains of their amniotic sac at birth. The absence of what I call amniotic design is the index of the *nele*'s shamanic capacity. This, as becomes clear in the second part of the book, is a striking example of how Kuna people think of the formation of the human person through a rather elaborate theory of the body that emphasizes its visual appearance. Amniotic designs are innate in the sense that they are "the visual instantiation of designs as entities in the world" (Lagrou 2007: 81). Their invisibility is an equally revelatory sign, as it points to the powerful, not fully human nature of the *nele*, which indeed gives him visual access to cosmic transformations.

I would like to point out at this point that throughout my work I refer to the *nele* as a male person, a he. This does not mean that there are no female *nelekana*; in fact, there are many. Kuna people always emphasize that only male *nelekana* are born *nele*. Women may become *nele* once they are adults, and this happens as a result of being pregnant with a *nele* son (see chap. 5) I have chosen throughout my work when I speak in general about seers to focus on the "ideal figure" of *nele* from birth as a male, as Kuna people described it to me. In several chapters I discuss individual cases of female *nele*.

AMONG THE KUNA

Until now, an ethnography that focuses on wood carving and shamanism among the Kuna has not been undertaken. This work is an ethnographic account of the Kuna people's lived world as I came to know it, living in the village of Okopsukkun between March 2003 and November 2004. Like the majority of Kuna villages in the Kuna Yala district of Panamá, Okopsukkun is situated on an island a short distance from the coast. The island is occupied by two independent villages, Ustupu and Okopsukkun. Although the border between them is not noticeable to foreign eyes, the division is clear in terms of administration and population.¹²

On my first visit to Okopsukkun I landed in a small aircraft at the small airport on the mainland coast. I then crossed the channel to the island by canoe with an outboard motor. I did not know at that moment how many times I would make that same trip, paddling in a dugout canoe, with a Kuna friend, back and forth from the island to the mainland forest.

Arriving from the sea, the sight of the densely inhabited island, one house attached to the other, was completely different from what I had seen from the airplane. Before reaching the island, I was struck by the incredible silence—except for the humming of the motor. Once I got to the island the picture changed completely. A crowd of people, mostly children, was waiting for Margherita—my partner and fellow anthropologist—and me in front of the house where we would live for the first period of our fieldwork. Margherita had already been living in Okopsukkun doing fieldwork for two months before my arrival, and thus everyone was already aware that her 'partner,' we sui, was about to arrive as well. Our luggage was instantly taken inside the house, and I soon found myself seated with a glass of matun, a sweet plantain drink, in one hand and bread in the other, attentively observed by a crowd of children.

In the months after my arrival in Okopsukkun I slowly learned how to adjust to the new style of life. I got rid of my shoes and many unnecessary clothes, and I soon bought a pair of rubber sandals sold by the Colombian traders who constantly travel along the Kuna islands. I learned how to eat *tule masi*, 'people's food,' by putting a pinch of salt and some chile on a corner of the plate, then with a spoon mixing alternating bites of plantain and fish. I learned to take three or four showers a day, with the fresh river water that, thanks to the aqueduct, ar-

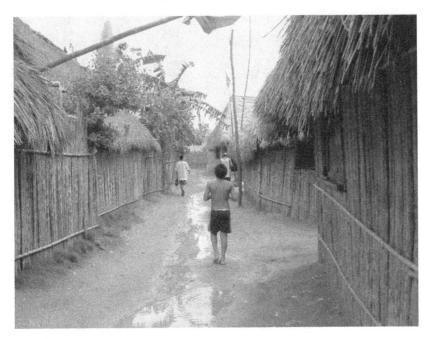

FIGURE 0.2: Pathway in Okopsukkun. Photo by Paolo Fortis.

rives, although quite irregularly, in each house. I learned to be ready by half past six in the evening, dressed in long trousers and a shirt, to go to the 'gathering house,' *Onmakket neka*, where the chiefs sing long mythic chants, describing the creation of the world.¹³ After two months I learned to wake up at five o'clock in the morning to cross the sea channel by canoe and get to the mainland forest. My first trip to the forest was with Beatriz Alba, a Kuna grandmother in her sixties who volunteered to accompany me to the forest to collect mangoes after she noticed that I was snubbed by most of the men. After that first experience I realized that I needed a pair of rubber boots, which all Kuna men have. But I had to wait for my next trip to Panama City to buy them, for it was impossible to find boots my size on the island or from Colombian traders. I felt very proud when I went back with my new boots and my new machete. However, it would be some time before I realized how hard the daily work of Kuna men is.

Kuna women spend most of their time in their houses, preparing food and drink, sewing *molakana*, attending the morning meetings in the gathering house, and visiting their kinspeople. Men travel almost

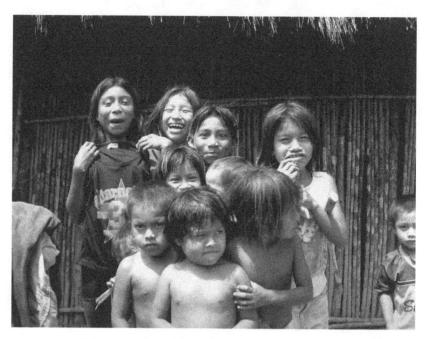

FIGURE 0.3: Children in Okopsukkun. Photo by Paolo Fortis.

every day to the forest, leaving at dawn and usually returning at midday. When they do certain kinds of gardening work, such as felling trees or sowing and collecting maize, they may stay away until late in the evening, sometimes until the next day. Accompanying Kuna men to the mainland forest to collect food, such as plantain or manioc, I soon realized that every man works alone most of the time. Except for felling trees and gathering maize, which are often done by groups of men, and except for working in the few big gardens that are cultivated collectively by the adult men of the village, gardening is an individual activity and requires skill and knowledge of the forest, its plants, trees, and animals. Most of all, it requires the energy of young men who alone carry great quantities of crops for long distances and then paddle back to the island, where their wives wait for them ready to bring the crops into the house and start preparing food.

Besides being gardeners, most Kuna men are fishermen, procuring their families' daily meal. They mostly fish in the sea near the island, usually with a simple line and a hook. Few people in Okopsukkun possessed fishing nets or an outboard motor during the period of my

fieldwork, which would allow them to catch great quantities of fish in the nearby Sukkunya gulf and sell it to other people. Fish and garden crops provide the daily food for each family, which is supplemented by and sometimes substituted with the products bought in the small local shops (Sp., tiendas) or by Colombian traders, such as sugar, cocoa powder, rice, pasta, and canned fish.

Although I had many occasions to travel to the mainland forest, I unfortunately never learned how to be a gardener and to procure the food to take home. Our Kuna friends used to laugh at me, saying that I was not a good companion for Margherita as I was not taking good care of her by working in the forest. But then they also added that as we had no children yet I still had time to learn.¹⁴

On one occasion I went to the forest with Garibaldo del Vasto, a Kuna medicine man in his fifties. Garibaldo decided to take me on a practice lesson to show me how he worked in the forest collecting medicines. That was probably the most amazing experience I ever had while living among the Kuna and remains vivid in my memory. We set out early in the morning with one of his sister's sons, who was his apprentice. After paddling for two hours we reached the coast at a place east of the island, close to the gulf of Sukkunya. We left the canoe among the mangroves and continued on foot. We walked in the forest for more than eight hours, during which Garibaldo never stopped talking to me. He explained almost everything he was doing, from the ways in which he cut the bark from trees to collecting medicines; he told me the names of the trees, vines, and shrubs as we walked along. He showed me his gardens, told me whose garden he helped to clear of trees in the past, and showed me the gardens of other people we passed by, commenting on the way they were looked after. He stopped to listen to the cries of animals, telling me which animals they were. He showed me how he put together different types of plant medicines in his baskets, depending on the medicine he wanted to prepare, in order to be able to recognize them once back home. He told me the names of the rivers and explained to me, while we were bathing, that the river water is filled with the properties of the plants that grow on its banks.

Then, on the way back to the canoe, he stopped at a huge tree, an *ikwawala* (*Dipteryx panamensis*). He took his machete out and started cutting off one of the exposed roots at the base. He cut out a piece of root about thirty centimeters long, sat on a stone, and started removing the bark. Once the inner white wood was exposed, he made a cut

on one side of the log, close to one extremity. He looked at me and with his usual pedagogic grin said, "You think that what I'm doing is for fun, don't you?" Then he put the log in his bag, along with the other roots and vines collected during the day, and we set out on our way back to the island.

ONE

Island, Gardens, and Ancient Trees

lmost from the moment I arrived in Okopsukkun in March 2003, I realized how important the forest is for Kuna people living in this insular village. Although a separate space from the 'island,' tupu, where people live, the 'forest,' sappulu, is ever present in people's dis-

courses—when they speak of food and medicines, as well as animals, plants, and powerful entities. The other space Kuna people refer to in everyday life is the 'sea,' temar, which provides fish and is also host to a large number of nonhuman entities. Both realms are important in Kuna life as sources of sustenance and nonhuman agencies. Therefore, both the forest and the sea are the object of Kuna taxonomic preoccupation and observation. In this chapter, as well as in the book, I concentrate mainly on Kuna ideas about the forest and the way people conceive of it as a space inhabited by a great number of entities and species. There are two reasons for considering Kuna ideas about the sea tangentially in this work: one is dictated by my ethnographic focus on the production of wooden ritual statues and on the life course of seers, which compels me to explore the forest more than the sea; the other is the overwhelming importance that forest animals and plants have in Kuna mythology, cosmology, and everyday practices.¹

Every day Kuna men travel by canoe to the coastal forest to bring back crops, plant medicines, and rough materials used for making objects such as baskets, water bowls, stools, and fire fans and for building houses, such as poles, canes, and palm leaves. Among the rough materials Kuna men bring back to the island are wooden logs, which are used to carve *nuchukana*. Thus there is a constant flow of crops and medicinal plants from the forest to the island. The former are edible plants and as

such are dead; the latter are conceived as alive. The latter are used for curing purposes by Kuna curing specialists, who bring them to the island and activate their power. According to the Kuna, the mainland forest is the space inhabited by animal and vegetal species and their entities, as well as by a variety of spirits and demons. The island is the space inhabited by 'human beings,' tulekana,³ with the exception of nuchukana, which retain the agency of living trees.⁴ The opposition of forest and island is marked by the contrast between the mainland, the site of the forest and gardens, and the island, which is crowded with houses and where hardly any trees are present.⁵

Furthermore, as I point out, another distinction is made by Kuna people—between cultivated and uncultivated plants in the forest. This distinction is relevant to understanding how Kuna people conceive the relationship between human beings and animal and plant species. Thus there is both a physical distance between the island and the forest and a qualitative one, marked, among other things, by the presence of trees on the latter and their absence on the former.

Kuna people moved to the islands of the San Blas archipelago quite recently, between 100 and 150 years ago. Previously they lived on the coast in small villages near the mouths of the rivers descending from the San Blas Range to the Caribbean Sea. Before that, Kuna people were living in the Darién forest, between the territories of Panamá and Colombia. Kuna oral history confirms the fact that they came from the Darién forest and their place of origin is Mount Takarkuna (Takarkunyala), located near the Colombian border.6 For various reasons, among which are the clash with other indigenous peoples (most likely the ancestors of the present day Emberá-Wounaan) and the pressure of Spaniards, they split into small kin groups and started establishing villages along the banks of the rivers. Following the rivers, scattered groups of Kuna reached the Atlantic coast, arriving in different locations along the length of the coastal strip that today, along with the islands, forms the territory of Kuna Yala.7 There they established more permanent villages at the mouths of the rivers, from which the sea was easily accessible.

By the end of the nineteenth century, most villages had moved to the islands located near the mouths of rivers, where fresh water could be taken. This migration did not occur at the same time for all Kuna villages; some villages remained on the coast, where they still are today.8 The reasons for the movement to the islands may have been various; one hypothesis is the good location they provided for trading with

foreigners (Tice 1995: 36). People from Okopsukkun told me that when they were living near the mouth of the Puturkanti River many children died of malaria. They decided to move to the island in 1903, where they had already established coconut plantations. Then, with progressive demographic growth, houses replaced the coconut groves and the entire island was used for living, while coconut cultivation continued on the nearby islands of Ustupir and Kusepkantup as well as on the coast.

Given this, it is easy to understand the symbolic and material importance of the forest in Kuna life, as the place of origin. The value attributed to the forest in everyday discourses is related to the fulfillment of two basic needs: the production and collection of food and the provision of medicines. Kuna people consider both needs basic to the growth and survival of each individual and thus of the group. Eating forest food and using plant medicines found there are essential aspects of people's everyday lives, which allow people to grow into strong and intelligent adults.

Food is cooked and eaten in the proper way and is referred to as 'people's food,' tule masi. Meals consist of a boiled soup with grated coconut, one of the many varieties of 'plantains,' machunnat, sinamas, waymatun; 'manioc,' mama, or other tubers such as 'yam,' wakup, and 'blue taro,' tarkwa, and of a boiled, smoked, or sometimes fried fish from the sea. More rarely, instead of fish, game meat is eaten, but hunting is not often practiced, and few people in Okopsukkun had rifles during my fieldwork. Tule masi makes people strong and able to work both in the forest and in the house. It builds human bodies and makes people 'happy' and 'healthy,' yer ittoke. There was always a strong rhetoric in favor of tule masi by adult and old people in Okopsukkun, who always stressed that they had all they needed from their land. Old men particularly used to tell me that unlike in Panamá, they do not have to go to the supermarket to buy food; they need only to work in the forest, and they can have whatever they desire.

Moreover, they always pointed out that their food was better than city food, because it came directly from the forest and did not remain in plastic boxes or in tins for many days, as the food eaten by strangers. When a family is short of fish, they buy canned fish (usually mackerel), which is sold by Colombian traders or in small Kuna shops. They mix this with rice or make a soup, but this is not considered proper food. As women used to tell me, laughing, "This is *ua non satte*, 'headless fish,'" stressing the odd nature of fish that comes from tins. Often Margherita and I were asked about what we eat in our place. When we

explained that our main meal consisted of pasta (macaroni in Spanish), they grimaced, commenting that that was machunnat suli, meaning "not real food," but food contained in plastic. For this reason they said we were weak and unable to bear their daily work routine. This last comment was not limited to alimentary habits, but the difference between us and them was also imputed to another important factor: strangers do not know plant medicines. As stated above, food and plant medicine has the same importance in Kuna life. Plant medicines are used for various reasons: for curative purposes, for strengthening the body, enhancing one's fertility, developing one's intelligence and skills, and intervening in other people's lives. An elder Kuna chief from Okopsukkun stressed the importance of forest plants and medicines:

Our forefathers lived on the mainland along the banks of the great rivers in the mountains before they came to know the sea. The rivers were places that they chose for their dwelling places. Our fathers were strong because they were nourished by the plants and trees that surrounded them. . . . The rivers touch the roots of many medicinal plants and therefore we have akwanusagana [magic stones]. This is why the old people then were much stronger than the men who live on the islands today. (Cacique Enrique Guerrero, quoted in Ventocilla, Herrera, and Nuñez 1995: 3)

Therefore tule masi, 'people's food,' and tule ina, 'people's medicine,' are the basic ingredients of Kuna people's specific sense of humanity, and both link people to the forest. Being islanders, it must also be said that Kuna people rely heavily on sea resources such as fish, which is part of their everyday diet. Nonetheless, for a complete meal, plantain or other vegetables are needed. Margherita and I saw fasting while living in Okopsukkun, when our hosts had fish but not plantain, manioc, or blue taro. In those cases the fish was smoked in order to be consumed later on. Fish, the islanders said, does not provide a full meal and is never consumed alone; you cannot make tule masi without masi.11 Machunnat (Musa paradisiaca)—from masi, 'food,' plus sunnat, 'real,' 'proper'-is considered the most appealing among plantain species. However, most meals in Okopsukkun were cooked using other varieties of banana, such as sinomas and waymatun, which, I was told, grow quicker and yield more fruits. If it happens that fish and plantain are scarce, people might buy and eat rice and canned fish; but this will not make them happy and satiated, as tule masi does.12

TAXONOMY OF SPACE

The first distinction in terms of lived space is that between island and mainland, respectively in the Kuna language tupu and sappulu or yala. The relation with the mainland is one of distance and separation. On the one hand, Kuna people speak about the mountainous region near the Colombian border as the place they came from. They speak about Mount Takarkuna as the place of their ancestors, from which they departed to eventually reach the Atlantic coast. On the other hand, Kuna people often refer to the mainland forest in terms of fear and anxiety; the forest is the place where most dangerous and frightening encounters occur and where evil entities are at play.¹³ Despite this, I am aware that some aspects characteristic to Kuna people living in Okopsukkun may differ from those of Kuna people living in the coastal communities of Kuna Yala, in the few villages situated in the Madungandí and Wargandí mainland districts, or in the two villages in the Colombian Urabá Gulf, Caimán and Arquía (cf. Calvo Buezas 1990). Although the distinction that I found between mainland and is-

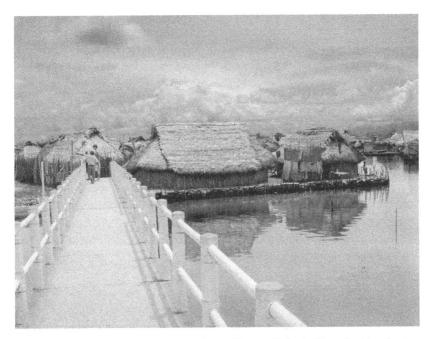

FIGURE 1.1: The bridge connecting Okopsukkun to Ustupir. Photo by Margherita Margiotti.

land is not applicable for Kuna people living on the mainland, I suspect that the key issue is the separation from the primary forest and ancient trees. Kuna villages on the coast or in the forest are situated near rivers and surrounded by cultivated gardens or coconut groves, in spaces where the forest has been cleared.

In Okopsukkun almost all available space is occupied by houses. The only open spaces are the basketball court and the area in front of the gathering house. A few trees grow at the edge of these spaces and within the courtyards of some houses, where they have been planted. They are breadfruit trees, matupur (Artocarpus altilis); papaya trees, kwarkwat (Carica papaya) and mango trees, manko (Mangifera). Interestingly, these are all food trees.

The island, which is entirely occupied by the villages of Okopsukkun and Ustupu, is linked to the nearby island of Ustupir by two small concrete bridges. The bridges were built when Ustupu's Escuela Segundo Ciclo Nele Kantule (Secondary School Nele Kantule) was constructed. The easternmost side of Ustupir, previously occupied by bushes and mangroves, was cleared in order to make space for the extended onestory school, which today hosts hundreds of students from Ustupu and Okopsukkun. Moving beyond the school, on the side of Ustupir looking westward toward the coast, there is the airport of Okopsukkun. The airport was being rebuilt and enlarged at the time of my fieldwork. This entailed a great deal of work and organization, which was carried out by all the adult members of the community. The airport was active until the U.S. company Cable&Wireless built a local plant on Ustupir that provides maintenance access to the line crossing the Caribbean Sea toward South America. The laborers used the earth landing strip for parking machinery and for digging the sand needed for building the plant, and in so doing they seriously damaged the airport.

The western and northern sides of Ustupir are still covered in mangroves, bushes, and coconut palms. In the past, Ustupir was used for the cultivation of coconut groves. The land was divided between families that still possess land there. The Cable&Wireless plant is located among the vegetation. An iron fence surrounds the site, which is always guarded by two Kuna men, one from Ustupu and one from Okopsukkun. Every evening at six o'clock the two 'guards,' wachimen, are replaced by two other men, who stay for the night. I remember Nixia Pérez, our host and friend, commenting that she would never spend the night there for she feared encountering kirmala, 'ghosts,' which are said to wander around that side of Ustupir, far from the houses where people live. From Nixia's and other people's words I soon realized that the

FIGURE 1.2: View of the mainland from the island. Photo by Paolo Fortis.

vegetated part of Ustupir was not considered much different from the mainland forest. It was a place where demons and dead people might be encountered and where people's souls could be abducted by evil entities. Spending the night guarding the Cable&Wireless plant requires the same courage that Kuna men need when going hunting at night in the mainland forest.

Another important distinction is made between sappulu and yarmala (sing. yala), "hills." The first is the coastal strip of flat land and hills where most cultivated gardens are; the second is the San Blas Range, Cordillera de San Blas, which stretches, close to the Atlantic coast, from the border with Colombia almost to the municipality of Chepo, before the Panama Canal. For what I translate here as "forest," sappulu, the Kuna use the Spanish monte; what they call in Spanish montañas, yarmala, I translate as "hills," as they are too low for what we normally call mountains. Nonetheless, it must be acknowledged that from the Kuna point of view those are mountains. The distinction Kuna people make between the two territories is quite clear; as a rough generalization I would say that the forest is where food is produced and collected and the mountains are where most plant medicines are collected and animals hunted. Although this is not completely accurate, it is rare that

gardens are cultivated on the hills, although a few are situated on the sloping foothills. This, I was told, is dictated by the lack of flat cultivable land near the coast caused by the overpopulation of the island in recent years. Moreover, since the end of the nineteenth century land has become private property. It has been divided among families and handed down from generation to generation, so that today land on both the coast and the island is fragmented into plots and parcels according to kinship (Howe 1976b; Tice 1995: 38–39). Therefore, new gardens are cleared deeper inland, on the hills, or in more distant areas along the coast, which require longer trips by canoe in order to be reached.

To reach his garden, an Okopsukkun man has to paddle for at least half an hour to enter the river Sukanti. Then, depending on where his garden is located, he will tie up his canoe along the riverbank and continue on foot. Walking on the flat land near the coast, one encounters mostly small trees and bushes. Coconut trees were and are still planted in this area, along with mango, avocado, cacao, and other fruit trees. It is also here where "wild cane," masarwar (Gynerium sagitatum), used for making house walls, is found and where Kuna men gather brushes like naiwar (Carludovica drudei), the stems of which are used in basketry and the leaves for roof thatching. These plants are not privately owned, and everyone can take masarwar or naiwar from other people's gardens. The difference is that these have not been planted by one's kinspeople, and therefore no one can claim ownership over them, whereas mango, coconut, and other trees have been planted by one's father or grandfather and are thus considered the property of the person who continues to take care of them. Taking mangoes or coconuts from someone else's trees is considered theft, but people are allowed to take fallen fruits. Leaving fruits to rot on the ground is considered a pity and a waste, and the owner of the tree will be considered lazy for not regularly visiting his garden.17

The forest space near the coast is also the place where Kuna women may venture alone, to collect mangoes or gather sand from the riverbank. They usually do this in groups of two or more, and they always keep moving quickly. Since the construction of the aqueduct women from Okopsukkun no longer have to collect fresh river water many times a day. Their trips to the river and the forest have become irregular, and young women especially have become less familiar with the forest. Moreover, I was told that women are frightened to be alone in the forest because they fear meeting way sappur, literally, "stranger of the forest," a foreigner who travels in the forest and may rape a woman if she is alone. 18 As for my habit of smoking while walking in the forest,

I was often called way sappur, and my Kuna friends mockingly told me that I alarmed the women passing nearby who could smell the smoke.

Moving inland toward the hills one walks through people's gardens. Gardens are cultivated mainly with one crop, for instance, plantain, manioc, or maize, although sometimes mixed gardens are found.¹⁹ This is allowed because each man and woman often possesses more than one garden, inherited bilaterally from the mother and the father. Therefore, men often look after more than one garden, cultivating different crops according to the season. Because men and women inherit gardens separately from their parents, men work in their gardens and in their wives' gardens. It is a man's duty to maintain his wife's gardens, which otherwise would soon be invaded by wild plants.

Some gardens may be left fallow for a number of years. They return to being nainu serreti, 'old gardens,' where trees grow up and the forest vegetation quickly regains ownership. When Kuna wish to reuse the gardens, they must fell and burn the trees before sowing a new crop. This is similar to what is done when new gardens are cultivated in primary forest. The felling of trees is normally done by groups of men working together under the guidance of an older man, ideally groups of brothers-in-law directed by their father-in-law. Kuna people consider this work very dangerous, and young men are often reproached by elders for the lighthearted attitude with which they approach this task. A falling tree might bring down others because they are tied together by vines, and the men are likely to disturb snakes. For this reason, the wives of the men who have gone to cut trees hang up the hammocks in the house during the day. This, they say, will prevent their husbands from tripping over the vines, with the risk of being hit by a falling tree.

The role of the eldest man in the group is also to teach the rest of the men how to cut a tree properly so that it falls in the desired direction, not only to assure the safety of the workers but also because the tree is alive. Ideally, it should fall on its back, so that it rests on the ground, much as a dead person rests when put in a grave. Moreover, some trees should not be cut because they are powerful entities; elder Kuna men say that they could take revenge against the cutter and even against his entire family.²⁰ Members of the family, especially the children, would fall ill and slowly die. The other trees may be cut only with the intervention of someone, usually an elderly man, who knows how to address the soul of the tree. He uses a brief chant to advise it that it is going to be felled, so that its soul has time to leave. In this way the tree becomes virtually dead before being cut.

Trees must not be cut in areas of the forest where evil entities have their abodes underground. These places are called kalu by Kuna people, which means "enclosure" or "pen," and indicates the invisible village of animal entities and demons. Although they live at an invisible level in the world, some kalukana may be identified by reading signs in the forest. For example, boulders are said to be the visible manifestation of the house of niakana, 'demons,' or kalutorkana, 'kalu dwellers.' Other kalukana are known because a nele has dreamed their exact location.21 The dangers represented by the kalu become obvious when new gardens are started in the 'primary forest,' ney serreti, literally, "old place." This is delicate work, and I was told that in the past, when Okopsukkun and Ustupu people started many gardens in the forest, before felling the trees, a preventive collective healing ritual, called nek absoket, was held, in order to cleanse the land of evil entities, which otherwise would have caused epidemics.²² Therefore, areas of the forest that are or have been cultivated are considered safer than those that have never been cultivated.23

Mainland forest and hills are thus conceived by Kuna people as a populated space, where one should venture conscious of the many risks attending him or her. From evil-minded strangers hiding in the forest to lurking demons, the forest is a space populated by entities that do not generally welcome the presence of human beings. Also, trees, the primary source of healing and protection, may be treacherous and revengeful. Moreover, the cemetery of Okopsukkun is situated on the banks of the river Sukanti, some one hundred meters above its mouth. Graves are scattered over a wide area along both sides of the river. This area is cleared of trees and looks almost like a copy of the village. Small shelters are built on the graves, in the same fashion as the thatched roofs on houses. Beside the graves, or small mounds, are objects owned by the deceased during life—a plate, a spoon, a mug, a wooden stool. Men and women walk tranquilly among the graves during the day, but I was told that they avoid the cemetery at night. They fear encountering the soul of a deceased person, and such an idea is terrifying. Even hunters, whose courage in venturing alone deep into the forest during the night is widely acknowledged, avoid walking in the proximity of the cemetery when it is dark.

The souls of dead people may also be encountered during the day in other areas of the forest. These were described to me as figures walking silently on their own, looking at the ground, not seeming to notice the passerby, or as scary figures, with rotten bodies, that try to attack the unfortunate person crossing their path. These daily encounters cannot

be foreseen or avoided, and they are often, people say, punishment for the bad behavior of a person. If a man is known to hit his sons or wife, or is considered mean because he does not provide enough food for his family, when he tells that he has met a ghost in the forest, people generally comment that he deserved it and it could have been worse.

TREES AND GARDENS

It could be said that bad encounters generally occur on the mainland. Island space is inhabited by human beings, where the trees have been cut, and it has never been as intensely vegetated as the mainland forest.24 Thus the forest is the space inhabited by primordial beings, animal entities, and the souls of the dead. But the vegetated part of the nearby island of Ustupir is also viewed as a scary place. What is it, then, that renders a place dangerous from the perspective of Kuna people? My aim in this chapter has been to show that the space in which Kuna people live is a space where trees are absent. At this point, a clarification is needed. If a first distinction can be made between tupu, the island where trees are absent and vegetation is tamed, and sappulu, the mainland, where trees and plants reign, a further distinction has to be made between areas of the mainland where the cultivated gardens are and areas where the forest, untouched by human action, is referred to as the old place, ney serreti. What is the difference between 'cultivated gardens,' nainumala, and 'primary forest,' ney serreti, for Kuna people? How does this distinction reflect the differences between types of plants and trees and the way they are conceived by human beings?

Kuna people distinguish the origin of trees and uncultivated plants from edible plants, which are included in their everyday diet. Forest trees descend from and are the visible manifestation of the first living beings that appeared on the earth during its creation, while all edible plants were discovered later on by the octuplet heroes. The myth of *paluwala*, 'tree of salt,' describes the discovery of salt and edible plants by Kuna octuplet heroes. The version presented below was narrated by the chief Gonzalo Salcedo to the ethnographer James Howe in the village of Niatupu in 1975.²⁶

During ancient times Tat Ipe was living on the earth. There were also the 'evil people,' poni tulekana. There was no light and it was cold. Ponikana were people with the face of a person and the body of an animal. There was the tapir, he had the face of a person and the body of a tapir. The white-lipped peccary had the face of a person and the body of

a peccary. The deer and the monkey were also like this. There were also the silky anteater, the sloth and the giant anteater. Tat Ipe and his siblings were eight. One of them was a woman called Olowayli. Their father was Olotwalipippiler. They were the grandchildren of Mako and Nana Olokwatule. Their mother was Nana Kapayai.

Tat Ipe traveled in all directions around the earth and realized that something bad was going to happen. He went to the underworld, the sky, the sea, where the sun sets and where it rises.

One day two women arrived. They were drunk and sang, "I drank salted soup." Tat Ipe thought, "Where do they come from?" They were called Muu Olokukurtili and Muu Olokewastili. Tat Ipe said that they were served food. After they ate, he tried the soup left in their plates and felt that it tasted salty. He thought, "Where did those women get this thing? How did they put it in the soup?" During that time Kuna ancestors did not yet know salt.

The two women left and came back after eight days. This time Tat Ipe watched them while they ate. One put her hand in her bag and took something out. Then she threw it into the soup. Tat Ipe thought, "That must be what tastes salty. Where did they get it?" Then he went into an 'enclosure,' surpa, and looked into the invisible world to discover the truth. He saw an enormous tree in the mist. It was the 'tree of salt,' paluwala. It was incredibly tall, and no one could climb it.

Then Tat Ipe transformed a person into an ant. Thus ants were born. Then he told the ant, "Climb that tree and discover which tree it is." Meanwhile, Muu Olokukurtili and Muu Olokewastili were carrying things. They carried taro, manioc, maize, sugarcane, plantain, pineapple and pumpkin. Tat Ipe thought, "Where did they get those things from?" Muu Olokewastili and Muu Olokukurtili transformed into butterflies and flew to the top of the tree. They went to the treetop to gather food.

Tat Ipe summoned the curassow, to go to the treetop and bring him all the food. But he could not make it. Tat Ipe thought, "What shall I do now?" So he called all his fellows, the tapir-people, the white-lipped peccary—people, the collared peccary—people, the agouti-people, the coati-people, the paca-people, the tamarin-people, the opossum—people, the lizard—people, the sloth—people, the silky anteater—people, the jaguar—people, the howler monkey—people, the spider monkey—people. They all came and Tat Ipe told them, "You will fell the *paluwala* and cut it into pieces." They started cutting the trunk, but the splinters coming off transformed into scorpions, spiders, worms, and river and sea lobsters. The bark and the splinters spun around and transformed into animals

The next morning they went back and saw that the tree was standing up again. Tat Ipe said, "How is that possible?" So he went into the *surpa* again to look at what was really happening. During the night he saw a golden toad, a golden devil, a golden snake, and a golden jaguar, licking the trunk. That was why the cuts on the trunk disappeared and the tree was able to stand up again.

Tat Ipe decided to gather medicine. He gathered the medicine of ikwawala (Dipteryx panamensis), isperwala, koypirwala, nakkiwala, kachiwala, ukkurwala (Ochroma pyramidale), ipewala, ilawala, napawala. He gathered medicine from all the trees that have a hard core. His brother Tata Ikwaokiñappiler bathed in water where he had put sichitwala (Genipa americana). Thus he blackened his soul. He went eight times in the surpa to look with his powerful gaze. Then he came out and said, "Tomorrow we will cut the trunk again." The day after Tat Ipe said to Ikwaokiñappiler, "Yes, let's go." The latter stayed in the canoe of medicine waiting and observing. He saw the golden devil putting salt in the trunk of paluwala. Then they began to cut the trunk again, but they were not able to fell it because it was held by vines that were stuck on to the clouds.

Tat Ipe called the tapir and told him to climb up the tree. He climbed to the top and cut some plantain, but then he fell down and hit his nose. For this reason the tapir's children have swollen noses. Tat Ipe thus transformed the tapir-people into animals. Then the white-lipped peccary—man climbed up the tree. Then Tat Ipe transformed him into white-lipped peccary—animal. All the animals tried to climb the tree unsuccessfully and Tat Ipe transformed them into animals.

Human beings had not arrived yet. All game animals were transformed. Tat Ipe realized that there was only one person left. He was called Olotiliwilipippileler and was living in the second level under the world. Tat Ipe sent the monkey to visit him. They greeted each other. Monkey asked for his help. The man replied that he would help if they found a woman for him. "Now I'm alone, if you find me a woman I'll work for you." Monkey went to Tat Ipe and told him that.

Tat Ipe went to visit Olotiliwilipippileler and told him about the problem of the tree and that he had no one left to climb it and cut the vines holding it to the clouds. "You are the only one left," he told him. Olotiliwilipippileler told Tat Ipe, "Go to the river and you will find the chief of masar (Gynerium sagitatum). He is called Olokinuypippileler. He has a small daughter. I want her." Tat Ipe went to Olokinuypippileler and explained to him that Olotiliwilipippileler was living alone and he wanted his daughter to marry. He argued that Pap Tummat did not make us to live alone, but to get married.

Olokinuypippileler said to Tat Ipe to go and fetch Olotiliwilipippileler. So they went and brought him there four times. They put him in a hammock and shouted, "suiiiiii," "Husband!" They brought the girl and put her on top of him in the hammock. Then Tat Ipe told Olotiliwilipippileler, "Now work for me," but the latter answered that he first wanted to stay with his wife. So Tat Ipe said, "In four days you will work for me."

The fourth day they met. Olotiliwilipippileler gathered one hundred and fifty men. They helped him climb up the tree. He reached the treetop and cut the vines. Sok! The tree went down and hit a rock. They all went to look for Olotiliwilipippileler but could not see him. They saw blood on the canopy. Tat Ipe said that he must have wounded himself with the axe he used for cutting the vines. But Olotiliwilipippileler had brought makep (Bixa orellana) with him. While he was cutting the vines he squeezed the makep. For this reason the leaves and the branches were stained with red.

The paluwala was lying on the ground. The enormous branches of the tree had scattered salt all around. Everything was scattered around. Maize, taro, plantain, manioc, pumpkin. The collared peccary stole maize and manioc. All the other animals fought to get the food and stole it.

That was what happened to Tat Ipe when he found the paluwala.

Myths on the origin of cultivated plants are present throughout the lowlands of South America (see, e.g., Basso 1973: 30-31; Descola 1994: 193-194; Lévi-Strauss 1969: 164-170). The common theme is the shift from a diet based on raw meat and roots or rotten wood to a diet of cooked meat and vegetables, associated with proper civilized life. Moreover, what the Kuna myth has in common with other Amerindian myths is that it tells of the origin of gardening as a human activity. All edible plants were stolen by animals after the felling of paluwala, and the consequence was, although not explicitly told in the myth presented above, that since that moment Kuna people had to practice the hard work of gardening in order to produce crops. Edible plants stopped being able to grow without human assistance after the felling of the tree and needed to be sown and nurtured by people in order to grow and produce fruits. Similarly, the Achuar myth of Nunkui describes how edible plants stopped being generated through the voice of the sloth-girl Uyush, who had been mistreated by people and left the village, leaving the men only a few seeds of manioc (Descola 1994: 268-269). In the Kalapalo myth, the tern-man married a woman, "prepared the gardens with his magic axe, and the manioc harvest was bountiful even though the men did not have to work at weeding or planting." Then the tern, reproached by his mother-in-law for having an affair with his wife's younger sister, left the village embarrassed. His wife tried unsuccessfully to follow him. "In pity, however he threw her a few manioc stalks, saying, 'Now men will make their own gardens, and will have to work hard. Men will wait a long time to dig up the roots'" (Basso 1973: 31).

It is interesting to note that all edible plants used to grow on the branches of the giant tree, paluwala. Similarly the Apinaye, Kraho, and Kayapo myths tell that maize used to grow on an enormous tree (Lévi-Strauss 1969: 165–167); in the Piaroa myths, all edible plants were on the Tree of Life (Overing 1985a: 264–265); for the Murui-Muinane, it was a giant manioc tree that contained on its branches all other cultigens (Yépez 1982: 63–69). In all these cases, people had to fell the giant tree in order to get the fruits of plants and seed them. The felling of trees for starting new gardens in the forest, as practiced today by indigenous horticulturalists, seems thus evocative of the origin of cultivated plants linked to the felling of a giant tree in some myths.²⁸

As I discuss more fully in chapters 2 and 3, for Kuna people trees are the antecedents of cultivated plants, and, most important, they are the antecedents of human beings and animals. Cultivated plants were discovered after human beings appeared and started living on the earth. Consequently, people learned how to cultivate, harvest, and cook them and stopped living off roots, leaves, and seeds. In general, trees and other uncultivated plants possess a soul and are like people, while cultivated plants seem to receive less attention from Kuna people in terms of their agency.29 The Kuna conceive the relationship between cultivated and noncultivated plants in chronological terms. In Kuna cosmogony trees and wild plants came first and were followed by cultivated plants. This is reflected in the way the Kuna name the forest space occupied by primary forest, secondary forest, and gardens. The first is called ney serreti, 'old place'; the second is called ney nuchukwa, 'young place,' or nainu serreti, 'old garden'; and the third is called nainu, 'garden.'30

Kuna people classify different spaces according to the types of beings dwelling in them. This classification also reflects degrees of alterity. The island is the space of human beings, where people live, where they eat, sleep, make love, give birth, cook, prepare medicines, transform forest materials into objects, and die. The forest is the space of plants, animals, spirits, and ghosts. It is in the forest, along the river-

bank, where the dead are buried. Within the forest further distinctions are applied between places where people grow their plants for everyday consumption and spaces where trees and other uncultivated plants grow. The former are the spaces where men regularly go to work and where they feel secure. But to reach their gardens Kuna men sometimes have to cross areas where the forest is wild and where the presence of nonhuman entities is almost palpable. Men venture into the primary forest and to the hills primarily when they hunt. Hunters must have a thorough knowledge of the forest and the hills extending along the coast near the island. They often stay away for days, walking most of the time and venturing deep inland. It is vital that they do not lose their orientation. When they do not see the sea from the hilltops or are too far away, they use the river as a point of orientation. Knowing the rivers and brooks well is essential to not getting lost in the forest and to being able to find their way out. For this reason, I was told, would-be hunters take a medicine made with the meat of the bare-throated tigerheron (Tigrisoma mexicanum), tuli in the Kuna language. This bird lives near the rivers and knows all the small tributaries, helping hunters to find the way back home.

Although few men hunted regularly in Okopsukkun at the time of my fieldwork, I heard many stories from hunters who had had dreadful encounters with demons, ghosts, or devils during their nighttime expeditions. To venture into the forest is thus to enter the space of alterity, where ancient and untamed forces have their homes. The forest is inhabited by ancient beings, among which trees are the primordial and most powerful. Their power is sought by Kuna specialists to protect against evil beings, but they may also be treacherous. Gardens are relatively safe places compared to the wild forest, but the separation is never clear-cut. Although it is easier to encounter ancient spirits in the deep forest, they used to wander in people's gardens. Under some circumstances and especially if annoyed by human beings, spirits and demons may also cross the channel to the island, provoking fear and epidemics among villagers.

The relation Kuna people from Okopsukkun have with the mainland forest, despite being separated and distant from it, is of paramount importance in their everyday life. Because the island is deprived of trees or animals, it is also deprived of their primordial entities. It is a safe place to live, but it lacks the vital source of knowledge that enables Kuna people to live their lives securely and fully. The relation with the forest is thus essential; it structures everyday practices and is

at the core of Kuna cosmology. The forest is the source of food, medicines, and power, and Kuna people rely on it and spend a considerable amount of time and energy learning about the different species and the different beings living in the forest. Let us now turn to the forest and its inhabitants.

TWO

Alterity and the Populated Forest

his chapter deals primarily with forest beings and how they are perceived in contemporary Kuna life. I focus on those species that figure most prominently in Kuna specialist knowledge and are both the cause of and remedy for illness. These species that live in the forest under the guise of animals and plants have a parallel life in the underworld that enables them to interact spiritually with human beings.

Kuna people conceive of the forest as it is today as the outcome of events that occurred in ancient times. Through their knowledge of these events the Kuna retain the awareness of the real nature of each living being, be it a plant, an animal, a bird, or a spirit. It is therefore by looking at both contemporary taxonomies of nature and the mythic discourses that inform them that I describe how the Kuna understand the forest as a richly populated space, dangerous because of its treacherous inhabitants and precious for its powerful potential to cure people.

KNOWING THE WORLD

Following a strict chronological order of arrival, the Kuna today organize nonhuman agents as more or less knowledgeable and powerful. Beings that arrived first on the earth gained the greatest knowledge as they observed the creation of all the other creatures that followed. For this reason a primary distinction the Kuna make is between animals and trees that are 'ancestral entities,' saylakana, and those that are their 'offspring,' apkilakana. As I show below, mythic discourses inform this order of arrival and explain the present state of things as the result of

a process of subsequent transformations and unions between different types of beings.

For Kuna people the spirits of forest animals are responsible for either stealing the souls of people or entering the body of a person in the form of illness. These animals are malevolent agents and prey on human beings either to take revenge against human acts that upset them in some way² or for their incurable desire to steal children or marriageable partners.³ Trees are mainly used for preparing medicines and for carving *nuchukana* but can take revenge against people who cut them without advising them or without following ritual prescriptions. At the same time *nelekana* learn in dreams from evil animal entities how to cure the illnesses, and ritual chanters cure ill people with the help of *nuchukana*.

For many Amazonian peoples the forest and the river are inhabited by the "primary sources of disease and of curing power" (Gow 1994: 94-95). Not making a distinction between evil forces of nature and good forces of culture, Amerindians put considerable effort into learning how to transform the knowledge that the plants and animals have into social praxis (Londoño-Sulkin 2000; Overing 1985a, 1986). The relationship that indigenous people have with the forest as a space inhabited by nonhuman entities entails a constant struggle over the acquisition of knowledge by shamans to protect their kinspeople against malevolent forces. The mainland forest, for Kuna people, is a space inhabited by beings who in ancient times were people too.4 For different reasons they were transformed into plant and animal species by both Great Father and culture heroes. Therefore, relating to forest entities is relating to beings that in the primordial past were close to human beings and with whom they intermarried.5 Entities that live in the forest and whose presence is acknowledged by Kuna people in the form of trees, rocks and boulders, and animals, are sometimes perceived only through noises, smells, and strange fleeting visions.

The forest for the Kuna is the result of both present and past agencies and of both human and supernatural entities (cf. Rival 2006). The relationship Kuna people have with the forest points in two different directions: on the one hand it is a power relation with ancestral beings mediated by shamanism; on the other, it is a nurturing relation with other humans, mediated by kinship. The former is a relation that points to the role of the ancestral past in the present, whereas the latter points to the recent past, present, and future, which are the temporal axis through which kinship is conceived. I show how Kuna people

conceive different plant and animal species, focusing on the different meanings that relationships with different species entail. This serves as a basis for my discussion later of how people establish individual relations with certain kinds of animals and trees as a form of bringing ancestral power into the lived present.

It is by examining this complexity that I investigate the way Kuna people see the forest and more generally the world in which they live and the ways they relate to all forms of agency within it. Human actions aimed at producing food through gardening and hunting have to be informed by the knowledge of nonhuman agencies to be successful and not to incur danger. Adults working in the forest have to know such agencies and learn how not to upset them during horticultural activities or when hunting. In the same way, ritual specialists have to learn how to approach and establish relationships with forest entities in order to be able to cure ill persons or, in the case of epidemics, the entire village.

Elder men in Okopsukkun put great emphasis on the telling of creation stories and other mythic narratives and on their transmission among generations. In Okopsukkun, as well as in almost all Kuna villages, meetings are regularly held in the gathering house, during which the village chiefs sing chants from the Pap ikar, 'Father's way.' Pap ikar is what the Kuna call the ensemble of stories, 'ways,' 'paths,' ikarkana, about the creation of the world by Pap Tummat and Nan Tummat, the adventures of several generations of culture heroes, and the emergence of Kuna culture and society as they are now. In Okopsukkun married adults sit in the gathering house every other day-men at night, women in the morning—to hear the chiefs sing songs from the Pap ikar.6 In this way young adults begin to learn "where things come from," considered the fundamental aspect of adult people's knowledge of the world. It is by learning how mountains, rivers, trees, and animals were created and how the world became as it is now that people come to know the world and become responsible adults. Other songs from Pap ikar narrate how culture heroes fought against evil beings and taught Kuna ancestors how to live well, to build proper houses, sleep in hammocks, cook real food, remember their kinspeople, perform puberty rituals, and bury the dead. These stories told in the gathering house are explicitly meant to give moral advice to young adults with the aim of making them loving and mindful persons. Without following these teachings, as I often heard old Kuna men say, "Pinsa anmar weki mai!," "We would live without purpose!"7

Chants sung in the gathering house, even if they cover a wide range

of topics (Howe 2002 [1986]: 47–50), often describe episodes from the mythic past when trees and animals were people and lived alongside human beings.8 The struggle between culture heroes and the fathers of animals resulted in the establishment of the present-day cosmological order.9 However, Kuna do not think that the world as it is today is the outcome of an irreversible process. On the contrary, it is constantly under threat and can always collapse once again into its ancient chaotic form. It is for this reason that Kuna people are constantly reminded by their elders that what men and women do should be rooted in the 'Kuna way of life,' *tule ikar*, and that this has not always existed but was constructed by means of a struggle against both ancestral evil beings in mythic times and foreigners in more recent times.

Another way to learn myths is by becoming an apprentice of a ritual specialist, such as a botanical specialist or a ritual singer. Thereby a young man listens to his master, who, before teaching him any specific medicine or curing song, gives him the basics of Kuna creation myths and mythic characters. This is a difficult task, as learning the names of each individual mythic being and those of the chief of plants and animals entails great mnemonic skills. Young disciples are often reproached by their masters for being overeager to learn and for lacking patience.¹⁰

One thing that Kuna elders often repeated to me was that it is not good to learn too much when one is young. Ideally, a man should wait until middle age to learn ritual praxis or memorize long mythic chants, lest he get headaches or is even attacked by those entities that he is learning to master through healing chants. This should also be seen in the wider framework of Kuna everyday management of knowledge. Although every aspect of it is highly interconnected, Kuna ritual knowledge is compartmentalized. For example, botanical specialists know about plants and trees and the short chants through which to address the souls of medicines; singers often specialize in particular healing chants; saylakana learn Pap ikar's chants; and arkarkana, 'spokesmen,' sharpen their rhetorical skills as well as their knowledge of myths.11 This amounts to a separation of different ritual careers and to the creation of different levels of knowledge, which are maintained and reproduced through particular forms of exchange between masters and disciples, fathers-in-law and sons-in-law, mother's brothers and sister's sons.12

Young Kuna adults are advised by older people (village chiefs and ritual specialists) both in collective gatherings and individually. Everyday individual advising is another way to learn about the world and is

carried out by an older kinsman, normally a father, a father-in-law, or a maternal uncle for a boy and the mother or an older sister for a girl. The aim of advising young people is to teach them how to do things and behave properly. Roughly, this means teaching people how to be a 'loving' and 'mindful person,' *tule sapeti*. Men and women have to be caring parents and kin and at the same time be well informed on the real nature of things. They must know how things are beyond their visible appearance; they have to learn how trees and animals became how they are now and what their relationship was to human beings in the ancestral past. In general, people must come to know how the world is and how to deal with it. It is by following this same principle that I intend to continue my analysis of Kuna cosmology and classification of forest animals and plants.

PAP MASMALA: THE YOUNG MEN OF THE FATHER

One day Margherita and I were sitting in the house of Nikanor and Raquel, where we had been living for most of our stay in Okopsukkun. Often during the afternoons we would pass some time in the house chatting with Nikanor, Raquel, Nixia, their youngest daughter, their kinspeople, and the friends who visited them. Late afternoon is the time for visits. Visitors are kin, close or distant, who live in other houses. They come to bring food, ask for some plantain, or borrow a canoe for the next day or just to sit down and exchange the latest news. The curiosity of people is palpable, and nothing is more welcome than a visitor coming into the house with the intense desire to tell something he or she has just discovered. A consequence of our presence in the house was an increase in the number of people stopping by, especially children, who were curious to see us. As we used to visit people unrelated to Nixia's family, it often happened that we were also called to eat in other houses. In such cases it was always a young girl who was sent to invite us. She would never dare to enter the house but would shout from the external door, "Maskuntakeeeee!," "Come eat!"

One day we received a visit from a young girl we already knew because she was the daughter of Elasia, Aurora's daughter-in-law. Although we knew Aurora well as we had lived in her house and we were also acquainted with Elasia, we had never eaten at her house and were puzzled when the young girl escorted us to her house. Once there, Elasia greeted us and told us that her father wanted to speak with us. We had never met him, which aroused our curiosity further. Garibaldo del Vasto, Elasia's father, was waiting for us in the house of a friend of his,

who offered to host our meeting. The house was one of the few concrete structures in village. We later learned that Garibaldo's friend had worked as an employee of the Panama Canal Company and had received a good pension when he retired, as was the case with all other Kuna men who worked in the Canal Zone (Margiotti 1999). We were greeted by the two men, and after a short introduction Elasia left us in a small room with them. The friend, who spoke Spanish fluently, made the presentation: Garibaldo as a medicine man and knower of *Pap ikar* and himself as a specialist in curing chants and of *muu ikar*, the chant for difficult childbirth. He also said that he was still learning, while Garibaldo was his master.

Then Garibaldo explained the reason he had called us. He had known us since our arrival and was aware that we were studying Kuna culture and way of life.13 He knew that I was interested in nuchukana and that Margherita was studying Kuna kinship, and he thought, with good reason, that it was very difficult for us to understand properly what people told us. He was also particularly concerned with the way we were taught things by other people, because he knew that no one would have told us "where things come from." This has a twofold meaning. On the one hand, Kuna specialists are jealous about their individual knowledge and do not teach it outside a properly established and compensated relationship between master and disciple. On the other hand, Garibaldo knew very well that our time in Okopsukkun did not allow us to learn as Kuna people normally do, that is, sitting daily in the gathering house for years, slowly getting used to the metaphoric language of Pap ikar and piecing together single stories to form a broader picture of Kuna mythology. This, as I realized only later, after my fieldwork, is something that takes a lifetime to be achieved, and Kuna men and women each have their own personal take on knowledge as there is no one way to learn it.

Therefore Garibaldo told us that he would teach us the origin of things in such a way that we could make sense of what we had learned thus far and would not go back home like cripples who could not walk properly on their legs. By that he meant that he was ready to give us a condensed version of Kuna mythology, skipping all the preliminaries and the lengthy and careful methods that normal teaching would entail. Although unusual by Kuna standards, Garibaldo's teaching proved extremely useful for my efforts to make sense of Kuna cosmology.

At six o'clock in the morning after our first encounter, when payment was agreed on, I sat with Garibaldo and his friend around a table and listened to the account of the creation of the world by Great Father

FIGURE 2.1: Garibaldo del Vasto and his grandson. Photo by Paolo Fortis.

and Great Mother. That was the first of many meetings during which Garibaldo patiently took me on as a special kind of disciple and helped me to clarify many aspects of his way of seeing the world. What follows is an edited extract of the longer story.

Pap Tummat [or Papa as referred to below] went down to the earth. The earth was not completely created yet. He wanted to see the earth. He went there four times. He started creating the *purpa* of the world.¹⁴ He created the *purpa* of the mountains, of the sea, of the rivers. He created the *purpa* of all living things.

Pap Tummat went to the earth four times. The earth was completely silent and dark and you could not see anything. Pap Tummat and Nan Tummat went down to the earth on a golden saucer. There were no mountains, no sea, and no rivers. Pap Tummat made the tornado wind blow. He blew it for four times. Then the boys arrived. They were Papa's boys, *paliwittur*. Papa said to them: "You will learn the *purpa* of everything. You will learn *purpa* while I create everything. You will learn by seeing how Nana and I create things."

Thus he sent them four times to the fourth layer under the earth. When they went there, the earth had no name yet. There was Pursoso,¹⁶ there was the river Oloispekuntiwar,¹⁷ there were a lot of marvelous things. There were no people yet and the earth was still. But when they listened, they heard noises; the earth was alive. They heard people speaking and laughing. The *purpa* of the earth was becoming alive.

Then they went to Papa and told him what they had seen. He sent them again to the fourth layer under the earth and there they saw that the earth was changing, that something was happening. The wind was blowing and different creatures were moving and dancing around. They told what they had seen to Papa and he said: "I see, now you will go there again."

The earth had become marvelous; the juice of the earth was whirling. They saw Pursoso in the middle of the creation. Then they saw a giant canoe. It was Kilupilaulesaulu. It was the canoe of Nia. Nia was standing on the prow of the canoe. When they came back, Papa told them that they had to go there for the last time.

The earth was powerful then, it was materializing. There were many people yelling. The earth was just juice, there were no rivers. These people were drinking from the many puddles that were around. The boys were watching and they saw many strange and different people. One had a thorn; he was the demon-thorn. They were *ponikana*; they who eat us. Papa's boys were learning by going into the places where *ponikana* lived. The master of *ponikana* was Oloniskakkiñaliler. Before, he had been living with Papa. Then he revolted against him. Thus Papa became angry with him and sent him away. Then the boys saw the mountains, the rivers, the sea and the stars appearing.

At that time it was still impossible to have babies. Men and women could not be together yet. Thus Papa told the boys: "You have been on the earth. You have seen the mountains, the rivers, the clouds, the stars and the sea. You have seen the *purpa* of the earth. Now I will show the *purpa* to you." The boys looked at the earth and saw many people walking on it. They saw a man with just one eye walking about. They saw a man with his belly inflated. They saw a man walking in a circle. They saw a man staggering and another man rolling about. There were many different types of people.

At that point the boys 'completed their learning,' nelekusa; they became wise. They terminated their university degree. They had traveled four times, they had learned how Nia had arrived, they had seen his transformations and observed his behavior. They knew all these things. Then they ascended to Papa. They wore beautiful red shirts, they had red bead necklaces, red hats and they were holding their staffs. Every-

one had his own shirt, different from each other. Papa told them: "My little ones, I sent you to the *purpa* of the earth, to the *purpa* of mountains. Now you are powerful beings. You are pointed noses, *Pemar asu tukku takkensoke*. You will transform into powerful medicines."

Thus he started calling each one of them by his proper name. They were Olowainanele, Olokurkinakwilotule, Olokurkinatirpitule, Olokurkinasuitakiñalinele, Olokurkinaekekiñalinele, Oloopanappinele, Olomekekiñalinele, Olotinkunappinele. Papa was going to transform them. They were powerful men.

Then, as a woman when she gives birth, the earth began to produce fruits. Papa had an automatic button through which he could transform anything. The boys were looking while he pushed it. The earth started whirling. It was little as a newborn baby. It was tender like rubber. It was growing up, as a child. While it was whirling, Papa called it: "Oloittirtili, Maniittirtili yee." The earth was solidifying. The boys saw all this. They looked toward the four directions. Papa was transforming them.²⁰ Then they went to the *purpa* of the earth. There was a big stone with a hole in the middle. They put their *purpa* in the hole.²¹ Their *purpa* whirled into the earth and changed into seeds. That was how the medicine against Nia was born.

Although this is an abbreviated version of the myth, it contains a great deal of information on Kuna cosmology, most of which I will not be able to deal with in this book. Speaking in general, this myth describes the first people who lived in the world, the eight boys of Pap Tummat, who generated the trees that now populate the forest. They also became the owners of trees, as I was told on other occasions, and went to live in their own villages in the 'invisible world,' ney purpalet. This mythic narration points also to the fact that their transformation was a consequence of the learning to which Pap Tummat exposed them. On the one hand, the eight young men of Papa appeared before all other beings during the creation of the world: "There were not yet people and the earth was still." Pap Tummat sent them down to the earth four times to witness the creation. Thus they saw the various stages of the generation of rivers, mountains, and the sea from the immaterial state of purpa to the liquid and then solid form. In this way they got to know how things were generated. They saw "Pursoso in the middle of the creation," which means that they assisted the first woman as she became pregnant and gave birth to all living beings. Knowing the secret of birth of all living species is part of the skill of Kuna ritual specialists. It means that a specialist possesses the key to the inner

nature of a particular animal or vegetal species and therefore is able to control it and, if necessary, counteract its actions.

Trees for Kuna people possess the most powerful knowledge as they derive from the eight boys of Pap Tummat who witnessed the creation of the world and of all living species. They saw Nia, the Devil, arriving in his canoe, and then they saw the first ponikana making their monstrous appearance on the earth. As Pap Tummat eventually told them, they had seen Nia and his offspring and learned about their behavior and their own transformations. Once their apprenticeship was completed the eight boys also completed their transformation. When their knowledge reached its fullness they ascended to the sky wearing "beautiful red shirts," "red bead necklaces, red hats," and "holding their staffs," to be individually named by Pap Tummat.²² Once they had acquired their names, they went for the last time to the earth, which is now represented as the body of Nan Tummat, soft, rubberlike, and slowly solidifying. They put their 'semen,' purpa, into it, through a stone, to be molded and to generate the seeds from which plants would grow.

Various people in Okopsukkun told me that today all forest plants are female and that male plants come down from the sky during the night to make love to them. This is why at dawn their leaves are covered with dew, which is the semen of male trees. Ancestral tree entities today live in Sappipe neka, the "house of the owners of trees," situated in the sky, along with *muukana*, celestial grandmothers who are responsible for the formation of human fetuses.²³ Animal ancestral spirits each live in a different *kalu* in the underworld where they look after their offspring, sending them occasionally to the earth.

NIA: THE FATHER OF EVIL

I would say that in present-day Kuna discourses animals are normally associated with dangerous alterity, whereas trees are associated with a more positive and manageable form of otherness.²⁴ In mythic times all animals originally had human form and were transformed into animals as an act of revenge undertaken by the mythical hero Tat Ipe (otherwise called Ipelele; we shall encounter him in chapters 6 and 7). Animals, when they were still persons, were not able to behave morally: they copulated with their own kin, fought among themselves, and were prone to getting drunk on every occasion. They were ignorant of social and cultural skills and were not able to establish kinship relations (cf. Overing 1985a, 1986; Londoño-Sulkin 2000). That is why today most animals have no *pinsaet*, 'love,' 'thought,' 'memory.' Neverthe-

less some forest animals are said by Kuna people to be 'powerful seers,' nele tummakana. How do the Kuna think of these animals and explain their ancestral origin? What is the difference between animals that are powerful shamans and other kinds of animals? In this and the following section I deal with these questions.

As I was told on many occasions, animals are the grandchildren of Piler and Pursop, the first human couple living at the origin of the world.²⁵ Piler and Pursop had five sons: Kana, Kuchuka, Topeka, Inoe, and Olokunaliler. Each one of them was the father of several animal species. As Luis Stócel, a Kuna man from the village of Cartí Tupile, recounted in 1969 to the U.S. Peace Corps volunteer Norman MacPherson Chapin, animals came from different fathers, depending on their characteristics:

The sons of Kaana were all the animal-people (*ibtulegan*) with claws that can climb trees: Wiop (bear), Achu Tummat (jaguar), Ibguk (anteater), Pero (sloth), Sulu (monkey), Tidi (squirrel monkey), Uskwini (squirrel) and others. The sons of Inoe were all the animal-people with big bellies: Moli (tapir), Timoli (manatee), Ansu (siren), Wedar (collared peccary), Yannu (white-lipped peccary), Sule (paca), Usu (agouti), Koe (deer), Yauk (sea turtle), Yarmorro (river turtle), all the fishes and others. The sons of Topeka were all poisonous animal-people: Naipe (snake), Tior (scorpion), Igli (army ant), Sichir (spittlebug), Bulu (wasp), Butarar (sea urchin), Nidirbi (sting ray), Naipeniga (centipede) and others. The sons of Kuchuka were all illness-people: Kalanuke (illness that eats bones), Tusi (rheumatism), Istardaket (tuberculosis). Tolotolo, Poni Kortikit, Poni Ginnit and others. Olokunaliler was the father of the Cold. (Chapin 1989:26; my translation)²⁶

The story goes on to explain that when the world was populated only by animal-people chaos was sovereign. Everyone got drunk during rituals and fought with one another. Everyone pretended to be the leader and did not listen to the words of Piler, their grandfather, trying to counsel them. They did not respect his authority and behaved without moral concern toward their own kin. Violence and incest spread, life was chaotic and disgusting, and the world was an unpleasant place in which to live. Social life, as it is today, was not yet possible.

Garibaldo del Vasto, always keen to explain things to me "as they were at the beginning of time," told me why corruption existed in mythic time. To understand the nature of the world as it is now, he said, another figure must be considered beyond animals and trees: Nia,

the Devil. Nia is the devil figure arriving in a canoe while the world was being created. He was described by Garibaldo as the companion of Great Father who turned against him and became evil. This description is similar to the Christian story of the fallen angel, who became the Devil. Although I am aware of the delicacy of these resemblances and do not wish to downplay their relevance in the understanding of indigenous cosmology, in what follows I focus on what Kuna people say about Nia and their perception of him.²⁷ I am also confident that once light has been shed on Kuna categories it will become easier to draw a clearer picture of the effects of this contact on indigenous categories.

As the myth of the young men of the father tells, Nia had never been a person, and he never transformed from his original state. Instead he masters the power of transformation at the highest level; he is able to transform into whatever form he pleases. He has no stable form; his form is transformation. Further, he generated all devils and demons and all sorts of evil animal entities and is today considered their father. Soon after Nia arrived, monstrous creatures made their appearance, people with ugly forms: black hairy figures, one-legged men, people with two faces or one eye, cripples, people with enormous bellies, people whose faces were on their knees or who had other kinds of deformities. Today's demons are descendants of Nia and are described as tall creatures, with black skin and curly hair; "Like Colombians!," some Kuna told me. Their houses are under boulders in the forest. Devil and demons are also the cause of madness for the Kuna. They cause people to lose their minds and to become homicidal, by killing people in their dreams. As Garibaldo explained to me, Nia was the father of various animals, namely, of those that are dangerous to humans.

Ipkuk [anteater], Olopapaniler, descends from Nia, who was a great nele, and Nan Tummat. Nia and Nan Tummat had five sons, who were quintuplets and were also great nelekana. Then Nan Tummat died and split in two: Muu Oloupikundisop, the sea, and Pursop, or Nana Olokwatule, the mountain. Like in all mixed marriages, some children are born the color of the father and some the color of the mother. Thus here, good animals come from Nan Tummat, while evil ones come from Nia. Piler was innocent; Nia cheated him. Like one who always goes to visit a friend just to see his wife. Then Piler was corrupted by his wife and himself became evil.

With the information Garibaldo imparted, it is possible to unfold the Kuna taxonomy of animals. Kuna people generally make a distinction between inoffensive and edible animals (peccaries, tapirs, most monkeys, agoutis, most fish) and dangerous and inedible animals (anteaters, sloths, jaguars, crocodiles, snakes). The former derive from the union of Piler and Pursop, human beings; the latter, from the union between Pursop and Nia, human and devil, and, as with their father Nia, they are powerful *nelekana*. *Ponikana* possess the ancestral knowledge that since humans and animals split they have guarded jealously. Their knowledge is also their capacity to attack humans; it is the cause of illnesses for human beings. But their dangerous powers are also the source of knowledge that *nelekana* seek in order to cure afflicted persons. The same knowledge that is vital for the formation of *nele* is poisonous for all other people.

Another point that I want to call attention to is that Nia is the primordial Other in Kuna cosmology. As the myth tells us, both Nia and the eight boys of Pap Tummat are, besides Pap Tummat and Nan Tummat, the first beings to appear in the world. All other creatures are the transformations of or generated by each of these three original figures. Nia is described by Kuna people today as the predator par excellence and is associated with a number of predatory figures and Others that populate Kuna cosmology and history and that in some way are its transformations. Such figures are jaguars, white people, and black Colombians. As Severi argues (1981b, 1987, 1993a) madness, as the illness provoked by an encounter with Nia, is a form of other-becoming and the ultimate risk for human beings. Nia and 'sky jaguar,' achu nipali, are interchangeable in Kuna descriptions of the cause of madness. Severi, in his analysis of the ritual chant for curing madness, called nia ikar, points to the fact that the sky jaguar is the invisible predator "whose presence could be conceived only under a deceptive incarnation: in the sound produced by another animal" (Severi 1993a: 135; my translation). Therefore he suggests that nia, which is also used to indicate an illness, is one of the transformations of the sky jaguar. Namely, when the supernatural predator seduces and copulates with a human being, the human becomes prey, who in turn generates nia, as the fruit of the union of a human and an animal (157). The human prey then becomes a mad person and slips into the category of enemy, showing a will to hunt and prey on those of his own kind (Severi 1981b: 91). Nia, as illness, signifies the point of no return, when the human prey becomes a predator of humans and therefore must be killed. The illness may still be treated, if diagnosed in time, with the use of plant medicines and through the performance of the long and powerful chant, nia ikar.28

But nia always leaves a mark on the person, even if he or she is cured. As I was told, until the recent past people who became affected by nia would be forced to drink a concoction prepared with ina nusu, a poisonous plant (Spieghelia anthelmia L.).29 If they survived, they became very intelligent and able learners.30 But once attacked by Nia, people are prone to fall ill again and are thus always regarded with some suspicion, a bit like nelekana. Even if nelekana are said not to cause any harm, their life constitutes a mystery for other people, who do not know what the nele really does during his dreams. In contrast, mad people, kia takkaler,31 are always considered evil and dangerous, because of their desire to kill their own kin (cf. Overing 1985a: 265; Londoño-Sulkin 2000: 175; Fausto 2001: 316-317). They are brave and ferocious beings who can disguise themselves, continuing their normal life during the day but lurking in dreams and seeking their victims. But sooner or later someone will see them in dreams, trying to strangle the dreamer. Thus they can be accused in front of the collective gatherings of the village and forced to drink the poison.32

Having seen how Kuna think of the origin of evil entities in their historic vision of the world, let us now return to how the Kuna perceive the mainland forest as a space populated by supernatural entities.

ANCESTORS AND OFFSPRING

I realized that what to my eyes seemed a uniform vegetated space for Kuna people is a space where specific kinds of trees, bushes, shrubs, and flowers grow and where specific animals, spirits, and demons dwell and wander. Furthermore, each plant and animal species has different properties that point to manifold relations between the visible and nonvisible forms they assume and between the past and the present. Plants, trees, and flowers have different properties, and people thus can use them for diverse purposes. Some animals can be hunted and eaten, for example, the collared peccary, white-lipped peccary, deer, tapir, agouti, and paca; others cannot, for example, the giant anteater, silky anteater, sloth, and crocodile. Other animals, like the turtle, can be eaten only according to certain restrictions related to age and sex.³³

Like many other Amerindians, the Kuna do not have general words for plants and animals (cf. Descola 1994). *Inmar* is a generic word meaning "thing." It is used to refer to abstract categories of things, such as *inmar iskana*, 'bad things,' *inmar nuekana* 'good things,' or concrete categories, such as *inmar turkana*, 'forest animals,'³⁴ *inmar kukkwalet*, 'birds'

	Latin Panam. Spanish	Tayassu pecari Tayassu tajacu Tapirus bardii Dasyprocta punctata Agouti paca Agono coliblanco Agouti paca Armado Armado Armadillo rabo de puerco Adouatta palliata Armadillo rabo de puerco Adouatta palliata Anno negro Acax rubra Agouti paca Agono cariblanco Agoutinus Agono cariblanco Agoutinus Agono cariblanco Agouti paca Agouti paca Agouti p
IMALS	English	White-lipped peccary Collared peccary Tapir Agouti Paca Red brocket deer White-tailed deer Green iguana Hawksbill turtle Nine-banded armadillo Naked-tailed armadillo Waked-tailed armadillo Great Curassow
TABLE 2.1 EDIBLE ANIMALS	Kuna	Yannu Wetar Moli Usu Sule or Nappanono Koe Wasa Ari Yauk Tete Uksi Sur sichit/ulur Opsur

(lit., "flying things"). Moreover, when a person indicates an unknown thing, she would say, a inmar, "that thing"; or when she forgets the name of a person she is referring to, she would take time by saying, "... inmar... Paolo."

Kuna people say that every animal is a person in the underworld, where they live in kalukana, which can be seen as such only in dreams or by seers while smoking tobacco. A general division is applied to differentiate animals that people meet in the forest: some are said to be the 'offspring,' apkilakana, of ancestral animals, which are now their 'chiefs,' errey, e tummat, or e sayla; others do not have a chief and are therefore ancestral beings themselves.35 Among animals that have a chief some are more endowed with 'agency,' pinsaet, than others. Ultimate agency is imputed to their supernatural chiefs, who live in the fourth level of the underworld and are extremely powerful shamans.³⁶ Conversely, animals that are themselves ancestors are said to be shamans and have a strong and clear agency. Both the chiefs of animals and the animalshamans retain the knowledge of ancient times, when they were mixed with human beings, although they never developed social praxis, as human beings did. Some of them are malevolent to humans, with the desire to kill them, eat their bodies, drink their blood, or abduct their children. All animals that are shamans and do not have a chief in the underworld are not eaten by Kuna people; while among the animals that have a chief some are edible.

For the Kuna the majority of animals are the offspring of their ancestral chiefs living in the supernatural dimension of the world. Among them there are the animals and fish that are hunted and eaten by people, animals whose body parts are used for preparing medicines, and dangerous animals whose proximity is avoided by any means. Animals that are normally hunted for food are not attributed individual agency.³⁷ In general, they are said to follow the orders imparted by their underworld chiefs, who are mainly busy making them run out of their *kalu* into the forest or keeping them within. These are usually animals that move in herds or small groups in the forest and feed on fruits and leaves, such as peccaries and tapirs, deer, agoutis, pacas, and monkeys.

Also among edible animals are fish that now constitute the main source of protein in the Kuna diet. Kuna people have developed a deep knowledge of marine fish, which is reflected in the number of names given to them (Martínez Mauri 2007). The reason why, in this work, I principally deal with forest animals is dictated by the fact that these animals still have a higher symbolic importance in Kuna cosmology than the marine fauna. However, Kuna people living in the San Blas Archi-

pelago say they do not hunt as much as they did in the past. Among other causes that I was told contributed to the decrease of hunting was the construction of a dam in the Bayano region, in the Darién forest behind the San Blas Range, which formed the huge Bayano Lake. This caused a massive change in the forest ecosystem, and people in Okopsukkun told me that it also changed the route of animals that used to pass close to the coast, the most accessible to Kuna hunters.³⁸ I heard many men in Okopsukkun say that they didn't hunt because of the cost of shotguns and bullets. But at the same time I was told that men in the past were skilled hunters and were constantly taking medicines to improve their ability to hunt. Lack of money is likely not the main reason for not hunting, since people buy fishing nets or diving equipment (spears, diving masks, flippers) when they can afford it.

Kuna people are wary about eating fish and sea creatures that are considered to have a bad temperament or characteristics that could cause problems to human beings. Biting fish like sharks and stingrays, for example, would pass their biting mood on to human beings. Kuna people do not eat octopus either, because in pregnant women it makes the fetus stick to the womb, causing problems in childbirth. In general, we can say that fish are less the object of symbolic speculation than are forest animals. This, Howe (Ventocilla, Herrera, Nuñez 1995: 12) has argued, is caused by the fact that the Kuna moved from the forest to the coast quite recently and are therefore still in the process of adapting a forest cosmology to the marine environment.³⁹

Other animals that have their chiefs in the underworld and are not edible are crocodiles and snakes. Although Kuna people do not associate the two taxa in any way, they are the most feared species, as they represent the most common danger in the two mediums of Kuna life, the sea and the forest. Crocodiles are among the animals that are able to steal the soul(s) of people. What the crocodile does, in fact, is bring the abducted soul to its chief or to the chief of other animals, who will keep it in his spiritual abode. In curing chants the crocodile is called the canoe of ponikana, due to its representation as a means of transportation between different realms. In the myth of Great Father's young men we saw that Nia arrives paddling in a canoe, which is called Kilupilaulesaulu. Kilu is the uncle (MB, FB) and is also used as a prefix to form the name of evil animal entities; 40 pila means "war"; ulesa might be the past of urwe, "to get angry"; and ulu is "canoe." Further, I was told that a nele travels using a canoe, which is actually a crocodile, in dreams within the supernatural world. What is seen by people in waking life as a crocodile is therefore a canoe from the point of view of spirits or in people's dreams. In daily life, dugout canoes are the means of transportation people use to move between different domains, from islands to mainland and along rivers. It is also in a canoe that the soul of a dead person travels to the house of Pap Tummat (Fortis 2012). Crocodiles are the only animals that are able to move between water and the mainland; they can swim and walk; and sometimes they can also reach the islands. People in Okopsukkun are often afraid of meeting crocodiles on the shore during the night when they go out to urinate, and there was always a great deal of nervous laughter when someone came back from a night walk saying that he had seen a crocodile near the rocks.

Snakes have a chief in the underworld but also possess dangerous immanent qualities that affect human beings. First, they can attack people, not only by biting, which is of course a source of great danger, but also by entering a person's body spiritually when he or she walks over their tracks. Unlike crocodiles, they do not steal people's souls but instead enter the body and keep on changing form, so that it is difficult for specialists to cure the illness (cf. Nordenskiöld 1938: 396–414). Snakes can appear in great numbers in a particular place in the forest as the consequence of some events that caused the rupture of the tranquillity of their supernatural village. If such a thing happens, villagers might decide to celebrate the collective healing ritual aimed at placating snakes' spirits and to send them back into their *kalu*.

Snakes are also considered 'beautiful,' yer tayleke, by the Kuna for the colored designs on their skin. The beauty of their designed skin, as I discuss in chapter 4, is associated with their capacity to transform and with their immortality. ¹¹ Snakes, besides changing form inside the human body, may also appear in dreams as beautiful sexual partners to both men and women, tricking them into believing in their human nature.

The most powerful predator and the most agile transformer for the Kuna is the jaguar. Jaguars are among the animals that do not have a chief in the underworld. They are themselves, I suggest, ancestral animals. Nonetheless, Kuna people distinguish between actual jaguars—dangerous for their ferocity when they are hungry but also, I was told, careful to avoid human beings in the forest—and sky jaguars. The latter cannot be seen by people in normal visual experiences and move about high up in the sky. I was told that they prey on turtles, which they grab and bring up into the sky. Once they have eaten the turtles they let the shell fall down. It is for this reason, a Kuna friend told me, that he once found a turtle shell deep inland. Jaguars are the most skilled predator of both animals and humans. They prey on animals in the forest and on

TABLE 2.2 INEDIBLE ANIMALS

Kuna	English	Latin	Panam. Spanish
Masar naipe	Red-tailed coral snake	Micrurus multifasciatus	Gargantilla
Nipa naipe	Neotropical bird snake	Pseutes poecilonotus	Mica pajarera
nan naipe	Tropical kingsnake	Lampropeltis triangulum	Coral falsa
Ukkunaipe	Tropical rattlesnake	Crotalus durissus	Cascabel
Tain	American crocodile	Crocodylus acutus	Cocodrilo
Iskin	Spectacled caiman	Caiman crocodilus	Caimán or guajipal
Achu parpat/achu migur	Jaguar	Panthera onca	Jaguar
hu kinnit	Puma	Puma concolor	Puma
Achu narkwinkwa	Jaguarundi	Herpailurus yagouraoundi	León breñero or yaguarundi

people in dreams.⁴² What renders them so dangerous to people is their capacity to metamorphose. Like snakes, they attract humans in dreams by transforming into beautiful women or men, irresistible to dreamers for their sexual appeal. At the same time, Kuna people say that their fur is beautiful, and they never fail to point this out when describing jaguars.⁴³ Like crocodiles, jaguars are considered a means of transportation in the supernatural domain.

As Severi points out, the sky jaguar is also called 'golden saucer,' olopatte, in the curing chant for madness (1993: 146). In his long description of this celestial animal Severi shows how its appearance may be characterized by blinding light or by dark obscurity. The golden saucer is mentioned in many Kuna myths I collected, and I found this used by Great Father and Great Mother, as a way to move between the sky and the earth, and also by ancient shamans, who descended from the sky on a golden saucer but used to descend to the underworld riding black jaguars and winged snakes.

What crocodiles, snakes, and jaguars have in common is that they are all means of transportation between different cosmological domains. In this sense they are *nelekana*, who are able to move between domains of the cosmos without losing their humanity, whereas for normal people the movement between different domains is dangerous and is associated with illness and unwanted transformations of the body.

Other animals are considered ancestral beings and not the offspring or instantiation of their supernatural chiefs. They are all ponikana, evil entities, and, most important, they might become the auxiliary spirits of nelekana. These animals are the sloth, the giant anteaters, the silky anteater, the porcupine, the river otter, and the sea siren.45 What they have in common is that they are normally found alone in the forest, in rivers, and in the sea.46 Once an old Kuna man told me, "Anteaters, porcupines, and the sloth are all ponikana. They are all jaguars. They eat scorpions, spiders, ants, and snakes. They suck their poison, and are therefore not edible for people." Most important, all these animals are powerful nelekana. They have the ancestral knowledge and are therefore sought by human nelekana, who want to associate with them to learn their knowledge. For this reason people must not hunt them; otherwise they may transmit incurable diseases to the hunter and to his children. This restriction is even more important for pregnant women, and their husbands should avoid looking at these animals in the forest. Once I was told, "If one shoots an anteater he must not to tell anyone. The anteater is a nele and has many helpers. Therefore it can hear you speaking about it and will attack you."

TABLE 2.3 SHAMAN ANIMALS

Panam. Spanish	Perezoso de tres dedos Perezoso de dos dedos Oso hormiguero gigante Hormiguero bandera Gato balsa Puercoespín Puercoespín Nutria neotropical Sirena/Manatí (hypothetical)
Latin	Bradypus variegates Choloepus hoffmanni Myrmecophaga tridactyla Tamandua mexicana Cyclopes didactylus Coendou rotschild Coendou mexicanus Lutra longicaudus Trichechus inunguis (hypothetical)
English	Three-toed sloth Two-toed sloth Giant anteater Northern tamandua Silky anteater Rothschild's porcupine Mexican porcupine Neotropical river otter Siren/Amazonian Manatee (hypothetical)
Kuna	Pero Pero Ippureket Palipirki Ukkuturpa Akkwanukku Akkwanukku Saipa

These animals, as well as snakes, prey upon human beings, not by stealing the soul, but by entering the body and eating it from the inside. I was told that the illness transmitted by the anteater, for instance, which is called *ipkuk*, can only be cured temporarily, for it always reappears, especially when the person becomes older, eventually causing death. Crocodiles and jaguars are responsible for what is called 'soul stealing,' *purpa suet*. This idea, quite widespread in Amerindian societies, is based on the fact that people have more than one soul, in the case of the Kuna, eight. One of these souls can be abducted by an animal spirit, causing the person to become ill and suffer a high fever (cf. Chapin 1983: 104–117). The Kuna say that one of the *purpa* is the first, *purpa nuet*, the most important and chief of the others. If that *purpa* is abducted the person will soon die.

I want to add here that the distinction between animal ancestors and animal offspring does not entail a temporal divide for the Kuna. Animal ancestors and animal offspring coexist at the same time and, during certain moments, in the same space. The only difference is that animal offspring are able to incarnate and assume the form of forest animals, whereas their chiefs live only in the supernatural world and can be seen by human beings only in dreams or by seers.⁴⁷ When they refer to the cause of illnesses, ritual chanters mention the names of the ancestral beings that are now the chiefs of the animals. They hold that there is a fundamental difference between the animals that live in the forest or in rivers and the spirits responsible for illnesses. The names of the chiefs of animals, I was told, are 'names of persons,' tule nuykana, meaning that the chief in the underworld is a person and lives with his animals as people live on the earth. They have their own villages and houses and eat their own food. Once a Kuna botanical specialist explained to me the relationship between ancestors-chiefs and offspring in the following way: "I'm going now to tell you the names of those who look after animals, of the persons who are saylakana of animals. It is as if I caught a little white-lipped peccary to grow up in my house; then my friends would joke, calling me 'host of white-lipped peccary,' even if that is not my real name." It is by knowing the personal names of ancestral animal entities that ritual specialists can effectively cure the ill, with the help of their auxiliary spirits, the small carved wooden figures, nuchukana or suarmimmikana.

Moreover, animals that are themselves ancestral beings have independent agency, as opposed to other animals that act according to the will of their chief. Animals that are themselves ancestors seem to flatten the spatiotemporal distinction between ancestors-chiefs and off-

spring. They are the manifestation of the category of *poni*, the evil that resulted from the mixing between human beings and Nia in mythic times. Two ethnographic references are particularly relevant here and may shed more light on the consistency of the Kuna classification of animal and supernatural species. The first regards the Bororo of Mato Grosso, described by Crocker (1985). In his description of the two allencompassing cosmological categories of *bope* and *aroe*, Crocker states, "Each is manifested in various 'pure,' undiluted, awful forms, but each is present also in an unstable synthesis within each living creature" (121). Then, considering the various degrees of manifestation of the *bope* in plant and animal species, he describes animals that for the Bororo are the pure manifestation of *bope*, as he calls them, that are themselves *bope*.

The *bope* creatures themselves are so tangibly filled with appearances and habits otherwise thought unique to the *bope* that a clear distinction cannot be drawn between them and the suprareal principle. These species, just like rain, thunder, the sun and the moon, are sensate evidence of the *bope*'s control of organic transformation. They are metonyms for the *bope*, revealing the spirits through mirroring (though in attenuated ways) their appearance and by being in physical conjunction with the serial changes of birth, death and decay. (180)

Following the inspiration provided by the Bororo classificatory system, I wish to draw attention to another system of classification, that of the Yawalapíti of the Upper Xingu in central Brazil. The Yawalapíti classify natural phenomena and relationships in relation to gradual distance from a model. This has been described as a "continuous-gradual cosmology" (Viveiros de Castro 1978: 9). Living beings are classified in relation to ideal forms through the use of linguistic modifiers. This allows for the definition of ancestral powerful beings and their manifestations in the sensible world, divided more or less closely from the supernatural model.

The addition of the modifier /kumã/ to the term for a specific animal, or object, reveals . . . that it is supernatural: big, ferocious, invisible. There are fishes-kumã, jaguars-kumã, canoes-kumã, pans for baking cassava bread that are kumã. Some animals do not need modifiers to be considered apapalutápa [spirits]: the jacaré, the jaguar, the deer, the macaque, were identified to me as apapalutápa. These animals (all apa-

palutápa-mina, 'terrestrial animals') are also included among the beings umañí, archetypical, that is, mythic beings. (33-34; my translation)

The Kuna thus do not group animals in a unique category. Depending on their habits and mythic history each species is considered independently and people relate to it according to practical and metaphysical concerns. What appears from the material presented thus far is that Kuna people consider certain animal species more endowed with agency and intentionality than others. These animals, besides being more dangerous for human beings, are important for the safe reproduction of human social life, as their power might be channeled by ritual specialists or transformed into curing knowledge. Differences between animals are reflected in the types of relationships that people entertain with each species, ranging from personal relations of shamanic affiliation to predatory relations manifested in hunting and illness. As we shall see below and in the following chapter, differences in intensity of power and effectiveness are also imputed, in a different way, to plant and tree species. Some trees are considered powerful ancient beings, others are used for their medicinal properties, others are poisonous, and still others are 'good to eat,' yer kulleke.

ANCIENT TREES AND YOUNG GARDENS

Plants, as well as animals, are classified by the Kuna following a precise scheme. My main interest here is to describe how Kuna people today think of trees in light of the myth of the young men of the Father.

Plants and trees are generally divided between those used for specific purposes, such as preparing medicines, building houses, making canoes and stools, and carving *nuchukana*, and those that produce food. Although not all plant species have a practical use, they all have a name and are recognizable by the Kuna. This means that the division between plants used for specific purposes and edible plants is not explicit but rather implicit, which points to the supernatural agencies attached to them.⁴⁸

The former plants form a group composed of large emergent trees and medicinal plants (see chapter 3). These trees were the first people to appear on the earth during the creation of the world; they were the young men of the Father and are therefore considered today the repository of the most ancient and powerful knowledge. Kuna ritual specialists choose them as their auxiliary spirits, along with animal spir-

its, and refer to them as *nelekana*. After trees, Great Father and Great Mother created other plant species, usually smaller trees, vines, and shrubs, which originally were people too and are considered the companions of the first trees. These plants also have a spiritual agency and are used by specialists to prepare medicines.

The category of edible plants is composed of those that are fruit bearing plants, especially plantains, bananas, coconuts, mangoes, and cacao. The Kuna distinguish between 'ancient trees,' sappi serretkana, which were the first inhabitants of the earth, and their 'followers' or 'companions,' sortamala, which came second during creation time. At the same time the Kuna seem to distinguish all forest plants that grow spontaneously from edible plants that have been planted by people.

As discussed above, trees were the first people to appear during the creation of the world. Since then the eight young men of the Father became the chiefs, or the owners of today's forest trees. My point is therefore that for Kuna people trees are the instantiation of their primordial ancestors, who were people in mythic times and then transformed into trees, becoming detached Others.

In the previous chapter I described the division between noncultivated land and cultivated plots. This division, I argue, is associated with and reinforced by the ancestral quality of noncultivated land and the sense of the present and continuation associated with cultivated gardens. Whereas noncultivated forest and especially its large emergent trees remind the Kuna of their ancestral past, cultivated plants point to the recent past, present, and future. Because the focus of my fieldwork was on uncultivated plants and nonedible animals and their relationship with the ancestral past, I do not discuss the potential ancestral history or power of cultivated plants for the Kuna, which exists among other indigenous people (cf. Guss 1989; Descola 1994). What emerged during my conversations with people in Okopsukkun was the link between cultivated plants and people. Kuna people remember who planted a mango or a cacao tree in their gardens, and this is often used during inheritance disputes over land: "That mango was planted by my father, and therefore its fruits are now mine." The present and the future are personified by people working in the gardens and by their children, for whom the fruits are destined. Kuna people say that they work the land to produce food to give to their children, so that they grow up healthy and happy. This forward-looking character of forest gardening is an important aspect of Kuna daily life and a strong incentive to face the hard work that such an activity entails, especially since Kuna

people today have to travel a considerable distance to reach their forest gardens.

With regard to the forest flora, Kuna people make a distinction between 'trees,' sappiwalakana or sappikana (sing. sappiwala or sappi), 'vines,' tupkana (sing. tupa), 'bushes,' kakana (sing. ka) and 'flowers,' tuttukana (sing. tuttu). These are explicit categories of everyday use. Most adult men know the types of trees, vines, shrubs, and bushes and their various uses. 'Firewood,' sappan, may come from certain types of 'mangroves,' ayli, or other hardwood trees; baskets and hats are made by weaving strips from the stems of naiwar (Carludovica drudei); house posts are made using the core of hardwood trees.

Botanical specialists have a vast knowledge of forest plants. They know the characteristics of each plant thoroughly, such as their everyday and ritual names, and where they usually grow. The Kuna divide plants using their properties in relation to medicine into pragmatic categories (Descola 1994). Trees are divided between 'trees with hard core,' sappikana kwa nikka; 'trees with sap,' sappikana kichi nikka; and 'trees with spines,' sappikana ikko nikka. These categories are used by botanical specialists to teach their young pupils how to distinguish trees and what types of medicines each tree provides.49 At the same time most adult men know how to distinguish trees that are good for making house posts and canoes or for carving stools, nuchukana, and utensils for daily use. Pragmatic classifications of trees and other vegetal species are thus directed toward utilitarian aims. Although categories often overlap and specializations often become integrated, Kuna people are quite keen to distinguish different fields of knowledge: medicine, mythology, and carving and other practical activities that require the use of wood.

There is no generic term in the Kuna language for edible plants. People refer to these plants using the name of the fruit they produce: plantain, other types of bananas, blue taro, manioc, yam, mango, breadfruit, maize, avocado, pineapple, and citrus. All these plants are important as they provide nutrition and strengthen peoples' bodies. They are the vital source of energy that enables children to grow up strong. Yet, when old men sit at the table, with their plates full of *tule masi*, made with boiled plantain and manioc, along with a big boiled fish, or more rarely a piece of meat, on the side, they feel happy. "Tule mas an kucha, an yer ittoke!" "I ate *tule masi*. I'm happy!" an old man would say as a sign of happiness and fulfillment after a life of hard work in the gardens and fishing. Happiness and fulfillment ideally derive from the fact

that he has many sons-in-law working arduously in the forest and fishing in the sea, bringing back plenty of food for the family daily meal. Cooked food is also the sign of a good life in the family, when people live in love and harmony and feel happy. If there is food people are happy, and people are happy that there is food. Sometimes when kinspeople fight men stop working in the gardens and women stop cooking. When people are sad, because they miss a dead person or a distant kinsperson, they do not feel hungry (cf. Lagrou 2000).50

Cultivated plants thus carry the memory of living or deceased kinspeople; uncultivated plants provide living people with a connection to their ancestral past. Kuna people consider forest trees ancestral beings, the knowledge and power of which accompany them in their everyday struggle against evil entities. By establishing a relationship with ancestral tree entities, ritual specialists are able to draw from their source of knowledge and to protect their living kinspeople against the evil predatory forces. As I argued in the first chapter, the island is inhabited only by human beings and *nuchukana*, the auxiliary spirits that inhabit ritual wooden figures. In what follows I will suggest that a *nuchu* is the transformation of a tree that maintains the tree's powerful agency yet makes it viable for human beings. The first step in this transformation is the carving of the figure of a person. It is to this issue that I now turn.

THREE

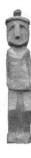

Carving and the Transformation of Male Fertility

ne day, in May 2004, I was speaking with Justino Lopez, an elder, about *nuchukana*. We had spoken about the same topic many times, and as usual he was very kind and willing to help me understand what I wanted to know and clear in his explications and examples. He

was used to my repetitive and naive questions, and he never seemed annoyed by them; rather he was patient and keen to repeat many times what for him must have been the most obvious things in the world. In this way he taught me many things about *nuchu*, how they live within Kuna households and their relationship with members of the family and with ritual specialists. That day I felt confident enough to ask him to show me his *nuchukana*. He replied, "Ask Beatriz. She is the one who takes care of them." So I did, and Beatriz, Justino's wife, told me to come back the next day.

Beatriz and Justino were living with their two daughters, their two sons-in-law, and three grandchildren. As I observed when I came back the following day, the *nuchukana* were kept in a wooden bowl at the foot of one of the two main poles of the house. Beatriz brought the *nuchukana* to the patio where we sat and started speaking. I asked her who made the *nuchukana*, and she told me the story of each one and what type of wood they were carved from. She said that with them in the house she felt secure. They protected all her family by keeping away dead people's souls and demons. Then she told me:

One day I brought my *nuchukana* to a *nele*, here in Okopsukkun. That *nele* saw them in dreams. She told me that the woman—and she pointed to one *nuchu* representing a female figure holding a cross—was very

powerful. If bad people arrive she does not let them enter my house. She also told me that this *nuchu* comes from far away and talks a lot. This is true; the man who carved it is from Paya [a Kuna village in the Darién forest close to the Colombian border], and he's a medicine man. He also knows how to make canoes and to weave baskets. He is old, but his wife is very young. He knows many secrets.

In this chapter I deal with the carving of *nuchukana*. I show how this activity is linked to the fertility of elder Kuna men and to their ritual skill in dealing with ancestral tree entities. Although virtually every man is able to carve *nuchu*, only a few men in Okopsukkun are recognized as *nuchu* carvers. Curing specialists are also able to carve their own *nuchukana*, but this is an activity usually carried out by someone else, and it is considered separate from the performance of curing rituals in which *nuchukana* are involved as auxiliary spirits. I argue that carving *nuchu* is an independent ritual activity requiring a specific skill. The skill of carving *nuchu* is developed throughout the life span of a Kuna man, who first learns to make canoes, stools, and other objects and later in his life becomes able to make *nuchu*. For the Kuna, creating *nuchu* comes as a transformation of previously acquired carving skills and is their highest manifestation.

I also point out that Kuna men who specialize in wood carving are particularly endowed with transformative and generative skills. Through mastering wood carving a man becomes able in his old age to deal with the powerful fertility of trees and to transform his own fertility. He transfers his own life-giving force, his *purpa*, to wooden logs, creating artifacts that will gain their own independent life. My point is that elder Kuna men transform the fertility that they had as young men—fathers—and become able to 'give shape,' *sopet*, to primordial entities. Giving shape is thus to be interpreted as the prerequisite for 'giving life,' *otuloket* (cf. Fortis 2009).

The praxis of wood carving connects elder Kuna men with muu-kana, the powerful entities who live in Sappipe neka and are responsible for the formation of human and animal fetuses (cf. Chapin 1983: 404). Kuna grandfathers and grandmothers are responsible for the fertility of younger couples, developing respectively the capacity to deal with supernatural fertile forces—those of muukana and those of primordial trees.²

Transformative capacities in everyday activities have to be seen in the larger framework of productive knowledge. Amazonian ethnography strongly suggests that men and women contribute to the everyday

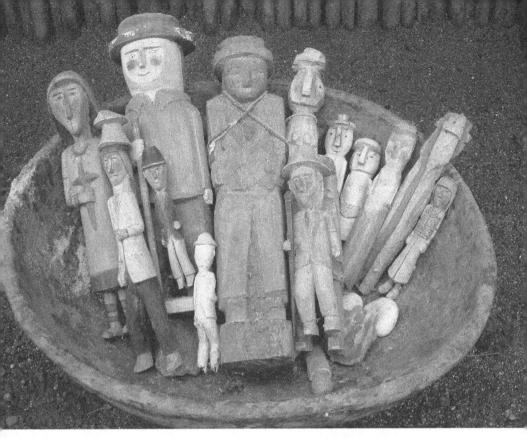

FIGURE 3.1: Nuchukana from Beatriz Alba's house. Photo by Paolo Fortis.

creation of social life with their respective creative knowledge (Overing 1989, 2003). This knowledge increases and accumulates in the person's body during the aging process. It is by looking at the different contributions of men and women in the creation of bodies and artifacts that it is possible to understand how individual creative processes fit into the wider Kuna cosmology.

In this respect the example of canoe making, inspired by the analysis of the same activity in Gawa (Munn 1992: 138–147), is significant for two reasons. First, it represents the first step in the learning of transformative skills among Kuna men. Second, it is an example of men's and women's participation in everyday productive processes. An example of the latter point is also found among the neighboring Emberá people, of whom it is said, in the making of dugout canoes, men "take the guts of" the trunk, while women prepare the food (Kane 1994). The food prepared by women serves two purposes, feeding the work-

ers and feeding the dying tree before it is transformed into a canoe. Men and women actively participate in the making of canoes, and their body parts are used as metaphors for the canoe's parts, resulting in "an elegant affirmation of unified but separate relation, the basic principle of Emberá social structure" (79).

The carving of *nuchu* should be seen as a transformation of a part of a tree into a living artifact, a person. The transformative capacities of elder men are linked to and in some way are the development of the reproductive capacities of younger men. Carving is described as a meaningful process by Kuna carvers, and it entails a set of steps to be performed in order to produce the final artifact. I will focus on three dimensions of *nuchu* making: (1) the skill of the carvers, which has to be seen as a transformation of the fertility of young men; (2) the material, which is the wood of particular trees associated with primordial entities by Kuna people; and (3) the process of carving as a combination of the fertility of elder men and their capacity to give shape to objects.

Nuchu in Kuna language means "little one," "young" and its adjective, nuchukwa, is often applied to youngsters, for example, wemar ampa nuchukwa, 'they are still young.' In the case of the small ritual statues, it has an affective meaning, such as "my little ones" or "the ones I take care of/I love." Other names used to refer to nuchu are nuchumimmi and suarmimmi. Mimmi means "child"; mimmikana are one's offspring, or children. One might say, mimmikana nikka? "Do you have children?" Suar means "pole," "stick," and derives from war, or wala, meaning "trunk," or more generally "straight long thing," used as a suffix for trees' names, as I discuss in more detail below.3 Added to the word 'water,' tii, it means 'river,' tiiwar. Suar is a straight log detached from a tree, like a branch, a root, or the main trunk. Nuchumimmi results therefore in a tautology, and suarmimmi means "stick/pole child." These three words are equally used to refer to one's nuchukana in nonritual situations, whereas when a chanter refers to his nuchukana while singing curing songs he calls them nelekana.

CARVERS

Carving *nuchu* is men's activity, and it is normally performed by elder Kuna men. In Okopsukkun during my fieldwork, there were four or five men renowned for their skill in carving *nuchu*. Although many men are able to carve *nuchu*, some of them become especially skillful and their ability is recognized by other people. As we will see, the ability to carve *nuchu* is connected to both aging and becoming a grand-

father, and goes along with the ability to make other objects and tools relevant in everyday life.

Soon after I started my fieldwork people suggested that I visit Eladio Pérez, a Kuna man in his late sixties who was a skilled wood-carver and basket weaver. Eladio had so many grandchildren that I could never count them all. People often commented that he had been a hard worker in his youth and still he was involved in minor agricultural and fishing activities. Many times I went to Eladio's home only to find out that he had gone shrimp fishing in the river, or that he was busy helping a friend repair his canoe, or he had gone to the gathering house to attend a meeting with other village elders. For his unstoppable work ethic, he gained the Spanish nickname hora zero, literally, "no time."

Armed with patience, I returned to his house many times. I remember meeting him during the afternoon when he would be carving a nuchu or weaving a basket. He was skilled at both, and many people would visit him asking if he could make a nuchu or a basket for them, for what he was usually paid just a few dollars. He also knew how to prepare some medicines and perform brief chants to counsel medicine. In addition, he was one of the arkarkana of Okopsukkun, a person chosen for his knowledge of Pap ikar, able to interpret them for the wider audience.

An arkar must be able to speak for up to half an hour, picking up the topics of the chant just sung by the sayla and connecting them to relevant matters of the everyday life of men and women. Such discourses are improvised, and, as I often heard, Kuna people are severe critics of both saylakana an arkarkana and of their respective abilities to sing and to speak. Most of all, an arkar should not bore listeners by being repetitive and giving the impression that he does not know what to say. He has to address the gathering with interesting topics and keep the people's attention alive, as many people, especially during the men's night-time meetings, fall asleep during the singing of the chant. His task is to 'open up,' arkaet, the meanings of the Pap ikar chants, in order to counsel people, communicating moral rightness and giving them the enthusiasm and the focus to confront a new day of work ahead.

If the most important role for a father is that of working hard in the gardens and fishing to provide food for his children, the role of a grandfather is to counsel his grandchildren and sons-in-law. Eladio is a good example of a man who has been a father, a man who has worked hard at providing food to nurture his children. When he became a grandfather his role changed to providing advice and counsel to younger generations. He also developed his capacity to deal with the powerful entities

of medicinal plants and trees, and he specialized in carving *nuchukana*. Together with his wife he is the center of the family.

As the Kuna put it, grandparents are like the pillars of the house, providing stability to the whole structure. Together they help the younger members of the household develop their own personal praxis. When major work needs to be carried out in the fields, like cutting and burning trees or sowing, groups of brothers-in-law work together under the guidance of their father-in-law. He is the one who directs the work, who decides when to rest and drink some unfermented maize drink.

Giving advice is a core aspect of the Kuna lived world.⁶ It entails the sharing of social values and the transmission of knowledge from the elders to young people. Therefore 'talking well,' nuet sunmakket, is an important quality for elder men, who during the day spend most of their time in the house and interact verbally with their young kinspeople, especially their grandchildren. Young men, however, are not expected to talk a lot, and they are appreciated when they are good listeners. Elder men are expected to speak about important issues in everyday life, such as the planning of gardening work for the coming season, the building of new houses, fishing expeditions, and the interpretations of dreams.⁷

Giving advice is not merely a verbal communication but also has to do with the transmission of inner and intimate properties from elder to younger men. Elder people transmit part of their purpa to younger people, thus strengthening the potential for the personal development of the latter.8 Through their everyday counseling grandfathers not only transmit their knowledge and experience to younger kinsmen, in order to make them grow into wise and responsible adults, but also transmit a part of their purpa to them, as their fertile capacity to generate and transform. Purpa is thus not only something that is transmitted through speaking, kaya purpa, the purpa of the mouth, and giving advice that teaches someone what to do and how to behave. It is also what people acquire from their elder kinspeople by being close to them, watching them, and listening to their voices. Young people are constantly encouraged by their elder kinspeople to increase and strengthen their purpa, because having a strong purpa is what enables them to have many children and to work hard. Plant medicines are regularly used from childhood to strengthen one's purpa. These medicines are prepared by botanical specialists who know the properties of plants and the chants that activate their effectiveness, as Eladio did. It is therefore through closeness to elder people and through the use of plant medicines that young people build up their purpa.9

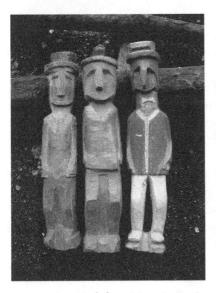

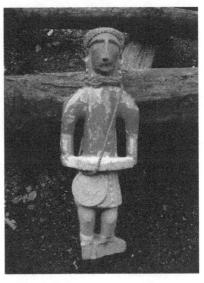

FIGURE 3.3: Nuchu. Photo by Paolo Fortis.

When a Kuna man carves a *nuchu* he transmits his *purpa* to the *nuchu* he is making. Therefore, if the man is someone who talks well, so it will be with the *nuchu* he carves. As Beatriz told me, one of her *nuchu* was especially powerful and eloquent. This, she said, was because the man who carved it was a wise man and a medicine man, meaning that he had the capacity to summon both people and plant entities. By mentioning that the man was from Paya, she meant to refer to the fact that the Kuna living on the islands perceive the Kuna living in the Darién forest as more skilled in ritual knowledge: "they know more secrets." Moreover, living in the forest means that one can easily find large trees that supply the wood used for carving *nuchukana*. Many of these trees are in fact said by Okopsukkun people to be difficult to encounter near the coast.

The quality of talking well is an important one for a *nuchu* to have. When a person becomes ill, one of his or her *nuchukana*—the one who is known to be more loquacious—is brought to a *nele*, who keeps it for some days in order to meet him or her in dreams. The seer then asks the *nuchu* about the nature of the illness that has affected the ill person and might also ask which medicine is appropriate. Not all *nuchukana* are keen to reveal the real nature of the illness at the first attempt of the *nele*, and not all *nuchukana* are easy to interrogate for they might refuse to answer to the questions. On the other hand, seers have their own

personal *nuchukana*, with whom they have established long-term relationships and who they regularly consult to diagnose illnesses and to learn medicines. Although some seers become powerful enough to see the illnesses alone, they might still refer to their *nuchukana* for specific advice. Much of the seers' capacity to see illnesses in the patient's body depends on the relationship they have with their *nuchu* auxiliaries, from whom they learned and who they ask for assistance. It is therefore important that *nuchukana* are loquacious, to reveal both the causes and the remedies of illnesses.

Nuchukana are thus an essential source of protection for Kuna people. They protect households against the penetrations of evil entities, they help seers to diagnose illnesses, and, not least, they are the auxiliary spirits of ritual chanters helping them to retrieve the souls of ill persons. The success of this latter task depends on two factors: the ability of the chanter to sing for a long time while remembering the complex structure of the healing chant, and the ability of his nuchukana to trick evil animal spirits. On the ability of nuchukana, one significant example is that of those carved from balsa tree. They are skilled orators, or diplomats, as some Kuna put it. Through their speaking ability they are able to trick the chief of animals, convincing him to reveal where he keeps the stolen human soul. It is also through their verbal skill that balsa trees direct other nuchukana in the battlefield against evil spirits. The balsa tree is the chief among trees because of its ability to give advice to other trees, much like Kuna village chiefs.11 On the ability of ritual chanters, it is important to note that, in addition to being skilled in memorizing and performing long chants, they have to know the purpa of the chants. Purpa, in this case translated in Spanish as secreto, "secret," is a short story repeated mentally by the chanter. It differs from the chant itself in that it is in common everyday language and comprehensible to nonspecialists.12 The purpa of a chant describes the birth of the primordial being to which the chant is addressed. Therefore, the chanter, repeating silently the purpa, is able to establish a personal relationship with his spirit helpers and to ask them to retrieve the stolen soul.

Singing and speaking, in the form of giving advice, are modes of transmission of *purpa*. If we assume this we can also see how the ability of Kuna carvers is not just manual but also a socially valued praxis of giving life by transmitting *purpa*. Given that for the Kuna *purpa* is also semen—the men's fluid that along with women's fluids is shaped into the bodily form of fetuses—we can now see that giving advice is a transformation of young men's fertility.¹³ Elder Kuna men are able to

control their *purpa* better than young men, and this ability makes them able to transmit their *purpa* through their voice, singing and speaking, and their actions, carving. The development of speech abilities is thus to be intended as hierarchically superior to other men's skills and has to be regarded as a purely creative capacity.¹⁴

Both young and elder men have to learn to manage the accumulation and transmission of their purpa. Young adult men take plant medicines to strengthen their purpa in order to be hard workers. Moreover, when a young man takes purpa-strengthening medicines people often say jokingly that for a while he will not let his wife sleep. It is therefore through the transmission of their purpa to their wives that young men become fathers. Together the woman's and the man's purpa contribute to the formation of babies. When a couple does not have children or has only a few, both the man and the woman are encouraged to take medicines in order to strengthen their purpa, and sometimes older kinspeople speculate about whether it is the man or the woman who is weaker.

When a man gets older, his workload diminishes, as does his sexual activity. It is therefore a commonly held idea that he would lose less *purpa* and need to take fewer medicines than younger men in order to increase it.¹⁵ As I have shown above, elder men continue to transmit their *purpa* but in a transformed way, namely, through singing and speaking. The transmission of *purpa* shifts from a predominantly physical level to the verbal level, almost as if speech is the substitute for both sex and work.

Kuna elder men dedicate most of their time to ritual activities, such as learning curing chants or myths, carving nuchukana, or learning medicines. Although still active in minor productive work, Eladio delegated hard jobs to his sons-in-law while he devoted himself to specialist activities. As most old men do, he used to sit in a corner of the house or on the patio while he was carrying on his activities and every once in a while scolding his grandchildren for misbehaving or asking them to bring him a tool. He told me that he did not like walking around the village, visiting friends, or going to the local small shops, hanging around and drinking cold beverages, as younger men do. If he wanted to meet his peers he went to the gathering house and spent some time chatting and smoking his pipe. Moreover, elder men are less prone to indulge in sexual adventures, which would cause their purpa to weaken. They are serreti, which means "old" but also "strong" and "hard." Most of the large trees used for carving nuchukana are serreti, meaning that they are ancient and that their wood is very hard. Contrarily, young men, who have just reached puberty, are called sappinkana, from sappileke, 'sprouting.'16

Nonetheless, elder men do not stop being fertile but rather continue to engage in seductive games and courtship. But they change the object of their seduction, turning their attentions to the female entities of plants and trees. Botanical specialists, for instance, treat plant medicines and trees as sexual partners. They perfume their bodies with sweet pisep (Ocimum micranthum) and paint their cheeks with makep (Bixa orellana) before going to the forest to collect medicines. They also avoid sleeping with their wife the night before, so as not to make the plant entities jealous. Then, when they return home, they sing to the collected plants to gently ask their help in the curing process. In counseling medicine they refer to medicinal plants as ina puntorkana, 'medicine girls,' and describe them as beautiful and seductive creatures.

TREES

The wood of particular trees is the material used for carving *nuchukana* and it is said to impart the property of the tree to the finished artifact. Both the hardness of the wood and its supernatural qualities are acknowledged by Kuna people. Combined with the carver's ability to carve the wooden figure and to transmit his *purpa*, the wood is also an essential part of a *nuchu*.

The difference between wild and edible plants consists in the fact that the former are said to be persons. Moreover, wild trees are called sappi, or sappiwala, meaning "tree," in contrast to plants, which are named according to the fruit they bear. Trees chosen for carving are hardwood tropical trees, with tall straight trunks that stand out in the dense vegetation. As noted in chapter 1, these trees are considered a category apart by virtue of the fact that they have not been planted by people. Two exceptions are the balsa tree, which grows quite rapidly in fallow land and has a notably soft and light wood, and the cacao tree, which is planted by people.¹⁷ Other trees grow only on uncultivated land, deep in the forest and on the hills of the San Blas Range.

Forest trees are important in Kuna daily life because they are the present instantiation of the first inhabitants of the world. A particular set of trees is associated with the young men of the Father (see chapter 2). These are ancient trees and possess the primordial knowledge of the creation of the world. They witnessed the birth of all living beings, the arrival of Nia, and the appearance of *ponikana*. They know the transformations and behavior of evil entities. Therefore Kuna people

seek the help of these trees to fight against evil entities that cause illnesses. Botanical specialists know how to use the bark, the sap, and the roots of these trees for preparing medicines; carvers are able to create statues out of their wood to make *nuchukana*, who become auxiliary spirits of singers and seers and protectors of Kuna households.

Garibaldo del Vasto explained that the trees from which *nuchukana* are carved are associated with the eight boys who helped Pap Tummat and Nan Tummat during the creation of the world (see table 3.1). Other informants told me that twelve species instead of eight are used to make *nuchukana*.¹8 Unfortunately, I could not identify all the trees that were mentioned in relation to *nuchukana*. For some I can only report the name used in current Kuna language. The ritual name is the one specialists use to summon *nuchukana* in ritual chants, and it is said to be a person's name.¹9

A Kuna man observing one of these trees once remarked, "We sappi serreti kkwichi sii," "That old tree stands straight." The adjective and the verb used in the sentence also apply to human beings, especially old people. Kkwichi sii, 'standing straight,' describes the vertical, upright position of a man or a woman either when they are still or when they are intent on doing something, such as speaking or looking at something. It is an active posture, and it expresses both a person's will and moral posture, even if it lacks movement. Usually, when men and women speak publicly in the gathering house they stand still, with their arms against the body, and utter their speech controlling the force of their voice. People who speak too loudly or gesticulate are not considered good speakers.²⁰

Sunmakkwichi, 'to speak standing,' is one of the most appropriate ways to speak in public, and it conveys the moral authority of the speaker.²¹ The other way, sunmaynai, 'to speak seated,' is appropriate for saylakana, who speak from the hammock at the center of the gathering house. Elder men are normally in the position of being good speakers and able to control both their voice and their gestures. They are also considered able to control their behavior better than younger people, who are prone to wander about in the village from one house to another. Elder men spend most of their time at home, although they normally have a circuit of houses where kin or friends live and whom they visit during the afternoon, before going to the gathering house. I remember seeing an old man passing in front of the house where I was living every afternoon and coming back after a while. One day I asked Nixia's mother, Raquel, where he was going during his regular visits. She replied that he went to visit his grandchildren who lived in Ustupu.

TABLE 3.1 TREES

Ritual name	Current name	Panamanian Spanish	Latin	English
Olowainanele	Mukksuwala			
Olokurkinakuilotule	Soylawala	Cativo	Prioria copaifera	
Olokurkinatirpitule	Sichitwala or	Jagua	Genipa americana	Genipa
•	Sapturwala)		•
Olokurkinasuitakiñalinele	Serupwala			
Olokurkinaekekiñalinele	Suurwala		Ficus sp.	Wild fig
Oloopanappinele	Mulasappi		1)
Olomekekiñalinele	Katepwala			
Olotinkunappinele	Tinkuwala			
	Ikwawala	Almendro	Dipteryx panamensis	
	Kapurwala	Caoba	Fam. Meliaceae	
Olokunipippinele	Ukkurwala	Balsa	Ochroma pyramidale	Balsa
Olonekakiñappinele	Nekawala		1	
Olotukkiñalinele	Mummutwala			
	Siawala	Cacao	Theobroma cacao	Cacao
Oloinuilipippinele	Masarwala	Caña brava	Gynerium sagitatum	Wild cane
Olokurkinakiappinele	Nipar)	
Olokurkinkilamakanele	Naiwar		Carludovica drudei	

Serreti is used to mean "old" or "hard." When people told me about old Kuna people, their ancestors living in the forest, they referred to them as their 'grandfathers,' tatkana, who were hard workers, possessed powerful knowledge, and had been strong fighters against the Spaniards and other indigenous people.22 My informants often told me, "Anmar tatkana serret kusa," "Our grandfathers were strong." By the same token, serret kuti, means that a person "is old." This means that, for example, a man does not work as much in his gardens, and if he goes to the forest he does not walk too far inland. On one occasion I decided to ask a medicine man about a medicine that would improve my energy. This kind of medicine is taken by men and women at regular intervals over the years in order to reinforce their blood. Once I started taking the medicine a young man commented that it would have only a weak effect, because the man who prepared it 'was already old,' seret kusa, and he collected only those plants growing closest to the coast. The man added that one must consult middle-aged specialists, who walk deep into the forest, hours away from the coast, to get the best and most effective medicinal plants. The relationship of elder men to the forest changes qualitatively as they dedicate less time to physical work and more time to ritual tasks. Instead of gathering food, they gather medicine.

Strength and stillness are thus characteristics of old age in people and are also associated with trees. Some trees are associated with the eight young men sent by Great Father to the earth, while others are said to be their followers, those who helped the powerful trees in the fight against evil spirits. For instance, *naiwar* and *nipar* are reeds that Kuna specialists use to build small crosses used in healing rituals alongside *nuchukana*.

Nuchukana retain the qualities of the trees from which they are carved. For instance mummutwala, the "drunken pole," is said to be like a drunk man, behaving violently and reacting with rage. I was told that when a nuchu of mummutwala meets demons or evil spirits he does not wait a moment but immediately strikes them. He does not speak but strikes. Nuchukana of kapurwala, Caoba in Spanish, and the smaller plant kapur, which according to Kuna is related to it, have a secret weapon: they intoxicate their supernatural enemies by lifting their hats, provoking the burning smoke characteristic of when one burns the small fruits.²³ Moreover, trees such as nekawala, mukksuwala, soylawala, and tinkuwala, besides carving nuchukana, are used to make canoes. Their hard wood and straight trunks are considered particularly good for this purpose. It also appears that these trees are used for making house pillars, as the name nekawala, composed of neka, 'house,' suggests.

In light of what has been said above, two cases seem to stand out as exceptions: the 'balsa tree,' ukkurwala, and the 'cacao tree,' siawala. The first is renowned for its lightweight soft wood and its ability to grow quite quickly on land where trees have been cut and burned. The balsa wood is also paler than that of other trees. In addition to being carved for nuchukana, it is used for making children's toys and for making sticks that are placed across one shoulder to balance the weight of produce that men transport. The cacao tree seems to be the only wood used for making nuchukana that is planted by people. This tree is not as tall as the others (between 4 and 8 meters), and it is not used for other purposes. Cacao trees grow under the shade of the foliage of taller trees. Kuna people distinguish different types of cacao depending on the color of the pod. The cultivars that they grow seem to be the Trinitario variety (Stier 1979: 275). Each household possesses a number of cacao trees, which have been grown by living people or inherited from deceased relatives. Cacao beans are mainly used for household consumption, both for preparing ripe plantain drink and for curing purposes. In some cases it has been reported that cacao groves were cultivated to sell the produce to traders (140-143).

Cacao beans are dried in the sun and kept in most Kuna households. Both ritual specialists and laypersons burn cacao beans in clay braziers. The former may do so to strengthen children's kurkin, 'brain,' 'intelligence'; the latter, to enhance the effectiveness of curing processes or to improve the visual capacity of young nelekana. Cacao is of paramount ritual importance for Kuna people, and its use is particularly associated with the curing of headaches and the first stages of the initiation of young nelekana, when their kurkin is fortified in order to make them capable of bearing the vision of nuchukana in dreams (see chapter 4). It seems, therefore, that there are good reasons the cacao is the only cultivated tree used for carving nuchukana.²⁴

LEARNING TO CARVE

When speaking with old Kuna men about their skill in carving nuchukana, conversations often turned to another, evidently related issue: the making of canoes. As happened on many occasions, when I asked a man about his life experience and how he came to learn about carving, he would start by telling me about how he learned to make canoes when he was younger. Also, when other people speak about a man who is skilled in carving nuchukana they often refer to his general woodcarving ability, as well as his ability to build houses and weave baskets,

as though these activities were related. Another comment I sometimes heard was that a man must be born with the predisposition to make such things.

When I asked Eladio how he learned to make canoes, he told me that he learned by himself. God gave him that gift. When he was a boy he made small wooden boats by observing the yachts moored by foreigners off the island. He also observed adult men making canoes and slowly became able to imitate them. Then he became very good at making canoes, and many people paid him for this work. Now he is too old and no longer makes canoes. Sometimes, if he is asked, he might repair one. Instead he carves nuchukana, and many people ask him to make a nuchu for them. He cuts the type of wood they request and then carves the nuchu. Once the nuchu is completed it is the task of the person who asked for it to bring it to a ritual chanter, who knows the chant to give life to the nuchu.²⁵

Another story is that of Leopoldo Smith, a man in his eighties and a renowned carver in Okopsukkun. Although limited by no longer being able to go to the forest because of his age and an aching knee, every day Leopoldo sat on his stool on the house patio and carved wooden objects, such as *nuchukana*, small canoes used in death ceremonies, and wooden pestles and other utensils. His daughters used to reproach him almost daily, suggesting that he should rest more in the hammock so he did not get worn out by so much work. This made him upset, and he would respond angrily and continue his work, stopping only for a quick lunch. In my field notes I recorded what he told me about his youth:

Leopoldo had a teacher [maestro in Spanish] who taught him how to make canoes. His name was Miguel Chiari. They used to make canoes together. They made medium- and big-sized canoes, which they sold in the Cartí area [western part of the San Blas Archipelago]. His teacher used to tell Leopoldo to observe him while he worked, then he gave him the tools and made him practice. In the meantime the teacher corrected him. Once, while Leopoldo was making a canoe alone, two older men came by and told him that his canoe was not good. He felt ashamed inside, because they were more expert than he. Then he made the canoe again. They came back, and once they observed the newly made canoe they approved of it and gave him the "diploma."

When his teacher was young, his father gave him as a medicine the heart of a giant anteater to eat. It is said that this animal was one of the first creatures to learn secrets and medicines.²⁶ But his teacher got seriously ill, and his father had to go to Caimán [a Kuna village on the

Urabá Gulf in Colombia] to learn the medicine to cure him. Once he recovered he learned how to work, he built his house alone, he learned to make canoes and other things.

Two motives are present in both Eladio's and Leopoldo's narratives about their learning experience, as well as in the story about Leopoldo's teacher: learning through imitation and learning as the result of an illness. The capacity to watch and reproduce an object is considered a valued ability by the Kuna. People who are born with such a form of intelligence are able to learn how to carve and to make canoes and other objects.

The emphasis on imitation is also applied to the female activity of sewing *mola* blouses, where reverse-appliqué designs are transmitted from one woman to another via imitation. Creating a beautiful *mola* design, as with making a good canoe, entails being able to imitate another design.²⁷ This act is not thought of as copying, as we might be tempted to interpret it, but as an act of making something anew, showing the personal skill and the specialization of the maker. In the process of making it, is therefore crucial to observe, to watch. This enables the maker to transform the mental image into an artifact. The skill of making canoes, sewing *molakana*, carving *nuchukana*, or making baskets, points thus to another skill, that of being able to see.²⁸

This point leads to the second motive, present in Leopoldo's story: his teacher's illness. Eating the heart of an anteater is a very dangerous thing to do, as all Kuna people would agree. Anteaters are powerful nelekana and are among the auxiliary spirits of human nelekana themselves. Generally, eating animal medicines is a dangerous process, which in most cases turns the eater into a mad person, dangerous to other people. I heard many stories on this subject, and all referred to the risk that eating animal medicines entails for the eater (cf. Nordeskiöld 1938: 341; Chapin 1983: 110). Eating the body parts of such animals is a way to absorb their ancestral knowledge, but it is considered by contemporary Kuna people a rather foolish way to do this. It is only born nelekana who are able through many initiation rituals to acquire the capacity to see and to learn from ancestral animal entities. A person who is not born a nele will not be able to learn how to master the dangerous knowledge of animals and will be poisoned. A similar case occurred in the island of Aylikanti, where I was told that some years ago a man suffered from the illness of Nia. In most cases this illness is considered incurable and a threat to other people as well. Fellow villagers feared the man would become a 'killer of people,' kia takkaler,

and he was condemned to drink a poisonous plant decoction, *ina nusu*.²⁹ Surprisingly, the man survived and recovered from the illness.³⁰ After that experience he was able to carve wooden objects. He was very good at making tables, chairs, and stools, and he constantly invented new forms. He used to have a little museum on his house patio. Some people, commenting on this case, told me that the man saw these things in his dreams before carving them.

These cases suggest that there are different ways to learn to carve. In all these ways it is important to be able 'to see things,' inmar takket, either in dreams or in waking life. The capacity to see seems in these cases to go beyond the normal act of seeing and points to the capacity that some people have to grasp the inner form of things with their own sight, to then make their visible and tangible instantiation. Kuna people use the expression inmar kaet, 'to grasp things,' when referring to learning processes. This applies to learning long ritual chants and foreign languages and to learning in dreams. Moreover, we can see a relation between the anteater, which is a shaman, and its ability to pass to humans the capacity to see, which is eminently a shamanic skill for the Kuna. For this reason, the ability to carve, which entails the ability to see, has to be considered specialized knowledge that can be acquired either through learning from other people or from contacts with animal entities. The cases of learning presented above suggest also a connection between activities, such as making canoes, carving nuchukana, building houses, and making stools and other objects, that have in common the act of giving shape to something.

GIVING SHAPE

In the Kuna language "too carve a nuchu" is nuchu sopet. The verb sopet is also used for a number of different activities such as 'carving a stool,' kan sopet; 'making a canoe,' ur sopet; 'weaving a basket,' sile sopet; 'weaving a hammock,' kachi sopet; 'molding a clay brazier,' sianar sopet; 'preparing fermented beer,' inna sopet (made by fermenting sugarcane juice with ground maize); 'building a house,' ney sopet; and 'making babies,' koe sopet.³¹ I argue that what these meanings have in common is that they all refer to the act of giving shape to something. As pointed out by Lagrou (1996: 223–224) for the Cashinahua, the uterus is the place where substance is transformed into fixed form. Furthermore, the Cashinahua use the verb xankeinkiki, 'weaving designs,' which bears a resemblance to the word xankin, 'uterus.'

Shapes for the Kuna may be created in different ways: by carving

out wood, as in the case of canoes, stools, *nuchukana*, and other wooden objects; by molding and cooking clay; by creating a structure using different materials, as in the case of building a house; or through the condensation of bodily fluids, as in the formation of fetuses (see Margiotti 2010). I therefore use the verb *carving* in this work with the specific meaning that the Kuna give to this activity, which is that of giving shape to a wooden log.

Another term that I sometimes heard used in the context of nuchu carving was opiñe, 'to transform' (from the intransitive form piñe). This more generic term also applies to supernatural transformations, meaning to change one's shape into another. This is what Great Father did when he sent the eight boys to the earth to see the creation of the world. Garibaldo used the expression "Pap Tummat masmala opiñali," "Great Father transformed the boys," meaning that exposing them to the visual spectacle of the creation made them powerful beings. Most important, Pap Tummat eventually gave personal names to each of them and made them rise to their celestial abodes dressed in their own clothes. Thus they became individual persons with specific qualities, which are those that each transmits to a specific tree species. It is therefore important to bear in mind that for the Kuna, giving shape is also transforming. Thus I suggest that, as with all processes of transformation, the act of carving is highly delicate and, though it does not have many restrictions as with other rituals, must be performed with complete awareness and follow ordered, meaningful steps, which I will explain below.

Kuna people give high value to the process of giving shape. They always regard a finished object very attentively, evaluating features such as the balance of proportions within the overall structure, the material used, and small details that may reveal the future duration of the object. They are also very critical of the work carried out by others, and they always note any imperfections that mar a new object. For example, the edges of a canoe must be neither too thin nor too thick, and the thickness of the hull must be consistent. The prow must not be too long compared to the stern, and the length must be proportionate to the width. If the finished canoe is well done it will also be one that will last for a long time and will be carried easily.

Men who are able to weave beautiful baskets, to make canoes, or to carve wooden objects are said to be 'intelligent,' kurkin nikkat. They are able to transform things, to give shape to objects.³² The capacity to give shape is not something that one can just learn. One must be born with such a gift, as Eladio pointed out, and the skills must be developed through the thorough observation of older men or, in particular cases,

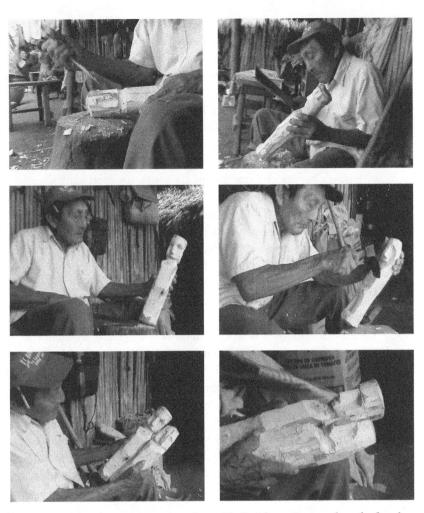

FIGURES 3.4, 3.5, 3.6, 3.7, 3.8, 3.9: Leopoldo Smith carving a male and a female *nuchu*. Stills from a video by Paolo Fortis.

through a personal moment of crisis and suffering. This creative intelligence and the transformational capacity attached to it are highly valued by Kuna people. Expert canoe makers have the same status as ritual specialists. As Beatriz told me, the man from Paya who carved some of her *nuchukana*, in addition to being a botanical specialist, knew how to make canoes and weave baskets.

The making of a *nuchu* starts in the forest, where the man cuts a branch or a root from a tree, and ends in the house, where he completes the carving. It can be the same man who cuts the wood and then

carves the *nuchu*, or it may be two different men. Often, in fact, a man cuts a log and gives it to a carver, asking if he can make a *nuchu* for him. Sometimes elder men ask younger men heading to the forest to cut a log for them from a particular tree from which they want to make a new *nuchu*.

The first thing that a man does in the forest is choose the tree. Elder men usually have a good knowledge of trees and their qualities. For example, I was often told that it is risky to carve a *nuchu* from the wood of *mumutwala*. If one really wants to do that he should visit the tree four times before cutting one of its roots, on each visit singing a brief chant to advise the tree's soul. Otherwise it will get upset and attack the carver. Once a Kuna friend told me that he had carved a *mumutwala*, but then one day when he was paddling his canoe he suddenly felt really bad, and when he went back home he fell ill for few days. He told me that it was the spirit of the tree that took revenge and almost killed him.

Once the tree is chosen a man cuts a root or a branch from it. I had the opportunity to assist directly in this stage, when Garibaldo cut a root from an enormous ikwawala (Dipteryx panamensis); branches were evidently too far up to reach. Then he instantaneously marked a part of the log with his machete. When he realized that I was watching him in a puzzled way, he said, "You think that what I'm doing is for fun, don't you?" Later Eladio explained that one must know, while carving, which part of the log was closer to the ground and which side was directed eastward, where the sun rises, when it was still attached to the tree. For this reason when a man cuts a log from a tree he immediately makes an incision corresponding to the part of the log that is closer to the ground and that is looking eastward. The incision will remind him later, when he is at home, where to carve the nose of the nuchu, which is also the first thing he will do. The same process must be followed when a man cuts a whole tree: observing the branches, one should be able to foresee the direction the tree will fall.

The analogy between trees and people is very strong. Eladio told me that sometimes the nose and the back of a *nuchu* are already visible on the branch; the nose is a small lump on the wood, and the back looks like a straight cut in the bark. In this case the carver will simply have to follow the signs on the wood to carve out the *nuchu*. I asked Eladio why the *nuchu*'s head is carved from the lower part of the log and the legs from its upper part. He answered that a *nuchu* in the tree is exactly in the same position babies are in their mother's womb. "When we are born," he said, "we come down with our head first, then the mid-

wife turns us face up."33 The analogy with birth turns out to be widely used by Kuna carvers. The connection with human birth appears even stronger if we think again about the meaning of the word *nuchu*, 'little one,' 'young,' reinforced by the more familiar *nuchumimmi*, 'little child.' *Nuchukana* as true powerful children of the forest are treated simultaneously as powerful entities and beloved ones to take care of.

NOSE: BEAUTY AND POWER

As Eladio and other carvers stressed, the nose is the first thing marked on the wooden log after it is cut from the tree. It marks the direction the *nuchu* was looking when it was still attached to the tree. The nose is also the first feature to be carved when making a *nuchu*; it is used as a reference for carving the head, the shoulders, the arms, the torso, and the legs. The eyes are the last thing to be made. The nose of the *nuchu* is always long, thin, and pointed. Despite the variations in the form of *nuchukana*, comparing my direct observation in Okopsukkun with published photographs (Nordenskiöld 1938: 424–425; Reichel-Dolmatoff 1961: 235; Chapin 1983: 94, 208, 358–359, 391; Salvador 1997: 44, 111, 222–227, 240–241, 333), it seems that the nose is always represented in the same way. Other features, such as arms, legs, feet, or clothes may be just sketched or, like the mouth or the hands, omitted.³⁴

The nose is the common thread among all types of *nuchukana*, whether they are made to look like missionaries, soldiers, or regular men and women. It is always accurately done and stands out from the whole figure. "You do not begin from the feet, do you?" Eladio once told me. This echoes again the importance of the head-down position for babies during childbirth but also has to do with supernatural powers, namely, with powers linked to sight and direction.

To understand why the nose represents such powers it is important to introduce another aspect. The nose is of great importance for Kuna people as a mark of beauty. It also marks the difference between Kuna and Others. I was told often during my fieldwork that white people are beautiful because they have long and thin noses, as opposed to the noses of Kuna people, which are flat and therefore ugly.

Nuchukana sometimes appear to Kuna people in dreams as white men or white women. They are said to be either beautiful and elegant or sturdy and sometimes dressed with military clothes. Interestingly, the chief of the trees, the most powerful of the auxiliary spirits of the specialists, is the balsa tree, typical for its pale wood.³⁵

Nuchukana made of balsa wood always appear to nelekana in dreams

as beautiful people, with white skin, shiny hair, and delicate features. But one must not forget that balsa wood is considered the chief of forest trees, the captain, as I was often told. It has diplomatic skills and the charisma to conduct other *nuchukana* in the battle against *ponikana*. It is balsa wood that leads other *nuchukana* and organizes the collective action against evil spirits. As a consequence balsa wood is also the most important among the plant auxiliary spirits of ritual specialists. Despite the softness and the lightness of its wood, balsa is the most important wood for carving *nuchukana*. In every curing ritual, both individual and collective, balsa woods are carved for the occasion and are often made in different sizes. The most remarkable example of carving, I was told, is created for the occasion of the celebration of the collective curing ritual, aimed at ridding the village of the presence of evil animal spirits or the souls of the dead, which bring epidemics or cause collective fright (Chapin 1983: 353–365; Howe 1976a; Salvador 1997: 222).

Force and beauty appear thus to be connected in the way Kuna people think about *nuchukana*. It is interesting to note that Kuna people think about themselves as less beautiful and less powerful than white people. As a Kuna specialist once told me, white people's blood is stronger than Kuna people's blood. In fact, he said, if a white person kills someone he will not feel his heart aching, whereas Kuna people cannot kill because they would suffer terribly, they would feel deeply sad. My informants were always eager to express to me their detachment from any form of violence, stressing that violent behavior is an issue of Others, whether strangers or supernatural beings.

It is interesting to note that while rejecting violence, the Kuna also attest their limits in terms of power. But it has not always been this way.36 Nuchukana and white people are more powerful than Kuna people. The technology of white people is the most frequently used analogy for the power of nuchukana. I heard them compared to wireless radios that get signals from far away. They are able to communicate with their fellows on other islands of Kuna Yala, as well as with ritual specialists who activate their power through singing. Nuchukana are also like radar, able to detect invisible presences approaching from a distance or to see what happens in distant as well as invisible places. They also have the capacity to hide and approach the enemy unseen, like soldiers who use camouflage to move on the front line.37 Nuchukana are powerful and beautiful; they may appear in dreams as seductive presences, but at the same time they are capable of violent revenge, inflicting pain or even death. In this sense white people and nuchukana are equated as forms of the most distant and powerful alterity.

In the myth of the young men of the Father it is said that when Pap Tummat decided that the eight boys had reached the fullness of their knowledge he told them, "Emiti pe ituet tummat soke. Pemar asu tukku takkensoke," "Now you have become chiefs. You have pointed noses, you see." He then went on to give each a personal name, giving them individuality and so beginning their process of transformation into powerful beings. Previously in the myth, Nia appeared standing on the prow of a canoe: asu tukku, on the "point of the nose" of the canoe. I argue that both the point of the nose and the prow of the canoe are linked to the sense of direction. The nose always points forward in the same direction that one is looking. The prow of a canoe, its nose, is always pointed toward the place one has to reach. The nose of a nuchu is carved on the side of the branch looking toward the direction of the rising sun, where the canoe of the sun rises every morning and where heaven, the house of Pap Tummat, is.

Kuna cosmology has been described by scholars as conceiving the world as composed of several layers below the earth and several layers above (Nordenskiöld 1938: 357; Chapin 1983). What has not been noted is that there is a strong relation between the east, where the sun rises, and the realm of the underworld. Through the trajectory of the sun, which passes through the underworld in its night travel and comes out again in the morning, the Kuna conceive the circularity of the world. East is therefore where different dimensions merge, and this is made evident by the appearance of the sun. It is where the celestial house of Pap Tummat is, where the souls of the deceased travel to. It is the entrance to the underworld, and it is also, if looking from the mainland, where the island is and where people live. Therefore, from the perspective of a *nuchu* still attached to a tree, looking eastward is being able to look through all these domains: the underworld and its spirits, the surface inhabited by human beings, and the celestial house of the dead.

The last thing that is created in a *nuchu* after it has been carved are the eyes. Once they are made, by making little holes and sometimes applying small beads, the *nuchu* is ready to be given life through the chant of the shaman. The eyes represent the power of sight through which a *nuchu* can see what happens in the underworld and can thus move through the villages inhabited by animal entities and spirits. It can find out who has abducted the *purpa* of an ill person and where it is being kept. It can see which animal entities are haunting a village, causing the spread of an epidemic. It can see within the human body to dis-

cover the pathogenic elements that cause an illness. At the same time *nuchukana* constantly observe human beings. They see what goes on in the everyday life of the village. They observe the members of the family in which they are staying. Sight and sense of direction are thus the abilities through which *nuchukana* move between different cosmological levels and see what happens in each one of them.

When Kuna people indicate a direction they do it by turning their head toward it. The prow of a canoe gives the sense of direction because it is always pointed toward the place to be reached.39 The crocodile is said to be the canoe that transports the abducted soul of a victim into the underworld village of the chief of animals. When a ritual specialist is making a medicine intended to have an effect on a distant person, he must face toward the direction where the person is, regardless of the distance. When a medicine man cuts the bark from a tree, he takes four pieces, one from each of the four cardinal points. As Garibaldo del Vasto explained to me after the narration of the myth of the young men of the Father, such present-day practice for collecting medicines in the forest goes back to what the eight siblings did during the creation of the world. They looked in the four directions while Pap Tummat made the earth whirl. Through the rotational movement the earth completed its generation. It became solid, from previous states of liquidity—"the earth was just juice"—and softness—"it was tender like rubber." The boys assisted in the transformation of purpa into sana, 'body,' 'flesh.' They observed the rotation, which stimulated the solidification of the earth by looking in the four main directions. This explains how sight and sense of direction are linked as two important features of nuchukana. For instance, once a Kuna man showed me a nuchu he had just finished carving that had four faces looking toward the four directions. I asked why, and he told me that it was because nuchukana are able to look in every direction; they are able to see everything everywhere.

As the myth told by Garibaldo explains, the process of solidification of the earth corresponds with the first woman, Pursoso—herself a transformation of Nan Tummat—getting pregnant and giving birth. It is Pap Tummat who makes the earth whirl, triggering the process of solidification. This process is explained as the 'condensation,' kwamakket, of purpa. Kwamakket literally means "making the core." Sappi e kwa is the core of the tree, the inner and hardest part of the trunk. Not all trees have kwa and, interestingly, trees that have kwa are used for making canoes, nuchukana, or house poles. Kwamakket describes the birth of the

world as seen by the Father's eight boys, the coagulation of bodily liquids in the women's uterus, and the creation of the hard wood of trees.

If we consider how in canoe making and in *nuchu* making the wood of trees is treated differently, we can now see that making *nuchu* is the closest male equivalent to making babies. In fact, tree trunks are hollowed when dugout canoes are made, in this way getting rid of the *kwa*, whereas when making a *nuchu* it is the *kwa*, the hard wood, that is carved, symbolically but also materially referring to the molding of the inner part of the tree, usually invisible.

In her analysis of marriage exchanges in Gawa, Munn (1986: 140) describes the roles of men and women in the transformative process of making canoes. The "artifact-making ability to work on wood" is given to men by women, who hold the productive knowledge. The raw material, wood, is metaphorically identified with women's internal bodily fluids. Furthermore, in the formation of babies, women give the internal body substance, blood, while men contribute the external bodily surface. Munn writes, "These ideas about the body connect the paternal contribution with a formative action that suggests parallels with the male role in canoe building in which men construct female-marked raw materials (homogenous substance) into a named, shaped artifact" (143).

What interests me here is the artifact-making ability of men and their capacity to shape female-marked raw materials. Kuna people hold that male semen, purpa, and female vaginal liquids mix and coagulate within the uterus. The form of babies is then shaped through the action of Muu. The same term muu also indicates the uterus. It is therefore not clear whether the transformative capacity to make babies is passed by Muu to the woman or if it is always ultimately held by this celestial entity (cf. Margiotti 2010). What is interesting is that Muu is the origin of transformative capacities. Muu, along with her granddaughters, lives in Sappipe neka, the village where the chiefs of trees also live. As Chapin reports, "Mu had many granddaughters. Her granddaughters and she give life to babies who descend to the earth; they give Kurgin and refresh their minds.... Her [granddaughters'] names were Mu Sobia, Mu Sobtule, Mu Sobgwa, Mu Sichina, Mu Koloba, Mu Parba, Mu Ibebayai, and Mu Wagarpuilibe" (1989: 39; my translation). The names of the first three granddaughters suggest an interesting similarity with the name given to Nan Tummat in the myth of the creation of the world. It is the prefix sop-, which most likely derives from the verb sopet, 'to give shape.' Pursoso, or Pursop, is what Nan Tummat is called in the myth when the earth is being created. The name is likely composed of puna, 'girl,' and *sopet*, 'to give shape.' Thus she is the girl who gives shape, the female creator who through her bleeding vagina, which had been previously cut open by Pap Tummat, gives birth to all living creatures in the world. Muu's granddaughters giving life to babies today thus retains the original shape-giving capacity of Pursoso.

The act of giving shape is carried out in everyday life by Kuna men responsible for the production of canoes, stools, baskets, houses, and *nuchukana*. Women are dedicated to making designs, a different activity expressed by the Kuna term *narmakket*.⁴¹ The skills of giving shape and making designs are originally held by Muu and guarded in Sappipe neka. The original design is known to be made by Muu when she draws on the *kurkin*, 'caul,' 'amniotic sac,' 'brain' of fetuses. Having so far considered the nature of giving shape for Kuna people, I describe in the next chapter the significance of designs.

FOUR

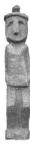

Amniotic Designs

he aim of this chapter is to provide a description of how the life cycle of Kuna seers begins, focusing on their personal relationships with both their kinspeople and nonhuman beings. I start here by considering the early stages of the life of *nele*, birth to childhood. I fo-

cus on two issues that Kuna people stressed when speaking about *nele*: first, one has to be born a *nele*; second, young *nelekana* are delicate and fragile creatures, whose dreams are particularly active and filled with vivid nightmares.¹ The questions I want to explore are, How do these issues provide an insight into Kuna socio-cosmological thought? and how does the perception of fear, and the way it is experienced by young seers, help us to understand how Kuna people think about the relationship between human beings and the supernatural?

To answer these questions I provide accounts of the birth of nelekana and their dreams and suffering during childhood. I explain how the Kuna interpret these issues as signs of supernatural calling. In particular, I discuss the meaning of what the Kuna call 'amniotic designs,' kurkin narmakkalet, which appear during the birth of gifted children and whose meaning, I argue, is helpful for understanding the nature of nelekana. This provides the grounding for the understanding of some aspects of the Kuna concept of personhood, discussed in the chapters that follow. It also provides the first step in describing how Kuna people work collectively for the initiation of young nelekana.

Inspiration for writing this chapter came from reflecting on the emotional dynamics of shamanism. Here I draw from the ground-breaking work of Overing on the aesthetics of community in Amazonian societies (1986, 1989, 2000, 2003) and on Santos-Granero's (1991)

analysis of the moral use of power among the Yanesha. Among others, Belaunde (2000) has contributed to this topic by addressing the issue of fear, a subject that has been overlooked in Amerindian studies. She has suggested how fear among the Airo-Pai of the Peruvian Amazon is caused by the expression of unmastered emotions. Thus, she argues, it is extremely important to teach children how to master their emotions in order to contribute to the creation of conviviality. Moreover, Gow (2005) has suggested looking at fear as a transforming emotion generated by getting to know powerful beings in Piro lived experience, from early childhood to adulthood. He has also pointed out that the continuous experience of fear of shamans is the first step in learning how to use fear to master hallucinations and eventually to cure ill persons. It is thus through looking at the emotional content of shamanic experience that I explore how young Kuna nelekana are considered different from normal babies and consequently initiated into becoming seers.

Fear is a key emotion in the life experience of Kuna seers. Kuna adults say that young *nelekana* experience intense nightmares and are very frightened by them.² Adults teach them to master their dreams and control their fears in order to become powerful seers. Manifestations and conceptions of fear seem to frame the problem of what it means to be a seer among Kuna people. The Kuna case shows the importance of the comfort provided by social relationships in the formative process of shamans. Young *nelekana* become able to overcome fears and suffering through the support of their family members together with the help of ritual specialists.

For Kuna people, as well as for other Amerindians, speaking of experiential states means speaking about the body and about relations. As some Amazonian scholars have argued, emotions and the body go together in the social life of indigenous people and therefore have to be seen as relational states (Taylor 1996; Overing and Passes 2000). It is my aim here to address the problem of fear experienced by a young nele, caused by nightmares and his closeness with powerful beings, according to the explanations that Kuna people gave me. I was told that nelekana are different from other babies and that this is visible at birth in the presence of the remains of the amniotic sac, the caul, covering the baby's head or another part of the body. Close attention is given to the newborn's head, as the presence of designs on the caul, or the complete absence of design, will tell much about its nature. I will therefore argue that a theory of design is needed to understand what it is to be a seer, as well as to shed light on issues relating to what it is to be human for Kuna people.3

At birth a *nele* is in great danger of dying. All newborn babies are indeed fragile beings, regarded with compassion by their kinspeople and thus helped to survive and grow. Kuna people say that newborn babies are helpless; they lack physical coordination and need the love and care of their kinspeople in order to survive. *Nelekana* are said to be particularly fragile when they are born. They need to be treated with special attention and bathed promptly in plant medicines. This is because, I was told, powerful spirits seek the company of young *nelekana*. But young seers are not resistant enough during the early stages of life to bear the closeness of powerful entities. Therefore, they are frightened when they meet spirits in dreams. In addition, they do not know how to deal with the trickiness of powerful beings. Therefore, they may be easily deceived by powerful beings, resulting in their unconscious complicity in the killing of their parents.

It is commonly held by Kuna people that nelekana are dangerous to their parents. "A nele can kill his parents," Kuna people used to tell me (see Chapin 1983: 139–140). Kuna parents are generally frightened by the idea of having nele children and try to avoid it. This fear extends to the whole of Kuna society. My hypothesis is that the fear of shamans has led Kuna people to create strategies for making shamans able to restrain their powers and thus to become less dangerous to themselves and their kinspeople. These strategies aim to mediate the relationship between a nele and the supernatural world and to reinforce his ties with human beings. Among these strategies, I suggest, are collective initiation; association with nuchukana, which act as the spirit guides of a nele; and the obligation for nelekana to get married, thus controlling their association with powerful spirits.

First, a *nele* is taught to master his dreams. He will then be able to transform his fears into powerful knowledge through repeated initiation ceremonies (see chapter 7). Beginning in early childhood many people are involved in the formation of the *nele* and help in various ways, by curing his headaches, giving him strengthening plant medicines, interpreting his dreams, or advising his parents. Moreover, I was told that a young girl is chosen to bring fresh water to the house of the young *nele* for his medicinal baths every day. Ideally she will become his wife. This process is what I describe as the Kuna collective strategy of creating shamans.⁴ This may start from before the birth of a *nele*, immediately after it, or during his childhood. Key figures in this mediating process are grandparents and ritual chanters.

KURKIN WITH DESIGNS

When a Kuna baby is born the midwife observes the white remains of the amniotic sac that sometimes cover the baby's head. These remains, as well as the amniotic sac itself, are called kurkin. Although all babies have their own kurkin, the amniotic sac when they are in the mother's womb, few are born with its remains still covering their heads. On these remains, as well as on the 'placenta,' achu, which means "jaguar," designs might be visible. It is in those very few moments after the birth, before cutting the umbilical cord, that the midwife looks at the amniotic designs and comments on them. She will then tell the child's grandmothers what she has seen in the designs. These designs give good hints about the nature of the baby and about its future. The Kuna say that the designs on the newborn's kurkin are drawn by the celestial grandmothers who are responsible for the formation of fetuses and for the delivery: muukana kurkin narmakke, 'grandmothers draw designs on kurkin.'

Although for the Kuna every human being has had his or her kurkin designed by celestial grandmothers, only a few babies show their designs at birth. The presence or absence of amniotic remains at birth thus creates a first distinction. Those born without showing their kurkin are considered normal babies, who will be able to learn during their lives. Those born showing kurkin are considered endowed children, with a heightened predisposition to learn. Among the latter there is a distinction between those showing amniotic designs who will become particularly skilled and intelligent persons and those born with white, immaculate kurkin, without any design, who will become nelekana.

The Kuna term kurkin, in addition to "caul," means "brain," "intelligence," "skill," "hat," and "headdress" (cf. Nordenskiöld 1938: 363–368). Considering the multiple meanings of the term, it would first appear that there is a relationship between what is visible on the surface of the newborn baby's head, the remains of the amniotic sac, or hat, and what is inside the baby's head, the brain. The 'hat with designs,' kurkin narmakkalet, thus describes a relationship between the external surface of the body and its interior. But what precisely is the role of designs in this meaningful tension between the inside and the outside?

First, the designs on the babies' kurkin at birth show a link with specific dangerous animals, for example, jaguars, snakes, and crocodiles. If a baby is born with the jaguar design midwives say that he is born 'on the side of the jaguar,' achu sikkit. If he has the snake design or if the re-

mains of the amniotic sac hang around the newborn's neck, he would be on 'the snake's side,' *naipe sikkit.*⁷ In both cases Kuna people agree that when the child grows up he will be in danger of attracting these animals, with the expected lethal consequences. Children will therefore be bathed in special plant medicines, during childhood and early adulthood, so that this dangerous link may be broken.

It is interesting to note the analogy that the Kuna make between human clothes and the skin or the fur of animals; both are identified by the same word, mola. For example, the skin of snakes and the fur of jaguars are both called, e mola, 'its clothes.' The foliage of trees are their clothes as well.8 What animal and human clothes have in common is covering their bodies. Human clothes, snakeskin, and tree foliage point also to the possibility of changing one's clothes. Furthermore, women's clothes, newborn's cauls, the skin of snakes, and the fur of jaguars have one remarkable aspect in common: the possibility of being covered with designs. The fur of jaguars and the skin of snakes are covered with designs, which Kuna people say are 'beautiful,' yer tayleke. The beautifully designed skin and fur of these animals are the manifestation of their power. They show the power of transformation of these animals, which is the most dangerous power the Kuna imagine. Jaguars are able to take on human appearance and get close to human beings in dreams, to seduce them and abduct their souls or to drive them crazy. They may either kill their victims or transform them into one of their kind, a predator of humans. Snakes are said to be immortal because they shed their skin.9

When a snake bites a person the illness is extremely difficult to cure, because it continues to transform within the human body. It may even disappear for a while, but it will come back sooner or later. Also, trees are associated with immortal powers. They shed their skin too, and they are the primary source for giving health and strength to human beings, via medicines obtained from their bark, leaves, vines, roots, and sap. Tree entities also have the power to transform. For this reason Kuna ritual specialists as well as nelekana seek their help as spirits familiar with curing illnesses. Moreover, as we have previously seen, trees possess the ancestral knowledge of the creation of the world. They know the transformations of animals and demons and are thus able to trick them on behalf of human beings.

Given this, it is possible to understand the meaning of *kurkin* as the first designed clothes of babies; their "hat with designs." Yet *kurkin* is what is inside the head; it is the brain. As I have shown above, the

meaning of *kurkin* conveys the idea of a relationship between what is inside and what is outside the human brain. I would argue that this relationship is in fact activated by designs. Designs on the newborn's *kurkin* show the inner capacity of the baby, its intelligence as Kuna people often say. Yet they also show the capacity to attract wild animals.

Designs make the openness of the human brain possible; they make it porous; from birth they enable the bidirectional inside/outside movement. This inside/outside relationship expresses receptivity, the capability to learn. It expresses the capacity to grasp things with the mind. If a newborn has beautiful designs on the kurkin at birth he or she will be very intelligent, capable of learning many things, or gifted, as some Kuna put it. They are children who will be good at school, with a talent for learning foreign languages, or when they are adults they will rapidly assimilate myths and ritual chants or whatever subject they decided to study. Having beautiful designs on the kurkin at birth also expresses the capacity to transform things. It is the capacity to create designs for women and to shape forms for men. It is also the generative capacity to give birth for men and women (see chapter 3). This capacity is in some way the other side of receptivity. It is the capacity of producing, of making things visible to others. As I have argued elsewhere (Fortis 2010), it is the expression of one's praxis in the social world. This double capacity of inward receiving and of outward transforming represents the two sides of human praxis for Kuna people, and it is beautifully expressed in their discourses and practices about kurkin. But what happens when the kurkin is without designs?

WHITE KURKIN

Kuna people say that the newborn nele has an immaculate white kurkin. Some people also told me that when a nele is born he is completely wrapped in the amniotic sac, as in a plastic bag, they said. Or, using a Spanish expression, "Nació con la camisa," "He was born with a shirt on." Another version I heard was that when a nele is born the midwives recognize him by the fact that he is covered by four layers of amniotic sac and has a shining light on his forehead. What is striking in all cases is that the nele has no designs on his kurkin. His amniotic hat is immaculate. However, this does not mean that muukana have not drawn designs on the nele's kurkin. In the translation by Pérez Kantule of the song for curing a nele when he has a headache, "it is told how Mu had perfumed Nele's kurgin with certain plants and had made it fine as well

as how Mu gives kurgin to Nele, so that he can have the power of seeing the animals which are his friends, among which can be noted saw fish, rays, turtles of different kinds, alligators, sea lions, sharks, dolphins, etc." (Nordenskiöld 1938: 542).¹²

I suggest that the designs on the *nele*'s *kurkin* are not absent but rather invisible to normal human beings, even to midwives, who are specialists in reading designs on the caul. This would point to a difference of perspectives between seers and normal people, insofar as visible designs allow for the sharing of perspectives between human beings and invisible designs create different perspectives. The *nele* will be able to develop a different perspective of the world, seeing animal transformations and sharing their point of view. Normal babies will have the partial capacity to see, shared by all other laypersons. The presence and absence of amniotic designs stimulate therefore the development of different capacities in human beings born with *kurkin*, that is, those with a heightened capacity to learn. Amniotic designs stimulate the development of human social praxis, while their invisibility stimulates the development of shamanic praxis—the capacity to see beyond the limits of normal human visual experience.

It seems, then, that newborn seers do not carry the sign that every human being normally does. Human beings, when they are born, have on their kurkin the mark of ontological alterity, which expresses both their capacity to learn and create and their human mortality. A nele does not show any design on his amniotic sac to other human beings. At birth, he thus lacks, in some way, one of the first signs of humanity. His nature is thus liminal and ambiguous. His relation with cosmic alterity is not visible to others, as it is not manifest in designs. But as every Kuna person knows well, a nele attracts nonhuman entities. He is also desired by evil entities that seek his company beginning at his birth. He is thus potentially able to establish powerful relations with those entities and become a seer.

Considering the intrinsic "openness" of children who are born with a designed kurkin, the lack of designs at birth of a nele would seem to suggest a relative "closedness." The bidirectional flow that enables human beings to communicate within the human social world is not inscribed by designs on the newborn nele's kurkin. As many Kuna told me, the intelligence of a nele is often blocked, his kurkin is closed, when he is born. This is why when he grows as a child he suffers severe headaches and has nightmares. This condition of closedness is directly linked to experiencing fear and suffering, with the attached risk of dying. In

fact, nele children attract spirit beings, but at the same time, their relative closedness does not permit them to see spirits in their original form, which is that of a person. Instead nele children see transformed monstrous forms, as visions in dreams, which they cannot bear. They are therefore terrified and wake up deeply shaken. Kuna people explain that in this way supernatural entities feel kept at distance by young nelekana and get angry with them. If a nele, because of his fears, does not establish a relationship with the approaching spirits, they will try to kill him in revenge.

This presents an interesting problem: why, if nelekana are to become seers, able to see and to move beyond the limits of normal people's vision, is their initial condition portrayed by their adult kinspeople as one of closedness? I suggest starting from the initial condition of relative closedness to understanding the peculiar powers of the nele. If we intend closedness as distorted vision or partial blindness, we can see how this condition is responsible for the fear and suffering of young nelekana. The main characteristic associated with Kuna seers is their powerful sight, their capacity to see within the human body and into other dimensions of the world. This potential is present at birth and must be developed during the seer's life with the intervention of ritual specialists, who activate the shamanic sight by strengthening and opening the seer's brain. If the young nele, who is still untrained, sees monstrous creatures, he cannot stand their vision and therefore withdraws from their presence. A nele has thus to make the frightening visions of spirits familiar and bearable in order to establish a relationship with them and to cultivate his own powers. A nele needs to be opened up in order to permit the flow of relations with the powerful forces of cosmic alterity. This is done through ritual practices, and in many cases, I was told, it is a matter of survival. If the ritual opening of a nele's brain is not collectively performed, sooner or later he will die, because of the jealousy of the supernatural entities (see chapter 7). Conversely, all other human beings must be closed to cosmic transformations, in order not to incur the risk of becoming ill and being killed by the animal entities to which they are linked from birth.13

Thus, to sum up, we can say that being born with visible designs means that a baby needs to be closed in order to survive and to develop human praxis, whereas a baby who is born without visible designs needs to be completely opened in order to survive and to develop shamanic praxis. Visible designs are thus the precondition of being human; invisible designs are the precondition of being a shaman.

TRANSFORMATIONS

In his analysis of the designs made by Piro people in western Amazonia Gow follows the idea proposed by Lévi-Strauss in his study of Caduveo face painting (1972 [1958]) that graphic designs have to be considered in their intrinsic relationship with the plastic form of the human body. Developing this idea further, Gow (1989: 16) says that "the primary function of designs is the domestication or 'taming' of visual transformation through the definition of the surface of a body." He also suggests that designs are the transformation and elaboration of the bodily experiences, namely, those relating to bodily fluids and fertility, of Piro women (1999: 243–244).

Creating designs is an important aspect of the everyday life of Kuna women. They learn from puberty how to sew their beautiful colorful 'blouses,' molakana, with designs and to make 'beadwork,' winni, to adorn their calves and forearms. They then progressively increase their skill by observing their older kinswomen. Sewing a complicated and colorful mola and wearing it, along with a fabric 'skirt,' sapuret, and a

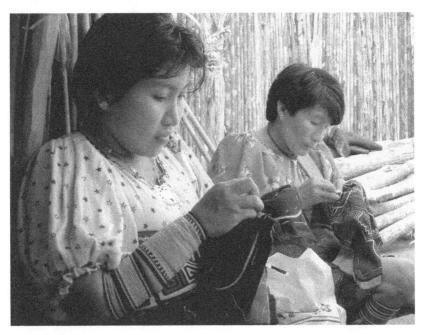

FIGURE 4.1: Sewing mola in the morning. Photo by Margherita Margiotti.

'foulard,' muswe, printed with designs, is what makes a Kuna woman 'beautiful,' yer tayleke, to the eyes of everyone else, especially to men.¹⁴

While women work at making designs to beautify the body, men, as I have shown in the previous chapter, devote themselves to plastic arts, such as making canoes, carving nuchukana, or weaving baskets. Men produce containers for food and persons—baskets and canoes—and trees' souls—nuchukana—while women decorate clothing to cover the surface of human bodies. 'Giving shape' sopet, and 'making designs,' narmakket, are therefore both the transformation into human praxis of the intrinsic openness to alterity, which is manifested through amniotic designs. As I have argued elsewhere (Fortis 2010) designs created by women in the form of molakana are but one manifestation of human praxis. Sewing mola designs manifests a woman's capacity to transform her relation to dangerous alterity into beautiful objects. The highest manifestation of her capacity to transform would eventually be that of giving birth to healthy human babies. A young woman begins to learn to make mola roughly after her first menstruation and then refines her skills in order to be able to sew beautiful designs when she gets married and has children. The most skilled and active mola makers in Okopsukkun were women in their thirties and forties. I was told that as a woman becomes older and has grandchildren, she has less time for sewing and has to work more in the kitchen, preparing and distributing food for all her kinspeople. Moreover, her sight weakens so she can no longer sew during the night by the light of kerosene lamps, an activity that, on the contrary, is happily carried out by younger women, who enjoy sitting under the lamps, chatting, laughing, and making mola.

Young women also love to wear their most beautiful *mola* when they are outside the house, such as in the gathering house—where they also sew—or when they go to the telephone post in Ustupu. New *molakana* are also especially sewn by women for puberty ceremonies, during which kinswomen tend to wear *molakana* with the same colors or the same design. Older women, who spend most of the time at home, wear simpler *molakana*, made of two colors and with geometric designs. Nonetheless, they do not hesitate to comment on the younger women's work and give advice.

Following the first point made by Gow, I argue that being born with visible designs is for Kuna people a sign of the future inability to see transformations and thus to transform, whereas being born with invisible designs means that the *nele* will be able to see transformations and thus to transform. Bearing designs on the caul is a sign of intelligence, which means being able to develop human praxis; being born

with a white caul is a sign of clairvoyance, which means to be able to develop shamanic praxis. Therefore designs seem to provide the body with stability against the possibility of metamorphosis, in order to provide the definition of "a specific humanity" (Vilaça 2005). The visibility of designs on the newborn's caul thus provides his adult kinspeople with a sign of the humanity of the baby and allows them to include him in their sociality, nurturing him and allowing his body to become a healthy human body. With the *nele* this is a bit more complicated.

Nightmares and headaches are the typical signs that a young child is a *nele*. I will use an ethnographic example that describes the case of two Kuna children who were born with *kurkin* and were described as "like a *nele*," meaning that although they had not been initiated they were able to learn in dreams. Transcribed below is part of a dialogue that took place in Okopsukkun in April 2004. The participants were Raquél Morris, a Kuna grandmother and my host, her daughter Nixia, her daughter-in-law Nepakiryai, who was at that time pregnant with her third child, and Prisilla, a *nele* who had come to visit Nepakiryai. The dialogue took place in the following way: Prisilla sat in front of Nepakiryai, placed a brazier in front of her, put some dried cacao beans in the brazier cup, and started smoking a pipe with tobacco. She remained, eyes closed, smoking her pipe for about five minutes. The conversation started after Prisilla revealed her diagnosis.

Prisilla: Your baby may be a *nele*. She has good *kurkin*. She is coming with *ispe* [glasses, mirrors]. That is why you are seeing *ispe* in dreams.

Nixia: Yes, that may be true. One relative of Nepakiryai's father is a *nele*.

Raquél: It is also true that Adam [Nepakiryai's second son] used to wake up often during the night. He was scared. He used to sleep badly because he dreamt of monsters.

Prisilla: That happens to babies who have good *kurkin*. Their brain works a lot during the night. What they dream of are actually *nuchu-kana*, not devils. But to see them without being frightened they have to bathe with special medicines.

Raquél: Adam was bathed with the wrong medicine.

Nixia: Also when Kanek [Nixia's second son] was a small child, he used to wake up scared at night. He had nightmares. A *nele* from Ustupu told me that he was ill, that he was born with the jaguar illness. That illness was the cause of his nightmares. So they bathed him two times with medicines to cure him. Then Remigio [a medicine man from Okopsukkun] visited him and said that he was not ill. On the contrary, it was his

brain that was working hard during the night. He told me that this is what happens to intelligent children, with good *kurkin*. Kanek has always dreamt a lot since he was a small child and sometimes he tells me that he has fought with a monster. Sometimes he uses unusual words, like those spoken by grandfathers in the gathering house. It is said that gifted children begin early to say words that their peers do not know. They learn them in dreams. Sometimes they are vulgar words, which refer to how babies are born. They already know how men and women have sexual relations, and they ask their parents questions.

To understand the link between nightmares and monstrous visions we need now to focus on transformations. These occurrences enable the young *nele* to perceive what other children do not: the transformations of powerful beings. Changing the external appearance is one of the common features of Amerindian spirits. For Kuna people, as well as for many lowland South Americans, powerful entities are able to transform on purpose into various monstrous as well as beautiful figures. Spiritual entities that live in the cosmos are able to freely change their outer appearance, maintaining their inner self, subjectivity, unchanged. The universe is thus seen as a constant flow of changing bodies and mischievous appearances, which easily trick human beings.¹⁵

As has been argued by Lima (1996) and Viveiros de Castro (1998), changes in the external appearances of beings correspond to changes in their points of view. Beings of a different kind see themselves as different, and beings of the same kind see each other as the same. To see beings of a different kind as the same, one has to change one's point of view. Animals normally see humans as animals and vice versa. To see animals in their inner form, which is that of a person, people have to become one of them; they have to transform their external appearance, their bodies. This is what shamans do in order to communicate with animal and tree entities. For example, Kuna people say that jaguars and sea turtles appear as beautiful girls to the nele in dreams. So he is attracted by their beauty and their seductive ways but has to be careful before making love to one of them. Demons, on the other hand, usually assume human appearance in waking life, disguising their black, hairy, and ugly form. Thus they can deceive unlucky people walking alone in the forest, approaching them disguised as a seductive woman, a friend, or a relative. As a result of such an encounter, the tricked person who is not able to recognize the demon loses his capacity to distinguish between humans and nonhumans and becomes a dangerous ally of the demon, chasing humans as his prey.

These examples point to the transformative capacity of *nelekana* who are able to change their point of view in dreams and see, for example, jaguars and sea turtles as beautiful women, while normal people, who are not able to see the inner forms of demons, are easily tricked by their beautiful outer costume. Furthermore, Kuna people make a general distinction between animal and tree entities on the one hand and demons on the other. The outer form of animals and trees is the one they wear in the visible dimension of the world, inhabited by human beings, while their inner form of people is the one visible when one ventures into the underworld, where they have their real abodes. On the contrary, the inner appearance of demons is monstrous, but they approach humans, both in dreams and in waking life, by dressing up in human robes.

Young nelekana are not yet capable of changing their point of view and cannot see animals and trees as persons, but they can see their transformations into demons. In fact the Kuna say that tree and animal entities are able to transform into demons, assuming their terrifying aspect. Herein seems to lie the difference between the dreams of young nelekana and those of other Kuna children. Kuna children are prone to be tricked by demons, who appear disguised as young friends in dreams, similar to the case mentioned above of adults wandering alone in the forest and meeting demons in disguise. They are not able to see demons in their inner ugly form, so they fall prey to their evil intentions. I heard of cases in which children met ponikana in their dreams. That caused their involuntary complicity in predation on fellow humans. I heard one story about a young girl who used to meet little friends in dreams. From them she learned to sing baby lullabies, which she sang during the day. But one day the entire island, where the village was, turned upside down into the sea. This was caused by the evil spirits who found a human ally in the little girl. Now if you go by canoe close to the place where the island was, I was told, you can hear the sound of the rattle and the distant singing of lullabies.

The difference between young *nelekana* and normal children explains the ambiguity expressed in the above dialogue about whether the nightmares of young Kanek should be considered an illness or rather a manifestation of intelligence. When young *nelekana* are approached by tree or animal entities, they perceive their capacity to metamorphose. The monstrous transformations of these entities are an intermediary state between the human and the arboreal or animal form. In fact Kuna people explained to me that animals and trees are able to transform and look like demons, while demons are only able to take the appearance of

people. So what children *nele* perceive in their nightmares is the transformation of animal and tree entities. Thus they become frightened. Fear is a signal that the young boy is confronted with powerful presences. Fear is perceiving transformations without being able to change one's point of view. It is, I would argue, the experiential state of getting to know alterity. It shows the potential of the child *nele* to change his point of view and to experience a different perspective of the world. Adult *nelekana* are in fact the only ones among the Kuna who see powerful beings in their original form, that of a person.

Like other Amerindian shamans, nelekana are able to master transformations, that is, to transform themselves. They do it in dreams and when they visit an ill person. I was told that in the past nelekana were able to transform into animals, such as jaguars or snakes, in waking life and were able with their body to penetrate different dimensions of the world. Today this capacity is said to no longer exist, because of the lack of powerful nelekana and the control that ritual specialists have over their nele pupils. Today's nelekana are able, once their initiation is completed, to voluntarily change their point of view in order to interact with animal and tree entities and to avoid demons. This enables them to obtain supernatural help in diagnosing and curing illnesses and to learn ancestral knowledge from these entities. Nelekana are also, and most important, able to restore their human point of view, before getting "lost in transformation."

THE SHAMAN AND THE ANTEATER

What I have defined above as the relative closedness of *nelekana* appears also to be a condition of fluidity that characterizes Kuna seers beginning at birth. Their bodies are not defined by amniotic designs and so are not fixed like the bodies of other children. Designs on the caul of normal babies convey the stability of the human body, they enhance its outward appearance, and they give to it its first visibility. Conversely, the body of a newborn *nele* is not equally visible to the eyes of his human kinspeople. It does not carry the beauty of designs, which Kuna people express with the exclamation: *yer tayleke*! 'beautiful!' This would explain his capacity to transform, and change his point of view, which he will be able to achieve later in his life.

What is interesting to consider here is that a young *nele* is in a condition of reflecting on himself. His receptivity is not open in the same way and in the same direction as that of other children. His percep-

tion is directed inward rather than outward. His condition of suffering and experiencing fear forces him to withdraw from social relationships. He is not able to enjoy the company of his peers, because he is often ill; and he cannot be too close to his parents. He cannot call them Mom and Dad, because dangerous spirits are listening to him and are ready to kill his parents, as I discuss in the next two chapters. He develops, therefore, a solitary tendency, which is increased during the long periods of seclusion for his shamanic initiation. His loneliness and tendency to introspection will eventually give him the capacity to see beyond the limits of human sensorial experience and to stop frames from the flow of transformations within the universe.

Kuna people use a particular expression to describe the act of reflecting on oneself: tukkin sii. It literally means "to sit looking at one's own belly," with the chin touching the chest. This refers to the action of directing one's own thoughts toward oneself. On one occasion one of my informants told me about a son of his brother who was a nele but died very young. The explanation my informant gave me was that the child was responsible for his own death because he directed his powers against himself. Tukkin imaysa, 'He did it himself.' This seems to me the extreme consequence of not being open to the world of human social relations, which eventually caused the self-destruction of the young nele. Thus the importance of mastering one's own powers through the help of other people that Kuna people often stress in their discourses about and practices of shamanism.

There is an interesting parallelism here, suggested by the words Kuna people use to describe physical as well as relational states. One of the animals that nelekana choose as their auxiliary spirits is the ukkuturpa, 'silky anteater' (Cyclopes didactylus). This animal was described to me as moving very slowly on trees, like the 'sloth,' pero, with long nails, and always assuming a characteristic posture by crossing its arms in front of itself and covering its face, tukkin sae. It covers its face, I was told, as if it were tied up in a knot. Its name in the ritual language of chants is Oloetiñapippiler. Olo means "gold," etinnet means "to tie," and pippiler derives from pippi, 'small,' and nele. Its characteristic posture evokes a condition of self-reflection and meditation and is connected to the solitary nature of this animal. Kuna people told me that the ukkuturpa is a wise person, doctor in Spanish; it knows many secrets, and its knowledge is precious for the nele. It is a powerful creature and especially vengeful, so hunters must strictly avoid catching it, or it will haunt them and their future generations.

Young *nelekana* have the capacity to see transformations, but they also suffer from loneliness and limitation. As they grow up and develop their powers they will become able to see beyond transformations. They will be able to see the real forms of animals and how evil spirits transform in order to enter human bodies as illness.

It seems, therefore, that young nelekana's closedness is relative, in the sense that they are closed to normal human perception. They do not develop human abilities and relationships in the same way normal people do, but they are completely and excessively open to cosmic transformations. They see beyond what normal people are able to see. At the same time, normal human beings' openness is based on the closing off of the perception of cosmic transformations, which they only perceive as illnesses and misfortune. As Harner (1972: 134) stated for the Shuar, "The normal waking life is explicitly viewed as 'false' or 'a lie,' and it is firmly believed that truth about causality is to be found by entering the supernatural world or what the Jívaro view as the 'real' world, for they feel that the events which take place within it underlie and are the basis for many of the surface manifestations and mysteries of daily life."

A nele starts from a position of loneliness and separation from other people, but as a Kuna man once told me, "One cannot become a nele alone. One cannot associate with animal spirits by oneself. To seek powerful knowledge alone is dangerous, because one would become mad and kill himself."

The transition from a condition of relative closedness, self-reflection, and suffering to one of cosmic openness is crucial to becoming a powerful *nele*. The shift is from seeing transformations to becoming able to transform, to change point of view. As I mentioned above and develop in the next chapter, young *nelekana* are dangerous to their parents. Given thus the double aspect of danger, self-destructiveness, and parent-destructiveness, it is crucial that young *nelekana* are made safe. This is accomplished both by the compassionate love of grandmothers, who take care of the young seer and listen to his dreams, and by the intervention of ritual specialists, who protect the parents, especially the mother when she is expecting a *nele*, and then lead the initiation of the child.

The young *nele* is thus progressively taught to become familiar with his dreams through the telling of them to his grandmother. He passes from dreaming of monsters to dreaming of young friends. Then, when the child grows up, the ritual master is contacted and starts to take care of the child, giving him medicinal baths and *nuchukana* carved especially for him. When the ritual master decides it is time for the initi-

ation ceremony, the first step in becoming a 'real seer,' *nele sunnati*, can be undertaken. Before turning my attention to this point, I will describe in the next two chapters first the figure of the mother of the *nele* and the problem of female shamanism and second the reasons the parents of the *nele* are likely to be killed by their son's auxiliary spirits.

FIVE

From the Perspective of the Mother

hile the previous chapter focused on the birth of *nelekana*, this chapter focuses on the pregnancy of the mother of a *nele* and postulates a hypothesis on how Kuna women become seers by acquiring the capacity from their unborn *nele* children. As I anticipated in the

previous chapter, Kuna people agree on the fact that a *nele* son represents a life-threatening danger to his parents. Both parents could die as soon as the *nele* is born and becomes able to see and establish relationships with animal entities. My concern here is with the risk for the mother, which begins during pregnancy.

I explore the effects that this danger produces in the lives of Kuna women who bear a *nele* and in Kuna social life more generally. The reasons for this danger are addressed in more detail in the next chapter. By analyzing the manifestations of this life-threatening pregnancy, I describe how Kuna people help the mother of a *nele* to survive, by protecting her in various ways. These ways are generally aimed at preventing the baby from developing his capacity to see as a *nele*.

First, dreams are a way of telling if the fetus is a *nele*. Second, the mother is protected by two means: either by making herself invisible to the animal entities attracted by the *nele* fetus or by "obscuring," "sealing," or even "stealing" the powerful attribute of the *nele* fetus: its *kurkin*.

As Colpron (2005) has argued, there has been and still is a widespread tendency in Amazonian ethnographies to consider shamanism a masculine role. Colpron points out that the dichotomy, based on Eurocentric biological assumptions, of the man producer and the woman reproducer has long influenced and biased studies on shamanism in Amazonia. She provides the counterexample of Shipibo-Conibo female shamans, arguing that there are no differences between men and women in the apprenticeship and practice of shamanism and that women are able to combine motherhood with shamanism (96).

Fertility and the capacity to give birth is acquired during a woman's life (cf. Overing 1985a, 1989) and enhanced through the use of plant medicines. Most important, a woman's fertility is considered the capacity to control her own reproductive force and to master her capacity of transformation, which eventually leads to the creation of new bodies. Adult women, as well as men, are given plant medicines to strengthen their purpa in order to make them able to have children. During pregnancy mothers and fathers have to follow a series of taboos, most of which relate to contact with animal species (cf. Margiotti 2010: 182-188), to ensure that their baby will be fully human. What has to be avoided is the interference of animal entities in the formation of the baby, causing illnesses and malformations. Despite the evidence that women are those who carry babies during pregnancy, the act of making babies is considered teamwork that involves the cooperation of parents as well as elder kinspeople in the creation of proper human beings (180-181).

When speaking of shamanism Kuna men often stress that female seers have the power of seduction, which men lack (cf. Perruchon 2003). Women are therefore considered able to become more powerful nelekana than are men by virtue of the fact that they can attract powerful beings and learn from them more quickly than men and even sometimes without undergoing initiation. Different from the Paracanã, who prevent women from acquiring shamanic capacities through dreaming (Fausto 2001: 341–342), Kuna men do not view women seers in a competitive sense. What is interesting is the different way that men and women become nelekana and it is to this aspect that attention is given below.

DREAMS

"It is dangerous for the mother, for her health, if the baby to be born is a *nele*." This was told to me by an old Kuna woman, and it expresses well the general concern that surrounds the birth of a *nele*. The small creature is extremely powerful and represents a threat to its parents, especially its mother. It is generally held that a woman when she expects a *nele* has a difficult and painful pregnancy. She feels very weak throughout the pregnancy, suffers severe headaches, has periods of fe-

ver, and is prone to fainting. Usually an older kinsman, often the woman's father, evaluates the symptoms and asks his daughter what she has been dreaming. When all the signs lead to the conclusion that the fetus may be a *nele* it is often suggested that the mother take medicines in order to prevent it. In general it is her parents who take care of the pregnant woman during gestation. Her mother gives her advice throughout the pregnancy and mediates with specialists who prepare medicines, while the father, or another older kinsman who has specialist knowledge, might prepare medicines themselves. As a general explanation I was told that a *nele* has huge powers that affect the mother who bears him.²

Along with physical symptoms, the dreams of a pregnant woman help to foretell if the baby is going to be a nele. Some "canonical dreams" (Basso 1987b) function as revelatory signs of the innate powers of the baby. Dreaming is an experience through which the dreamer can see and interact within the immaterial world, which is neither visible nor accessible in waking life, except to seers.3 Kaptakket, 'to dream,' is a compound verb formed by kape, 'to sleep,' and takket, 'to see.' As noted in chapter 3 in reference to learning to carve wooden objects, seeing is crucial to the incorporation of specialist knowledge in dreams or waking life. As Basso notes for the Kalapalo, "During dreaming the visual experience of a concept is associated directly with the acquisition of knowledge, 'seeing'-rather than 'watching'-being a form of 'understanding" (1987b: 94). Through dreaming people can see what happens at the level of purpa, the immaterial dimension where humans, animals, trees, and all kinds of entities interact. During dreams the purpa of a person leaves the body and wanders around in the world, meeting purpakana of other beings. Therefore during dreams a person is able to see what happens to his or her own purpa as it interacts with other beings. People may also learn about what is going to happen either to themselves or to other people, by seeing them interacting with other purpakana. Or, as Basso puts it, "dreamers learn about themselves by literally seeing their akua ['interactive self,' as she translates it]" (94).

During certain moments of a person's life dreaming becomes more intense and more revelatory regarding one's transitional status. For a woman one of these moments is pregnancy, especially as childbirth approaches. Pregnancy is the period in a woman's life in which she partakes in the *purpa* of her baby. That is, by containing another person she has two *purpakana* within her, which make her more alive and more powerful on the one hand, more attractive to otherworldly beings on the other. She is constantly in contact with the supernatural dimen-

sion, since her baby lives between the two dimensions: between the physical world and the house of Muu, where the purpa of fetuses come from. The contact between the mother and powerful entities becomes even stronger when the baby is a nele, because animal entities are attracted by it. Therefore when a woman expects a nele her dreams contain particular signs that reveal the nature of the baby. She dreams of encountering people and of receiving particular gifts from them. Below is an example from a conversation I had with a Kuna woman about a dream she had when she was pregnant with her son.

One day I dreamed that I was amidst cacao trees. There were also sweet basil plants. A man came to me and told me that he was from the headwaters of the river. He gave me a pair of glasses. When I told this dream to a specialist, he told me that my baby was going to be a *nele*.

All the elements of the dream speak of the shamanic powers of the fetus. However, in most cases single elements appear individually in women's dreams. At the same time the mother, through her dream, learns something about herself and her future. By being pregnant with a *nele*, to a certain extent, the mother participates in her son's shamanic powers. What is the Kuna interpretation of the scene in the above dream?

First, it is a scene seen in dreams. Dreaming is the primary condition in which a person comes into contact with the supernatural. As noted above, during dreams a person's *purpa* leaves the body and wanders through other dimensions of the world. Dreaming is considered by the Kuna, similarly to other Amerindians, the privileged field of shamanic experience (cf. Kracke 1989; Fausto 2001). *Nelekana* meet their auxiliary spirits, and they travel to the underworld in dreams. During dreams they also learn how to recognize and cure illnesses.

Second, the man from the headwaters of the river represents a powerful entity. The headwaters of rivers are considered by Kuna people as a place where powerful creatures live and where people are afraid of getting too close because of the risk of being pulled in by treacherous spirits. I was told that saipa lives here. Saipa is a creature also known by the Kuna as "river siren," related to the 'sea siren,' ansu. Both creatures are half fish and half woman and rarely show themselves to human beings. As I suggested in chapter 2 (table 2.3), evidence suggests that the sea siren could be the manatee (Trichechus inunguis) and the river siren could be the Neotropical river otter (Lutra longicaudus). Most important, saipa and ansu are among the potential auxiliary spirits of the nele.

For instance, I was told that the famous Nele Kantule, who lived in Ustupu, learned many things by traveling in dreams to the river Puturkanti, where he met with *saipa*.

The third element of the dream is the glasses. Kuna people use the word *ispe* to refer both to spectacles and to mirrors. The ambivalence is worthy of note. Spectacles are intended as a sight intensifier. They clearly refer to the powerful gaze of the *nele* and his capacity to see beyond the limits of the visible. They point to his capacity to see plants and animals in their real form, that of a person, and to see within the human body in order to identify illnesses. Mirrors are intensifiers of light. They refract as well as enhance the intensity of light. A *nele*, as I was told, may be born with a shining light on his forefront, showing the intense power reflecting through his body. Mirrors produce and reflect luminescence, which is one of the ways animal and tree entities manifest themselves to human beings (cf. Viveiros de Castro 2009). This could explain why, among the ingredients for the medicinal baths of training *nelekana*, glasses and light bulbs are sometimes used with the aim of strengthening their capacity to see.

Moreover, Severi (1993: 165) noted that the pictographic representation of the contagion between a human being and an animal is that of a spirit looking at its own image in a mirror. The ill person sees the reflection of his own image in dreams only when his *purpa* has been contaminated by an animal entity, when he becomes other to himself. This may be related to the state of a pregnant woman who, expecting a *nele*, perceives the alterity within herself. She perceives the contamination between her unborn child and powerful spirits, and this contamination affects her also.

Finally cacao beans are usually burned in braziers by nelekana when they visit a patient. The smoke produced covers the face of the nele and enhances his sight. Cacao beans contain properties that help cure and sooth headaches and are burned at most curing rituals. Sweet basil, pisep (Ocimum micranthum) and other sweetly perfumed leaves are added by nelekana to their bathwater. They perfume themselves before going to sleep at night, and this attracts nuchukana, their auxiliary spirits, which come to visit them during dreams. Moreover, sweet basil and other aromatic plants, achuer yala (Lippia aff. Americana L.) and kokke (Hyptis suavolens L.), are used by medicine men before going to the forest to collect plant medicines. They perfume their bodies before approaching plants, asking for permission to cut part of them to help afflicted persons. They have to be seductive to obtain the help of the female spirits of medicines (cf. Chapin 1983: 89).

Both cacao and sweet basil have an important function in the ritual praxis of nelekana. The first, through smoke, enhances communication with the supernatural and acts by establishing contact and communication between separate realms. In this sense burning cacao can be understood as an enhancement of the sight of the nele: it helps him to see within the human body, to see the purpa of a person. The second has a seductive function, working as an attractor that men use when they go hunting or when they want to seduce a woman. Botanical specialists use perfumed plants before they go to gather medicines in the forest, while nelekana and ritual chanters bathe in aromatic plants when they want to attract their auxiliary spirits, the nuchukana. 6 Communication between separate realms and attractions of supernatural entities are both key features in the mastering of nele's praxis. The capacity to see is a skill that a nele has to master in order to learn from the supernatural, and it is necessary in order to establish contact with powerful entities. On the other hand, the capacity to attract and seduce is a key feature in establishing an agency within the supernatural world and constitutes the difference between nelekana and laypersons. The nele is the one who has agency in dreams and throughout his life he learns how to master them.

The interpretation of dreams is an important part of Kuna life. Dreams, by showing what is not visible in waking life, can help to both predict future events and understand the underlying causes of certain manifestations in daily life (Harner 1972: 134). In the case of a pregnant woman her dreams may thus show if the baby has particular powers. Given the risks that the mother of the *nele* is exposed to, it is important to correctly interpret her dreams. It is a chief preoccupation for Kuna parents to help their daughters to prevent the dangers entailed by the powers of *nele* fetuses. As soon as the parents of a pregnant woman discover that she is expecting a *nele* they act to prevent this occurrence in the ways I describe below.

As I observed in Okopsukkun, there are people who are renowned for their ability to interpret dreams. These are usually older men or women who learned through their lifelong experience of dreaming. Often these people told me that they learned by observing the relation between their dreams and what actually happened in waking life. They then were able to interpret other people's dreams. Depending on their individual knowledge, some Kuna grandfathers and grandmothers also become able to interpret dreams and are thus attended by those who are bewildered by their own dreams. The word used for "interpreting," otuloket, indicates the action of "unfolding the meaning" of a

discourse, and it refers in particular to the interpretation of metaphors. Dreams as well as mythical chants are interpreted by a specialist so that their meaning is "made alive" to the listeners. The same verb, *otulo-ket*, is also used when a ritual singer sings to make a new *nuchu* alive by means of calling its *purpa* from the underworld.

As Basso (1987b: 96) noted for the Kalapalo, "The link between dreaming and interpretation is metaphorical." Among the Kuna both mythic and healing chants are sung in a metaphoric language, and although most adult people can understand it they often miss the meaning of metaphoric images. I was often told that only people who have extensively learned ritual chants and myths are able to associate particular formulas with their meanings. They are able, as Kuna people put it, to interpret the meaning hidden in myths and make it available for daily lived experience. Some formulas recur in both healing chants and myths and are therefore key to understanding the meaning of particular passages or sentences, but only people who master these ritual languages are able to readily grasp their meaning.

A MOTHER IN DISGUISE

The dreams of an expectant mother are thus a way to ascertain whether the baby is going to be endowed with shamanic powers. Once this condition has been established some precautions need to be taken to protect the mother. The general assumption is that the baby attracts powerful entities, which, once it is born, try to kill its parents. Let us look now at the relationship between the baby and his mother.

During her pregnancy the mother is a victim of the uncontrolled power of the fetus and is sometimes overwhelmed by it, especially when the time for delivery approaches. On more than one occasion I spoke with Aurolina Tuny, a Kuna woman around forty years old, mother of the young Inaekikiña, a twelve-year-old boy. For two months Margherita and I lived in her house, where she was living with her parents, her sister, her husband, their children, and their first granddaughter. Aurolina told me that when she was pregnant with Inaekikiña, her third child, she was often ill with fever and had strong headaches. Her mother's brother, a medicine man, told her that maybe it was because the baby was a *nele* and gave her and her husband plant medicines. These were meant to protect them, as Aurolina told me, from the attacks of the potential auxiliary spirits of their unborn baby. For the preparation of the medicines, among other plants, her uncle used genipap leaves, which have the propriety of making people invisible to

spirits.⁷ Taking these medicines and bathing in water mixed with forest plant medicines would disguise the parents of the *nele*. Aurolina used the expression *purpa otukkuoe*, meaning that the medicines would "disguise her soul." After this treatment she and her husband would not be recognizable as Inaekikiña's parents to supernatural entities.

It is interesting to compare this with the Piro use of black genipap dye during shamanic curing sessions. Gow (2001: 137) explains, "When a person drinks toé, his or her close kin paint their faces black with huito paint, and avoid working. The face paint prevents the drinker from recognizing them." Piro people explain that the drinker of toé (Brugmansia fam.) sees his or her kin as white, rotten tree fungi. "The taker of toé 'knows everything,' and therefore sees Piro people's mortality, their general condition, as the ugly pallor of their faces." Gow concludes, "A kinsperson in toé hallucinatory experience no longer acts like a human, but like a malign powerful being. What Pablo told me about having 'no body' refers to the world as seen by the drinker. The drinker becomes a powerful being, like the mother of toé, and so experiences the world through the perceptual apparatus of a powerful being" (137).

The case of the nele fetus differs from that of the Piro drinker of toé. The fetus does not yet have independent agency, whereas the toé drinker is an adult who already has an established knowledge of the world. Moreover, he has a human body, which has been fabricated through the loving and nurturing actions of his kinspeople, which also makes him a loving and mindful person. It is the metamorphosis of this body and the shift in the perceptual apparatus of the drinker that creates a danger for his kin. He is no longer able to see them as kin and thus inflicts their future fatal illness. What instead happens with the nele fetus is that he is still devoid of the perceptual apparatus of a human being, that is, a human body.8 Indeed, he is also devoid of love and memory for his kin. It seems likely, then, that the nele fetus is seen by the Kuna as a refractor or a mirror who makes visible his kin to powerful cosmic entities. The fetus causes its parents to be seen and thus to be victims of powerful beings. It is actually an intensifier of the condition of connectedness that the mother and the father too suffer during pregnancy.

If we assume that during every pregnancy a woman is more open to the cosmos, then, I argue, this state is intensified when she is carrying a *nele*. It was because of the need to escape from this overintensification of contact with cosmic entities that Aurolina and her husband took genipap medicines when they suspected that their son was going to be a *nele*. But this had a consequence. In fact, as Aurolina told me,

FIGURE 5.1: Inaekikiña cleaning crabs before cooking. Photo by Paolo Fortis.

now Inaekikiña does not ask her for any food or drink. Instead, when he is hungry or thirsty he asks his grandmother. That was caused, Aurolina thought, by the medicines she took during pregnancy that prevented her from establishing a maternal relation with Inaekikiña and to be seen by him as his mother.9

For the Kuna, as well as for many other Amerindians, the period of pregnancy and that after the birth of a child, known in anthropological literature as couvade, is regarded as particularly delicate, and both the father and the mother have to deal with many restrictions and precautions (Rivière 1974; Rival 1998). The primary aim is to ensure the birth and development of a proper human baby. Kuna people aim, through their prenatal and postnatal restrictions, both to prevent the baby from assuming animal characteristics and to protect the mother against evil entities.

In the prenatal stage and right after the birth of a child there are many restrictions aimed at avoiding contact between the mother and the father with those animals that would contaminate the baby. The mother stops going to the forest and has to avoid eating game meat and certain types of fish. These practices are mainly intended to prevent

the baby from being born with animal qualities. By the same token, the father has to avoid killing jaguars and snakes, which would cause the baby to be born on the side of the jaguar or on the side of the snake (see chapter 4). He also has to avoid visual contact with anteaters and sloths, which would cause the baby to be born with an illness called *ipkuk*. What the parents do and what they eat has a direct effect on the formation of the body of the baby. They have to carefully avoid contamination from animals that would make their baby not human, and they know that some animals are more evil and powerful than others. Not accidentally, these animals are the ones that may be the auxiliary spirits of *nelekana*.

In addition, a pregnant woman should spend most of her time at home. She does not go to the forest and restricts all her movements to the minimum. This is done so as not to be seen by evil animal entities. The condition of invisibility is important to protect the mother from the predatory intentions of these animals. During pregnancy she is more open to cosmic agencies and thus more exposed to their predation. When a woman is pregnant Kuna people use either of two expressions, *kurkin nikka kuti*, 'she is with *kurkin*,' or *poni kwar kuti*, 'she has an illness.' Both expressions point to the condition of openness to alterity. *Kurkin*, the amniotic sac, is also the "hat" that connects the human body to the external world, as I argued in chapter 4, and to cosmic alterity. To be with a *poni* suggests that the fetus is never seen fully as a human being, but as I describe below, it is still part of a nonhuman environment.

A pregnant woman thus needs to adopt a low profile; that is to say, she has to hide from the gaze of predators. This is also reflected in the way Kuna women dress when they are pregnant: instead of *mola* and beadwork, they wear loose shirts or just bras when they are at home. The first thing that came to my mind was that a woman's *mola* blouses and beadwork would not fit when her belly grows and her arms and legs swell, but this is not the reason she stops wearing them. (In fact, I saw many women adjusting the size of their blouses and beadwork when they gained weight but never during pregnancy.) I suspect that the different clothing has to do with the condition of invisibility that a woman aims to achieve when expecting a baby. She does not want to appear 'beautiful,' *yer tayleke*; she does not want to enhance her visual appearance as she would normally do. Thus she stops wearing her beautiful *molakana* and beadwork, preventing the gaze of *ponikana* from being attracted by her seductive appearance, in the same way as the

kinswomen of a person who was bitten by a snake reverse their *mola* and stop wearing beadwork to stop attracting snake *ponikana* (see chapter 4, note 10).

Kuna people say that babies come from outside the world inhabited by humans. They say that babies come from Muu neka or Sappipe neka, the house inhabited by the celestial grandmothers and by the 'masters of trees,' sappi ipekana.¹¹ In ritual language Muu neka also refers to the maternal womb, while in everyday language it indicates the maternity house, located near the shore of the island towards the open sea (Margiotti 2010: 189–191).¹² The maternity house is one of the places that a nele would visit during his dreams in order to learn. As was described to me more than once, Muu neka appears in dreams as a house surrounded by various species of animals who wander around it seeking to steal human babies.

The separation between the visible and invisible domains is a matter of perspective for the Kuna and not a fixed or unbridgeable boundary. Kuna people acknowledge that during certain moments of a person's life, or during certain ritual events, this separation becomes weaker and the connection between human beings and spirits gets stronger. One of these moments is when a woman is pregnant; hence her efforts to become invisible. My aim here has been to show that this connection becomes even stronger when a *nele* is conceived, so that additional precautions have to be taken, such as in the case of Aurolina and her husband who hid themselves through the use of genipap.

The absence of designs on the nele's kurkin at birth shows his "invisibility" to his adult kinspeople; but it also shows his "hyper-visibility" to cosmic entities. This is a problem of perspective. What happens instead with other children is that their designs at birth often show the link with some particular animals. The midwife assisting the birth is able to read and interpret these designs.13 Thereby the baby's kinspeople are responsible for calling a medicine man to provide the right medicines to break the link between the baby and the particular type of animal. The baby will normally be bathed for a specific amount of time—usually eight days—and then will be seen by an adult nele to verify the results of the medicine. This operation is phrased as 'jumble the path,' ikar opurret, impeding the animal entities from finding their way to the body of the baby. Normal children are thus made invisible to animal entities after their link to them has been seen by adult kinspeople. By the same token, nele children, who already are visible and who refract their parents' images to animal entities, need to be rendered opaque in order to protect their mothers and fathers.

SEALING THE KURKIN

Another way in which a pregnant woman tries to make herself invisible to cosmic alterity is by 'sealing the kurkin,' kurkin etinnet, of her nele fetus. In this way the fetus is prevented from acting as a mirror and so cause his parents to be seen by evil entities. By closing his kurkin he will not be able to establish contact with animal and tree entities. The sealing of the nele's kurkin is thus meant to prevent him from being born with the qualities of a nele. This, however, will have negative consequences for the child.

Aurolina's father, Reinaldo, told her to take special medicines in order to seal the *kurkin* of Inaekikiña when she was pregnant. A medicine man was contacted to prepare plant medicines for Aurolina. This prevented her son from becoming a *nele*. "This is why," Aurolina explained to me, "Inaekikiña left the school before finishing the primaries." She stressed that he has always been a lazy student. This is also why he is not able now to see *nuchukana* in dreams and learn from them. Inaekikiña's uncle Wikiño, Aurolina's youngest brother, added, "Inaekikiña gets scared when he dreams of *nuchukana*, because he is still too young. He has to grow up to become a real *nele*, to talk to *nuchukana*."

When I got to know Inaekikiña by living in his grandparents' house, he was always a smiling and quiet boy. He did not go to school and therefore hung around the house in the morning, waiting for his father to return from the forest with plantains, manioc, or wood for the fire. Sometimes he went off fishing with his mother's brothers or his brother-in-law. Sometimes he organized fishing expeditions with his own friends, with whom he also played football on the path in front of the house or other games as they pleased. He never seemed willing to follow his father into the forest. His attitude to work seemed playful, and his trips to the sea or into the forest were aimed rather at enjoying the company of friends, as most of the boys of his age did. Nonetheless, his older relatives never forced him to do anything. Inaekikiña had a close relationship with his grandmother Aurora, Aurolina's mother, with whom he spent a lot of time at home, occasionally helping with chores. She also used to send him to buy things from the small shops in the village or to buy kerosene at night for topping up the lamps in the house. In general he was a happy and tranquil boy, like most of his peers. Therefore, all the discourses about being a nele I heard seemed tangential to Inaekikiña's experience.

One day, however, during the last month of our fieldwork, he began to suffer an extremely painful headache. He remained at home, lying in

his hammock for three days, eating a little and visibly in pain. Aurora had no doubt that the cause of her grandson's pain was the fact that he was a nele and his kurkin had been closed before he was born. She told me that her grandson was suffering because his auxiliary spirits were forcing entrance through his kurkin. They were upset at not being able to establish contact with him. Thus Aurora told me that they had contacted a ritual specialist from the nearby island of Mammitupu. The old man, a ritual chanter, knew the medicine for initiating nelekana and for healing their kurkin. All the preparations were made quickly in order to leave in the next few days, and money, always the critical issue, had to be found soon for paying the specialist.

Aurolina told me that this sort of medicine is very expensive, between \$30 and \$40, a considerable amount of money for a Kuna household. On top of that, they had to buy cigarettes, lightbulbs, and glasses to be used along with plant medicines during the ceremony. Plants used as medicines for the *nele* are very difficult to find, for example, *kartup*, which occurs in the forest deep inland.¹⁴ Aurolina had said to me in previous conversations that a *nele* is a great problem for his family. Paying for the specialist and for all the tobacco to be smoked during the initiatory ceremony amounts to a large sum of money, which they could never afford, although if the initiation succeeds the *nele* will pay back the money through his work. This is why they have never bathed Inaekikiña in medicine before. But this became vital when he started suffering severe headaches.

Many people told me that until the recent past ceremonies for the initiation of a *nele* were supported by the whole community in Okopsukkun. Adult men and elderly women participated by smoking tobacco for eight days within the prescribed hut, and the whole village took responsibility for covering the expenses. Now it is no longer like this, and families have to deal with the economic burden alone. They also have to pay those who smoke tobacco during the ceremony. Such expenses are rarely within the reach of a Kuna household in Okopsukkun. There are usually two solutions: asking someone to lend the money or delaying the initiation of the young *nele* until his condition requires urgent intervention. In this case they will be forced to ask for the intervention of the ritual master and also to find the money in some way.¹⁵

Aurora did not tell me how they eventually got the money. One possibility is that it came from her husband, Reinaldo, and her four sons who were all divers and thus able to earn good money rapidly by catching and selling lobsters to Panamanian traders. That the money had been found quickly made me realize the seriousness of Inaekikiña's

condition, which had seemed to me neglected by his family until that moment. Indeed, I was wrong. I would argue that this behavior corresponds to the broader tendency to delay *nele* children's initiation as long as possible to protect their parents and to the general ambiguity that surrounds the figure of the *nele* in the Kuna lived world.

This behavior is also in line with the medicines that Aurolina took during her pregnancy to seal the *kurkin* of Inaekikiña. All these practices point to the unwillingness of Kuna people to have *nele* children. In Aurolina's words there was more than just a complaint about money. I think that what was at stake was also, and more important, the maintenance of a safe equilibrium between the world of humans and the world of spirits. While Inaekikiña was well no one seemed to worry about his condition, but when he began to suffer he elicited the 'compassion,' *wile takke*, of his kinspeople, especially of his grandmother Aurora. She saw him in his state of suffering and loneliness and decided that the moment had come to open his *kurkin*, which would have been the first step in his ritual initiation as a *nele*. Initiating a *nele*, as I show in chapter 7, is the only way to control his powers and to master them for the good of village life.

STEALING THE KURKIN

I will now consider another case, that of a female *nele* who told me that she acquired her capacity to see after she stole her son's *kurkin* when she was pregnant. This case is particularly relevant for shedding light on Kuna female shamanism. I suggest that stealing the *kurkin* of their *nele* fetuses is the way Kuna women become seers. This would explain why many people in Okopsukkun told me that women *nele* are not born as such but become *nele* when they are grown up, or, as some people put it, "they become *nele* along the way." ¹⁶

I do not want to make any generalization about fixed gender differences in Kuna shamanism here. I am aware that shamanism is in itself an extremely open and flexible category and does not reflect fixed local sociocultural specificities. Moreover, Kuna people told me on many occasions that the role of the *nelekana* has changed over time. I was told that in the past *nelekana* were more powerful: they were able to transform into jaguars or snakes; they traveled physically through the underworld; they possessed the capacity to kill people through sorcery, to cut trees with the power of their mind, or to cause thunderstorms (cf. Nordenskiöld 1938: 85–87). All these capacities are no longer possessed by *nelekana*.¹⁷ The presence of women *nele* in the past seems to have

been more widespread than it is today, although we do not know much about their social role (82). We have therefore to look at present-day life in Okopsukkun as the transformation of past life in the forest, where Kuna people lived in small groups more prone to movement and resettlement than island villages today. In my opinion, the figure of the *nele* in the past was likely to coincide with that of a political leader, responsible for the survival of the whole group, as among other Amerindians (cf. Overing 1989). The *nele* was the one who decided where it was safe to move the village, and he was responsible for prosperous hunting (cf. Århem 1996) and for deciding where to start new gardens. ¹⁸

I intend also to clarify that the following argument is restricted to the figure of the *nele*, as there are women who possess botanical knowledge, know how to prepare medicines, and know short curing songs. There are also midwives who are specialized in preparing medicines for pregnant women, helping throughout childbirth, and performing the postnatal ritual (Margiotti 2010: 189–205). Moreover, the wives of curing specialists know how to prepare medicines from plants, and they often help their husbands, who sometimes just take the plants from the forest and leave their wives to prepare the medicines.¹⁹

The contemporary role of a female nele is not dissimilar to that of a male nele. Though there are fewer female than male nelekana, I was often told that female nelekana are more powerful than their male counterparts. This is because they can learn more quickly than male nelekana. As I explain further in chapter 7, a nele learns by seducing an animal partner. In the case of men, this leads to a more or less stable relationship with an animal woman. This is described as a marriage union, where the nele has to learn from his poni father-in-law. Female nelekana, Kuna men told me, are freer and can seduce as many ponikana as they want, and each time they learn something new. Seduction is thus considered their most powerful quality (cf. Perruchon 2003: 326–327). Women are beautiful and men cannot resist them. Men, instead, have to resort to medicines to seduce women. This situation is true both in human social life and in the relationships with cosmic entities.

During my stay in Okopsukkun in 2004, I became increasingly keen to speak with a female *nele*. Although I was told by some people that there were few of them in the village, other people told me that they were all quite old and "did not see" people anymore.²¹ In addition, none of them seemed keen to speak with me.

Prisilla Diaz arrived in Okopsukkun in April 2004, after having been living in Panama City for some months. I first met her because she used to come regularly to Nixia's house, where Margherita and I were liv-

ing at the time. She was called to see Nixia and to give her medicines for her pregnancy. The day she came to see Nixia's sister-in-law, Nepakiryai, she remained longer to talk with Margherita and me. She told us about her personal experience and how she became a *nele*:

When I was expecting my first child I used to dream of glasses. My father then told me that this meant that my son would have had strong *kurkin*. He would have been a *nele*. Then he gave me medicines to leave my son's *kurkin* in Muu neka. It so happened that his *kurkin* remained with me and gradually I became a *nele*, while my son has always been a dunce at school.

Considering the awareness of Kuna people of the risks the mother of a nele undergoes, it is perfectly understandable that Prisilla's father gave her medicines to leave her son's kurkin in Muu neka. What adds a new meaning here is that Prisilla claimed that she became a nele as a consequence of this act. So far we have seen three types of actions aimed at protecting the nele's mother: making the parents invisible to cosmic entities, "sealing the kurkin" of the nele, and "stealing the kurkin" of the nele. In the last two cases plant medicines were used to manipulate the kurkin of the nele fetus. The aim in both cases was to prevent the fetus from attracting ponikana who would kill the mother. Sealing the kurkin, in Inaekikiña's case, or leaving it in Muu neka, in Prisilla's case, are two actions that work toward the same aim but have different outcomes. The first obscures the baby's shining kurkin, preventing the possibility of establishing a relationship with powerful entities. The second is intended to deprive the fetus of its kurkin.²²

I had few opportunities to speak with Prisilla after that first meeting, and I soon realized that her status was different from that of other women. She must have been in her late forties or early fifties, and she was born in Ustupu where she had been married to her previous husband, whom she had divorced. She then spent periods in Panama City, living with her relatives. When she came back she moved into the house of her father's kinspeople in Okopsukkun, where her son was married. She then remarried to a widower in Okopsukkun and moved to his house. This relationship, however, did not last long, and after they split up she moved to live on another island, after which I did not see her anymore, although some people commented to me that there she became involved with Mormon preachers and went around to proselytize.

All these events are in stark contrast to the normal life course of

a Kuna woman. Matri-uxorilocality is the usual pattern of residence among the Kuna. Although it is not a rule, in case of divorce or temporary split of the couple, it is the man who moves back to his maternal house. Women tend to live with their sisters in their mother's house, and if they move this is usually done by building a new house and making space for the growing number of kinspeople in the original household. Also in these cases the uxorilocal residence is the preferred way of living (Margiotti 2010: 54–57).

Prisilla moved from her house and from her village and then to the house of her new husband. All these things are quite unusual for Kuna women. What I gathered from people's comments was that the reason for her behavior was because she was a *nele*. Sometimes she visited Nixia's house every day, bringing her medicines and giving her advice; then she disappeared for few days, forgetting to bring over new medicines and upsetting Nixia's mother, who eventually resorted to another *nele*. Her popularity in Okopsukkun saw a rapid increase followed by an equally sudden decline. After her arrival from Panama City, she was very busy for a couple of months "seeing people" and preparing medicines. Then people started commenting that she was not a real *nele*, that she was not telling the truth, she was lying, and soon she became quite unpopular. This caused her split with her new husband.

The increase and decrease of popularity is a common aspect in the life of male and female *nelekana*. I often heard contrasting comments about individual *nelekana* and realized that a *nele* often experiences good and bad moments. Often the solution is to retire to private life and stop "seeing people" or participating in collective healing rituals. This prevents the *nele* from becoming unpopular, especially because the *nele* is the first person blamed in the event of an unsuccessful cure.

Another common aspect is that nelekana often work or live in villages other than their own. For instance, one nele used to come to Okopsukkun from the coastal village of Mansukkun, several hours away by motorboat. He was highly regarded by the majority of people in Okopsukkun, and his skills were considered superior to those of any of the nelekana in Okopsukkun and Ustupu. Trusting shamans from neighboring villages, neither too close nor too distant, is a common aspect of Amazonian shamanism. This is often linked to the possibility that a shaman may also be a sorcerer and therefore liable to be accused when an illness or a death occurs. Accusations of sorcery also have the negative outcome of causing social tensions between groups of kin. Therefore, the sorcerer "threatens the very possibility of collective life" (Teixeira-Pinto 2004: 218). It is thus considered safer to call a shaman from an-

other group, preventing the possibility of internal conflicts. Although I have never heard of sorcery accusations made against a *nele* during my fieldwork, the blurred distinction between *nele* and *kia takkaler* and the widespread concern to control the *nele*'s initiation would be signs of the collective consciousness of the dangerous potentialities of *nelekana*.

What Prisilla achieved through her unstable residence was not to be associated with any specific kinship group. This gave her the freedom to move between households and to practice as a seer without the restrictions of kinship. In addition to potential social conflicts, women nele have the problem of having a jealous husband. Nelekana meet their sexual partners in dreams, from whom they learn. As noted above, the seductiveness of women is regarded as an advantage for shamanic learning, but this causes female nelekana to be regarded as somewhat unfaithful. For instance, once I was told that a man made his nele wife stop dreaming because he was jealous. However, I do not think that the reason is that Kuna men are more jealous than women, as the reverse could easily be said to be the case. I think rather that the solution to this problem might reside in the fact that male nelekana have permanent partners in dreams, while female nelekana have many partners. Kuna people say that the behavior of a nele in dreams is paralleled by his or her behavior in waking life. This clearly indicates the gender differences of Kuna seers and their implications in social life.

MUTUAL EXCLUSIVITIES

To conclude, I wish to consider some aspects concerning kurkin as a bodily attribute in the light of what Prisilla told me. Kurkin is what gives a nele the ability to see, and it is an attribute that can be manipulated through medicine and even stolen from the unborn child by the mother. What does all this mean?

Kurkin is the bodily attribute that enables human beings to learn both from cosmic entities and from human beings. It mediates in the acts of learning and creating. Kurkin is both the "hat" of the fetus, which will then become the intelligence of the baby, and the "amniotic sac," which separates the mother from the fetus. In the case of Prisilla kurkin was stolen from her unborn son to thus remain with her. This image becomes more powerful if we consider the double meaning of Muu neka, as celestial house of grandmothers and as maternal womb. For the Kuna the maternal womb and the house of grandmothers are the same thing (cf. Holmer and Wassén 1947). The fetus is contempora-

neously living in the mother's womb and in the realm of spirits where it receives the *kurkin* from Muu and her granddaughters, depositaries of social praxis. We can thus say that the *nele* fetus causing the mother to be seen by animal entities may also give her the capacity to see. During pregnancy a woman participates in her son's powers. The shamanic capacity to see is initially experienced by the mother during her dreams, as she sees animals as people and mirrors/glasses that are the *nele*'s capacity to see.

Going back to the white *kurkin* of *nele*, it is possible to say that it is an open door to the world of *purpa*, the world of unfixed forms and transformations. We can now add that *kurkin* provides access to this world either for the mother or for the baby. It would seem that during pregnancy both share this potential access, but after birth only one of them will retain it. The mother, as in the case of Prisilla, can acquire the *kurkin* of the son, or the son, as in the case of Inaekikiña, can maintain his *kurkin*, even though it had been closed before his birth.

Mother, father, and baby are a complementary whole that breaks up after birth, specifically, after four days when the placenta is buried and restrictions weaken (Margiotti 2010: 198–203). The case presented above shows that this unity may be broken before birth, causing an earlier separation between mother and son and resulting in either the mother acquiring the powers of the son or the son not establishing a filial relationship with the mother. The mother's capacity to see depends thus on her son's incapacity to see, the exact reverse of Aurolina's case: had Inaekikiña fully developed his capacity to see, becoming a real *nele*, Aurolina would have stopped seeing altogether; she would have died. In the mother-son couple the capacity to see of one depends on the other's incapacity to see, or even the other's death.²³

There is a connection between the two main characteristics that the Kuna ascribe to *kurkin*: intelligence and capacity to see. Both features have been described so far as being fairly independent, but what I want to show now is their intrinsic interconnectedness. Intelligence is *kurkin*, which entails the capacity to see and to grasp the inner image of things. Intelligence is intended by the Kuna as the capacity to learn, to acquire knowledge. Being intelligent, *nono nueti*, 'good headed,' means to be able to learn things quickly. On the contrary, being obtuse, *nono serreti*, 'hard headed,' means being forgetful and slow to learn things. Indeed, intelligence and obtuseness are not unchangeable fixed characteristics for Kuna people. As I noted in the previous chapter, being born with *kurkin* means that a person has the possibility to develop particular praxis; it does not mean that the person already has them. At the

same time a boy who is not good at school may be sent by his parents during vacations to another village to bathe in medicines to increase his learning abilities.

In the experience of the *nele* seeing is the precondition of learning. The learning experience of a *nele* is a strongly visual one. Nightmares are the distorted visions of a young untrained *nele*, who will then be trained to transform them into proper visions. Dreaming is a form of knowledge too, and it is connected to shamanic experience, with the only difference that normal dreamers cannot control their dreams and they do not know if what they dream is an authentic image or a fake appearance. A *nele*, once trained, is able to distinguish between the real image, *purpa*, and its external appearance.

Pushing the argument presented in the previous chapter a bit further, it could be said that designs on the *kurkin* of *nelekana* are invisible to human beings but are visible to cosmic entities. It is therefore a matter of perspective. What human beings see as white, animal entities see as designed and beautiful. And what human beings see as designed and beautiful, animal entities see as white. At the same time the absence of designs on a *nele's kurkin* is also perceived as a source of light and refraction by human beings, showing the connections between small *nelekana* and invisible animal entities. This would match with the dreaming of mirrors and glasses, intended as light intensifiers and transformers of human vision into vision of animal spirits.

The kurkin of nelekana is what enables them to see and to be seen by animal entities. It is for this reason that adult nelekana will use cacao beans and tobacco smoke to increase their capacity to see and will bathe in water perfumed with sweet basil to attract and seduce their companion spirits. The blank kurkin of nelekana, beginning from their prenatal life, is like an open door between humans and supernatural entities—a door that adult Kuna people would often prefer to keep closed. Kurkin therefore might be considered the bodily locus through which relations with alterity take place. For this reason kurkin has to be manipulated. The head of newborns is often fumigated by burning cacao beans in clay braziers. This is done to fortify their kurkin, to prevent attacks from evil entities. If this action is not performed in the early months of life, the child may suffer from headaches later on, as the result of its kurkin being weak or closed.

The kurkin of young babies must therefore be prepared by adult kinspeople for the baby to become an intelligent and healthy child. Moreover, when a person grows up, he or she may decide at some point to undergo ritual treatment to enhance their kurkin. For example, a man

who wants to learn ritual chants or myths may decide to increase his learning capabilities. Most ritual treatments are performed during periods of seclusion, conducted in a different household from the one where the man lives. Usually the man moves to the house of the medicine man who prepares the medicines for him. It is important that he does not go out during the day. During ritual treatment, the kurkin of the patient is treated with plant medicines and is highly sensitive to the heat produced by the sun, which could cause headaches and make the treatment fail. The secluded person can go out for his physiological needs only during the night and has to follow a particular diet, avoiding game meat and big fish, eating coconut and plantain or rice soup and small fish. Plant medicines, depending on the desired goal, are put in fresh river water for making medicinal baths, which the secluded person would pour over his head repeatedly during the day sitting inside an old canoe. This water also has a refreshing property, which, as opposed to the heat of the sun, helps the plant medicines to have effects on the body of the secluded person.24

The process through which the ritual seclusion and the use of medicines work was once described to me as follows. First a path must be opened for the medicines to work. At this stage, I was told, the kurkin must be softened and should reach a rubberlike consistency. It is the same as when a person makes a strainer from a halved calabash, piercing it with an awl. Similarly the brain of the secluded person is prepared to receive medicinal treatment by being spiritually pierced. The first type of plant medicine used is thus intended to make the brain permeable to the action of further medicine. The secluded person then enters a liminal stage, during which he has to follow a strict set of ritual avoidances, a special diet, avoiding the light of the sun, avoiding sex, and in general avoiding closeness with any young woman. Then a particular plant, depending on the specific outcome to be achieved, is used for bathing. For example, to increase the capacity to memorize long ritual chants or myths, the ake pantup vine is used as medicine. It is shaped like a hook, giving it the property of attracting things. At the end of the seclusion another medicine is used to reinforce the kurkin of the secluded person and to allow him to go back to his normal life.

Kurkin is thus a central attribute of the human person, formed by spiritual grandmothers and worn by fetuses. Then it is retained as an internalized body part throughout each person's life. Childbirth is the only brief moment in which kurkin may be visible to human beings. This brief moment shows the border between the life of purpa and the life of sana, the immaterial life of unstable images and the material life

where fixed images assume the form of more stable bodies. It is a moment in which the baby appears complete to the eyes of the beholders, showing its potentiality, its characteristics, its weakness, and its mortality, similar to how the Piro drinker of toé sees his kinspeople when hallucinating: pale and helpless. It shows what will no longer be visible to the eyes of normal people. The kurkin will then become invisible, and only nelekana will be able to see it. It is the full visibility, yer tayleke, of the newborn and the fact that their kinspeople feel pity for them that renders the baby able to establish social relationships in the future with its adult kinspeople (cf. Gow 2000). I was told that a newborn nele is regarded with yet more pity, because of his higher fragility and loneliness. He is a child who will never be close to his mother. As Aurora once told me referring to Inaekikiña, "I feel great pain for my grandson. I want him to be well."

As I have shown, visibility is the precondition for establishing relationships in waking life as much as in dreams, with human as well as with nonhuman beings. 'To see,' takket, and 'to be seen,' tayleke, are equally important actions for establishing relations between newborns and their kinspeople. Adult people see the newborn in its full potential existence. The baby, by being seen, receives the love and care necessary to grow up and survive the early stages of its life. Visibility is the precondition for relationships; invisibility is their negation. But there is always another side to reality.

What has emerged in this chapter is the importance of avoiding filial relationships between a *nele* and his mother. The precautions taken during pregnancy prelude, and in some occasions also cause, the future detachment between the mother and the son. The mother will not have to be recognized as the mother of the *nele*, lest she be attacked by evil spirtis. As a consequence, the severing of the relationship between mother and son creates the possibility for either the son or the mother to become a *nele*.

One last bit of ethnography needs to be added here in order to introduce the topic of the chapters that follow. The birth of a nele is a particularly dangerous moment for the mother, because she may die during the birth. I heard once that a woman fainted before giving birth to her nele baby and was unconscious during the delivery. Thus she did not see her son when he was born, suggesting an anticipation of future detachment from him. There is an existential state of loneliness in the lives of Kuna seers. Being able to see other people's perishable condition, the young nele will live a somewhat detached existence from the rest of his kinspeople and fellow villagers, whereas a female nele, who

became such after acquiring her son's *kurkin*, has to put up with her new condition of being a seer, which may entail moving from her household, away from her own kinswomen. It is to the explanation of these existential states and their social implications that I turn my attention in the next chapter.

SIX

Tarpa, or What Lies between Us

n this chapter I deal with the major problem that has emerged from the analysis of the birth of *nelekana*. Why are the mother and the father of the *nele* bound to die? Why do animal entities want to kill them? What does this tell us about the way Kuna people conceive of

their relationship with cosmic alterity?

Answering these questions entails a description of the concept of tarpa, which I analyze in the first two sections of this chapter. I then discuss how Kuna people conceive of the relation between human beings and animals by looking into a Kuna myth that describes the killing of the mother of the octuplet mythic heroes and comparing it to related South American myths. I argue that shamanism is closely linked to what it is to be human for the Kuna. By the same token, exploring representations of humanity, birth, and death in myths leads to a better understanding of Kuna shamanism. This points to the importance of considering shamanism as one way of exploring the ontology of indigenous people, which cannot be artificially detached from other spheres of daily life. As with many other anthropological categories, shamanism remains thus devoid of meaning if it is not linked to its lived, embodied reality, that is, if it is not analyzed by remaining as close as possible to the explanations of the people that re-create its preconditions through their daily lived experience.

THE OTHER OUTSIDE

I first came across a definition of *tarpa* when speaking about *nelekana* with Kuna people in Okopsukkun. *Tarpa* is what Kuna people call the

entities with which a *nele* associates in dreams, his auxiliary spirits, as normally defined in Amerindian ethnography. However, it would be too simple to limit the definition of *tarpa* to this single aspect. As I show below the Kuna theory of *tarpa* is complex and points to a relationship of mediation and help towards the attainment of a specific goal and an extension of the human body beyond its material limits.

Tarpa is not only a category of beings; it is also a relational concept. Specific animal entities may become tarpa of the nele. The nuchukana that a nele keeps in his house and regularly consults in dreams are his tarpakana. Ancient powerful nelekana were said to have many tarpakana, including objects, such as stools, which allowed them to hear people speaking in faraway places. Tarpa is what stands in the middle of the two in an intersubjective relationship with the nele. All nelekana have tarpa. Since his birth a nele is approached by animal entities who are willing to establish a relationship with him and take him with them. Having tarpa also means that the nele has the means to learn. Tarpakana allow the nele to establish contact with the chiefs of animals and to learn secret knowledge from them. Once the nele has grown up and has undergone his initiation he is able to control his tarpakana and to make them work as mediators and helpers in his quest for knowledge. But when the nele is still a child his tarpakana are dangerous and uncontrolled forces. My Kuna informants told me that animal entities surround the young nele and always stay close to him. For this reason he might see them in his dreams, and he is likely to be frightened by seeing their transformed monstrous appearance.

In some way tarpakana perceive the young nele as one of their kind, or perhaps one with whom it is possible and desirable to establish a relationship. More precisely, they want to establish a kinship relation with the nele. The risks for the young nele are high, because he is still not strong enough to deal with them, nor is he prepared to master their forces. He also has to learn how to mediate between his powerful allies and his human kinspeople. When he is still young he has not yet developed "memory" and "thought," and he does not yet know the world. Thus he will easily reveal the identity of his parents when his tarpakana ask him. He does not know yet that his tarpakana want to kill them because they want him completely for themselves.

It is only by strengthening his *purpa* and his *kurkin*, through ritual seclusion and with the use of plant medicines under the supervision of an elder ritual specialist, that the young *nele* will prepare to meet his *tarpakana*. This strength will be the precondition for approaching animal spirits to make them his *tarpakana* and start learning. This prep-

aration will continue during the growth of the *nele*, who will eventually get married and have children, both within the visible world of human beings and in the invisible world of nonhuman entities. Learning to master his shamanic powers and having a family are two intertwined sides of the shamanic formation of a *nele*; they are both part of the quest for knowledge and important for keeping the *nele* attached to human sociality.

When the *nele* is a fetus in the womb of his mother and when he is a small child, animal entities are free to move unmastered around him, listening to his words and observing his behavior. They try to discover who his parents are in order to kill them. Thus young *nele* children must not use the terms *nana*, 'mum,' and *papa*, 'dad,' because animal entities are listening.

One day Erlinda Harris, a *nele* woman in her fifties, married to a botanical specialist and grandmother of many children, told me:

When I was young I didn't know the world. When I was already grown up I had headaches. Then I bathed in plant medicines and started to see *nuchukana* in dreams. They came to me. I was not scared because I had bathed in medicines. Then my parents died. I killed them, because the *nuchukana* asked me if I had a father and a mother, and I did not hide this from them. My parents got ill and died. Also *ponikana* wanted to know if I had a father and a mother.

The day after my conversation with Erlinda I commented on her story to a Kuna friend, asking him to clarify the meaning of it, as it appeared to me rather obscure. Why was she responsible for the death of her parents? Who had actually killed them? And why? He answered by explaining that tarpakana are the animal entities that surround the nele. They are like soldiers; they have radios with which they hear everything. If the nele speaks with a nuchu they hear him. This is why Erlinda, speaking with her nuchukana, caused the death of her parents. When she was still young, as she pointed out, she did not know the world. She was unaware of the lethal consequences of her acts as a nele, and she was unable to control the evil intentions of her spirit friends.

As has been pointed out in the study of child sorcery in northwestern Amazonia, children are not blamed for having caused the death of other people (Santos Granero 2004). They are not considered responsible, assuming that their evil actions are not intentional but rather caused by maleficent forces. Child *nelekana* do not kill their parents directly by means of magic, but it is their unconsciousness of evil that permits maleficent forces to kill through them. Among the Asháninka, orphans and war captives were the preferred target for witchcraft initiation by demons, because they lacked kinship relations (276). Kuna people say that animal entities try to detach the *nele* from kinship relations by killing his parents. They aim to include the young *nele* in their social world by making him one of their kind and eventually a predator of human beings. This occurrence is prevented through ritual actions performed on the child's parents, thanks to the loving care and the ritual expertise of both his grandmother and his grandfather. These acts and precautions aim also to prevent the stealing of the baby by animal entities, by including and keeping him within the circle of human kinship relations.

Through everyday closeness with his adult kinspeople the small nele is taught to master his thoughts and to think as a human being (cf. Belaunde 2000). He has to learn to master his dreams so that he will be able to understand what he will learn and not constitute a danger for his kinspeople. He receives more affective care and advice from his grandparents than other babies. This is meant both to compensate for the lack of a close relationship with his parents and to deal with the powerful knowledge with which the child nele enters into contact.1 In fact, I was told that, besides being visited by friends' nuchukana, who show him how animals look in the underworld, a young nele is shown in dreams how babies are born. A friend nele once told me that when he was a small child he dreamed that a boy his age, who used to meet him in dreams, brought him into the maternity house, where he saw a woman sitting on a hammock and giving birth. This dream scared him, and he recounted it to his grandmother, who told him not to tell this to anyone, especially his friends. From that time on, he had to keep silent about his dreams with everyone but his grandmother, who decided to contact a ritual chanter for advice.

THE OTHER INSIDE

In addition to indicating the auxiliary spirits of a nele, tarpa is used to indicate an attribute of the human person. When I asked Nixia to explain tarpa, she replied, "Tarpa is what lies between us, and it is also what always stays with us, like our purpa. If you don't want to reveal who told you something you say, 'My tarpa told me this.'" I already knew at that time what tarpa was for a nele, but new meanings were about to emerge.

We are composed of kurkin, purpa, nika,² and tarpa. 'Thought,' 'soul,' 'body' and 'spirit.'... God sent to all of us a special guide, the tarpa. It orients us. Like when one goes to the forest and hears the cry of kika [squirrel cuckoo], he knows that back home something is happening. A drunk person doesn't have nika, purpa and kurkin. They don't work anymore. It's his tarpa that leads him back home. If the tarpa gets drunk too, he cannot walk.

These are the words of Remigio Lopez, a medicine man from Okopsukkun with whom I often sat for long conversations. He introduced me to the concept of tarpa as a component of the human person that works as a guide and a helper on different occasions. The reference to the bird kika, the squirrel cuckoo (Piaya cayana), brings us back to the link with animals visible on kurkin designs. Fetuses are connected to nonhuman entities, and transformed connections are retained after birth. Kurkin retains the quality of connecting and communicating with the world of animals and spirits.

"He had a *tarpa* in his head," Remigio once told me, referring to a patient of his who suffered from headaches and dizziness. Remigio explained that the brain has *tarpa*, as well as the soul, and that people pick up everything with the brain, both the good and the bad. Everyone has this potentiality because Muu wrote it on their *kurkin* before they were born. In another conversation Remigio told me about the training of *nelekana*, which consists of descending into the various layers underneath the earth to visit the different villages of animal entities. But, he stressed, "the thing that the *nele* studies first is the human being. Every person is a *kalu* and has his own *poni*. In this way the *nele* learns about different *ponikana*."

The theme of the body as an open cosmic unit resonates in Remigio's words. It is true, as Isacsson points out for the Emberá, that "the human body is a representation of cosmos, it is a cosmological chart and 'manual' to comprehend the principles that reign in the cosmos" (1993: 106). But it is also true that, as Kuna people put it, the cosmos is a chart for figuring out the human body. The world out there and the world within the person intermingle, and the limits become less and less apparent as the Kuna specialist unfolds his knowledge. As it emerges from Remigio's words, knowledge of the world and knowledge of the human person overlap in the learning process of the *nele*. Nonetheless, separation is needed and necessary; limits must be acknowledged, especially by ritual specialists whose task it is to diagnose and heal illnesses. On an-

other occasion Remigio told me that "everyone has three souls: the animal one, inmar turkana, the material one, sanalet, and the spiritual one, purpalet." When a nele sees an ill person, he continued, his aim is to discover which animal entity has entered the body. This is a difficult task because many animal entities show up to the nele or roar to him. Therefore he has to be able to single out the true one and not be tricked by all the other animals. The nele has to identify the animal that is eating the patient's body. The expression poni nai is used in this occasion to indicate that an animal entity occupies the body. As I gleaned from Remigio, the possibility of having an animal entity within is immanent in each human being. It is in fact part of human nature itself.

As I have highlighted so far in this work the duality of danger and knowledge is at the core of the notion of shamanic power for Kuna people. Now it appears also that this duality is at the core of the Kuna notion of personhood, insofar as everyone is born with the possibility of either developing human praxis or becoming ill, being a predator or being preyed on, living or dying.⁶

As I argued in chapter 5, nelekana have this duality within themselves. By not showing their designs they do not show their internal double, their tarpa. They do not make themselves fully visible, in their fragility, as other babies do. They do not show their potentiality to learn and their intrinsic mortality, written in the lines of their amniotic design. Nelekana thus have to undergo the processes of socialization conducted by their human kinspeople in order to make their internal duality external, to see themselves and to be seen by others as human beings. They have to make visible the design that was not visible at the moment of their birth. When a layperson is born, this duality becomes external to him or her, by the simple act of showing his or her designs to kinspeople and midwives attending to their birth.

Externalized in the form of designs, this duality immediately produces a creative tension—the possibility to switch between human and nonhuman, knowledge and disease, life and death, intelligence and wildness. Thus, duality, once it has taken place outside the person, becomes the propelling and creative force of human life. For the *nele*, the lack of exteriorization of this duality in the form of designs creates the possibility for a hidden, introverted life shared with animals and gives him the capacity to see illness in other people. Once a *nele* has learned to master his internal duality with animal entities, he is able to see how this duality takes place within other people in the form of illness. Illness can thus be seen as a form of return to the prenatal internal dual-

ity and the loss, or collapse, of separation with animal alterity caused by an act of predation.

The same possibility of becoming ill as a consequence of animal assault derives from the possibility of communication between humans and animals. It derives from their prenatal closeness and the possibility of sharing *purpa*. The possibility of communication and exchange of substances derives from the sharing of a common nature among humans, animals, and trees, which all have *purpa*. It seems likely that *tarpa* is the attribute that enables human beings to establish contacts with animal entities. In the case of *nelekana* it becomes a source of power, while in the case of laypersons it is a source of danger.

"Tarpa is what lies between us," Nixia sharply explained to me. Tarpa is what links human beings to animals. It is the supernatural extension of the human self. It is the extension of the person beyond the limits of its body. The bird kika is the tarpa that warns the man walking in the forest that something is going on at home and he should go back. The idea of tarpa points therefore at a continuity between human beings and animals. It is a continuity between beings acknowledged as different and between which relationships are always delicate and dangerous but still necessary and vital. The myth that I discuss below, I argue, is pertinent to our discussion insofar as it addresses the nature of the relationship between humans and animals from the present perspective of Kuna people.

ONTOLOGICAL PREDATION AND DANGEROUS PROXIMITY

Here I want to explore why a nele's tarpakana kill his parents. I intend to look comparatively at a Kuna myth and at two myths from Amazonia: one from the Kalapalo, a Carib-speaking group from the Upper Xingu basin of Brazil (Basso 1987a), the other from the Piro, an Arawak-speaking group from the Lower Urubamba River of Peru (Gow 2001). These two Amazonian myths bear various resemblances to the Kuna myth I am going to present and form part of a wider group of myths on the origin of the Sun and the Moon widespread in South America. I suggest that the main point of these myths is the origin of human mortality by an act of predation by animals. More precisely, what the three myths have in common is the killing of a woman by animals and the consequent birth of powerful heroes whose actions will eventually generate humanity as a separate condition from that of animals.

The following Kuna myth was told in 1969 by Luis Stócel to Chapin and supplemented with information Chapin received from Horacio Méndez, a chief from the village of Ustupu, in 1970. Presented below are excerpts from the longer original version. The myth tells of Olotwalikipileler, who committed incest with his twin sister, Makiryai, by making love to her during the night when she was asleep. Makiryai, unaware of the identity of her lover, tricked him one night by touching his face with her hands that she covered with the black dye of the genipap fruit. When she discovered her brother with the stained face the next day he fled, ashamed of himself. In search of her brother, with whom she had decided to live as husband and wife, Makiryai traveled to unknown places and met along the way animal men who seduced and made love to her. Eventually, she saw her brother on a hilltop, but before she could reach him he ascended to the sky, becoming the moon.

After almost nine months Magiryai arrived at the river Olokoskun Tiwar and tried to enter a forest of multicolored nettles (take), but she found the path closed. An old toad-woman called Mu Kwelopunayai saw her and took her to her house, which stood on the riverbank. Mu invited her to stay but warned her that her grandsons, a ferocious group of iguana-men, collared peccary—men, tapir-men, and fish-men, would eat her if they found her when they came back in the evening. Mu was skilled in the fabrication of clay pots and jars and hid Magiryai in one of them in a corner of the house.

The grandsons came back at the usual time, noisily entering the house, and at once started grunting, saying that they smelled pineapple. When they asked Mu about it, she answered that there was no pineapple. "You are all so lazy that you did not sow anything around here," she told them. The grandsons ran to every corner of the house to find where the smell came from but stopped searching when the sun rose. Early the next morning they woke up and went to the garden. As soon as they left Mu called Magiryai and hid her in the beams of the roof.

The grandsons returned in the evening and smelled the same sweet odor. "Where does this smell of pineapple come from?" they cried, and started searching. But once more their search was fruitless, and when night fell they slept. The next day when they left for the garden, Mu called Magiryai again and hid her behind a beam wrapped with rags like an *aku*.8 When the grandsons came back and smelled the flavor of pineapple, they again began to wreck the house searching for the fruit. Suddenly one of them saw Magiryai's foot poking out of the beam and

called his brothers. They all went up to the roof and grabbed her. They took her to the river where they started devouring her. Mu was sitting on the crest of the hill, and when she saw what they were doing she shouted at them to leave her the guts.

Mu Kwelopunayai took the guts and put them in a clay jar above the fire. That broke, and she moved the contents into another clay pot, which also broke. Successively seven different types of jars broke, until eventually she used a gold jar (olomete), and this one resisted. Suddenly a rooster appeared on the edge and crowed, "Ibelele, Ibelele." Soon after another bird showed up, a Paaru, which leaped from the mixture and, standing on the edge, started singing, "Olele, Olele." Then other birds came out: Suisupi (yellow breast), Malin, Dagir, Olodeengipiler, and others. They were Ibelele, Olele, Pu Tule, Kwatkwat Tule, Olowigapipileler, Olosuignibeleler, Pugasui, and Olowai-ili. Losing no time, Mu Kwelopunayai gathered them and laid them in the hammocks and treated them well, because she understood that they were deemed to be wise and powerful. (Chapin 1989: 35–36; my translation)

Mu Kwelopunayai took the octuplets as her own children. Therefore they grew up thinking that she was their mother.9 But one day Sigli, the curassow, told the eight youngsters that the old woman was not their mother. Their real mother's bones had been swallowed by Inaitikilele, a giant fish. After that discovery the eight siblings embarked on a long trip around the world in order to find out the remedies to revive their mother. When they went back, Ipelele, the Sun, the wisest among his siblings and the one who was born first, cut the fingers of Mu Kwelopunayai so that she turned into a toad and ever since then remained like that. Then Ipelele and his siblings took their mother's bones and put them into a hammock woven by Olowai-ili.10 Ipelele sang for eight days to revive the mother, but he did not succeed. He tried to do it four times, but every time an animal-man interrupted the ritual and the mother returned to bones. The fourth time, the mother turned into a jaguar. So the eight siblings decided to stop their efforts and buried their mother, mourning her death.

Ipelele and his siblings, I was told many times by my Kuna informants, were great *nelekana*. Through their travels around the world to find the remedy to revive their mother they learned powerful knowledge. They went to Sappipe neka, where they learned medicine from the owners of trees. They went to the village of balsa tree, whose name is Olokunipippiler.¹¹ "This man was one of the most powerful of that

place: he had eight kurkins and eight nigas" (39). Then they met Muu and her granddaughters, responsible for the formation and growth of babies.

As this myth shows, the eight siblings are born after the killing of the mother, and they actually come out of a single birth, which makes them effectively octuplets. They are born from the cooked guts of the dead mother, and as the grandmother toad immediately noted they were deemed to be wise and powerful. They were eight powerful nelekana.

Ipelele heads the siblings. He is the wisest, the cleverest, and the most cunning. He will then become the Sun, Tat Ipe.¹² Pukasui, his brother, is the archer, the one with the ability to strike enemies, whose skill has no equals; he will then become the morning star. Pukasui, or Puksu, is the Kuna name for Venus. Olowai-ili is the only sister among them. She learned the art of making designs, weaving textiles and baskets, making pottery, and the culinary arts, and she then taught these to Kuna people.

The myth of Makiryai is, among other things, a myth of shamanism that sheds light on the life of present-day nelekana. Muu Kwelopunayai's animal-grandchildren killed Makirvai, as animal entities today seek to kill the nele's mother. Ipelele and his siblings were raised by their grandmother, recalling the attachment that a young nele has to his maternal grandmother, as in the case of Inaekikiña. Furthermore, Makiryai was seduced and made love to by various animals before arriving at the house of Muu Kwelopunayai, behaving like a nele herself. Are her children conceived with those animals or with her twin brother? The myth does not tell us. However, what is interesting is that animals are portrayed as affines. The grandmother-toad would be in the position of Makiryai's mother-in-law, and the animals that kill Makiryai would be her brothers-in-law. With this in mind, we can now begin to understand how Kuna people are aware of the risk that young nelekana will be stolen by animal entities. Tarpakana want to kill the mother of the nele because they want to steal him. Kuna people, by preventing the death of the nele's mother, try to keep the nele among his human kinspeople. The process of initiation operates to control the nele's association with animal entities by not completely releasing him to his tarpakana's predatory intentions.

The theme of the duality of knowledge and danger assumes here a further connotation. In mythic terms, knowledge and power derive from the dangerous proximity between humans and animals. Predation and affinity frame the problem of the creative yet dangerous tension between humans and animals. Makiryai is devoured by her affines,

the animal grandchildren of the grandmother-toad. Mu Kwelopunayai is Makiryai's mother-in-law, who does not help her when her grandchildren devour her but ask them to leave her the guts/children. She wants the grandchildren, which she takes and raises as her own. Therefore animals in mythic explanations, as well as in Kuna daily experience, stand for affines to humans, and the relationship with them is one that entails danger and predation.

Studying the life course of *nelekana*, it becomes even more evident that the relationship between humans and animals is characterized by predation and affinity. The *nele* is a figure in-between, he is the one that re-creates the bridge between humans and animals that had been broken in mythic time. As we shall see below, this separation has been engineered by Ipelele and his siblings who separated humans from animals and created the possibility for a human life. Today the *nele* is the one who can turn danger into knowledge and mediate between human and animal life. Following Overing Kaplan's (1984: 146) suggestion that for Amerindians "in-laws are strangers who may eat you," I argue that animals from the point of view of the *nele* are like potential affines, with which there is no exchange yet. For this reason, they desire human flesh and aim to steal human babies.¹⁴

Kuna ethnography shows with clarity that marriage acts as a tool for managing relationships between beings of a different kind. Affinity, from an Amazonian perspective, as pointed out by Overing Kaplan (1984) and Viveiros de Castro (2001), is the cosmological backdrop onto which actual matrimonial relationships might be projected to obtain their symbolic and practical significance. Though I am not going into detail here regarding these issues, I want to note that the correlation between animals and affines recalls the widespread practice among many Lowland Central and South American societies of creating alliances between potential enemies through marriage. By marrying outside the group of kinspeople, strangers are turned into kin, and relations based on suspicion, fear, or open animosity are turned into relations of exchange. It is therefore through constant exchange and successive marriages that alliances are kept alive and renewed, maintaining relations between groups and enabling the reproduction of local social groups.

The problem of cosmological predation and affinity has been widely discussed in Amazonian ethnography (e.g., Viveiros de Castro 1992; Fausto 2001). Descola (1992) argued that the relationship between humans and animals in Lowland South American societies is often based on either reciprocal or predatory schemes or according to a dual-

ist principle (121). Rather than fit with either one or the other model, Kuna cosmology and ritual practice show how the dangers of alterity are made safe through establishing relationships with powerful Others, such as animal entities and *nuchukana*. It is by being aware of those risks that the combined actions of various members of the community are carefully undertaken, to allow the *nele* to establish a relationship within the sphere of affinal entities without allowing his ties with humans to weaken excessively. In this way the *nele* will learn from his animal affines how to cure his human fellows. He will thus acquire the knowledge and the power to enable the human group to survive and reproduce. Human social life thus becomes possible only through the proper mediation between beings of different kinds (Overing Kaplan 1984).

MORS TUA VITA MEA: THE ORIGIN OF HUMAN MORTALITY

Prominent in the reading of the myth of Makiryai are three points that I analyze in the remainder of this chapter and in the next chapter. Namely, Makiryai's pregnancy ends with (1) giving birth by being devoured by the animals and her guts/children being saved by the grandmother-toad, while (2) her death is achieved when she is found by her children. When they realize that they cannot revive their mother, they bury her, completing her death with a human social act. The myth seems here to say that one is dead only when her body is seen and then buried by her kinspeople. Eventually (3) revenge for her death will produce the separation between animals and humans in mythic times. Before starting with the analysis of these three points I present the Kalapalo and Piro myths to add a comparative dimension to my argument.

In the Kalapalo myth (Basso 1987a: 29–79) Kwatingi is the name of the culture hero, son of the tree Dyekuku and the fishing bat (9).¹6 After having met Nitsuegi, the jaguar, Kwatingi carved new daughters from the wood of a tree because he did not want to give his real daughters in marriage to the jaguar.¹7 Tanumakalu and Itsangitsegu, the two "made ones," eventually went to the jaguar's village and married him. Itsangitsegu soon got pregnant. One day, when she was about to give birth and working in her husband's house, while the jaguar was out working in the garden

Itsangitsegu was making agave string, agave string, while her mother-in-law pisuk, pisuk, pisuk, swept her son's house.

Then her mother-in-law came closer to her just as she spat out a bit of agave.

"Pïtsuh!" she suddenly went, "Pïtsuh!" "Hey why did you start to spit at me, you fool?" She addressed her daughter-in-law most rudely.

Then her mother-in-law tore off a fingernail *tsiuk*, and threw it *toh*. *Ubom*! Itsangitsegu fell down, she was dying.

Tsiuk, her mother-in-law had slit her neck. (57-58)

Then the jaguar came back and found Itsangitsegu dying, and he put her up in the roof of the whirlwind's house. In the meantime she gave birth to her two children, Sun and Moon. The children were raised by their aunt Tanumakalu, who pretended to be their mother and did not tell them about the death of their real mother. When they grew up, one day they met their grandmother, the Red-Winged Tinamous, who told them the truth about their mother. So they searched for their mother and found her dying body on the rooftop. Their grandfather Kwatingi arrived, and together they pulled her down from the roof. But while they were doing so, she died. So altogether they mourned her (68–71).

The Piro myth tells of Yakonero, a woman who had been married to a jaguar but left him to marry a human. When she got pregnant, one day her son Tsla, still in her womb, made her follow the wrong path in the forest, so she ended up again in the village of the jaguars. There, her mother-in-law, Yompichgojru, the jaguar's mother, told her to hide high up on the roof of the house before her sons came back.

They arrived and said, "We smell human meat." Yompichgojru told them not to kill her. They lined up outside on a balsa log. Yakonero came down to delouse them. Yompichgojru gave her charcoal to chew, rather than have to bite their lice. When Yakonero came to the last jaguar, she had no coal left, and she bit the louse. "Klaaajji," she retched!

Because of this, the jaguars got angry and leapt on to her and tore her apart. Yompichgojru asked for her guts to eat. She hung them up in a *achiote* bush.

After three days, three birds emerged, three little *manacaraco* birds. They were Tsla and his brothers, the Muchkajine. The Muchkajine grew rapidly, in a few days they were men. But Tsla was small, stunted, a cry-baby. But he did miraculous things. (Gow 2001: 104)

The three heroes appearing in the myths presented above, Ipelele, Taugi, and Tsla, are considered powerful beings in their respective mythologies. Following what Gow has argued about Piro twins and ex-

tending it to the three heroes, I suggest that they represent the image of the prototypical shaman.

Tsla's society with the Muchkajine has an even odder feature for Piro people: he clearly has "twins." Piro people can be twins, but they cannot have twins. A Piro person can be a twin (gepirutu, 'one who is two'), but cannot have a living twin. As Teresa Campos, herself a mother of a twin and grandmother of another, explained to me, "When twins are born, one always dies. If we try to keep both alive, then both die. Only one can live." Everyone denied this was caused by neglect, but said instead that it was an intrinsic feature of twinness: only one can live. The surviving twin is a born shaman. . . . Tsla too is unquestionably a shaman, of miraculous powers, but he is able to keep his "twins" as living companions. The Muchkajine's "twinness" with Tsla is marked by an excess: not only do they double Tsla, they are themselves multiple. (Gow 2001: 108)

Ipelele and his seven siblings are marked by an even more striking excess: they are octuplets. Moreover, they are birds at birth, "and hence are born without placentas" (108). So they do not lose their placentas at birth, and, as Gow notes, are intrinsically multiplied (150). Kuna people call a twin koe tarpokwat, which refers to the twins as two things stuck together. Tar- is in fact the numerical classifier for things that come stuck together, or in multiples, and -po is the number 2. Although I have never heard about the association between twins and nelekana among the Kuna, this would not seem too far-fetched, given their belief that the nele is linked to an Other from birth. Furthermore, tarpa would be "three things stuck together," or, as Nixia said, "what lies between us," thus pointing to a further multiplication of the Kuna person toward wider spheres of relationships. However, this lies beyond the scope of the present work.

What the Kuna octuplet heroes, the Kalapalo Sun and Moon, and the Piro Tsla and Muchkajine have in common with present-day *nelekana* is the association between their birth and the death of their mothers. Ipelele is the master shaman; he leads his siblings in the quest for knowledge so as to revive their mother. Back from his supernatural travels, he brings knowledge in the form of chants and the seeds of medicinal plants. He will sow them on the earth, and he will sing the curing chants trying to revive his mother. Taugi is the great trickster but also the creator of all kinds of human beings: Indians, Christians, and

Fierce People (Basso 1987a: 77–79). Tsla, by being born with two twins, is "unquestionably a shaman."

The first point is that these heroes were born in ways that are monstrous and unnatural from the point of view of present-day people. They were born when the life of humans and that of animals were undistinguished. They had been conceived through incest between twins, through the union between a woman and a jaguar, and between a treewoman and a jaguar, that is, from unions between beings either too close or too distant. Human reproduction did not exist yet, and fertility was unmastered. When the heroes were born, in all three cases, they had to deal with a situation of chaos, where human social life was not yet possible. Their birth occurred in a strange way: the guts of the mother were cooked in a pot or hung on an *achiote* bush. Then, when the twins or octuplets appear, in the form of birds, they were not brought up by their mother, who had been killed by her brothers-in-law, but by their grandmother or their aunt.

What is interesting here is that when Ipelele sang to revive his mother's bones, he was interrupted four times by the appearance of an animal-man, whose presence jeopardized the ritual, each time causing the mother to turn back into bones. But the last time, when she was at the point of being revived, she transformed into a jaguar. Thus Ipelele stopped singing and along with his siblings decided to give up in their effort and bury their mother.

This episode portrays the first human birth, as opposed to the birth of the octuplets. The transformation of Makiryai into a 'jaguar,' achu, and then her definitive separation from her children, is reminiscent of the separation of the newborn from the 'placenta,' achu. The separation from the placenta through the cutting of the umbilical chord marks the baby's birth (Margiotti 2010: 192–205). Therefore the separation of Ipelele and his siblings from their mother represents the first human birth, signing the beginning of human life in ancient times.

Following what emerges from the cross-interpretation of these three myths, the fear for the life of the mothers of young *nelekana*, expressed in Kuna everyday discourses, begins to acquire meaning. As Kuna people told me, the "real *nele*" is the one whose parents are dead.²⁰ Myths give us a key to the interpretation of this statement. The acquisition of a *nele*'s powers derives from the actual or potential death of his mother. The Kuna woman giving birth to the *nele* is a woman about to die. Her condition is similar to the one portrayed in the myths of Makiryai, Itsangitsegu, and Yakonero, all of whom gave birth after their death.

Moreover, these three mythic characters did not see their children when they were born. This strengthens my argument about the lack of visibility of the newborn nele suggested in chapters 4 and 5. The lack of designs on his kurkin means that he is one that is not seen by anyone, neither by his mother nor by the other women assisting the birth. He does not have designs that women may say are yer tayleke, 'beautiful.' The nele's powers will then consist of being able "to see" anyone, humans and nonhumans alike. Through his powerful sight and the capacity to master his dreams, he will be able to see what is not visible, which means the inner image of human beings, animals, and trees. He will be able to see their purpa, 'soul,' 'inner image,' their image beyond external visual appearance.

The second point is about the origin and conception of mortality. The death of the mothers of the heroes in the three myths is not just a consequence of an act of predation perpetrated by animals; it is also a social occurrence. As we can see in the Kuna and Kalapalo myths, the mother eventually dies when her children see her. If she was not completely dead after having been eaten by animals, she dies when her children discover her, so they can mourn her death. In the Kamaiurá version it is made clear that this represents the first culturally acknowledged death: "it will always be this way; people die and never come back. They will die only once" (Villas Boas and Villas Boas 1970: 64).²¹

In Kuna mythology this is also the first representation of death. As the birth of the eight siblings may be seen as the first human birth, the death of their mother signals the beginning of human mortality. When Ipelele sings to his mother to revive her she transforms into a jaguar. This represents the primordial state of never-ending transformations. People did not die in ancestral times, instead they assumed new forms in a state of uncontrolled fertility. Everything was regenerating and rebirthing, as with Makiryai. But eventually her children decided to leave her to die. In this way they interrupted the cycle of transformations and inaugurated human mortality.

Mortality is thus linked in its mythic explanation to the emergence of kinship, memory, and affect. It is by being seen dying by one's children that one really dies. It is the act of mourning and the consequent feeling of grief that makes a person dead and sanctions the transformations of its person into a new ontological state. Therefore my argument is that shamanism among the Kuna is propelled by kinship. As I have shown so far in this work the *nele*'s birth entails his mother's death, and his initiation begins from learning the secret of birth in dreams. Thus

shamanism has its roots in the experiencing of the limits of human life. It is moved by the recognition of kinship. It is the grief and anger produced by the death of the mother that moves the *nele* to endeavor in shamanic training. It is to avenge his mother's death or to prevent it that the *nele* learns healing knowledge from animal entities. Thus shamanism has to do with the basic meaning of what it is to be human in a Kuna lived world.

SEPARATION AS A CREATIVE SOCIAL ACT

To conclude, I want to introduce another topic: the social consequences of the emergence of shamanism in mythic times. As the myth of Makiryai showed, in trying to help their dying mother Ipelele and his siblings learned curing knowledge. This explains that the *nele* today is the one who fights against the causes of death. He is ultimately moved by the love he feels for his mother and by the grief produced by her actual or feared death. This then extends to the protection of all kinspeople and others out of the sense of compassion that a *nele* develops from his own personal experience. Being a shaman is certainly not something desirable per se. As we have seen, from a young age the *nele* experiences deep fears and suffering, he faces dangerous experiences throughout his life, and, not least of all, he is at risk of becoming an orphan.

Becoming a nele is not motivated by the self-enhancement of the person alone but should be seen as an attitude toward life moved by profound existential motivations and sometimes moments of crisis. Kuna men visit their mother's house almost every day when she is alive. At their mother's home they always find a plate of food waiting for them. Losing one's mother at a young age is not an idea easily accepted by Kuna men, nor would it be by anyone else. Therefore the actual occurrence or the fear of death of one's mother is the motivation that leads young nelekana to pursue shamanic training. As Taylor (1996: 207) noted, "The integrity of one's feeling of self is vulnerable on two counts. First, it is exposed to the death of others, the shattering of bits of that mirror on which it is dependent—an all too frequent occurrence in the course of an Achuar life, and one that provokes, as its first reaction, intense socially directed anger." The grief and anger that Ipelele, Taugi, and Tsla felt for their mother's death was directed toward avenging her by killing the animals. The grief and the anger of a nele are projected outside the human social sphere, by fighting against the causes of illness.

Today shamanism is connected to the separation and mediation between humans and animals. The work of the *nele* is the maintenance of human life by keeping away all external destructive energies. But how did the separation between humans and animals take place? How did human social life begin?

In the Kalapalo myth, after having discovered the death of their mother, Sun and Moon began their empowerment. In doing so they generated humanity: Taugi, Sun, impregnated his mother's sister, who gave birth to the Fierce People, who, in turn, killed the jaguars, avenging their mother's death. Along with the Fierce People, she gave birth to the Indians and the Christians. Each people took their own path and became the different people of the world (Basso 1987a: 75–76). The Piro's Muchkajine were the first white people. They left the Urubamba because it was a land marked by mortality (Gow 2001: 106, 132–133). But before doing so, helped by Tsla, they killed the jaguars, leaving just two exemplars alive.²²

The third point I wish to make concerns another aspect that the three myths have in common: by killing the animals that devoured their mothers, the heroes separated humans from animals. Ipelele turned the grandmother-toad into an animal by cutting her fingers, and, as we will see in the next chapter, he fought against the animal-people who killed his mother, effectively turning them into animals. Taugi, as well as Tsla, killed the jaguars and spared just one, creating the lonely animal it is today. The killing of animals is intended as a transformation. From that moment onward, animals lived as people in villages under the world, separated from those of humans, and assumed animal shapes only when venturing on the surface of the earth.

My point here is that the act of separation is to be seen as the prototypical act of curing that Amerindian shamans perform. The Amerindian shaman is the one who looks after maintaining the separation between humans and animals in everyday life, as well as the one in charge of connecting the two social spheres. Being able to master the duality inside himself, being of the same kind with both humans and animals, the *nele* can establish kinship ties with both. He is the only one who can manage the proximity with animals and turn it into something creative for human life. The *nele* is deeply aware of the difference between humans and animals, hence he can work by reestablishing the boundary between the two domains when circumstances require it.²³ What for other people is illness for the *nele* is personal empowerment, knowledge. By being born mythically through an act of predation, the

nele will devote his life to avoiding subsequent acts of predation by keeping the evil intentions of animals away from humans.

In the next chapter I analyze the way in which a *nele* obtains his powers and curing knowledge and how he has access to the powerful knowledge guarded by animal entities. I explore this topic by looking at the continuation of the myth of Makiryai and at the ethnographic data.

SEVEN

Images of Alterity

otalio Pérez, a Kuna man in his forties, father of four girls and a *nele* himself, gave me a good hint to explain why animal entities want to kill the parents of the *nele*. This was never explicitly explained to me by Aurolina or by anyone else. Rotalio talked to me extensively

about his personal experience when he realized that I was interested in learning about nelekana. He was born a nele but never succeeded in developing his capacity to see. His kurkin had been sealed and he could never "see people" to diagnose illnesses, nor could he "see animals" in dreams. He told me that this was the consequence of the wrong medicine a ritual master gave him when he was undergoing his initiation during childhood. So he could never succeed in opening his kurkin or strengthening his sight. But there was a further consequence: he could die at any moment. The nele who cannot see his tarpakana cannot establish any kind of relation with them. Rotalio explained that the tarpakana want to receive the visit of the nele, and if he does not visit them they become upset and want to kill him. "When you marry," he said, "you have to go to your wife's house, don't you? If you don't go there every day, your father-in-law gets angry with you. How could you not visit your wife's house!"

This remark introduces an important issue concerning the experience of *nelekana*. The *nele* is the one who has a spouse in the underworld, or he has a wife in his dreams: both were common expressions used to explain to me the relationship a *nele* has with animal entities. To have a wife in the underworld is what a male *nele* tries to achieve in order to learn. His marriage will in fact give him the possibility of estab-

lishing a relationship with his animal father-in-law, master of an animal species, who will teach him secret knowledge.

Kuna people say that female *nelekana* do not get married to animal entities; instead they just seduce as many of them as they can in order to learn something different each time (see chapter 5). By seducing and making love to animal entities, they obtain their knowledge directly, without needing the mediation of their sons. Women can thus obtain many auxiliary spirits, whereas men have to establish a fixed relationship with one auxiliary and cannot change it in order to learn from someone else.

ALLIANCE AND TRANSFORMATION

Before analyzing further the relationship between a *nele* and his *tarpakana*, as the key feature for understanding present-day Kuna shamanism, I wish to show how myths account for battles and alliances between humans and animals during ancestral times. The myth presented below shows how alliances were intended as a way to gain power against enemies and ended up with the transformation of animals into their current form and their separation from human beings.

Ipelele, otherwise Tat Ipe, Sun, and his siblings were seeking revenge for the killing of their mother by the animals, who are themselves grandchildren of Piler, the husband of Pursop (see chapter 2). Tat Ipe, who is associated with wit and strategic skills by the Kuna, realized that they needed to use their intelligence to win the battle against evil. Two episodes illuminate this issue. In the first case, following the death of Makiryai, Tat Ipe decides to give his sister Olowai-ili as a spouse to Olourkunaliler, master of thunderstorms. He wants to establish an alliance with Olourkunaliler in order to receive his support in the fight that he is planning against Piler and his five sons, the chiefs of the animals. Thus Tat Ipe and his siblings celebrate the marriage between Olowai-ili and Olourkunaliler by putting them in hammock together, with hot embers beneath. The second episode proceeds as follows:

When Piler saw that Olourkunaliler had been recruited by Tad Ibe and his fellows, he worried and called all his sons. They realized that their opponents had the advantage and that they had to attract one of them onto their side to compensate for the loss of Olourkunaliler. So they decided to send Olobagindili, the daughter of Kuchuka [one of Piler's sons], dressed in an elegant dress, painted with achiote and deliciously

perfumed, in the direction of Tad Ibe's house, to make one of them fall in love, and so attract him to the family of Piler.

When Tad Ibe saw Olobagindili he wanted to marry her. He was not motivated by her beauty, rather he thought this a way to gain entrance into the family of evil and so learn its secrets.

... Tad Ibe, during his stay on the earth, got engaged to various women, who were the daughters of evil spirits (*ponikan*). He did so to learn the secrets from their fathers, in order to fight the evil they possessed more effectively.... It is known that when an Indian marries an American girl he gains entrance into the United States and learns all that the Americans know.

... Tad Ibe and his brothers decided to kill Piler's grandchildren. Pugasui said that he would strike them with his bow and arrows, but Tad Ibe told him that he would rather face them by using his diplomatic skills. With this aim they organized a chicha ceremony and invited Piler, his sons and his grandchildren.

... Tad Ibe was the kantule [ceremonial singer], and he tried to teach those assembled how to celebrate the ritual. When they brought him the chicha he said, "Itomargwele" [let's try it], before drinking. Piler's grandchildren looked at each other in surprise because they had never heard such a word and did not understand it. Then Tad Ibe told them that they had to yell to awake the chicha: "yor yor yor sio ko." Again they were surprised, because they could not understand what was going on.

... When Tad Ibe saw that all were full of chicha he went to the entrance and put an akwanusa [magic stone]² on the ground. He knew that soon they would all fight against each other and compete among themselves. In a short while, Oloaligiña and Oloidikaliler were fighting in the middle of the house producing a great confusion with their huge force. Oloailigiña went toward the door to urinate and fell over the akwanusa. When he stumbled Tad Ibe kicked him and sent him flying onto the patio. When he stood up he started kicking his legs on the ground and snorting angrily. Then Tad Ibe told him: "From now on people will call you Moli [tapir] and Siluga Asu" (nose of 'siluga,' a tree). Then Oloidikaliler went out, stumbling through the door, and fell over the akwanusa. Tad Ibe kicked him hard, and he fell into the river with a great plunge. "From now on," Tad Ibe said, "people will call you Timoli [manatee] and Soilagwak (warty nose; the plant 'soilagwak' is covered by warts)."

... Then all the grandchildren of Piler fell over the akwanusa because of their drunkenness, and they were sent away from the house and transformed into animals. Some of them fell on the ground, others

were kicked into the trees, others fell in the river, and others went into the sea. (Chapin 1989: 59-62; my translation)

What Tat Ipe achieves in this episode is a double goal: first he gets into Piler's family by marrying one of his granddaughters and then he transforms Piler's grandchildren into animals with the help of akkwanusa, the magic stone used by shamans. The myth concludes with all the animals being sent into the "fourth level" under the earth through a whirlpool. That is where they still live today, congregated in their villages where each species is ruled by its own master. Furthermore, the end of the myth reveals how Pukasui kills Olopakintili by shooting her with an arrow. Then Tat Ipe's siblings tell him that "from then on he could only see his wife in dreams" (63).

By transforming Piler's grandchildren into animals, Tat Ipe performs an act of creation as well as one of separation. He creates animals, which were humans before.³ Therefore Tat Ipe creates animals by fulfilling his thirst for revenge for his mother's killing. In this way he also reaches another goal, that of separating the human condition from that of animals, thus creating the precondition for human social life.

Kuna people constantly draw on the source of knowledge and fertility that is located in the supernatural world, inhabited by animal as well as tree entities. Both give people the capacity to be fertile and to produce cultural objects as well as other human beings. Trees are the main source for improving bodily substances, and they are associated with birth, rejuvenation, and reproduction. Animals provide hunting skills and ritual powers and are considered the primary cause of human mortality and illness.

Human social life is based on kinship, which is based on the mastering of fertile forces and emotions through memory, thought, and love (Gow 1991, 2000) and on the reproduction of culture and the protection against supernatural enemies through shamanism. Animality is a condition that for the Kuna lacks kinship and has more to do with unrestrained appetites, predation, and uncontrolled reproduction (Overing 1985a). Therefore, by creating diversity, separating humans from animals, social life becomes possible. Birth and death become the limits of life as Kuna people experience it today. From the moment of this separation human beings had to be born as well as to die in order to live as people. The human condition was bound to birth and mortality, and the main cause for the latter is precisely animals, which seek revenge for their removal and transformation. The temporary human condition of being alive is possible through the separation from the animal

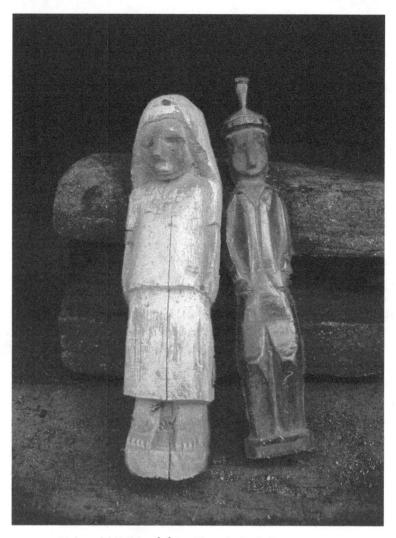

FIGURE 7.1: Male and female nuchukana. Photo by Paolo Fortis.

condition, which nonetheless means a constant struggle and negotiation with animals, entailing danger, illness, and death. Life is difference, separation, and fertility; death is identity and nonfertility (Overing Kaplan 1984: 131).

As Kuna people told me, when people die they go to the house of Pap Tummat, where they will live with their partners. There the men will be surrounded by the animals they hunted during their lives. Moreover, the man and the woman will look the same, will live alone as a couple, and will not have children. Life becomes a sterile identity in the afterlife, and the absence of danger and conflicts stands for the absence of life as reproduction (Fortis 2012).

In explaining what it means that "the nele is the one who marries in the underworld," Rotalio told me that the nele marries the daughter of one of the chiefs of animals, who, according to Kuna mythology, is one of the grandchildren of Piler, transformed into animals and sent under the world by Tat Ipe and his siblings. Today the nele seeks to study the nature of ponikana, to learn their secrets and to protect his human kinspeople against predation. Knowing what a poni looks like, how it behaves, how it walks, what it eats, provides the nele with the knowledge to diagnose illnesses. Thus the nele, by getting to know ponikana closely, learns how to cure people of their evil actions or even to prevent them. To do so, the nele reenacts the primordial alliance between Tat Ipe and Piler: he marries the daughter of a chief of animals. By entering via marriage into the underworld villages of animals, the nele gains access to the knowledge of the enemies.4 It is only by knowing how animal entities live that human beings can survive in the world, and it is the task of nelekana to provide this security. But how does the young nele get to marry the daughter of a chief of animals?

OPAKKET: CROSSING TO THE OTHER SIDE

The initiation ceremony for a young nele is called opakket or nelopakket, 'to cross,' 'to traverse.' The ceremony is led by a 'ritual chanter,' api sua, who knows the chants that may go on for up to eight days. The api sua chants during the night, while the nele is asleep. Through his chanting he guides the nele's purpa in the underworld in order to meet his spirit helpers. Various nuchukana are carved especially for the occasion. Usually two couples of balsa wood formed by two men and two women are made. They will be the nele's guides in his travels in the underworld domains of animal entities. Other nuchukana may be brought by the ritual chanter and the other participants to the ceremony. An 'enclosure,' surpa, is built within the house. Inside it the nele will lie in a hammock, surrounded by nuchukana.

In addition to the *api sua* and the *nele*, other people are involved in the ceremony, usually elderly women and adult married men. Their task is to smoke tobacco and keep adding cacao beads to clay braziers to burn them on hot embers. Elder women smoke tobacco pipes and cig-

arettes and sit inside along the cane walls of the house outside the enclosure. One man is called the *sianar takketi*, 'he who looks after the brazier,'⁷ and his task is to ensure that the embers that burn the cacao beans remain lighted, by waving a woven fire fan. Another man is the *war ueti*, 'tobacco smoker,' generally a middle-aged man, who smokes long cigars.⁸ He keeps the lit end of the cigar inside his mouth and blows, producing a great amount of smoke on the heads of the *api sua*, the *nele*, and the *nuchukana*. The *api sua* lies in a hammock beside the *nele*'s within the enclosure.

During the day the nele bathes with plant medicine water and never goes outside the house. When the night comes the api sua starts singing in a low voice, while the nele falls asleep. He sings for many hours and pauses only once in a while, when the tobacco smoker puffs tobacco smoke on his head. Outside, the elder women, sometimes accompanied by some men, quietly smoke their pipes or cigarettes and collect the ashes in small gourds. They are called inna opanneti, 'those who swing the chicha.' Tobacco smoke is in fact the refreshing 'unfermented chicha,' inna ochi, for nuchukana, which gives them the energy to work hard and to protect the nele during his cosmic travels. The ashes of pipes and cigarettes are the 'fermented chicha,' inna kaipi, offered to animal entities, which makes them happy and drunk.9 I was told that female nuchukana bring the chicha and offer it to animal entities. They have a cheerful manner; they dance and sing while they offer chicha, as Kuna women do during puberty ceremonies, singing and stepping rhythmically. For this reason animal entities are thrilled and drink what they are offered happily, ending up very drunk.

Through his chants the ritual master guides the purpa of nuchukana and that of the nele in the oneiric exploration of the villages of animals in the underworld. During the first nights of the ceremony the nele is guided by the api sua and escorted by nuchukana close to the proximity of the animals' villages, so they can observe their places without being seen. This first survey is meant to provide the nele with general knowledge of animal entities. In their underworld homes animals look like persons. Though I was told that they have particular features that make them different from human beings, I obtained few and always rather general descriptions of how animals look in the underworld. On occasion people hinted at peculiar aspects that a particular species has; for example, the woman-turtle was said to be beautiful. Then, progressively, night by night during the ceremony, the nele is conducted closer to the villages of animals, until he is able to see animal women, to get close to them and choose the one he prefers. To make the right choice is

crucial; in fact, there is always the possibility of being deceived by entities that are not real *tarpa* of the *nele*.¹¹

"Women ponikana are beautiful!," Rotalio told me. Each poni tries to seduce the nele, but he has to resist until the right woman comes along. For this reason the ritual master gives advice to the nele during the days of the ceremony, telling him how to recognize each animal woman. Also, nuchukana stand beside the nele, to help, guide, and protect him along the way.

Nelekana bathe for eight days to cross to another village. Not just another village, but to go into the village of ponikana, to get in there. Nuchu is my guide, it accompanies me. Look, when you came here you asked me, "Rotalio, when are you going to Panama?" I thought, "How could I go, I have no money." You helped me: "Don't worry, I'll take you."

The first time I went to Panama when I was young, I was innocent, I didn't know anything, I stayed still. Where is my uncle's house? I thought. I didn't know. So I looked for a person who could bring me to my uncle's house. In the same way the *nuchu* brings me into the house of *ponikana*. To see the house in their village. To see how they live: do they live like us? How did God create these *ponikana*? Are there rivers? What do *ponikana* have? Are they like us? Are they different?

... Nuchukana have telephones, as strangers, but we do not see them. In dreams they begin to look like soldiers. As the soldiers have their own weapons, they have theirs. So they bring me to the village of neilu kalu [unspecified supernatural village]. The nuchu tells me: "This is neilu kalu, this poni is ansu, this is achu, he is tain." They are alive. I see them, but my face is hidden. My body doesn't show up. The poni do not see me. Just my eyes show up. The nuchukana are protecting me.

Then during the night I wake up and I feel weak, because my soul went out. When I dream my soul goes out, but my body stands still. My soul is working. Therefore the api sua asks me, "Hey, Rotalio, which tarpa do you want to get close to? There is ansu, achu, tain, akkwanusa. There are many tarpakana. There is ukkuturpa, pero, akkwanukku. These are doctors."

Look, now I live here, I got married to Alejandrina and I have four daughters. *Nelekana* are always married to two women. One lives spiritually. If you don't get married you don't know anything. You live alone, you don't think, you don't do anything. When I am married, one day my wife tells me, "Today I don't have wood, go get it. Today I don't have coconut. Today we haven't eaten, tomorrow you'll go fishing." If I live alone no one is going to tell me so, are they? My mouth eats alone.

Now I have four mouths. Spiritually a *nele* always gets married. This is my *tarpa*, it is said, like my wife. Only the name changes: *tarpa*. This is my wife.

Look, I got married to Alejandrina. Her father was a *kantur* [ceremonial chanter]. Here we have his maracas and his flute. . . . I don't know where they threw them! I got married to her and moved here. My father-in-law told me, "Rotalio, you live in my house, so you will learn to be a *kantur* like me." He taught me. How did he teach me? Look, I got married to Alejandrina, Roy's daughter. He had eight disciples, but they didn't live in his house as I did. Who did he teach more? Me, because he thought, "When Rotalio is a *kantur*, they'll always eat meat."

Rotalio's words indicate that approaching the village of animal entities for the first time represents a great danger. The *nele* is escorted by his guides and spirit helpers, *nuchukana*, which hide him and allow him to see without being seen.¹²

The first days of the ceremony are dedicated to the slow and careful exploration of the underworld. The ritual chanter sings his long chants, guiding the *nele's purpa* and the *nuchukana* in their supernatural exploration. Knowing in detail the supernatural geography of the territory around the village is one of the skills of the ritual chanter. As testimony to this, one day I had a long conversation with one of the two ritual chanters present in Okopsukkun and Ustupu at the time of my fieldwork. He illustrated to me the supernatural topography of the place, by naming the various *kalukana* where animal entities live in the surroundings of the island, both in the sea and on the coast. Each place has its proper name and is associated with one, or sometimes more, animal species.

Kalukana are specific topographic places, located in specific areas in the sea or in the forest. The exact location and the name of the majority of kalukana near Okopsukkun are known only by ritual specialists. Nevertheless, the location of some of them is known by most adults, as in the case of a place on a hilltop in front of the island called Sarsip kalu, known for having been infested by demons in the past.

All *kalukana* are dangerous for people to get close to. They are inhabited by either demons or animal entities. If the person passing by cuts a tree branch inaccurately, or even worse, if he decides to start a new garden there and cuts the trees, the entities living in that *kalu* may get upset and attack him and his family. In some cases, the evil entities, disturbed by the inattentiveness of people, may decide to attack the entire village, perhaps by causing an epidemic, when people and espe-

cially children suffer from diarrhea and high fever. In these cases a ritual chanter and a *nele* are called, and a collective healing ritual, called *apsoket*, is performed to send the evil entities back into their *kalu*.¹³

In addition to the kalukana inhabited by animal entities and demons, there are kalukana in which the chiefs of natural phenomena, like thunder, wind, storm, and earthquake, reside. Each one decides when to liberate its energies. There are also kalukana in which cultural skills are contained. They were created by Pap Tummat and visited by culture heroes like Tat Ipe and his siblings in ancient times, who went there to learn and eventually transmitted their knowledge to Kuna people. The Kuna today call these "administrative kalukana," which they describe as having huge and wonderful buildings with "offices with lots of people that execute the will of God in relation to the earth" (Herrera and de Schrimpff 1974: 208). One of these places is called Kaluypakki, and, I was told, it is the place where all nuchukana present in every house in the Kuna territory gather every day. There they organize collective meetings in which they tell each other the news from each village. In this way every nuchu is updated about what happens in other villages and can reveal this information to its nele owner.

Each kalu can be represented graphically. Depending on the animal chief or demon residing in it, the kalu has particular features, which help to identify it. The name of each kalu is the same as one of the animals living in it. For instance, moli ipekun kalu is the "kalu of the chief of tapirs." There are different types of kalukana, some that are part of the local topography and thus differ from island to island and others that are shared by all the Kuna, regardless of where they live. The latter form part of a more fixed tradition, while the former might change with time and disappear after some years.

By moving steadily closer to *kalukana* the *nele* gets used to the visual appearance of animal entities and learns to cope with their proximity without being frightened. Kuna people often stressed the importance of being able to stand the presence of animal entities, to be courageous enough not to run away and thus wake up, thereby spoiling the learning progress made thus far. The meaning of the *opakket* initiation ceremony is likely to be related to the fact that the *nele* actually crosses the space between humans and animals, reaching the place inhabited by the latter. *Opakket* stands for the completion of this process, when a *nele* has successfully gained entrance into the house of the master of animals.

As I described in chapter 4, the sight of animal entities in dreams frightens the young *nele*. It is for this reason that *nelekana* have to take plant medicines during their childhood, before they undergo their ini-

tiation, in order to strengthen their purpa, nika and tala, 'soul/immaterial double, 'bodily force,' and 'capacity to see.' Thus prepared and fortified, the nele is able to see animal entities as people and to approach them during the initiation. The strengthening of his bodily capacities and the guidance of the api sua are therefore essential to the completion of the nele's initiation. Moreover, the companionship with nuchukana is a further help and guidance in unexplored territories that ensures the security of the nele. Nuchukana are in fact the spirit protectors of humans par excellence. Their knowledge of animals and demons is precious insofar as the nele establishes a personal relationship with them and gains their trust and companionship. As noted in chapter 3, some of the most desirable qualities of nuchukana are their truthfulness and their willingness to share their knowledge with nelekana. This can be achieved only through the daily visits that the nele has to pay to his companions through dreaming, in which they actually speak and exchange information.

The initiation process was described to me as 'learning,' nerkuet. So prepared, guided, and accompanied, the nele learns, and he literally 'becomes a nele,' nerkue. He learns about animal entities, their behavior, their way of life, their powers, their tricks, their transformations. But first and foremost he learns how to change his point of view. Moving toward animals' villages, the nele learns how to transform himself and to adopt another point of view. By becoming able to see animal entities in their inner and real forms, the nele learns how to adopt their perspective, becoming eventually but momentarily one of them. By seeing animal-women as beautiful women he has transformed himself in order to be seen by animal-women as a man. But what needs to be emphasized is the importance for the nele not to be trapped into an animal perspective, which means that he has to maintain his human agency within the animal world. In this task he is helped by the ritual master and by nuchukana, who during his initiation help him to readopt his human perspective and to maintain his human intentionality.

As Rotalio brilliantly explained to me, a man alone does nothing. It is only when he is married and starts having children that he learns how to do things properly. It is the aim of working for one's kinspeople that makes a man learn. As explicitly told to me, this is also true for the *nele*: he learns in order to help his kinspeople; therefore he should live with them. Kuna people emphasize that a *nele* must not learn alone, or he will go mad. This, they pointed out, contrasts with the practice of shamanism in the olden days, when *nelekana* became too powerful and used their knowledge against their kinspeople.¹⁴

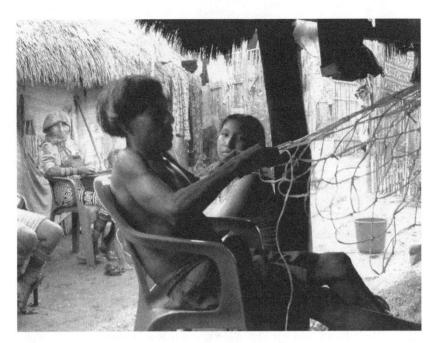

FIGURE 7.2: Rotalio Pérez weaving a bag. Photo by Paolo Fortis.

For Tat Ipe, learning about medicines was motivated by the desire to revive his mother, and marrying Piler's granddaughter was a way to know evil from the inside. The reason a nele undergoes the whole initiation and associates with animal entities today is to cure his human kinspeople. This reason is important, and Kuna people often say that a nele is good for the community; he helps people and would never harm anyone. Underlying this statement there is the awareness of the dangers that the union between a nele and animal entities represent for the whole village. The nele might be overtaken by the perspective of animals and stop seeing human beings as similar but instead as prey. For this reason it is essential that the nele be guided by the ritual master and watched closely both during his initiation and later, until any doubts about his moral fiber are cast off. Social relationships and kinship keep the nele attached to human intentionality during his entire life by preventing him from losing his love for and memory of his kinspeople. Power and knowledge for their own sake are discouraged by Kuna people, and practices such as shamanic initiation and the killing of witches aim to control the emergence of overly strong individual powers.

It is the ritual master who judges when the moment has come and the *nele* is finally ready to enter the village of animals. It is the ritual master who lets the *nele* in, by means of his chants, to complete the crossing and unite with the daughter of a chief of animals.

MARRIAGE AND RECIPROCITY IN THE LIFE OF A NELE

The *nele* must be prepared for the first close encounter with his future spouse, which should never happen before a certain time. Furthermore, the meeting between the *nele* and *ponikana* must not happen empty-handed. Permission to enter the village of animals is given by their chief in return for the marriage of the *nele* to one of his daughters. The meeting with the chief of animals must happen when the *nele* is prepared to marry one of his daughters and has already made his choice. Therefore the ritual master asks the *nele*, when he wakes up between his dream-travels, which animal-woman he likes most. He also tells the *nele* about the qualities of each animal-woman, so the *nele* can make his choice. What is important to note is that in the first stages of the initiation ceremony animals are depicted as enemies. They must not see the *nele*, or they will kill him. This relationship changes once the *nele* marries a *poni* woman, even though it will always remain a precarious relation, as we will see below.

The *nele* must be prepared to establish a friendly relationship with animal entities at the first actual encounter. Something must be offered as a sign of friendliness and a denial of animosity when *nele* and *ponikana* meet. What mediates the encounter is the offering of fermented chicha to *ponikana*. By drinking fermented chicha, animal entities get drunk and become happy. This calms any aggressive attitude toward the *nele*. "If *ponikana* are drunk, they are happy," Rotalio told me, "and they do not want to kill the *nele*." On the contrary, they become benevolent with him, as they realize he is going to be part of the family.

The first resemblance here is to the myth in which Tat Ipe and his siblings organize a chicha ceremony to celebrate his marriage to Piler's granddaughter. Fermented chicha is collectively drunk by Kuna people during the girl's naming ritual. Three different rituals are held during a girl's life cycle: during the early days of life, for the perforation of her nasal septum, *iko inna*; after her first menstruation, *inna mutikkit*; and for the name-giving ceremony, when the ritual cutting of her hair is performed, *inna suit.*¹⁶

Puberty ceremonies, especially that of name-giving, were, and in some cases still are, the moment for combining marriages. This issue is also clearly shown in the myth presented in this chapter, where Tat Ipe

and his siblings decide to celebrate a chicha ceremony to organize his marriage to Olopakintili. Puberty ceremonies are thus linked to marriage and alliance but also to danger and animosity. These are occasions when the whole village gets together and when unrelated people find it easier to talk together and spend time laughing and telling stories. It is completely acceptable and even expected that families agree on the marriage of their children during these festive times.

Kuna people explained that in the past, when arranged marriages were more frequent than today, the parents of the bride, having chosen the potential husband for their daughter, asked for the agreement of the parents of the groom. Both sets of parents thus met during the three-day name-giving ceremony and agreed to the marriage of their children. It is said that the gay atmosphere of collective drinking eased the meeting between potential affines. When the parents of the groom agreed to their son's marriage to the girl and thus to his moving into her parents' house, the father of the bride, together with some male friends or relatives, went to drag the boy from his house. Sometimes the boy was taken by surprise, completely unaware of the agreement reached by his parents. He was taken into his future wife's house and was put on top of her in a hammock. The first time he remained for only a few minutes in the house of the girl, sometimes not even speaking with her. Then, the second day, his father-in-law and his friends took him to the house again where the girl waited for him. They did this for four days, and each day the boy stayed longer and spoke more with the girl. The last day he remained for the entire night, and the next day he went to the forest with his father-in-law to collect four trunks for the home's cooking fire. With the husband starting to work for his wife's family the marriage was completed, and the husband moved into his wife's house more permanently (cf. Prestan Simón 1975: 91-94; Margiotti 2010: 169-173).

Today, although marriages are less frequently the outcome of the decision of the couple's parents, the practice of 'dragging' the groom, kakaleket, is still in use. The mock capture of the boy by his male affines is done jokingly, and the movement of the boy to his wife's house is not sudden but gradual. Older people emphasized their initial embarrassment about their first days of marriage. I also heard older men remember how embarrassed and lonely they felt the first days in their wives' houses.

The man's gradual move into his wife's house is due to the importance of getting to know each other. Unknown people always represent

a potential threat. Eating together, sleeping together, living together are the only ways to become of the same kind, to become kinspeople, as it has been emphasized in Amazonian ethnography (Gow 1991; Belaunde 2001; McCallum 2001). Similarly, the *nele* moves slowly into the house of his wife-to-be. His marriage in the underworld is the mirror of his marriage to his human wife, as I explain below. The *nele* at first maintains his distance from the house of his future wife, and then he progressively gets closer until he eventually moves into the house of his animal affines.

The fact that girl-naming ceremonies were commonly the place where marriages were arranged is probably linked to the fact that social relationships are eased by the atmosphere of happiness and amusement created by collective drunkenness. Relations with potential affines are in this sense similar to relations with animal entities. For this reason, girl-naming ceremonies are also moments of danger and trouble. On the one hand, the peaceful collective atmosphere might be suddenly interrupted by a fight breaking out, especially between young men, who are soon separated, although I was told of cases in which opposing factions formed around the involved parties and the process of calming down the spirits was longer and more complicated. Furthermore, drunk men might mistreat their wives, thus causing troubles within households. Recently young men started drinking rum outside the chicha house, which causes them to become more violent. On the other hand, animal entities are attracted during chicha ceremonies and come closer to the village. The ritual singer, who is in charge of calling on animal entities and inviting them to drink, is in a dangerous position, and his security depends on the proper performing of ritual tasks by other officiants, such as the tobacco smokers.¹⁷

As the myth in this chapter and those in the previous chapter show, humans and animals were the same in ancient times. Then animals and human beings split, each one moving to a separate place in the world and ceasing to be able to communicate. The outcome of this separation was the creation of human sociality as distinct from that of animals. Human beings were also bound to mortality and birth as characterizing their life on the earth. From the end of ancient times, therefore, the relationship between humans and animals was marked by predation and hostility. Death and birth are not seen by the Kuna as natural facts but as the outcome of a process, which entails human as well as nonhuman agency. Death is in fact most often caused by animal malevolent agency, even though, up to a certain point, it can be caused by human misuse of

medicines and ritual knowledge. Birth must be completed through human agency, as the end of a process that starts beyond and before the world of human beings.

Kuna people eat animals, and animals eat Kuna people. As the grandchildren-animals ate Makiryai in mythic time, today's animals eat people by consuming their blood and stealing their souls (cf. Howe 1991). It is the form of killing that has changed from mythic to present time, but the threat is the same.

Separation is thus seen as safety, while proximity and union means danger. It is the task of the *nele* to venture close to animal entities and to establish strategic alliances, to steal their knowledge for the sake of his human kinspeople. On the one hand, animal entities try to steal the young *nele*, killing his parents and cutting his links with his human kinspeople. On the other hand, the *nele*, with the assistance and guidance of his kinspeople, ritual specialists, and *nuchukana*, plays the game of marriage and alliances cunningly, with the aim of tricking animal entities and stealing their secret knowledge.

Once the marriage alliance between the *nele* and animal entities has been established, reciprocity is implicit between the two domains. Through marriage a relationship of reciprocity between the *nele* and the chief of animals is therefore established. As Rotalio told me, it is important that this relationship is constantly acknowledged and looked after. If the *nele* does not visit his wife's family in dreams, if he does not go to his wife's house, his father-in-law will strike him dead. The most common cause of death for *nele*, I was told, is stroke, which is caused by the attack of animal entities while he is asleep.

Once a *nele* has started his personal journey toward knowledge, through his initiation, he cannot turn back. Once he has married an animal-woman, he has to live with her in dreams, in the same way that a man has to work for his human wife's family. Moreover, when the *nele* has children with his human wife, he also becomes a father in the world of *ponikana*. The two lives of the *nele* run parallel, and he is expected to do the same things for his human family and for his animal affines. He has to work for his children in both realms, and this amounts to living two lives at the same time—one during the day with his human family, the other during the night with his *poni* family.

As Rotalio reiterated to me on various occasions, he feared he would die at any moment. He had already told his wife, Alejandrina, to be prepared for this occurrence. This was because he had not succeeded in completing his initiation and thus could not see his *tarpakana* in dreams. He could not meet or speak with them, thus causing a rupture in the reciprocal relationship. They were angry with him, he told me, because he never went to visit them.

GAINING DESIGNS

Let us now explore further what I defined above as reciprocity. Reciprocity is an important aspect of kinship and affinity among Kuna people. It is what keeps the man and the woman together and structures relationships within the extended family. A man who gets married has to work for his affines. He inherits gardens from both his parents, which he will work along with those of his wife to bring food to his in-laws' family. All the food he gathers from the gardens will become his wife's on reaching home. It will then be his wife's duty to send raw food to her mother-in-law (Margiotti 2010: 79–81). When the couple has children this becomes even more important, as everything that a man does for his original family, rather than for his wife's family, might be a matter of controversy and may even drive the couple apart, with the man going back to his mother's house.

Married men are expected to fully participate in the economic life of the families of their wives. A married man often works under the guidance of his father-in-law, together with his unmarried brothers-in-law and his co-brothers-in-law. Even if men work alone and tend to cultivate their own gardens, there are occasions when sets of brothers-in-law work together, for example, when they have to slash and burn trees before sowing an old garden. On the other hand, as Rotalio told me, the father-in-law transmits his knowledge to his sons-in-law. This can be whatever the father-in-law is knowledgeable in—how to make canoes, prepare medicines, or sing ritual chants.

Ritual knowledge is valuable, and men have to pay for it when they become disciples of a master. I was told that in the past a disciple worked for his master in return for his teachings. He would work in his master's gardens, go fishing, or help him to fell trees. Today, I was often told, it no longer works like this: people have to pay money in order to learn. Money is also the most common form of exchange when a cure is performed. If money is especially short, the family of the ill person may give crops or fish as exchange. Even if the healer is a close kin he has to be paid. In one case, a man told me that he once paid his brother \$5 for curing him, and then his brother gave the money back to him. Otherwise, he said, the cure would not be effective.

In all these examples reciprocity and exchange are crucial to the es-

tablishment and maintenance of social relationships. Receiving something makes one give something else in return, as between a father-inlaw and a son-in-law, or something is given in exchange for a service, as between a healer and a patient. What also emerges is that what is given in exchange or what is reciprocated may vary—as work transformed into money-but the relationship remains key in the transference of knowledge or in the curing process. In the case of work exchanged for teaching or money, or in the case of the father-in-law teaching in return for the son-in-law's participation in his family's economic life, what is always acknowledged is the relationship between the two parts. Reciprocating or not, or what is given in exchange, has the meaning of stressing the importance of relationships for the people involved. This traffic in social life points up the main aspect of Kuna social theory: everyone is involved in relationships. Not being able to reciprocate means that a person is becoming other, an enemy, or, from the point of human beings, a nonhuman, or both.

Relationships are immanent in the nature of human beings for Kuna people. This can be seen in the concept of *tarpa* and in the birth of a *nele*. People are born with the mark, visible or not, of animal companions. When the mark is visible in the form of amniotic designs the relationship itself is acknowledged and recognized by the kinspeople of the newborn. In the case of the *nele* the relationship is not evident and must be made so throughout his life. Therefore what Kuna people do in their daily lives through reciprocity and exchange is to make relationships visible to the eyes of everyone else. Exchanging and reciprocating are forms of acknowledging relationships and making them visible in everyday life. 18 As has been argued by some Amazonian scholars (e.g., Overing and Passes 2000), relationships are at the core of Amazonians' everyday preoccupation with the constant construction of "living well."

By acknowledging the inner relational nature of human beings, people devote much energy to dealing with the everyday dynamics of social relationships. This is equally true for relationships between human beings and between humans and nonhumans. The Kuna expressions nuet kuti, 'being well,' and akkar akkar suli, 'nothing is wrong,' convey the preoccupation with, as well as the value of, a state of tranquillity and serenity, as opposed to one of fear, anxiety, and disruption. This preoccupation leads to the collective effort of individual members of society to achieve the common aim of keeping life on the safe side.

My point is that the final aim of the opakket initiation ceremony is precisely to "make visible" the nele's relationship with supernatural be-

ings. It is a way to reveal to his kinspeople, and to the members of the community, the amniotic designs that were hidden at his birth. His lack of designs at birth will thereby be compensated by his collective initiation and his relationship with powerful supernatural entities will be acknowledged by his kinspeople: he will be married to a animal entity.

This does not mean that the *nele*'s relationship with his auxiliary spirits is completely manifest and known by other people. On the contrary, a *nele* would never speak overtly about it, primarily for fear of retaliation by his *tarpakana*. Besides, it is not a topic that would normally be discussed with other people by a *nele*, but rather it is perceived as private and intimate. Once I was told by a *nele* from Ustupu that I was the first person with whom he had spoken about his relationship with his *tarpakana*. He had never even spoken with his father about this. He told me that he found that he could speak with me because he understood that I was studying, but he stressed that these were things that he would not discuss with anyone else. "I wouldn't know how to answer to their questions," he told me.¹⁹

Therefore what is rendered manifest is the relationship between a *nele* and his *tarpakana*. The fact that a relationship has been established with the help and the supervision of the ritual master is a guarantee that the *nele* has taken the first step toward becoming a real *nele*. He will thus become able to see other people's inner designs, that is, to diagnose their illnesses.

What the nele does when he marries in the underworld is in some way formalizing and making public his union with animal entities. He establishes a relationship similar to his earthly relationship with his own family. By acknowledging the potential threat entailed in his relationship with animal entities, the nele establishes a relationship of alliance and exchange/reciprocity with them. This relationship is aimed at being socially profitable for his human kinspeople and, as a consequence, for all fellow villagers, who directly or indirectly participate in the ceremony, and for those who have previously participated in the rearing of the young nele. People's participation in the initiation of the nele, such as those who swing the chicha and those who look after cacao, is thus aimed at securing a link based on reciprocity. People say that the nele should then feel grateful to his fellow villagers and help them when they are in need, both through individual curing and, most important, when a collective healing ritual is performed. Nevertheless, as I stated previously, active nelekana are rarely safe from criticism; when their position in the village becomes too precarious they may find it convenient to move to another village or to Panama City.

By the same token the relationship between the *nele* and *ponikana* is made intelligible in terms of social categories, that is, through marriage. From this logic stems the imperative that a *nele* must marry in this world to be married in the other world and that he must have children "here" to have children "there." Is this an act of reciprocation between human beings and animals? Is the *nele* a mediator between worlds previously united, whose task is that of granting animals what was negated to them in ancient times?

AN ACT OF CREATION

What the *nele* and the ritual master do, helped by other people during the *opakket* initiation ceremony, is to re-create humanity. They in fact reenact the ancestral alliance between humans and animals through which culture heroes transformed animals and sent them to live in a separate domain from that of human beings. Through the marriage of the *nele* to a *poni*, the primordial alliance with animals is reenacted, as is, I would argue, the creation of human social life.

Here I wish to compare once more the Kuna with an Amazonian people, the Yawalapíti, as described by Viveiros de Castro (1977, 1979). The Yawalapíti live in the Upper Xingu area of central Brazil and speak an Arawak language. They show strong similarities in their mythology and cosmology to the Kalapalo, Kamaiurá, and Kuikúru. As Viveiros de Castro notes:

The demiurge Kwamuty²⁰ is designated, in myths, by the term *itsatí*, which also means "party," "ritual," and probably the ceremony of death. This ritual, the most important in Xingu society, is, as Agostinho (1974) showed, a reenactment of the primordial creation. Its core symbol is logs of primordial wood, truly doubles, *colossoi* of the dead (Vernant 1965). It is the privileged moment of the public presentation of the youth who just emerged from his or her puberty seclusion. Therefore it is a ritual that intertwines death and life; the girls who emerge from seclusion are like the first human women: mothers of men (because the exit from seclusion coincides ideally with the first marriage). (1979: 43; my translation)

The primordial condition of proximity, and lesser differentiation, between humans and animals is described in the Kuna myths as one that generated chaos, conflict, and predation. But it was in this condition that human life was generated. More precisely, as the myth of Ma-

kiryai tells, it was the death of the mother of the octuplets that triggered the chain of events that led to the creation of humanity and the emergence of the human condition as bound to birth and death. The death of Makiryai and the mourning for her by her children constituted the inauguration of human mortality but also coincided with the first human birth, that of Tat Ipe and his siblings.

We have seen how the myth of the marriage between Tat Ipe and Olopakintili informs and renders meaningful the *nele*'s association with animal entities during his initiation ceremony, in which Kuna people reenact the primordial alliance between humans and animals. As that first association had the strategic aim of defeating Piler's grandchildren, the animal-people, so the union between the *nele* and his animal companion ultimately aims to keep animals' malign agency under control.

Being able to observe and participate in the lives of *ponikana* means that the *nele* has the capacity to intervene when they leave their abodes to attack human beings. The *nele*, unable to rescue his mother from animal predation, associates with animal entities to protect his human kinspeople against further acts of predation. In the same way Tat Ipe avenged his mother's death. Like the Yawalapíti, where death and birth are at the core of their main ritual, among the Kuna the shamanic initiation ritual reenacts the primordial association between humans and animals. This association caused death and mortality, originating life as Kuna people experience it today.

Bringing together the elements analyzed in the previous two chapters, I wish now to draw some conclusions. Tobacco is at the core of the ritual initiation of *nelekana*. Tobacco smoke and the ashes produced are respectively the unfermented and fermented chicha, the former drunk by *nuchukana*, the latter offered to *ponikana*. The consumption of fermented chicha is therefore a common element in the *nele*'s initiation ritual and the girls' puberty ritual. Both rituals have to do with marriage. Puberty rituals constitute the proper moment for combining and celebrating marriages, at the same time proclaiming publicly the marriageability of the pubescent girl. The ritual initiation of *nelekana* aims at a marriage between the *nele* and an animal-woman.

Chicha and tobacco are the elements that facilitate both forms of union by easing relations that contain a potential threat. In the Kuna myth presented above, we are told that the marriage celebrated during the first chicha ceremony served to seal an alliance between culture heroes and animal enemies. Furthermore, a previous marriage had been arranged between Tat Ipe's sister, Olowai-ili, and Olourkunaliler, master of thunderstorms, in order to gain an alliance. These alli-

ances had the strategic scope of enabling Tat Ipe to transform Piler's grandchildren into animals, thereby ridding humans of their dangerous proximity. This act of transformation created the precondition for human social life on the earth—humans and animals acquiring different appearances and habits and living in separate domains. Going back a bit, we have also seen that the transformation of animals was the consequence of an act of predation, that against Makiryai, mother of the octuplet heroes. Going back a bit further, we have seen how the birth of the octuplets was the outcome of the death of their mother. Thus we have a chain of death, birth, marriages, and transformations, which seems to create the basic structure for understanding shamanism among Kuna people.

One last aspect remains yet to be understood. The Yawalapíti case is in fact illuminating for a further reason, besides the one listed above. Considering the Xinguano myth of the death of the mother of the twins, Sun and Moon (see chapter 6), it makes sense, as Viveiros de Castro states in the passage above quoting Vernant, that the wooden logs, core symbols of the ritual, are "truly doubles, colossoi of the dead." As the Kalapalo myth tells us, the mother of the twins and her sister were the first women. They had been made out of wood by their father, the creator Kwatingi, who did not want his "real daughters" to marry the jaguar. One of the two "made ones," the mother of the twins, was the first woman to die, while the other became the mother of all human beings, by giving birth to Indians, Fierce People, and white people (Basso 1987a). Reading the myth of the "made ones," it becomes clearer why in present-day Xinguano death rituals wooden logs stand as the core symbols of collective rituals, around which the idea of death as an unchangeable state revolves.

Even more illuminating is the Kamayurá myth, which narrates that the first mourning ritual was set up by the creator Mavutsinim (Villas Boas and Villas Boas 1970: 55–56). He wanted to bring back to life the dead people. Therefore he cut three wooden logs from the forest; he decorated them with "feathers, necklaces, cotton threads, and armlets of macaw feathers" (55) and then put them at the center of the village. While some people started singing to turn the logs into people, Mavutsinim told the others not to look at the logs. Slowly the days passed, and the wooden logs started to transform into real people. When the transformation was nearly complete, the creator called all the people to come and celebrate the dead coming back to life. But one man, who had not observed the taboo of avoiding sexual relations during the ceremony, ran among the crowd in the middle of the village. This caused

the three figures to turn back into wooden logs again. After scolding the man, Mavutsinim concluded, "All right. From now on, it will always be this way. The dead will never come back to life again when kuarups are made. From now on, it will only be a festival" (55).²¹

This myth describing the origin of the feast of the dead is closely related to the myth of Kwatingi presented in chapter 6, and, I argue, it is key to understanding what *nuchukana* are in the Kuna lived world. In both the Kalapalo and the Kamayurá myths human figures are made out of wood in order to protect or to restore people from death. Wooden statues, or logs, are thus "substitutes," "doubles," or "images," of real people.

As I have shown, humankind originates from an act of rupture, that is, the separation of the children from their mother because of her death. The condition of becoming human entails the loss of immortality and the need to be born through the separation from the mother. As I argued in the previous chapter with respect to the Kuna myth of the death of Makiryai, this separation is irreversible. This would explain why Kuna people say that a *nele* kills his mother. From this perspective we can look at the mortuary ritual of the Xingu as the representation of a loss, which at the same time enables a creation, a birth. They are the constant regeneration and celebration of human life.

What interests me now is what visual forms the representation of this loss acquires in the everyday life of Amerindians. The people attending the first mourning ritual in the Upper Xingu remained with three wooden logs. In this sense the Yawalapíti use wooden logs as the core symbol of their ritual. What is it that the Kuna remained with as a reminder of their ancestral loss and of their human condition? To answer this question, I will explore ethnographically the similarities in the Kuna and the Xinguano myths, by looking at the core symbol of Kuna ritual life: the *nuchu*. I turn now to the initial question of this work: what is a *nuchu*?

EIGHT

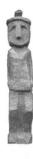

Sculptural Forms

n this chapter I want to gather together the threads unraveled so far. In the previous two chapters I compared Kuna and Xinguano myths; here I suggest that *nuchukana* are the instantiation of primordial beings in present-day Kuna life. As I have shown in the previous

chapter, the carving of wooden logs is linked to the mythological attempt to bring the dead back to life. Even though this is a worthless effort, as it is said in Xinguno myths, it is an operation that is carried out regularly in rituals. Following the example of Xinguano mortuary rituals (Agostinho 1974; Viveiros de Castro 1977), I will suggest looking at the social worthiness of carving a *nuchu*. Namely, Kuna people carve their *nuchukana* with the specific aim of seeking protection from evil beings and to heal ill persons.

Furthermore, considering the fact that *nuchukana* are anthropomorphic figures we have to consider them as Kuna people do, that is as the 'figure of a person,' *tule sopalet*. Moreover, their agency is intimately linked to their form. If so, what distinguishes them from a real person? Reflecting upon this question will eventually lead to a consideration of the two main attributes of the human person that have emerged in the course of this ethnography: *kurkin* and *purpa*. I will eventually suggest that we look at the ambivalence between the deindividualized and generic form of *nuchukana*, as opposed to the personality and individual qualities that human beings possess. It is thus their human form that gives *nuchukana* the possibility of momentarily acquiring subjectivity through relationships with human beings.

Generoso, followed by his assistant, quickly and silently enters the house where I have been speaking with Meliña for a while. She tells me about her seven-year-old niece, Nekartyli, who has been sick for a few days and is not recovering. Generoso's wife, who is a *nele*, saw her the day before and told the mother [Leobijilda, Meliña's younger sister] that the young girl was the victim of the theft of her soul by a jaguar.

Generoso carries his wooden staff, on top of which there is the carved figure of a person, much like the *nuchukana* that are gathered in a plastic tub underneath the hammock where Nekartyli is laying. Meliña tells me that Generoso had sent over his own *nuchukana* the day before, giving instructions to put them with the ones already in the house. She is keen to tell me that in her family they have many *nuchukana* because her father, Leopoldo, has made them. He has always been a skilled *nu-chu* carver, especially since he retired from his work in Panama City and was too old to work in the gardens.¹

Now their *nuchukana*, she goes on, are working with those of Generoso, to help Nekartyli.

Generoso, she explains, is an api sua, a ritual chanter, and his nuchu-kana are used to working with him. He sings to summon them. Therefore Generoso's nuchukana are now going to lead their nuchukana too, in order to cure Nekartyli.

Leobijilda comes in bringing a clay brazier containing hot embers, then she sits on the hammock beside her daughter and starts rocking it slowly to comfort and reassure the young girl. Meanwhile Generoso has taken a seat on a chair at the head of the hammock, underneath the rope that ties it to the house poles, while his helper sits beside him. Then he starts singing. His voice is loud and comes directly from the throat, with a stable and hoarse tone. He holds his staff in his right hand and every once in a while puts some cacao beans into the brazier.

His assistant smokes a pipe. Twice during the ritual Generoso stops singing. He lights up a pipe and smokes it silently with rapid puffs. During these moments his helper smokes a long cigar,² blowing the smoke four times onto Generoso's face and then onto Leobijilda's face. He repeats this operation four times.

At the end of the curing session, which has lasted for about an hour and a half, Generoso speaks to Leobijilda. He tells her that he cannot come back to sing the day after, because he has been called for an urgent case on another island, but he will leave his *nuchukana* to look after

Nekartyli while she recovers. Then he and his assistant leave the house, with the same silent and quick pace with which they came in.

This episode is an example of curing performed by Kuna ritual specialists that I observed during the last period of my fieldwork in Okopsukkun in fall 2004. The cause for Nekartyli's high fever had been imputed to a soul theft and therefore had been cured by calling a ritual chanter. Later I had the opportunity to speak with Generoso, and he explained that on that occasion he had sung the *kapur ikar*, the 'way of the Spanish Pepper.' Through this chant he had spoken to his *nuchukana*, telling them to travel to the fourth dimension underworld looking into the villages of animals, in order to find out where the *purpa* of the girl was being held prisoner. He told me that he knows where these villages are and thus guides his *nuchukana* as though he had a wireless remote control. He also told me that his *nuchukana* are already expert because they are used to working with him. He used to put his *nuchukana* together with the ones of the ill person so they act as elder brothers teaching the others how to bring back the abducted soul.

While he was singing to retrieve Nekartyli's soul he did not mention her name directly. Instead he referred to her as *inna ipekkwa*, 'owner of the chicha.' This expression is used in ritual chants to refer to the ill person, who is in fact the one who ideally offers tobacco smoke, unfermented chicha, to the *nuchukana* in her or his house. The owner of the chicha is the person who takes care of the *nuchukana* in daily life and emphasizes the attachment between family members and the *nuchukana* that are kept in their household.

When a person falls ill, she or he usually holds one *nuchu*, pressed to the chest, asking kindly for help and for revealing to the *nele* the causes of the illness. If one of the *nuchukana* is known to be more powerful and more loquacious, this is the one chosen to be held by the ill person. Then the *nuchu* is sent to a *nele*, who will keep it with his *nuchukana* for some days, waiting to meet and to speak with it in his dreams, where the *nuchu* will hopefully speak to the *nele*, revealing the causes of the illness of the owner of the chicha. Sometimes, I was told, the *nuchu* of the ill person does not speak directly to the *nele* but instead with his *nuchukana*, who will then relate it to the *nele*.

For this reason *nuchukana* are treated with respect and amity by members of Kuna families. They are nurtured by grandmothers, who blow tobacco smoke on them and wash them with water perfumed with sweet basil, and are called by grandfathers when it is time to eat.

As Meliña told me, it is a good thing for a family to have many *nuchu-kana*, for they protect the house from evil spirits and help kinspeople who fall ill.

LIFE OF A NUCHU

At the beginning of my fieldwork it seemed to me that *nuchukana* were forgotten, kept on the ground, sometimes in a corner of the house. I soon realized, however, that *nuchukana* stand in the middle of Kuna houses, and once I started asking people, I discovered that men and women were keen to speak about their *nuchukana*, telling interesting stories about a particular *nuchu* or a particular event linked to one *nuchu*. They seemed to be fully part of the group of coresidents.

Family members are thus the "owners of the chicha" for the nuchukana who live in their house. This sheds some light on the relationship between people and nuchukana. The former are the caretakers and providers of food, who look after their nuchukana as if they are friends or visitors who need a meal and a roof to sleep under. They wash their clothes and see that they are always in good company. As a Kuna friend once told me, nuchukana do not like to be alone; they like the company of other nuchukana. It is better therefore to have many of them grouped together in the house so they will be happy and will not look for a better place to live. I have never actually seen a nuchu alone in a house but rather boxes full of them, one close to the other and kept well tied together.⁵

By the same token, family members, and especially grandparents, refer to their *nuchukana* with an affectionate tone. As I described in chapter 3, the term *nuchu* entails a certain degree of intimacy, as when parents refer to their children. However, this does not hide the fact that people are aware of what *nuchukana* are: powerful beings. Therefore children are strictly prohibited from playing with them, and restrictions are applied when relating to them. Only grandmothers or young girls can wash *nuchukana*. I have never seen an adult woman or man performing such an activity.

A different type of relationship exists between a ritual specialist and his or her *nuchukana*. In this case the relationship is personal. Some specialists have their own *nuchukana* and may keep them separated from the others in the house. Others only have a special relationship with a

FIGURE 8.1: Mikita Smith posing with her nuchukana. Photo by Paolo Fortis.

specific nuchu among those kept within the house. In any case, the specialist, a nele or a ritual chanter, is called kana by his nuchukana. Kana means generally "master," and it is what a master is called by his disciples. Kuna people explained to me that the kana is the one who is able to advise nuchukana and ask them to help him to cure or diagnose illnesses. In the case of a ritual chanter, he is able to speak the language of nuchukana through ritual songs; in the case of a nele, he or she is able to see nuchukana and to speak with them in dreams.

A nele would normally directly take care of his own nuchukana and would also bathe himself with water perfumed with sweet basil in order to attract his personal nuchukana. As with Generoso, ritual chanters often bring their own nuchukana when they go to cure an ill person, and they stress that their relationship with their auxiliaries is very important in the performance of the cure. As with a nele, it is important to be close to his personal nuchukana, the ones that are met in dreams and accompany them in underworld travels. I was told that when a nele travels to other villages he always brings one of his nuchu with him for help and protection.

In addition to being personally linked to a specialist, *nuchukana* can be inherited from people who have died. This is the case with *nuchukana* that remain in the house when the person who originally carved, or had them carved, dies. I sometimes heard of *nuchukana* still being referred to as belonging to a deceased person, usually a grandfather. I never heard of *nuchukana* being buried with the dead. In other cases a *nuchu* may be brought by a married man to his wife's house and added to the *nuchukana* already present there.

When a *nuchu* starts to rot, or breaks, or is considered too old, it is simply disposed of. Some people told me that a ritual chanter is asked to sing to the *nuchu* in order to ask its *purpa* to leave and go into the underworld. Others told me that a *nele* is asked to ascertain if the *nuchu* is still alive. Still others told me that the *purpa* of the *nuchu* leaves on its own once the wood has started to rot. The wooden figure can then be thrown into the sea or kept as a doll for children.

IMAGES OF THE DEAD

To understand what a *nuchu* is for Kuna people, I will follow Viveiros de Castro's insight about the wooden logs of the Yawalapíti death ceremony, which he described as "truly doubles of the dead." Elsewhere he described the curing process as follows: "This [soul's] theft is expe-

rienced by the sick person as a particularly intense dream travel (every dream or bout of fever is a soul traveling); it ends when the shaman retrieves the soul with the help of a doll *spirit catcher* (*yakulátsha*; cf. *yakulá*, 'shadow,' 'soul of the dead') thought of as the image of the sick person" (Viveiros de Castro 1978: 35–66; my translation, italics in original).6

I suggest that it is useful to consider the connection between "double of the dead" and "soul of the dead" in order to understand what a nuchu is for Kuna people. The connection between what Kuna people conceive of as 'figure,' sopalet (the external form of a nuchu) and 'soul,' 'image,' purpa (the internal form of a nuchu as well as of humans and animals), should be explored. Despite the difference between the two concepts, I would like to call attention to the relationship that holds between them. Namely, if one of the meanings of purpa is the image of a person, I argue that a nuchu is the "instantiated image," the figure of the soul that it hosts.7 As we have seen so far the wooden shape of nuchukana is key to mediating the relationship between the primordial souls that inhabit them and living human beings during healing processes and in the dreams of nelekana. To put it another way, to carve a nuchu is to create the precondition of this relationship, fixing temporarily a primordial soul into a specific internal image by means of carving an external figure. I suggest therefore that the meaning of carving a nuchu resides primarily in its key role of mediating between human beings and primordial souls.

As Taylor (1993) has demonstrated for the Achuar, the souls of the dead are floating images devoid of the memory that the living previously attributed to them. By being detached from human sociality, through the active process of living people who forget them, the dead become part of the group of ancestral souls. From this new position the souls of the dead become empowering visions, arutam, for the living, giving them moral authority and strength (661). Following Taylor's interpretation, I argue that a nuchu is a primordial soul, which is sought after by the nele, who seeks its vision to acquire powerful knowledge and to help in the process of curing. Moreover, nuchukana are instantiated images of primordial beings, with the special characteristic that they are the visual representation of a person devoid of any personal trait, apart from the gender, as I describe below. They are generic images of a person.

Two issues are strikingly similar between the Kuna and the Yawalapíti case, as well as those of the Kamayurá, Kuikúru, and Kalapalo.

First, the first people to live on earth in Xinguano mythologies were trees, or people made of wood (Basso 1987a; Villas Boas and Villas Boas 1970; Viveiros de Castro 1977, 1979). Furthermore, as illustrated by the Yawalapíti case, the creator made primordial human beings by carving wooden logs and blowing tobacco on them to give them life. Thus he created the mother of the twins, Sun and Moon (Viveiros de Castro 1979: 42-43). Kuna mythology portrays the first people as treepeople, the young men of the Father. They were eight boys sent by Pap Tummat to the earth to observe the creation of the world and of all living beings. When the task of learning was completed, the boys were transformed into trees and moved to Sappipe neka, where they now live as the owners of trees. Today it is from there that they descend to the earth during the night to visit female trees, to whom they make love. This is what makes female trees in the forest shine with dew in the morning and beautiful with their green foliage. This also enables trees to have children, who are brought to life by Kuna elder men in the form of nuchukana.

The act of elder Kuna men who carve nuchukana begins with the cutting of a branch or a root from a selected tree following a precise process that is explained as a birth. I suggested that the process of making a nuchu has to be interpreted as the fertile act of elder men. I would like to add now that this process might also be regarded as an act of extraction of a baby nuchu from the mother-tree. In this sense, pushing my interpretation a bit further, elder Kuna men may be seen as the male equivalent of midwives. They both help and participate in a process of birth. The former bring to life primordial beings, the latter new human beings. The social position of elder men and women seems to be the human equivalent of the supernatural figures of the owner of trees and of celestial Muukana. Both live in Sappipe neka, where the former are responsible for the reproduction of trees and the latter of human beings and animals. Furthermore, elder men are responsible for carving nuchukana, which have been generated through the perennial fertility of the owner of trees and their female earthly companions. Elder women are responsible for checking the amniotic designs, which have been drawn by the celestial Muukana. Aging Kuna men and women thus become able to master the principles of life and death. Images and designs work as synthetic visual categories of the opposing forces of life and death through which human life is made possible.

What an elder Kuna man does is precisely bring primordial beings back to life. An elder man, cutting the branch of a tree from the forest and carving it in a human shape, resembles the creator Mavutsinim, who decorated the wooden logs with feathers, necklaces, and armlets with the aim of turning them into living people. Or Kwatingi, who carved his daughters out of wood.8 Once a nuchu is carved into a human shape, the carver drills the holes for the eyes and puts glass beads in them. Then he decorates the cheeks with annatto dye (Bixa orellana). Eventually, in the case of a male nuchu, he puts a necklace on it to make it look like a medicine man. Once the outer form is completed, the nuchu is sung upon by a ritual chanter, who revives it. I argue that his act is guided by the same logic that informed the singing of the maracá-êps singers of the Xinguno myth, who sang to revive the dead people, and of Tat Ipe, who sang to revive his mother. But as both myths tell us, dead people do not come back.

Comparing the ritual use of wooden logs in the Upper Xingu and that of *nuchukana* in Kuna healing rituals, I wish to show how the latter might be regarded profitably as images of primordial people. As a matter of fact, *nuchukana* represent the first people who lived on the earth and who transformed into trees before Kuna people appeared. For this reason we can say that *nuchukana* are the instantiation of primordial entities in the present-day Kuna lived world. Following this, I will further argue that *nuchukana* are images of a person.

To understand this point I need to introduce the Kuna conception of the afterlife. As I was told, men and women after death do not live with their kinspeople. Each one will live in a house with her husband or his wife. They will not have children anymore. On the patio of their house there will be plenty of animals and plants, so that they will not have to garden or hunt anymore. Furthermore, and this is important to my analysis here, their bodies will lose any personal distinctiveness. Any distinctive personal trait that each of them had in life will be erased. The man and the woman will look like each other; the only difference maintained is that of their gender. Despite looking almost the same, the man and the woman will keep their respective sexual attributes. This will allow them to still enjoy the pleasure of sex, although a sterile one (cf. Carneiro da Cunha 1981).

The image of a couple of generic persons, living a sterile afterlife, powerfully recalls that of a couple of *nuchukana*: generic images of gendered persons, devoid of any distinctive visual trait. The way in which *nuchukana* are carved aims therefore to create images of persons devoid of their singularity, in the same way that Kuna people imagine the dead. This also corresponds to the way in which the ceremonial

wooden logs of the mortuary ritual of the Upper Xingu are created. Although there are variants in which different groups living in this area carry out this operation, they all follow the same basic procedure in representing the dead. A section of a tree trunk, more than a meter high, is cut, and then a band in its middle, from where the bark has been previously detached, is decorated with the same motifs used in body paintings. The upper part is decorated with feathers, and cotton belts are bound over and under the painted section around the log. As Basso noted, "The designs painted on them indicate whether the person represented was a man or a woman, but otherwise all are identically decorated with yellow feather headdresses and cotton belts" (1973: 142; see also 1985: 139).

Another aspect of the preparation of these posts caught my attention. Although Agostinho (1974: 90-91) could not find gender-specific decoration of the *kwaríp* among the Kamayurá, he was told that each specific post corresponds to a specific deceased person. Furthermore, "with the same white colour they do the small triangular face of the *kwaríp*, whose eyes and mouth are represented by small black circles: because the face is painted on the east side of the trunk, at this height it is oriented to look at the rising [sun], like the dead in their graves" (91).

Kuna people say that after death each man will again encounter all the animals he has hunted during his life—a powerful metaphor for the idea that all that is different during life becomes equal after death. Many times during the night meetings in the gathering house I heard saylakana singing long and detailed descriptions of life after death. This subject was often listened to with curiosity and sometimes even generated laughter among young men, especially when people, as my friend Juan Mendoza once did, verbalized what translated in Spanish sounded like "cada uno hará su zoologico in paraiso," "everyone will have their own zoo in paradise."

IMAGE OF A PERSON

To understand what it means to Kuna people to make a *nuchu* we need to reflect on the impossibility of bringing human bodies back to life, as theorized by the set of myths previously analyzed and compared in chapters 6 and 7. The importance of the visual form of bodies is stretched to the point that Kuna people are aware that they need an image of the human body in order to establish contact with primordial entities. What a *nuchu* has, instead of an actual body, is an image

of a body, which, although it lacks mobility, a basic attribute of human bodies, is endowed with subjectivity. *Nuchukana* have a wooden substitute for the human body, which is going to rot after a certain amount of time, as is the case for people after death. They are therefore an image of a person, where their external visual form is the reverse of the visual form of dead people, that is, a generic individuality. Having a generic external form, they act as the instantiation of internal forms, souls. Unlike actual bodies they are devoid of personal distinctive traits, which otherwise would contradict the fundamental axiom of the differentiation between the living and the dead and the irreversibility of the mortal condition.

What an elder Kuna man is doing by carving a nuchu is building a house for primordial entities, as Hector Garcia explained to me at the onset of my fieldwork (see introduction). Creating the image of a body is thus the prerequisite for calling primordial entities to reside among the living. In this way Kuna wood-carvers create the conditions for mediating between living human beings and immortal entities. Though immortal beings cannot have a human body, just as the dead cannot be revived, the emphasis is nonetheless put on the temporality of the life of nuchukana. They are made of wood, which sooner or later is going to rot, and their existence is linked to the span of human life. Each nuchu tends to be associated with a specific human owner, either the carver or the eldest man in the house, after whose death it begins losing significance for the family members and is eventually substituted by newer nuchukana attached to living people.

If we consider that the chief of all *nuchukana* and of the trees in the forest is the balsa tree, we can see how emphasis is put on the temporality of the life of a *nuchu*. It is balsa wood that rots most quickly. As Kuna people told me, when a *nuchu* rots or breaks it means that it is going to die soon. It was explained to me that the wooden statue is like the *mola*, or clothing, of the *nuchu*. For this reason each *nuchu* must be cleaned often with water perfumed with sweet basil. Its clothes are cleaned to prevent decay from dust, sand, and sea salt. Balsa wood is very soft and light, and *nuchukana* made of it do not last long. Nonetheless, *nuchukana* of balsa wood are considered the most powerful and are used in all Kuna rituals, in particular in the collective village-wide healing ceremony.

Often balsa wood figures are carved specifically for the celebration of a ritual, as in the case of the *nele*'s initiation. Once the ritual finishes they are disposed of or kept as dolls for children.¹⁰ It seems as if their

shorter life is connected to their greater ritual power. It is as if the impossibility of having an actual body is substituted by emphasizing the shortness of their substitute bodies' life, thus recalling the temporariness of human life.

In lacking a human body a *nuchu* is just the image of a person. Kuna people refer to many forms of figuration with the word *sopalet*. The shape of a canoe is 'its image,' *e sopalet*. To weave baskets is *sopet*, 'to give shape,' 'to create the form.' Carving a *nuchu* is one of the highest forms of figuration, second only to creating actual bodies, *koe sopet*, 'making babies.'

What do these different forms of figuration have in common? On the one hand, canoes, nuchukana, and baskets are containers. Canoes contain food and people, nuchukana contain purpakana, and baskets contain food. On the other hand, photographic images are like shadows, dreamed images, and are considered closer than any other figurative form to the purpa that is portrayed. They contain (or are) the purpa of a person. "To take a picture with a camera" is said potto kaet, or in some cases wakar kaet, 'to catch the face.' Kaet means "to take," "to catch," "to get" something. To go fishing with a net is ua kaet; to be imprisoned is kalesa; when someone's soul is stolen by an evil entity it is purpa kalesa. The action implied by the verb kaet is not a metaphor of a concrete action, as we would intend it in the case of taking a picture of someone. Elder Kuna people are still fearful of their pictures being taken by tourists because their purpa is taken away, and they are particularly worried when they cannot see the photos that are printed afterward.

Even if today familiarity with cameras has increased, I dare say that the meaning has not changed. Taking a picture is still taking one's purpa. What has changed perhaps is the attitude toward photography. When we started using our camera, Kuna friends were always very keen that Margherita and I took pictures of them, and they always wanted us to bring back the prints from Panama City for them. During the first months of fieldwork we printed the photos that we thought were beautiful, portraying, for example, a close-up of a woman sewing her mola. That photo, to our surprise, would be regarded by the woman portrayed in it with disappointment and slight embarrassment. It was not what she expected. Luckily we used a digital camera, so we started to show people the images right after they had been taken, and we could thereby improve our photographic skills up to Kuna standards. Whenever I took a head and torso shot of the person, I was asked to take an-

other one portraying the whole figure, from the feet to the head. The second shot was always received with more satisfaction. In this way we learned to portray the whole image of persons.

Considering the meaning of purpa, 'immaterial double,' 'image,' and 'sexual fluid,' I want to explore further the relationship between nuchu and purpa, between sopalet and purpa, or, to put it in another way, between figure and image. I suggest that to understand what a nuchu is, we must understand what purpa is, and vice versa. Namely, I argue that if we agree on the definition that a nuchu is the image of a person, we should acknowledge its metonymic relationship to purpa. This leads us to explore another issue: if purpa is the inner image of a person, what is its relationship with what it is an image of? Or to put it in another way, what is the relationship between the inner form and the visual appearance of a person? To explore this issue we shall look again at what Kuna people intend for design. I also suggest looking at design as the "emphasis on surface appearance," so relevant for many Amazonian peoples (cf. Gow 1989). The relationship between designs and images can be profitably explored within the framework of Kuna ideas of what it is to be human.

DESIGN

As I argued in chapter 4, the meaning of kurkin must be located in the complex pattern of relationships that link human beings and animal entities. Central to the concept of kurkin is its designed nature. Muukana 'draw design,' narmakket, on kurkin when the fetus is 'being shaped,' soplesi, within the mother's womb. Kurkin is thus the support of each person's "first design" (Gow 2001: 112), which is visible to midwives at the birth of the baby and later during a person's life by nele.

In the case of a *nele*, the invisibility of his design at birth culminates, as I have shown in the course of this work, with his capacity to see the 'real image,' *purpa*, of animals and trees, as well as of human beings. His capacity to see, and by the same token to be seen, goes beyond the limits of normal human life. By being unrestrained by a human perspective only, he is able to acquire multiple perspectives and to see the changing forms of unstable images in the cosmos. The design on a newborn's *kurkin* makes manifest the relationship between the small baby and the animal entity with which it is associated. This association is then severed through the baby's inclusion within kinship ties and manipulated

through the use of plant medicines. The relationship between the baby and the animal is thus substituted by the relationship between the baby and its kinspeople.

Therefore, what remains is the "good side" of design, the sign of an interspecies association rendered safe through inclusion in human social life. *Kurkin* designs thus become a human attribute; they are turned into human designs. Design, as the sign of alterity, transforms into potential human praxis, although it retains the ambivalence of showing the intimate relationship with an animal, immanent to each human being.¹¹

Here I want to explore further the definition of kurkin and the relevance of its design. As I have shown before, kurkin stands for praxis still to be developed, that is, potentialities. This issue may be analyzed further in two ways: one is that linked to the idea of destiny as something predetermined in the life of a person, familiar to Western cosmologies (cf. Gow and Margiotti n.d.); the other is that of the individualization of a person, familiar, I suggest, to Kuna ontology. My argument is grounded in the idea that Kuna people, as well as other Amerindians, conceive of the individual as a collective person. This point has been made by Amazonian scholars, who showed that the indigenous idea of humanity is "intrinsically multiple" and that people form "communities of similars" (Overing 1999; Gow 2000). Furthermore, the image of oneself "is based on the attribution of others' images of it" (Taylor 1996: 206). In this sense the idea of individual destiny is viewed by Kuna people only as the outcome of a series of relationships through which the person is formed. I suggest that the designed kurkin stands right at the beginning of this series of relationships, involving human and nonhuman entities that cause the emergence of personality and individual distinctiveness.

Each person is in fact born with potential capacities inscribed on the *kurkin*. Praxis will develop in the course of a person's life, increasing innate tendencies with the use of medicines as shown by a child in particular kinds of culturally determined activities, like sewing *molakana* for girls and making canoes for boys. A person often comes to be associated with a particular skill by others, and this becomes embedded in his or her personality. For example, a man whose expertise in making dugout canoes is called *ur sopeti*, 'canoe maker,' by his friends, in the same way that a botanical specialist is called *ina tuleti*, 'medicine man.' A person may also be called by various names during his or her life course. For example, many men decide to change their Spanish name

when they become old or when they learn ritual knowledge, in order to stress the change in their status.

The reflection of one's skills or ritual status in names points to the relational nature of one's self. It is when other people call one person *ina tuleti* that he becomes a medicine man; otherwise, if this is not publicly recognised, he will not change his own status.¹² Even if he decides to change his name, it is only when other people start calling him by his new name that it will be actively associated with his person.

As Garibaldo del Vasto once told me, one's name changes during life because one is not always the same. A person is thus conceived of as an identity in process associated with the development of particular praxis. This is reflected in the use of prefixes in Kuna ritual language. Four different prefixes are repeated each time by ritual specialists to invoke supernatural entities. The prefixes olo-, mani-, ikwa-, and ina- are used in front of each entity's name when the ritual specialist refers to it during the singing. This may refer to the powerful nature of ancestral entities; four names indicate that they have completed all the stages of enhancement of the self. As described in chapter 2, the eight young men of the Father looked toward the four directions and saw the whole world being created. This also symbolizes the full (ideal) trajectory of a nele, who should undergo four times the initiation ceremony to become a real nele.

Therefore *kurkin* is associated with the development of individual praxis and personal identity. It is a relational category through which to look at each person's development of its own particular way of acting within the world. Conceiving of themselves as intrinsically similar to one another, Kuna people have a theory of the social that is based upon the development of personal capacities, which I argued are intimately linked to their idea of design. Design, for the Kuna, has thus to do with the possibility to see and to be seen in one's own personal, human, transformative state.

PEOPLE AND NUCHUKANA

The outside surface of the body is the place where one's design is. To see one's design at birth will enhance the development of praxis and personality through the life course of a person. During growth the design becomes interiorized and is transformed into individual praxis, which is how the Kuna conceive the 'brain,' 'intelligence,' kurkin, through which a person is able to learn, to see, and to listen: in

other words, to communicate. The inside of the body is instead what contains one's *purpa*, that is, one's image, the self on which personality is inscribed and which develops during life through the images that other people project onto oneself. In other words, *purpa* is intersubjectivity insofar as *kurkin* mediates between different subjects, human and nonhuman alike.

If, on the one hand, the image of a living person is composed of all such attributes and personal capacities and is the locus of other people's projected love and memory, then, on the other hand, the image of the dead person is devoid of all such personal traits. As Taylor (1993) has vividly argued, the Achuar dead are actively forgotten by their living kinspeople so they become part of the group of ancestral souls that provide living people with the possibility of reproducing their social life. With this in mind, I have suggested that nuchukana are images of primordial beings. Similar to the Achuar dead, Kuna immortal tree entities are devoid of personality and are conceived of as generic beings, until they become alive as individual nuchukana. Furthermore, they are "ideal dead," for they are primordial beings that had never lived with Kuna people, as animals instead did in ancient times. As the myth of the young men of the Father explains, they are primordial beings sent to the earth during creation time. Once that was completed Pap Tummat transformed them into powerful beings and sent them to live in villages separated from those of humans and animals.

Moreover, nuchukana are distant others and radically different from living Kuna people, for they do not have kinship. Kuna people told me that nuchukana may live in couples, but they never mentioned their families. They live in heterogeneous ensembles that may act together when guided by human specialists toward the end of fighting evil entities. They live a sterile life and cannot have children, like Kuna people in the afterlife. Perhaps we can say that nuchukana are themselves children, in a perennial state of being born and of self-replication. They are similar to themselves but at the same time others to themselves, as they do not establish kinship relations. Moreover, they are born only through the intervention of human beings. In this sense a nuchu is radically different from a ghost, who retains part of its personality as a living being and is still attached to its living kinspeople. It is by losing its individuality that the ghost of a dead person will slowly fade away, detaching from human sociality and becoming part of the generic ensemble of the souls of the dead. Only deindividualized, generic persons live in heaven.

A nuchu becomes a person by being individualized through the act of carving and ritual summoning. It becomes a nele by canalizing its ancestral powers through a relationship with individual human beings. Seen from the other perspective, human beings can access ancestral powers only by bringing nuchukana to life as individual persons. As in the case of the Xinguano mortuary ritual, the dead are brought back to life for a limited time, enabling the living to mourn their dead chiefs. Through reenacting the mythic birth of the first women carved in wood by the creator, Xinguano ritual aims to bring dead kinspeople back to life. Through reenacting human birth, and using it as a metaphor, Kuna people aim to bring primordial beings back to life. Kuna carvers are like the Xinguano demiurge: they carve people out of wood.

Only when a *nuchu* has been carved does its *purpa* acquire an individual form, which can be seen by a *nele*. Although the wooden figure of *nuchukana* is only a deindividualized, generic image of a *person*, the image of a *nuchu* that is seen in dreams is that of a specific person. *Nelekana* describe in fact their personal *nuchukana* and any *nuchu* that they see in dreams as men or women with specific bodily features, a specific personality, and a personal name.

In addition to retaining the qualities of the tree species from which it is carved, each nuchu develops its own personal character. For this reason Kuna people often refer to one of their nuchukana as the one that they rely on most, as Beatriz Alba told me (see chapter 3). But one last thing must be noted: nuchukana develop their personal traits only through their relationships with human beings. They receive loquacity from the carver, they become expert curers through their association with a chanter, and they become reliable diagnosticians by talking with a nele. Moreover, it is by being in a relation with family members that they learn to be somewhat sociable. People in the household take care of their nuchukana. They are remembered, nurtured, and perfumed. Thus they become part of the group of human kinspeople, who they will protect and help in return. Nevertheless, they remain powerful beings, devoid of kinship, who must be treated with respect by Kuna people and whose revenge in case of negligence and mistreatment must be feared.

One day I was speaking with Leopoldo on the patio of his house, between the kitchen and the dormitory, while he was carving a *nuchu*. At a certain point he stopped carving, took the *nuchu* with one hand, and told me, "When there is plenty of food in the kitchen, when people are eating, you may hear someone calling, 'Come eat, come drink.'

So you think, 'Who is hungry? Who is he calling? Everyone is eating here!" Then, holding the *nuchu* close to his chest, Leopoldo went on: "I'm the one who looks after you. I'm going to give you food and drink. Although I cannot see you, you are going to protect me. Evil people and demons will not come to me. You will remember me and I will take care of you."

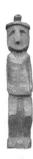

Conclusion

his book is the outcome of a series of reflections that originated from a conversation with Héctor Garcia in May 2003. More broadly, this book has been concerned with exploring the visual categories that inform and organize the way Kuna people perceive their

world. By exploring visual practices in the directions that Kuna people themselves pointed out to me, I individuated three categories, "image," "design," and "body," which, I argue, structure the everyday visual experience of Kuna people. In particular images, which carved statues are an instantiation of, are seen as an important category of Kuna and more generally Amerindian visual art, which has nonetheless received scant attention in the ethnography of Central and South American indigenous people. Treating Kuna art as an experiential category that informs the perception of the world that Kuna people come to acquire throughout their lives has led me to explore Kuna ontology and cosmology in the course of this work.¹

Kuna people do not utilize such a conceptual category as art. I have used this category to address a Western audience, which is used to associating the idea of art with that sphere of experience pertaining to the visual perception of purposefully made objects, such as paintings and statues. I use the term art conscious of the risks this entails but also confident that the reader has understood that my aim is to provide an analysis of Kuna categories as Kuna people explained them to me and whose practical realization I observed rather than to force them into Western categories. One reason for talking of art is that we can establish comparisons and see that the link between experience, ideas, and material life in human lived worlds produces wonderfully vari-

able products. It is therefore by exploring this link, which makes objects meaningful to the people who produce them, that I have explored Kuna visual art with the aim of making it meaningful to us as well.

A SYSTEM OF OPPOSITIONS

Underpinning the experiential dimension of Kuna art, instantiated mainly in the production of designed blouses, *molakana*, and carved wooden statues, *nuchukana*, is a relational schema in which designs and images stand as oppositional categories. Images and designs are linked to a third category, that of the body, which gives dynamism to the whole of the Kuna visual system. To outline this relational schema, or system of oppositions, it is worth recalling some of its features, to show how they point at the opposition between visible and invisible in the domain of Kuna everyday visual experience.

Molakana decorated with designs are the quintessential manifestation of the visual appearance of Kuna women. A woman walking down the path, wearing her new mola, with her forearms and calves wrapped in beadwork and wearing her headscarf, is commented on by men as 'beautiful,' yer tayleke. Kuna men often proudly stress the beauty of women who wear their full attire, which is a complex combination of colors and designs and which is the quintessential manifestation of visual beauty in the Kuna lived world. They literally cannot pass unnoticed.

Similarly, newborns catch the eyes of midwives when their bodies are covered in designs. Their visual appearance becomes noticeable due to the geometric patterns showing on the remains of the amniotic sac adhering to the head of the baby. Designs are key to the way bodies are perceived and viewed in the Kuna lived world. Designs cover the external appearance of bodies and enhance their visual appearance. The more a body is visible, that is, the more it is made visually available through designs, the more it is beautiful. The more it is beautiful, the more it is healthy and fertile (Overing 1989; Gow 1999, 2001).

It is worth suggesting that designs are virtually infinite. This is demonstrated by the continuous innovation of Kuna women, who create new designs tirelessly, by means of copying them from magazines, from the *mola* of other women, adding small variations, changing colors, choosing new subjects. In this way Kuna women constantly create new designs. Novel designs are created through variations from the original, which means that most often Kuna women create their own design by slightly altering the design made by another woman. Inter-

estingly, I have never observed a Kuna woman directly portraying an object in one of her *molakana*.

Although many mola designs are, as defined in the West, figurative, I argue that making a mola is not a figurative process. A design is made by using already existing designs as a source. The attention of Kuna women seems less attracted by the subject of the designs that they copy than by their visual appeal, that is, their intrinsic quality to be transposed into mola designs. Although the criteria for the choice of designs are still obscure to me, I wish to point out that the creation of designs defies the Western distinction between geometric or abstract on the one hand and figurative on the other.2 Kuna women reproduce already existing designs that they observe in the world around them. These can be the designs covering the foliage of particular trees, those drawn on the sand by walking shell crabs, as well as those covering the bodies of other women in the form of already made molakana or those visible in newspapers, magazines, or children's textbooks. Designs are already present in the world; they are not created ex novo by women. What women do is see designs and make them into their molakana, through their sketching, cutting, and reverse-appliqué sewing technique.

The independent nature of designs that preexists human creativity is further evidenced in the myth of the origin of designs. Kuna people explain the origin of designs through the personal journey of Nakekiryai, a woman who traveled to the underworld village of Kalu Tukpis, where she observed all types of designs covering tree trunks and leaves. When she returned to her village she taught other women how to make such designs (Méndez, in Wakua, Green, and Peláez 1996: 39–43). Designs for the Kuna already existed in the world prior to human beings and were discovered, not invented, by them.

The propagation of an incredible variety of designs is opposed to the standardization that characterizes Kuna wooden figures. Different from designs, sculptural forms are remarkably uniform. They are similar to each other and striking in their lack of visual clues that define their personal identity. Kuna carvers, unlike seamstresses, are oblivious to innovation and variation. While Kuna women make it a point of pride always to change slightly their own design from the source from which they copy it, Kuna carvers create figures that are remarkably similar to each other, putting little effort into individual details.

Kuna wooden statues, in contrast to design-covered bodies and design-covered blouses, are not the object of the visual scrutiny of people. They pass almost unnoticed in Kuna everyday life. *Nuchukana* usually stand in the darkest spot of the house, at the foot of one of the

two main poles, far from the light filtering in from the outside. They are rarely moved, and when need arises, for curing purposes, they are wrapped in a piece of fabric and carried to the house of the ill person or the nele. There they are kept out of sight. In contrast to mola designs, which are made to enhance the visual beauty of women, nuchukana point to the realm of the invisible. They are literally 'not to be seen,' akku tayleke, in daily life by people. When they appear in dreams to normal people, or young untrained nelekana, they are monstrous and unbearable visions. Their aspect is defined as ugly and visually repulsive. A nuchu becomes visible to a nele only after a long period of training and repeated sessions of medicinal baths to improve his capacity to see.

I wish to suggest that besides that between visibility and invisibility, another opposition characterizes the difference between designs and images. Designs were not created but learned by Kuna women, whereas images were created during mythic times. Archetypical images originated in an act of transformation carried out by Pap Tummat, the creator god, who in conjunction with Nan Tummat created the world and its inhabitants. As Garibaldo del Vasto explained to me through the telling of the myth of the young men of the Father (see chapter 2), the carving of nuchukana has its origin in the archetypical act of transformation carried out by Pap Tummat, who made the eight boys into powerful knowledgeable beings and named each one of them, thus making them people. I demonstrated in the course of this work that Kuna carvers replicate the original transformative act of Pap Tummat by giving shape to their nuchukana, who come to acquire a personal identity and a personal name, leaving their generic state of spirits. Carving wooden statues is thus conceived of by contemporary Kuna people as an act of giving shape that entails a process of transformation and individualization similar to the process by which Pap Tummat created the first people.

A nuchu is a person insofar as his or her personhood emerges through the relationship with a human being—first with the carver, who produces its external visible form, then with the nele, who is able to see its internal invisible form. By the same token, once entered in their ligneous form, nuchukana become able to see human beings. They are seen and able to see at the same time. They become persons. The relationship between human beings and nuchukana can only be established when the generic soul of a primordial being comes to acquire an individual form.

In sum, a nuchu becomes a person by undergoing a man-made pro-

cess of individualization. This process constitutes the reverse of that through which human beings come into being. The source of the individuality of a *nuchu* lies in its internal form, visible only to *nelekana* in dreams, instead of in its external visual appearance, visible to everybody and remarkably similar from one figure to another.

Images and designs stand thus in opposition to each other and emerge as independent categories, which, I argue, could be used to further explore Amerindian visual systems more generally. Not only do they instantiate opposite principles, but they also constitute the elementary structures of the Kuna visual system. Similar to what Lévi-Strauss (1972 [1958]) suggested in his reading of Caduveo ethnography and to what Gow (1989) and Lagrou (2007) have demonstrated to be true respectively for the Piro and the Cashinahua, Kuna people conceptualize images and designs as the basic elements around which they organize their visual experience and their aesthetic production. Images and designs are separate but linked categories, and their relationship is constantly perceived and effected by Kuna people in the daily experience of their lived world. Therefore, if we look at Kuna ethnography in the light of what the above authors have noted for people living across such distant geographic areas, we might suggest that the opposition between images and designs is a widespread phenomenon among Lowland Central and South American people and that it forms the scaffolding of their aesthetic epistemologies.4

However, in order to render the opposition between images and designs meaningful in Kuna everyday life, I argue that a third element needs to be considered. This is the body. The body provides the synthesis through which image and design can coexist without pushing each other apart. Through the body Kuna people can think of images and designs as part of their everyday experience. Through the processes of birth, creating new bodies, becoming ill, curing illnesses and dying, the opposition between images and designs becomes meaningful for Kuna people. The body is the only place where these aesthetic categories find their synthesis and by the same token become meaningful to people. We can even say that Kuna people do not conceive of images and designs other than in their relation to human bodies.

I argue that we are therefore dealing with a system of oppositions, whereby the body constitutes the third element of a false dualism.⁵ As Taylor and Viveiros de Castro (2006: 150) noted, "the work of art that really matters for Amazonians is the human body." The body, for Kuna people, is the synthetic catalyst that provides the common ground for

the otherwise opposing and distancing forces of images and designs. Nonetheless, it is only by acknowledging the opposition between the latter and their status as independent categories that we can proceed toward a definition of Kuna visual art.

THE INTROVERTED PERSON

Recent discussions in the Amazonian literature bear witness to the link between designs, personhood, and the body (Gow 1999; Taylor 2003; Lagrou 2007; Fortis 2010). Amniotic designs, the paradigmatic case of Kuna designs, help to elucidate further the complex role of designs in relating the human person to spirits and animals. In chapter 4, I showed how the visual appearance of babies born with amniotic residues on the head indicates the nature of their relationship with animal entities, whereas the external visual appearance of the body of nelekana is devoid of designs at birth. This is the precondition for their capacity to see beyond the boundary of bodies and to interact with the image of spirits and nuchukana. I would therefore suggest a parallel between the standardized visual appearance of carved nuchukana and the lack of amniotic designs on the bodies of newborn nelekana. Both lack an individualized external appearance, which is compensated by their intensified capacity to see beyond the limits of normal human visual experience. This adds another dimension to the system of oppositions, whereby images and designs are coterminous with internal and external appearances. When internal images cannot be abducted by external appearances enhanced by designs, normal human visual experience is substituted by the visual praxis of seers. The crudeness of the visual appearance of Kuna wooden statues is opposed by their aliveness and internal beauty.

Alfred Gell (1998: 143–153) explored the worship of images in three different Asian societies. Gell's argument revolves around the idea that images are considered alive when people think of them as endowed with interiority, or mind, as he puts it. People worship images because they know they are alive. Their aliveness depends on a perceived tension between the inside and the outside of the image—either a statue or a painted image. Gell illustrates this point by describing different cases in which the statue of the idol contains smaller figures in its hollow interior, giving a physical sense of interiority. In brief, what Gell defines as the "internalist theory of agency" would explain why people who worship images consider their idols persons.

In the case of nuchukana I suggest that they are already "internal

forms." They come from the inside of a tree. Kuna people carve the interior of a tree, its core, into a figure of a person. The bark, the tree's skin, is normally used for preparing medicines. Figures that come from the inside of a tree, *nuchukana* become figures that contain soul images. From being undifferentiated and contained, they become the containers of new discrete subjectivities. Another Amerindian example is illustrative of the same inside/outside inversion. This is the case of the *mariwin*, or ancestor, masks worn by the Matis of western Amazonia, which are "thought to possess a true set of teeth deep inside their head (*ukëmuruk*), located on what could be called their underface" (Erikson 2007: 225).

Another inversion is at work in the case of Kuna wooden figures. As I noted above, the real image of a nuchu is that which is seen in dreams and which resides inside its wooden form. As Héctor Garcia told me, the nuchu is a house for the souls of trees. The inside of a nuchu is what counts in the visual encounter with a nele: it is therefore its true visual appearance. The outside of a nuchu does not convey any visual information about the real image and is therefore conversely its invisibility. When Kuna people say that they have seen a nuchu, they are referring to their dreamed experience. This is the inverse of everyday visual experiences that focus on the external visual appearance of bodies and objects (cf. Ewart 2008). As I showed in chapter 4, visual relationships between people are based on sharing the same perspective, that is, possessing the same type of bodily capacities that enable human beings to see each other as people (see Viveiros de Castro 1998). Human beings see each other as similar because they came to share the same body through the process of externalization of internal relationships with animals and spirits. To explain, each person is ideally the result of transforming amniotic designs into human praxis, through substituting a relationship with an animal entity with intersubjective relationships with human kinspeople. Nelekana, whose internal relationships with animal entities did not become visible at birth, are able to see the "other side" of human beings, their design, which makes their relationship with an animal entity visible and which is therefore the manifestation of each human being's mortal condition.

To see the real image of a *nuchu* a *nele* must be seen by it. Their visual relationship is based on an inverted relation between inside and outside of the body. The bodily appearance of *nelekana* and *nuchukana* is generic from the perspective of normal human beings—that is, non-nelekana—and it literally makes the former 'invisible,' akku tayleke, to the latter. Normal people cannot see the internal images of *nuchukana*,

nor they can ascertain to which animal entities newborn *nelekana* are linked. However, *nuchu* and *nele* share the same perspective. More precisely, they are able to switch from a human to a nonhuman perspective and vice versa, and in virtue of this quality they work as mediators between the world of humans and that of nonhuman others.

Here lies perhaps the basic similarity between nuchu and nele. They are both seers in the sense that they are able to transcend the limits of bodies, as external opaque boundaries that separate human and nonhuman entities, providing highly unstable divisions. The difference between nuchu and nele from other persons lies instead in their inverted process of externalization. Whereas normal people are ideally born with a visual design describing an internal relation with an animal, nuchukana and nelekana are born with no visual sign to describe which type of relationship constitutes their being. For this reason they have to make their designs visible by establishing personal relationships with other human beings. I have shown how this occurs for a nele in my analysis of the initiation process in chapter 7. Ideally, a nele, as Rotalio Pérez told me, becomes visible to other people as a full human being when he gets married and has children. This is a strong statement about the nature of humanity, insofar as a nele, intrinsically and constitutively a mixed being, is seen as fully human only when he has children and thus acquires full responsibility for his human kinspeople. Nuchukana, on the other hand, cannot have children. This is their main difference with nelekana and perhaps explains why Kuna people need nuchukana to perform those actions that their nelekana no longer perform. Due to their nature as others, nuchukana are able to deal with animal entities. to transform and mediate between humans and nonhumans. Nuchukana are powerful others who cannot entirely be made into humans.

SPLIT REPRESENTATION IN THE ART OF KUNA PERSONHOOD

If design is key to the creation of bodies and part of the human person, what is a person without designs? As Lévi-Strauss suggests in his study of split representation in the art of Asia and America (1972 [1958]), face painting among the Caduveo, to which he adds tattoos among the Maori, are to be intended as an integral part of the person. Designs inscribe the social role on the person, creating an indissoluble link between the self and the group, person and society. Therefore, Lévi-Strauss argues, to understand how the person is considered to be constituted we cannot split body and design. Design and face are in-

separable in Caduveo aesthetic epistemology. There is no design where there is no face, and vice versa (259).

Lévi-Strauss then extends his analysis to sculptural forms, following Boas's lead on the split representation in the art of the Northwest Coast of North America, where animals are represented (pictorially and sculpturally) by splitting the figure in halves, folding the back half of the figure toward the front, thus flattening the whole figure, making it wholly accessible at a glance. Similar to the painted face of Caduveo women, totem poles can be seen at one glance, surpassing the visual difficulties intrinsic to three-dimensional plastic images, which cannot be perceived thus. What are split representations if not a beautiful illustration of the Kuna theory of the person? A newborn can be perceived in its plenitude—the fullness and the fragility of its future development as a person—only at birth, when it shows its amniotic designs. By being separated from its amniotic design the baby becomes alive (cf. Gow 2001: 112). But it is only by transforming design into an attribute of the person, visible in social life through the person's praxis and capacity to interact properly with his or her kinspeople, that humanity is fully achieved. Design is thus an integral part of the human person, insofar as its predatory-like nature is transformed into human praxis. Similar to the argument of Turner (1995) for the Kayapo, body designs and decorations manifest specific capacities that people activate through social relationships. Alternatively, Seeger (1975: 221) suggests that "body ornaments above all make intangible concepts tangible and visible."

Gell (1998) goes a step further in the direction suggested by Lévi-Strauss, relating the Amerindian material to the Marquesan tattoo practice. By referring to Lévi-Strauss's suggestion that a person can be separated by its social role only by being "torn asunder," Gell says that

it was actually the case in the Marquesas, that dead chiefs were "torn asunder," and with this precise purpose in mind, that they should have removed from them the social identity conferred on them by their tattooing. The tattooed skin of chiefs was removed because, in Marquesan belief, deification and a pleasant afterlife were denied to the tattooed because of the association between tattooing and the mortal condition. (1998: 195)

Although it might seem far-fetched, I should like to remark that Marquesan dead chiefs, detached from their tattooed skin, recall the image of dead people described to me by my Kuna informants: gendered figures of a person stripped of individual attributes. Going back to the question that I directed to Kuna ethnography above, I therefore argue that a person without design is a dead person for Kuna people, a person whose soul image is irrevocably detached from the body.

Death is the end of difference and fertility (Overing Kaplan 1984) and the beginning of pure alterity. *Nuchukana* are images of others, of persons stripped of identity that look to humans like self-identical images, deprived of any differentiation. More precisely, from a human perspective, they are others to themselves, insofar as they lack a body, which is the component of the person that endows it with identity. A human body is made by others and endowed with identity via commensality and coresidence. *Nuchukana* are infertile beings. Their sexuality is not reproductive, as some Kuna specialists pointed out to me. Different from human beings, they are not the outcome of the mixing of male and female reproductive fluids, or of a mixing of identity and alterity. Self-identity, another word for self-alterity, is a deadly attribute for human social life, which instead needs difference and a proper combination of identity and alterity at the level of the person (Viveiros de Castro 2001; Fortis 2012).

I suggest that the power of *nuchukana* to look after human social life resides in their potentially destructive force, associated with the domain of alterity. They are befriended by people, and through their personal relationship with ritual specialists they help in the performance of curative acts to free human beings from evil entities. By the same token, it is essential that their subjectivity remains attached to individual ritual specialists, who can thus control them. Laypersons treat them as a collective of people living together without establishing kinship ties. Only *nelekana* can really see and interact with them on an individual basis. The invisibility of *nuchukana* for laypersons is accompanied by the fact that they live an invisible life, which is based on the negation of those very values that make Kuna social life possible and desirable.

FIGURES OF ABSENCE

In the last three chapters of this book I outlined the link between sculptures and alterity by comparing Kuna and Xinguano myths and ritual praxis. Kuna wooden figures appear to be strikingly similar to the wooden logs at the center of the mortuary ceremonies in the Upper Xingu. Nuchu and kwarip are both figures of absence, in that they represent others, nonhumans that can never become human, or former humans that the living cannot bring back to life. The former represent

immortal beings, free-floating souls that live an eternal ethereal life and live inside trees. The latter represent deceased chiefs who are commemorated by the living through sumptuous intergroup rituals that gather all the living around the symbols of life and death.

As suggested by the Kuna and Xinguano myths analyzed in chapter 6, dead people cannot come back to life. If we gather the evidence provided by these two cases and compare them, we can thus see how the carving of wooden figures is a meaningful social act through which people re-present the basic conditions of humanity by acknowledging mortality as the precondition of life. What Kuna and Xinguano woodcarving indicates is that death is literally impossible to represent. It is also unthinkable, as thinking of dead people carries one adrift, in a state of loneliness, distancing the self from social life. Death is the negation of life, insofar as it is the negation of any viable social relationship. Furthermore, invisibility, as not being "visually available to social relationships" is often equated with being dead among Amerindians (Ewart 2008: 514).

The origin of human mortality is portrayed in the Kuna myth of the birth of the octuplet heroes. Tat Ipe and his siblings are prototypical shamans, in that they are intrinsically multiple and motherless. Their birth is concurrent with the death of their mother, Makiryai, who conceived them through too close a union with her twin brother, who then became Moon. The effort of the octuplet heroes to revive their mother, by way of medicinal plants and singing over her bones, is worthless. After several unsuccessful transformations, she transforms into a jaguar, one of the most powerful figures of alterity for the Kuna. At that point Makiryai is declared dead. Her children leave her when she assumes the semblance of a jaguar, when she has become an Other (cf. Viveiros de Castro 1992: 252–272).

It is in this logic of transformations that I suggest looking at *nuchukana*. They are figures of persons. They are the outcome of a process of transformation, through which a part of a tree is made alive. An immortal being is made mortal by transforming the virtual into the actual, by making a replica of the image of a person. This explains the astounding uniformity—both synchronic and diachronic—of Kuna wooden figures.*

I argue that for the Kuna carving the figure of a person is an act of proliferation of generic images rather than an act of representation. Ideally, there is no limit to the act of replication of soul images, which exist out there in the world as a multiplicity of undifferentiated images. On the one hand, these images do not have any specific form; on

the other, they constantly transform and assume different appearances when they cause themselves to be seen by seers or dreamers. What Kuna carvers do is to fix the form of generic and heteromorphic soul images, dragging them into individual shapes, as if they drew at the infinite source of the cosmos in order to create individual visions. If spirits have the power to cause themselves to be seen by humans, so often causing illnesses and misfortune, carvers have the power to cause spirits to be seen by lodging them in their wooden forms. As long as there are skilled carvers, able to transform wooden logs into figures of a person, there will be proliferation of *nuchukana* in the Kuna lived world. By catching powerful souls from the cosmos and incorporating them in human social life, Kuna people protect themselves from the predatory forces that constantly threaten their lives.

Kuna people value their life in densely populated villages, where houses are built in close spatial proximity. Each densely inhabited house contains a 'box,' ulu, with several nuchukana, adding another level of proliferation and density that distinguishes the "large scale of Kuna social life" (Margiotti 2010: 14–38). It is therefore at proliferation that we have to look rather than at representation or lifelikeness (Kroeber 1949: 411) if we want to understand Kuna as well as, I suggest, other Amerindian theories of images. What counts is less what an image represents than what it does not represent. Nuchukana defy representation by instantiating the virtual proliferation of images, or the proliferation of virtuality. They represent what they are not: human bodies. They are what they do not represent: souls.

TOWARD A KUNA THEORY OF IMAGES

In this work I have demonstrated that Kuna ethnography provides a fruitful contribution to the study of Amerindian aesthetic epistemologies. I have shown that the opposition between design and images is key to understanding the Kuna visual system and that the body provides the third element of a system of oppositions, which I argue lies at the core of the Kuna visual system. The study of Kuna wooden figures contributes to the little-explored topic of the nature of images in Amerindian aesthetics. I suggest that to shed light on how Kuna people conceive of their wooden figures, and images more generally, we should acknowledge that *nuchukana* are the outcome of a process of replication. This has important implications for a Kuna theory of images. Kuna wooden figures are imperfect replicas of a model. Their wooden 'figure,' sopalet, is only an instantiation of the invisible 'image,' purpa,

which they host. *Purpa* is the underlying principle of all living beings, which precedes and follows the body.

As Kuna mythology explains, the *purpa* of everything was created by Pap Tummat and Nan Tummat before things and beings appeared in their material form. At the beginning of time everything and everyone existed as immaterial images. Kuna people consider images the real form of things and beings. As Chapin notes:

The Father mixed his "semen" (purpa sippukwat) with the Mother's "menstrual blood" (purpa kinit). And from the Mother's womb everything was born. At this time, the Earth was pure spirit (purpa), and the children of the union of the Mother and the Father were without substance. (1983: 62)

Subsequently, in a footnote, Chapin explains that the word purpa, in addition to the above-mentioned meanings, "is the term used for the 'origin stories' of important spirits, and in this context means the secret or underlying essence of the spirits" (62). Purpa is thus the origin and the ultimate form of beings. It is the original model from which living beings, including animals, plants, and humans, originated and continue to originate in their actual form. Purpa is close to the Yawalapíti concept of umañi, the original model, after which actual beings are created and from which they are separated by an incommensurable gap (Viveiros de Castro 1977: 122-123; also see introduction). Purpakana are the real images, invisible and internal, that originated at the beginning of times, that defy normal human vision and manifest in manifold ways. Purpa is the sexual fluid of Pap Tummat that mixed with the sexual fluids of Nan Tummat, whose glutinous body solidified and formed the earth. It is the sexual fluid of the eight young men of Pap Tummat that originated plant and trees. It is by knowing the purpa of animal and plant entities that today's Kuna ritual specialists control their power and bend it to their aims. Purpakana may be controlled, coaxed, transformed, fixed, abducted, restored, but they certainly cannot be created ex novo.

Kuna people, like Amazonians, "live in a highly transformational world where What You See Is Not Necessarily What You Get" (Rivière 1994: 256). Given the intrinsic distance and incommensurability between original and replica, image, and figure, we cannot talk about the power of imitation, or mimesis, since, as I demonstrate ethnographically in this work, the power of Kuna wooden figures resides in their being different from any possible model. Kuna people do not aim at

creating real images, because they know that real images already exist in the world and they are the original form of every living being.

Moreover, images, in their immaterial state, are fundamentally multiple, they do not exist as single units, like, for instance, the souls of the dead, which are not thought of as individuals but always as a couple (see chapter 7). Dying is therefore thought of as a process of becoming multiple, of losing one's individuality. Here we can observe a similarity with the way the Emberá from Colombia consider the *jaï* spirits who exist only in couples, who are inseparable and are male and female at the same time. It is only when they cause illnesses to people that one of their sexual sides dominates (Losonczy 1990: 82–83).

Going back to the Kalapalo myth presented in chapter 6, we see that Kwatingi made his daughters out of wood in order to spare his real daughters from marrying Jaguar. The "made ones" were therefore prototypical replicas. They were not Kwatingi's real daughters but only a replica, different from his real daughters. This would further suggest a specific Amerindian theory of ancestrality, whereby the mythic ancestors of humanity are separated from living human beings by an incommensurable gap, which can only be understood as ontological difference. Dead people become closer to the archetypal model of mythic ancestors in people's memory, although they still maintain a difference from those models. The deceased live like historical ancestors, until the memory of the living fades and the ancient dead slip into the category of mythic primordial beings (cf. Viveiros de Castro 1977).

Nuchukana are images in proliferation but cannot autonomously reproduce themselves. To come into existence they need the fertility of human beings. This would also explain why Kuna people talk of 'mirrors,' ispe, when they describe the visual capacity of nelekana and their expectant mothers. Nelekana and their mothers see the reflected images of spirits. They can only see images in their reflection, infinite proliferation, and constant replication. What is, then, the true nature of images? This is the question with which I end this book.

What I wish to suggest is that perhaps the nature of images for Amerindians lies beyond their visual appearance, paradoxically beyond their being images. In the words of Davi Kopenawa Yanomami:

The spirits are so numerous because they are images of the animals of the forest. All those in the forest have an utupë image: those who walk on the ground, those who walk in the trees, those who have wings, those who live in the water. . . . These are the images the shamans call and make descend to turn into xapiripë spirits. These images are the

true centre, the true core of the forest beings. Common people cannot see them, only shamans. But they are not images of the animals we know today. They are images of the fathers of these animals, images of our ancestors. (Cited in Viveiros de Castro 2009: 46)

By carving a *nuchu* an elder Kuna man endows a spirit with subjectivity. He renders individual the generic. That which is infinite is made finite; that which is multiple is made one. The outcome of this process, the wooden figure of a person, retains, however, an unstable and multiple nature. In being a figure it has to remain generic. It has to remain an Other. As is made clear by the myth narrating how Pukasui shot Olopakintili, Tat Ipe's wife, with an arrow: "from then on he could only see his wife in dreams."

NOTES

INTRODUCTION

- 1. In using the term *art object*, I am not referring to its usage in the Western art world but draw from Alfred Gell's apt definition: "a system of action, intended to change the world rather than encode symbolic propositions about it" (1998: 6).
- 2. For some examples of how Amerindians experience the invisible world, see Harner 1972: 134–169; Gow 2001: 130–157; Viveiros de Castro 2009.
- 3. Kuna women's cloth designs, in addition to being the object of much amateur and travel literature, have been studied by Sherzer and Sherzer 1976; Hirshfeld 1976, 1977; Salvador 1971, 1978, 1997; Helms 1981; Perrin 1998; Tice 1995; and Margiotti 2010, n.d.
- 4. I agree with Sherzer and Sherzer (1976), who argued that *mola* designs have no symbolic meaning. They based their assumption on Kuna women's lack of interest in tracing the referent of their designs—when asked by ethnographers—while on the contrary spending much time discussing color, spacing, forms, and relevant sewing techniques aimed at producing fine designs.
- 5. It follows from this consideration that images represented in *mola* designs are conceptualized in a different category from the wooden figures of *nuchukana*. While the former can hardly be said to evoke in the onlooker any meaning beyond their visual form, the latter pushes human imagination beyond the boundaries of the visible.
- 6. See the recent position of Henare, Holbraad, and Wastell (2007), who argued for an ethnographic study of objects to be treated as concepts in native ontologies.
- 7. See Margiotti 2010 for an analysis of Kuna village plans and everyday life in terms of density, which takes onboard Sherzer's linguistic study.
- 8. In my analysis of the Kuna visual system, I also drew inspiration from Gow's (1999) analysis of Piro designs as an instantiation of Piro women's lived experience.
- 9. See Stathern 1979 for an analysis of self-decoration in Mount Hagen, Papua New Guinea, which has been inspirational for interpreting the Kuna concept of design. See also Ewart 2008 for an analysis of the importance of vision in the everyday life of Panará people from central Brazil.
- 10. There is a large body of literature on Kuna people. However, it is not my aim to discuss this literature here. Nonetheless, in the course of this work, I refer to various sources. See, for example, on Kuna language and verbal art, Kramer 1970; Sherzer 2001 [1983], 1990, 1997, 2003; on village political organi-

zation, Howe 2002 [1986]; on ethnohistory, Howe 1998; Wassém 1955; Squillacciotti 1998; on the aesthetics of *mola* making, Salvador 1978, 1997; on *mola* commercialization, Tice 1995; on the political economy surrounding *mola* making, Hirschfeld 1977; on acculturation, Stout 1947; on cosmology and ritual, Chapin 1983, 1997; on ethnobotany, Ventocilla, Herrera, and Nuñez 1995. For a transcription of Kuna ritual chants, see Holmer and Wassén 1947; for narratives and oral history, see Wassén 1934, 1937, 1938.

- 11. Viveiros de Castro (2002 n. 18) noted that in early colonial times the Tupinamba considered white missionaries powerful beings, due to their association of white skin with the motif of immortality, achieved through sloughing the skin.
- 12. Although Ustupu and Okopsukkun people may intermarry, and married men participate in the collective activities of the village of their wives, each person continues to be identified with his village of origin.
- 13. I use the term gathering house as a literal translation. Onmakket means "to gather," and is used in reference to food as well as people. Neka means "house." Okopsukkun people assemble in the gathering house every day (women in the morning and men at night) to listen to the chants of saylakana, the village elder chiefs, and for discussing political and administrative matters. The term gathering house has been used recently by Kuna scholars (Howe 2002 [1986]: 12) as a substitute for "council house" (Nordenskiöld 1938: 52).
- 14. For this reason, our Kuna friends suggested that we take plant medicines to improve our fertility. We did; after returning from fieldwork, we learned that they had been effective.

- 1. In many Amazonian societies fish have the ontological status of food, whereas game animals are considered more similar to human beings (Viveiros de Castro 1978; Århem 1996).
- 2. Today Kuna women in Okopsukkun do not travel frequently to the forest. Men undertake all the work of gardening. Women sometimes go to collect coconut and fruits, to catch river crabs, and to collect sand from the river. Elder women told me that in the past they participated more in the gardening, helping their husbands and sometimes working alone in their own gardens. In addition, they used to go many times each day to collect fresh water from the river. When Kuna people were living in the forest, gardening was a female task, while men felled trees, hunted, and fished. For an historical and ethnographic account of the change in the division of labor by gender, see Tice 1995: 35–38, 124–126, 145–147, 165. Although her analysis takes into account the commercialization of mola as the main reason for this change, Tice points out that the change did not happen consistently in all Kuna communities. It depended on tourism and on whether the village is located on an island or on the mainland.
 - 3. Tule (sing.), "people," is what the Kuna call themselves, and this extends

to other indigenous people in Panamá (or, as some Kuna told me, to all indigenous people). The Kuna distinguish themselves from other indigenous people by calling themselves *olotule*, 'golden people.' Panamanians and Colombians are called *waka*, 'stranger,' and white people are *merki*. The latter often refers to North American white people, with whom the Kuna have had extensive experience in the past century (Howe 1998, 2009).

- 4. Plant medicines, such as leaves, barks, and vines are also 'alive,' tula, after the specialist addresses them with short chants before sending them to the ill person; the only difference is that their effectiveness is temporary, and new plants need to be gathered every four days.
- 5. Sherzer noted that "this sharp division between workplace and village, between mainland and island, stresses the island-village as the place of leisure and of ritual and political activity" (2001 [1983]: 6).
- 6. It is interesting to note that historical sources, although there is no agreement on this point, tend to identify the first indigenous people met by Europeans at their arrival on the American mainland (at the mouth of the Urabá Gulf, during the expedition of Vasco Núñez de Balboa) with Kuna ancestors (Howe 1998: 10).
- 7. Kuna Yala was the first region to be recognized as indigenous territory (Comarca) by the Panamanian state in 1938, and to enjoy a considerable degree of autonomy. Today there are a total of five Comarcas in Panamá for the different indigenous groups: the Comarca Kuna de Madungandi, Kuna de Wargandí, Emberá-Wounaan, and Ngöbe-Buglé.
- 8. See Nordenskiöld (1938: 8-28) for examples of how Kuna people from different insular villages account for their movement from the mainland to the islands. Today there are still five villages located on the coast of Kuna Yala.
- 9. Quichua people from Ecuador made a similar remark about the alimentary habits of the ethnographer, by saying, "Usted come puro quimico!" "You eat only processed food!" (Elisa Galli, pers. comm.).
- 10. In this work I will not deal specifically with Kuna ethnobotanical knowledge. My aim is rather to understand the way Kuna people see and relate to the world of nonhuman entities and how this relates to social issues and to their specific ideas of what it is to be human. For an extensive ethnographic account of Kuna ways of curing and on conceptions of illness and medicine, see Chapin 1983 and the older but highly interesting ethnography of Nordenskiöld (1938), based on the information given by two Kuna men: Ruben Pérez Kantule and Guillermo Hayans.
- 11. For an analysis of the composite nature of *tule masi*, made of both vegetable and fish or meat, and its gender implications, see Margiotti 2010.
- 12. Unfortunately today Kuna people buy more and more bad-quality food from Colombian traders, such as canned fish or meat, cocoa, coffee, pasta and rice, which, as they reckon, is not good for their children and does not provide the necessary nutrients for their growth.
 - 13. See Gow on the Peruvian Piro: "What [people] fear most are the evil be-

ings like the devils, the deceased, the souls of the dead, and even the trees themselves" (1987: 117; my translation). My Kuna informants told me that Emberá shamans used to meet, during the night, the devils that reside within the tree, which the Kuna identify as the *suurwala* (*Ficus* sp.).

- 14. Mango, native to Southeast Asia, has no Kuna name. Nevertheless, the many types of mangoes are given different names in the Kuna language: manko suit, 'long mango,' manko pompea, manko tirkwa, ormanko, iles manko, manko ochi, 'sweet mango,' sikkwa manko, tule manko, 'people's mango,' manko wakarkine.
- 15. Coconut was the main product the Kuna exchanged particularly with Colombian traders. It provided them with an economic, money-like, medium for dealing with foreigners (Chapin 1983: 463–465; Tice 1995: 43–44).
- 16. Starting from a population of around thirty or forty people at the beginning of the twentieth century, now Okopsukkun has 1,419 inhabitants (according to a 2003 village census) and Ustupu about 3,000. For an ethnographic analysis of how the dramatic demographic increase in Okopsukkun is linked to Kuna ideas of sociality and kinship, see Margiotti 2010.
- 17. See Howe and Sherzer 1975 on Kuna plant classification related to the possibility of having access to other people's plants depending on kinship ties and on what kind of crop one is asking for.
- 18. At times it was also mentioned that these men were guerrillas from Colombia and moving within the forest to hide from the army, which usually travels by sea. Okopsukkun is not far from the Colombian border, and many times during our stay we heard of episodes in which Kuna families from neighboring communities had to flee from their village in order to escape guerrilla or paramilitary retaliation. On one occasion the rumor spread that during the night a boat was patrolling the sea around the island looking for a Kuna family that had escaped from another village.
- 19. I have to say here that my knowledge of Kuna gardening is limited, and I cannot say with enough precision which kinds of crops are cultivated together and the preferences related to proper mixing. For example, I observed that pineapples are cultivated between plantains, and various types of plantains and bananas are often cultivated in the same garden. For a detailed description of Kuna gardening, see Stier 1979; Martínez Mauri 2007.
- 20. Sometimes the danger comes from bringing down the invisible clotheslines that 'evil entities,' *ponikana*, had strung between trees (James Howe, pers. comm.).
- 21. See Chapin 1983: 78-83 for a description of *kalukana* inhabited by demons but also by animals, which are released on the earth by their masters.
- 22. See Guss 1989: 36 for an account of the way Yekuana men "cleanse" themselves after having felled the trees when starting a new garden. See Howe 1976a for an interpretation of the *nek apsoket* ritual as a collective "exorcism" of evil spirits affecting the whole village. See Stier 1979: 132–144 for case material on the conditions leading to *nek apsoket* rituals.
 - 23. As Rival says, "The Huaorani are very conscious of past human activ-

ity, and are perfectly aware of the fact that every aspect of their forested territory has been transformed in equal measure by their ancestors, other indigenous groups, and the forces of nature and the supernatural... Their relation with the forest is lived as a social relation with themselves across generations, hence its eminently historical character" (2006: 89).

- 24. I do not have accurate descriptions of the island's appearance before people moved there from the coast. Kuna people were living at the mouth of the Puturkanti River (on the mainland coast east of the island) before they started clearing the land on the island and planting coconut trees. I was told that there were many mangroves and some other trees but certainly not the high hardwood trees found deep in the forest. There was also a dense population of 'agoutis,' usukana, from which the name Ustupu (Agouti Island), is derived. The only island in Kuna Yala that has a forest is Tupak, east of Okopsukkun, which is also the only nonflat island. It has a hill at its center that rises above sea level. The island is named for its characteristic shape: tupu, 'island' and pakka, 'whale.' The vegetation on the hill is dense, like the mainland forest, and the people living in the village situated on its coast say that in the past there were many animals there.
- 25. See chapter 6 for an analysis of the myth describing the birth of the octuplet heroes and its relation to Amerindian myths of twins.
- 26. I translated and edited the original recording of this myth (Salcedo and Howe 1978). Any mistake or misinterpretation is thus my own. Although I was told the story of *paluwala* several times while in the field, I unfortunately never recorded a full version of it. Other versions of this myth are transcribed and translated into Spanish by Chapin (1989: 64–70) and Wagua (2000: 44–53). The version published by Chapin ends by describing how the sea, the rivers, and the land inhabited by Kuna people today originated from the felling of *paluwala*. The version published by Wagua ends by describing how the islands of Kuna Yala originated from the pieces of *paluwala*.
- 27. All the trees named here are identified by Kuna people as having a 'hard core,' kwa nikka, an important quality for their ritual use in contemporary curing practices. This is not the case of ukkurwala, 'balsa tree,' which is nonetheless highly important in Kuna botany and cosmology. See chapter 3 for more details on Kuna tree classifications and the exception of the balsa tree.
- 28. Lévi-Strauss (1969: 164–195) demonstrated the link between myths about the origins of cooking fire by felling trees, of cultivated plants, and of human mortality.
- 29. During my fieldwork the supernatural entities of edible plants were hardly mentioned. In other contexts plants such as manioc are considered bloodthirsty vampires (Descola 1994: 208–209) or endowed with supernatural masters (Guss 1989). In these contexts the relationship that women have with cultivated plants entails specialist knowledge and is more complex than the relationship between Kuna gardeners and their plants. Since Kuna women abandoned gardening when they moved to the islands and men took over agricul-

tural work, it would be interesting to consider whether this change entailed the loss of female knowledge of cultivated plants.

30. See Ventocilla, Herrera, and Nuñez 1995: 16 for a similar distinction between spaces in the forest and Margiotti 2010 for an analysis of the term *nainu* and its implications in the kinship system of Kuna people.

- 1. I use the term arrival to translate the Kuna verb ayteket, 'to descend,' which is often used in mythic narratives to describe the birth of specific beings generated by the union between Great Mother, Nan Tummat, and Great Father, Pap Tummat. Each being is said to "descend" out of Great Mother's birth canal (cf. Chapin 1983: 62–66). Subsequent generations of Kuna culture heroes are said to have descended to earth flying a 'golden saucer,' olopatte.
- 2. For the Kuna not all animals are directly responsible for transmitting illnesses to human beings. Some animals do so only when ordered by their chiefs. As the Piaroa say, "it is not on the animal's volition that it sends disease" (Overing 1985a: 266; 1986: 147).
- 3. Kuna oral history mentions people called *puki puki tule* and *sawi sawi tule* who used to raid Kuna villages when they lived in the forest, killing their people and drinking their blood. I was explicitly told more than once that these people correspond to the present-day Emberá. It could be that the place today occupied by supernatural predators previously corresponded to neighboring people, such as the Emberá or other people with whom the Kuna had previously been in contact (see Ventocilla, Herrera, and Nuñez 1995: 10; Wassén 1955: 61–64) or with whom the Kuna fought. This hypothesis would suggest a change in the cosmology and the removal of violence from everyday relationships to the supernatural sphere. This point has been addressed in a different fashion by Severi (1987: 82–83). I refer again to this shift in chapters 6 and 7.
- 4. "We must remember, above all, that if there is a virtually Amerindian notion, it is that of an original state of undifferentiation between humans and animals, described in mythology" (Viveiros de Castro 1998: 471).
 - 5. For a discussion of this point, see chapters 6 and 7.
- 6. See Howe's description of the variation in frequency and modes of the gathering house reunions in the different Kuna villages. Despite these differences, he says, the pattern and the aim of the reunions are shared by all Kuna (2002 [1986]: 276 n. 1).
- 7. Despite syntheses of *Pap ikar* (Howe, Sherzer, and Chapin 1980; Chapin 1989; Wakua, Green, and Peláez 1996; Wagua 2000) and single myths (Howe 1991) that have been published in recent years, *Pap ikar* is not a completely coherent corpus of myths. It is highly complex and sometimes includes borrowings from external sources, with characters such as Simón Bolívar and Jesus Cristo (*Pap machi*). Although all Kuna people refer to *Pap ikar* as the principal source of historical knowledge, there exist different "traditions" that developed

independently in different areas of Kuna Yala, where particular narratives acquired importance or became alternative to other versions. This, however, does not prevent Kuna people from different communities understanding each other's myths. It is with interest that Kuna people in Okopsukkun listened to new myths/versions sung by chiefs visiting from other communities.

- 8. For some examples of chants sung by *saylakana* in the gathering house, see Howe 2002 [1986]: 31–50; Howe, Sherzer, and Chapin 1980; and Sherzer 2001 [1983]: 76–89.
- 9. Different generations of culture heroes succeeded in mythic time, and Kuna people see their present-day life as the outcome of several cycles of acquisition and loss of their way of life. Tat Ipe and his siblings form the first set, followed by Ipeorkun, and then eight great shamans, whose actions are deemed to have been positive and disruptive at the same time.
- 10. While in the field I often heard elder Kuna men complaining that younger men were not interested in learning ritual knowledge and that it would die out eventually. This lack of interest in Kuna tradition is often thought to be caused by school education, and it is most acute among those youngsters educated in Panama City, who often grow up looking skeptically at their own cultural background. It is nonetheless interesting to note that since the early twentieth century a small group of Kuna intellectuals, either educated in the traditional systems or in formal schools, played an important role in mediating between Kuna authorities and foreign missionaries, colonial officers, travelers, and, later, anthropologists. Howe (2009) deals with the role played by Kuna intellectuals during the past century and also pays attention to what he calls "native ethnography," mostly conducted by educated Kuna men, who focused on such topics as language politics, the history of struggle against colonizers and the nation-state, environmental issues, and Pap ikar. Moreover, Martínez Mauri (2007) describes the role of Kuna people working in NGOs dealing with environmental issues and mediating local interests with global dynamics.
- 11. For a description of the different ritual statuses, see Chapin 1983: 134-178.
- 12. I was told that in the past it was often the case that a young man who wanted to learn from a knowledgeable specialist would move into his house and start working his gardens in exchange for the teaching. If the relationship worked well and if the young man demonstrated that he was a good worker, he would often marry one of his master's daughters.
- 13. Many Kuna in Okopsukkun have an idea of what an anthropologist is, either from hearing stories from their kinspeople or from direct experience. Among other anthropologists, Chapin, a former Peace Corps volunteer, lived for a number of years in Kuna Yala (1967–1970) and then conducted his Ph.D. fieldwork in Ustupu and Okopsukkun (1975–1976). Today in both Okopsukkun and Ustupu there are people claiming to possess notebooks handwritten by Ruben Pérez Kantule and Guillermo Hayans, two Kuna who worked with the Swedish anthropologists Erland Nordenskiöld and Henri Wassén in the 1920s

and 1930s (see Nordenskiöld 1938 and Wassén 1934; 1937; 1938). Both Pérez and Hayans collected and transcribed a great number of ritual chants, myths, and stories, which have been published in the above mentioned volumes. Some of their original transcriptions are kept in the archives of the Museum of World Culture—Världskultur Museet—in Gotebörg; others are claimed to be jealously possessed by Hayans's heirs in Ustupu. I found it interesting during my fieldwork that such written documents were considered incredibly valuable by people, some of whom compared the Swedish museum to a *kalu*, a spiritual village where cultural skills and knowledge are kept under the surveillance of the chiefs of animals.

- 14. The word *purpa* means "immaterial double," "image," "soul," "sexual fluid," "menstrual blood," and "origin." I will deal with this complex concept throughout the book. For an interpretation of the Kuna concept of *purpa*, see also Chapin 1983: 75–78; Nordenskiöld 1938: 334–360; and Severi 1993: 221–247.
- 15. The meaning of the word *paliwittur* is unclear to me. On one occasion a Kuna man translated it in Spanish as *angeles*, "angels."
- 16. Pursoso, Pursop, and Punasop are the various names given in myths to the first woman in the world, who was married to Piler. Pursop is the transformation of Nan Tummat after the earth was created and the mother of the fathers of animals. See below.
- 17. The name of the river means *olo*, 'gold,' *ispe*, 'mirror,' 'glass,' *kun* (perhaps a plural modifier), *tiiwar*, 'river,' the 'river of the golden mirrors.'
- 18. Nia is usually translated into Spanish by Kuna people as *diablo*, or devil. See below for more on this figure in Kuna cosmology.
- 19. I translate the verb *oyoket* as "to show." Kuna people translate it in Spanish as *enseñar*, "to show," or *interpretar*, "to interpret." You can show or interpret something of which you have a deep understanding or a direct visual experience. For example, a seer may show to the patient the illness he has seen within his body; a dream interpreter may interpret the dream of a person using his knowledge accumulated from his direct personal experience (see chapters 5 and 7 for more on this issue). Furthermore, the *arkar* interprets the *sayla*'s chants for the public audience.
- 20. "You are also transforming here with me. You're learning our language, *tule kaya*, and you are changing into a *tule*, Kuna. Listo!" Garibaldo told me this to explain the use of the verb 'to transform,' *piñe*, at this point in the story.
- 21. In this case Garibaldo specified "e purpa, e raiz soke," "their purpa, their root, I mean."
- 22. Each one of them is called by four different names by Great Father, each name beginning with the four prefixes *olo-*, *mani-*, *ikwa-*, *ina-*. Following Kuna ritual logic, this indicates that a person has reached full power after having undergone four consecutive processes of transformation.
- 23. Chapin (1983: 66) writes, "A male spirit named Olopenkikkiler and his female companion Olokkekkepyai were given life and placed in a community near Muu's house, in the 'Region of the Trees' (Sappipe Neka)."

- 24. The problem is indeed more complex. On the one hand, I was told that old Kuna people in the past used more animal medicines because they were more knowledgeable and powerful. They knew how to "handle" (aguantar in Spanish) them. Kuna people told me that today such powerful knowledge has been abandoned because of the dangers it entails. People became mad and even killed each other, overwhelmed by the poisonous animal knowledge. On the other hand, in many cases I heard that cutting trees for clearing the land is a dangerous thing because people do not know if a nia, or devil, lives in the land, and they may upset him, with disastrous consequences for the whole village. I suggest that the abandonment of animal medicines corresponds to the huge population growth of Okopsukkun and Ustupu (from about 30 to about 4,500 people within one hundred years). As a consequence, a pro-tree discourse may correspond to the progressive clearing of the mainland forest of large trees, for opening more gardens to compensate for the increased numbers of people living on the island (Fortis 2011).
- 25. Pursop is the transformation of Nan Tummat, Great Mother. I am tempted to say that Piler is the transformation of the Great Father. However, this has never been told to me by the Kuna, who instead draw a comparison between Piler and Pursop and Adam and Eve, as created by God. The overlap with Christianity, with which the Kuna have now been in contact for centuries, is evident here.
- 26. Similarly the Piaroa tell of the origin of poisonous animals by the hand of Kuemoi: "Through the desire for and the malice towards jungle beings, he created all the poisonous snakes and insects of the world; he created poisonous toads; he poisoned all large rock formations and streams" (Overing 1985a: 258).
- 27. See Overing 1996 for an analysis of how the Piaroa borrowed the image of the conquistador and made it a figure of their own cosmology. This is analyzed by Overing as related to the Piaroa's concern with alterity as an immanent cosmological fact and their reflection on how to master forces that prey on social life. Indeed, these predatory forces have been associated with Spanish invaders since the time of the conquest. However, evil, untamed, and destructive forces are also associated with the origin of time in indigenous mythologies, when they were possessed by mad heroes, who eventually died and gave space to the emergence of human-controlled sociality (Overing 1985a).
- 28. For a French and a Spanish transcription of *nia ikar*, see Severi 1982 and 1983 respectively.
- 29. This plant is literally called "worm medicine" and is used in small doses for ridding one of intestinal parasites. However, used in greater amounts, it may be lethal to humans.
- 30. It is interesting to note that the capacity to see images in dreams of a person cured of *nia* is similar to that of *nelekana*, who are able to see animal entities as people in dreams.
 - 31. Kia takkaler is the nominal agent form of the verb kintakket, 'to kill.' In-

terestingly, in the Kuna-Spanish dictionary of Father Jesus Erice kiataka nele is defined as matasanos, "quack." As we have seen, a kia takkaler is more dangerous than a quack, but what calls attention is the reference to the nele. Erice seems in fact to refer to an evil nele able to cause harm through his wild knowledge and power. Chapin (1983: 115) suggests that the name is composed of kia, meaning "pieces," a numerical classifier, and takkalet, which derives from takket, 'to see.' He further points out that such an accusation is often directed at ritual specialists who are considered overambitious, thus functioning as a form of social control (116–117).

- 32. It is interesting to note that the person in charge of forcing the mad one to drink the poison was usually a hunter, one who had taken medicine for hunting and was thus considered brave but also easily overcome by rage in arguments with other people. Good hunters are said to be able to confront jaguars face to face, without fear.
- 33. See Nordenskiöld 1938: 382–389 for a slightly different taxonomy of animals. For the specific case of the turtle, he gives details about its hunting, saying that in the past Kuna people did not hunt this animal for food but just to sell its shell (342–343). See also Martínez Mauri 2007: 274–282 for a description of taboos and illnesses concerning marine species.
- 34. *Inmar turkana* might derive from *tula* (pl. *tulakana*), 'alive.' See also the description of animals among the Araweté as "those that are really existent" (Viveiros de Castro 1992: 72-74).
- 35. The Kuna concept of chiefs of animals is very similar to that of masters of animals, often found in Amazonian literature. I use the word *chief* in my work, as it is closer to the Kuna words *sayla* and *tummat*, which are used to refer to village authorities. The word *errey* seems to be of Spanish derivation; from *rey*, meaning "king."
- 36. Margiotti (2010) points out that although for Kuna people most animals lack *pinsaet*, when understood as human beings' love and memory for their kinspeople, a few animals have *pinsaet*, as intentionality, which often is manifested as a form of predation on human beings.
- 37. The word for hunting is makket, 'to pierce,' and refers to killing animals, birds, or fish with bullets, spears, harpoons, or arrows. Inmar makket and ua makket respectively mean "hunting (forest) animals" and "fishing with harpoons." A large fish called sábalo in Panamanian Spanish and mila in Kuna (Megalops atlanticus) is hunted by the Kuna with the harpoon. Fishing with a line is ua soet; fishing with nets is ua kaet.
- 38. The Pan-American Highway also had a profound impact on game animals in the mainland forest (Hanbury-Tenison and Burton 1973). Nonetheless, Kuna living in the Darién forest still hunt on a more regular basis than those living in the San Blas islands (Ventocilla 1991; Ventocilla, Herrera, and Nuñez 1995: 43–51).
 - 39. Martínez Mauri (2007: 266–291) shows nonetheless the importance that

marine ecology has in Kuna cosmology and provides good ethnographic examples from the use and representation of marine species in daily life.

- 40. The link between this kinship relation and animal entities is worthy of further study. See chapter 6 for a discussion of how affinity is a useful way to understand human-animal relationships.
- 41. The association between snakes and immortality is also present among the Emberá (Wassén 1933: 110) and the Piro (Gow 2001: 132).
- 42. See Viveiros de Castro (1992: 74–76, 335) for a description of the jaguar spirit of the Araweté. The author notes that " $Me'e\ \tilde{N}\tilde{a}$, 'Jaguar-Thing,' and his partner Moropici, the Master of Snakes, both of which eat tortoises, may become enraged and release their pets against humans who are negligent in inviting them to banquets of tortoise meat" (76).
- 43. Jaguars and snakes are also considered beautiful animals by other groups. See Gow 2001: 110–124 for a description of the Piro's perception of these animals and the transposition of their designs onto objects and bodies.
- 44. See Viveiros de Castro 2009 for an interpretation of the Yanomami spirit vision, which highlights the relevance of light, mirrors, and opacity as terms describing indigenous visual experiences of beings of the other world.
- 45. 'River otter,' saipa, and 'sea siren,' ansu, were described to me as half-woman/half-fish creatures. Although I cannot say it with certainty, I am tempted to associate ansu with manatees (tii moli, 'water tapir'). I was told that in the past there were many manatees along the coast, especially close to the river mouths. Then people in Okopsukkun and Ustupu celebrated many collective healing rituals, sending these animals back into the underworld, where they now live. This would explain why today this animal appears only rarely, often during the night, and it is said to have a half-human form.
- 46. As the distinction between animals that are offspring of their supernatural chiefs and animals that are themselves ancestors was not clear to me during fieldwork, I unfortunately failed to ask more precisely which animals pertain to each group. The animals listed above in the text are those that were the most commonly cited as potential auxiliary spirits of the *nele*. However, other animals have on some occasions been added to the list, such as turtle, barracuda, shark, stingray. Also, 'quartz stones,' *akkwanusakana*, found in riverbeds, are among the *nele*'s auxiliaries.
- 47. The difference between animal ancestors and offspring among the Kuna resonates with the Yawalapíti's distinction between original mythic beings and actual animals, interpreted as a dialectic between archetype and actualization by Viveiros de Castro (1977).
- 48. For a definition and an application of explicit and implicit natural categories among the Achuar, see Descola 1996.
- 49. For a more detailed description of Kuna ethnobotanical taxonomies, see Chapin 1983: 223–229.
 - 50. What I sketch here is the issue of Kuna sociality, which is addressed by

Margiotti (2010) and has been addressed previously by Amazonian scholars who looked at the importance of conviviality in the ongoing generation of the indigenous way of life (Gow 1991; Overing and Passes 2000; Belaunde 2001; McCallum 2001).

- 1. Justino used the word *sapeti*, 'the one who takes care,' derived from the verb *sapet*, which means "to take care" of someone, implying love and affection.
- 2. In Kuna cosmology Sappipe neka is the place where the entities responsible for the reproduction of all living beings reside. As Chapin (1983: 66) writes, "The Mother and the Father then abdicated their reproductive duties, leaving the future birth of all animals and humans to Muu and her daughters, and the on-going reproduction of plants in the hands of Olopenkikkiler and Olokkekkepyai."
- 3. Pole, stick and trunk were translated in Spanish by the Kuna with the same word *palo*. Nordenskiöld (1938: 344) reports that "the Cuna Indians call them *suar nuchukana* or *suar mimmikana*."
- 4. The currency in Panamá is the balboa; it is equated to the U.S. dollar, and there are only coins in balboa. Therefore 'money,' *mani*, only circulates in the form of American dollars.
- 5. Chants from *Pap ikar* sung by *saylakana* are not comprehensible to everyone, especially to younger women and men, because of their metaphorical language. The task of the *arkar* is 'to interpret,' *otuloket*, the chants. Often this task is accomplished by focusing on some aspects of the chant and relating it to contemporary events or contingencies. For an example of a chant and its interpretation, see Howe 2002 [1986]: 31–50.
- 6. In his extensive study on Kuna language and ways of speaking, Sherzer also deals with "the frequent use of verbal advice as both counsel before the action and punishment after one" (2001 [1983]: 9).
- 7. On the other hand, most financial issues are directly administered by women, who buy items from Colombian traders and lend money to each other.
- 8. For the meaning attached to this word, see chapters 6 and 7. The soul, immaterial double, or image of a person, *purpa*, is composed of multiple *purpakana* situated in various parts of the body, for example, in the hair, fingernails, or eyes. Similar concepts reflecting the idea of an immaterial double, detachable from the body in dreams and after death, is widespread in South America: *yuxin* for the Cashinahua (Lagrou 1998); *wakan* for the Achuar (Taylor 1996); *akua* for the Kalapalo (Basso 1987b).
- 9. I often heard that the mother's brother prepares a young boy's medicines, while for girls it is either the mother or the grandmother.
- 10. On the one hand, Okopsukkun people think of their ancestors who lived in the Darién forest as powerful shamans who were skilled in many cultural ac-

tivities (see Fortis 2011). On the other hand, Kuna specialists often learn secrets, (Sp. secretos) from the Emberá who also live in the Darién on the Pacific side of Panamá. Chapin noted this (1983: 551-554), but dismissed it as a borrowing without further significance. I find it to be rather a form of acquiring knowledge from an external social source completely compatible with Kuna shamanic learning, whereas the knower of secretos is one who managed to venture into another social world to learn.

- 11. See Howe 1977 for an analysis of tree metaphors referring to Kuna chiefs.
- 12. See Severi 2000: 143-144 for a translation of the purpa of nia ikar, 'the way of nia,' which narrates the birth of the balsa tree.
- 13. See Margiotti 2010 for an analysis of Kuna ideas about the role of men and women in procreation.
- 14. Extending this hierarchical organization of skills to nonhuman beings, it is interesting to note that in the Kalapalo theory of speech and sound the latter is considered the manifestation of the hyperanimacy of powerful beings (Basso 1985: 69-71).
- 15. The Ecuadorian Achuar associate sexual activity with the weakening of the semen's force. For this reason it is explained that a man preparing curare poison must refrain from sex so as not to cause a dilution of the poison (Taylor 1998: 321).
- 16. Similar to the Kuna, in the Kalapalo cosmovision, as described by Ellen Basso, the first people to appear on the earth were trees, "so our livesas the nephew of the leader explained to the anthropologist-begin in childhood like resilient sprouts; we grow towards 'firmness,' 'ripening,' and strength in adulthood; and end with an increasing 'over-ripeness' and decay during old age" (Basso 1987a: 10). Another time metaphor that makes reference to the trees growing is associated with the spatial organization of clans in the village of the central Brazilian Panará, where the names of two clans make reference to the base and the leaf of the buriti palm (Ewart 2003).
- 17. See Rival 1993 for an examination of the value of the balsa tree among the Huaorani and especially for her analysis of the significance of the complementarity of hard and soft wood in cultural artifacts and myths.
- 18. Both eight and twelve are multiples of four, which is the ritual number for the Kuna. For example, each tree-boy received four names by Great Father; when botanical specialists cut tree bark, they take pieces from the four sides of the trunk; the supernatural domain is located in the 'fourth layer under the world,' pillipakke.
- 19. Ritual names are usually formed by the prefix olo-, 'gold,' and the suffix -nele with a name describing some characteristics of the plant in the middle. For instance in the name Olokurkinkilamakkanele (Carludovica drudei) kurkin, 'hat,' indicates the palmlike leaf of this plant; kila, 'leg,' refers to the stem and together with the verb makka (kilamakka) indicates the stems that stand together in groups like many people standing together.

- 20. This is the ideal way of speaking, which I often heard remarked on by elderly men. However, it often happens that people gesture during their speech (cf. Howe 1997).
- 21. See Sherzer 2001 [1983]: 56-60, 98-99 for a description of the speaking abilities of Kuna chiefs, and Howe 2002 [1986]: 84-86) for morality and leadership.
- 22. Some colonial chronicles, while describing the bellicosity of Kuna Indians vis-à-vis Spaniards, suggest that the Kuna also used to prey on the Cueva (Salcedo Requejo 1908 [1640]: 115–130). More recent studies show that the Emberá from the Panamanian Darién considered the Kuna dangerous enemies (Wassén 1955: 61–64; Howe 1998: 218).
- 23. In the text of the curing chant performed by the specialist this moment is vividly described. For an English translation of *kapur ikar*, 'way of the Spanish Pepper,' see Chapin 1983: 483–511.
- 24. The ritual importance of cacao among the Kuna is suggestive of its significance throughout Mesoamerica, which has also been documented for the ancient Maya. Moreover, there are wild cacao trees, although the geographic origin of this species is still debated. It has been traditionally assumed that "Mesoamerican plants were introduced from South America and later domesticated in Mesoamerica. However, there are some problems with this assumption. First, there is no proof of the cultivation of cacao or the use of its seeds in South America" (Gómez-Pompa, Flores, and Fernández 1990: 249). Among the neighboring Emberá its cultivation but not its consumption and ritual use has been documented (Duke 1970).
- 25. I translate the Kuna verb *otuloket*, along with Howe (1977: 147), as "to give life to." The verb derives from the noun *tula*, 'alive,' and the prefix o-, which turns intransitive verbs into transitive form.
- 26. Ippureket is the giant anteater (Myrmecophaga tridactyla). Interestingly, in Piro mythology the anteater is the master of canoe making (Gow 2001: 104-105).
- 27. I have dealt in more detail with the cognitive implications of *mola* making in a previous work (Fortis 2002), suggesting that there are various ways in which a Kuna woman makes her own *mola* designs; imitation is just one of them. The creation of new designs by Kuna women is, however, a topic still to be properly addressed.
- 28. The Kuna distinguish between 'to see,' takket, and 'to watch,' 'to observe,' attaket. 'Ability to see,' 'vision,' 'sight,' are generally called tala. A similar distinction between a general capacity to see and the action of watching specific objects or persons is noted by Basso (1987b: 94) in relation to the acquisition of knowledge in dreams.
- 29. I was told by a Kuna specialist that the noun *kia takkaler* derives from the verb *kintakket*, 'to kill,' which interestingly also contains the verb *takket*, 'to see.'
 - 30. In many cases ina nusu was administered in graduated doses. Only if the

person was not considered to be cured, and thus still offensive, the dosage would be increased until he or she died (Howe, pers. comm.).

- 31. In the case of making babies the act of "shaping" the baby's body is carried out in conjunction by both *muukana*, 'celestial grandmothers,' and the expectant mother.
- 32. On one occasion *sopet* was translated in Spanish by a Kuna man as *sacar la forma*, "to bring out/to extract the shape." This would contrast with my translation, where I use "to give" and not "to bring out." The opposition between "adding" and "subtracting" in visual arts, noted by Leonardo da Vinci, has been taken seriously in ethnography by Goldman in his analysis of candomblé initiation in Bahia, where he notes that in Afro-Brazilian ontology it is more profitable to think in terms of subtraction rather than addition to understand the process of construction of the person (Goldman 2009: 120).
- 33. On another occasion, while speaking about canoe making, Eladio told me that different from *nuchukana*, for making a canoe the upper part of the trunk is where the prow is made and the lower part is where the stern is. We can also observe that while a canoe is a dead tree, cut down and with its interior dug out, a *nuchu* is a part of a living tree, which is made out of the interior, the hardest part of a tree, *kwa*, 'core.'
- 34. I have noted elsewhere that the roughness and lack of details of *nuchukana* has nothing to do with the skill of carvers but is rather an aesthetic choice (Fortis 2009, 2012).
- 35. I was told that there is a medicine that may be used by parents to have an albino child. However, Kuna people generally do not want albino children as they say that they will not be able to work like other people because of their incapacity to stand the sun's light. The topic of albinism among the Kuna has been explored by Jeambrun, who also noted that, as among the Hopi, the explication of the origin of albinism is given by the analogical thinking that sees the influence of a white object as responsible for the birth of white children: "Among the Hopi eating the seed of white maize, having a white ass, loving to make the portrait of Eototo, white katcina (sacred dolls), working with white sand at the time of conception and indeed sleeping with a white man or a woman [will cause the mother to have a white child]. For the Hopi, the father before conception, or the mother after conception, has to eat the white leaf that is inside maize" (Jeambrun 1998: 905, my translation) For the Kuna, if the expectant mother dreams of the moon she will have an albino child. Jeambrun also notes that in comparison with other indigenous Americans, what is unique among the Kuna is that they have a medicine to have albino children (905).
 - 36. See note 16 above and note 2 in chapter 2.
- 37. The knowledge most middle-aged and elder Kuna men have of military technology is more accurate than I briefly describe here. It derives from their experience at the military bases of the Panama Canal Zone as wage workers. Many Kuna men worked in the Canal Zone since the beginning of the con-

tract between Kuna authorities and Canal administrators until the Canal was devolved to Panama in 1999 (See Howe 1998; Margiotti 1999).

- 38. See Lévi-Strauss 1973 and Gow 2012 on Amerindian canoes and their place in social life and cosmology.
- 39. The use of anatomic terms to refer to parts of objects is quite widespread among Amerindians. Erikson noted that the Matis often use the terms *head*, *feet*, *bottom*, and *nose*, which "are more apt to indicate a position, see a direction, than any formal resemblance between a part of the body and a part of the object described....[T]hey point to an internal, *sui generis*, orientation, because they enable a description of the directionality intrinsic to the morphology of the object" (1989: 289–290). See also Isacsson 1993: 124–127 on the Emberá concept of vaginal nose and its synesthetic implications.
- 40. Also, when a botanical specialist molds the boiled leaves mixture into small bars, which will be then sun dried, the operation is called *kwamakket*.
- 41. Lévi-Strauss (1972: 256) noted that masculine art is centered on sculpture, while feminine art includes weaving, plaiting, and drawing, comparing the art of the Northwest Coast Indians and the Caduveo art from Paraguay.

- 1. The first issue has already been noted in previous ethnographies (see, e.g., Nordensköld 1938: 80–81; Chapin 1983: 138–140). However, no attention has been paid to the life experience of the *nele*, which I argue is important for an understanding of how Kuna people think of seers and of the relationship between the human and the supernatural world.
- 2. Chapin notes, "Children who have an exaggerated fear of the dark are also recognized as having supernatural abilities, for they are believed to possess acute powers of vision which enable them to see objects that are invisible to others" (1983: 139).
- 3. I analyzed elsewhere the Kuna theory of body and personhood in relation to their idea of design (Fortis 2010).
- 4. My Kuna informants told me that nelekana are not able to harm other people because their supernatural actions are mediated by their spirit helpers, nuchukana, who do not deliberately act evilly against human beings. There are no nele sorcerers, strictly speaking, as we may encounter among other South American indigenous people (Harner 1972; Fausto 2001; Whitehead and Wright 2004). People who become 'sorcerers,' kia takkaler, are not born as nele. I was told to be clear about this distinction during fieldwork. Nonetheless, in the past evil nelekana did exist. Myths tell of powerful nelekana who used their powers to kill. In most cases these stories ended with the sorcerers being killed by their fellow villagers or by another seer on being discovered.
- 5. The question of whether the designs on the newborn's head are different or have different meanings from the designs on the placenta is still obscure to me. What is true is that for the Kuna placenta and newborn baby are the same

thing until they are separated by the cutting of the umbilical cord (see Margiotti 2010).

- 6. Lévi-Strauss has noted, "Indeed, in American Indian thought and probably also elsewhere, the hat has a function of a mediator between up and down, sky and earth, the external world and the body. It plays the role of intermediary between these poles; it can either unite or separate in different instances" (1995: 8). For the Kuna the hat is a symbol of ritual status and mystical power. 'Old wise men,' sappin tummakana, wear a hat when they go outside their houses. It is normally a black-brimmed hat, purchased in Panamá, which symbolizes their status. Headdresses made of woven vegetal fibers and feathers are worn by kanturkana, the ritual specialists singing in the female puberty rituals. Further, male nuchukana are often carved wearing a hat. During their supernatural battles against pathogenic entities the hat is used as a powerful weapon. When the spirit of the nuchu takes his hat off a cloud of intoxicating smoke comes out of it, knocking down the opponent.
- 7. I also heard of newborn babies associated with sharks and thunder. Nordenskiöld states, "An Indian can have more or less *kurgin* for hunting and fishing, though the *kurgin* for each kind of hunting and fishing has its definite place in the brain. They speak of *kurgin* for tapirs, peccaries and so on" (1938: 363). However, he does not make reference to particular kinds of designs.
 - 8. Interestingly, the bark of trees is called e ukka, 'its skin.'
- 9. In Amazonian mythologies the origin of designs is linked to the anaconda, as, for example, among the Brazilian Cashinahua (Lagrou 1998, 2007), the Peruvian Shipibo-Conibo (Gebhart-Sayer 1986), and the Wauja of the Upper Xingu (Barcelos Neto 2004). Its paradigmatic transformative capacity is linked to its power to create new designs endlessly. Anaconda is therefore believed by these people to be the creator of designs who taught human beings how to draw them. Among the Kuna, although snake designs are considered beautiful and attract people's curiosity, the myth of the discovery of designs I heard does not mention serpents explicitly.
- 10. See Chapin 1983: 112, 284–296 for a description of snake illnesses. He notes, "The women in the patient's immediate family strip off all the beads from around their necks, arms and legs, and wear their blouses inside out, because their flamboyant, snake-like designs might attract snake ponikana" (293).
- 11. This was also described by Nordenskiöld, following the information given by his Kuna informant Ruben Pérez Kantule. "When a child is born with a 'victory cap,' that is, is born to be a nele, this child has gotten from Mu kurgin for being able to associate in dreams with spirits and in this way the ability to be a Seer. With certain medicines one can however vitiate the kurkin when one does not wish the child's capacity for being a nele developed. This one always does if the father of the child born to be a nele is living because this man may die if the child's kurkin is allowed freely to develop" (1938: 367). Chapin notes, "Most nerkan are born with the fetal caul covering part or all of the face, a sign that marks them as seers" (1983: 138).

- 12. The whole song follows in the Nordensköld's text (1938: 542-551), both in the Kuna language and in its Spanish translation.
- 13. Rosengren, paraphrasing Viveiros de Castro (1992: 61), writes, "One can say that it is the separation from the spirits that is the precondition and reason for Matsigenka shamanism" (2006: 808). Moreover, among the Araweté, "while they are still small, children are often made to undergo a shamanic operation that 'closes the body'... or 'seals it off." Its aim is to permit the parents to gradually resume their activities and to prevent the child from suffering "flesh ache" (Viveiros de Castro 1992: 183).
- 14. Overing (1989) talks about beauty and body decorations as the outward manifestation of the inner creative capacities of Piaroa women. Kuna men conversely wear white people's clothes, apart from ritual occasions in which some men wear Kuna shirts made of red fabric and hats woven with natural fibers.
- 15. Chapin notes, "While all the inhabitants of the spirit world are able to change their shapes at will, and are therefore sometimes seen as animals, plants, or grotesque, distorted monsters, they are frequently pictured in human form" (1983: 88–89).
- 16. Chapin (1983: 140-142) along with Nordenskiöld (1938: 85-89) notes that nelekana of the past were called naa nelekana, due to their capacity to levitate their 'rattle,' naa, during rituals; today's nelekana are called ulup nelekana, which, Chapin explains, means that they are born from women, instead of coming directly from the sky aboard 'flying saucers,' olopatte, as ancient nelekana did.

- 1. Chapin (1983: 139) also writes, "When a nele is born his power may be so great that his parents run the risk of being overcome and killed. The danger is most acute for the mother of a nele, and it is often said that the most gifted ner-kan are motherless; their mothers die either during childbirth or shortly after."
- 2. A similar notion about powerful fetuses is contained in the Piro myth "The Birth of Tsla" (Gow 2001: 104). The same motif is contained in the Carib myth, "The frog, the jaguar's mother" (Lévi-Strauss 1973: 219). In both myths the fetus is responsible for making the mother lose the right path, ending up in the jaguars' village.
- 3. Chapin (1983: 75–101) gives a detailed description of how his informants described to him the immaterial world and its inhabitants, setting up an opposition between 'the world of spirits,' ney purpalet and 'the world of substance,' ney sanalet.
- 4. See Howe 1991 for a discussion of a Kuna myth where he interprets the headwaters of rivers as places close to the celestial level.
- 5. Lévi-Strauss (1982: 134) noted the widespread representation in the Americas of "cylindrical eyes," made by rolling out various materials, depending on the context. He also suggested that these objects have pre-Columbian origin, as archaeological findings in North America would support. "According to

the Tlingit myths, Raven, the trickster, before leaving the Indians, had warned them that upon his return to earth, no one would be able to look at him with the naked eye without being turned to stone. Henceforward, one would have to spy him through a tube made of a rolled-up leaf of skunk cabbage. Thus, when La Pérouse's vessels were driven ashore in 1786, the neighboring Tlingit thought that these great birds, whose wings were the sails, were none other than Raven and his retinue. They hastily made up their curious telescopes. Equipped with protuberant eyes, they believed that they had thus enhanced their visual power, and now dared to contemplate the astonishing spectacle that presented itself to their sight" (Lévi-Strauss 1982: 131).

- 6. See Perruchon 2003: 315–345 and Colpron 2005 for a discussion of the relation between shamanism and seduction.
- 7. The 'black dye,' sichit, produced using the genipap fruit is also used on other ritual occasions. In some curing rituals children's bodies are completely painted with black genipap in order to make them invisible to pathogenic entities. See Chapin for a description of one such case (1983: 371–393; 1997: 239–242). Also during the three-day-long female naming ritual, inna suit, the secluded girl is entirely painted with black genipap dye. On an everyday basis genipap dye is used to trace a black line along the nose of women. In this case the aim is to make them beautiful to men. Piro girls make similar use of the genipap black dye: Before the beginning of the public ritual "the secluded girl constantly blackens herself with huito. This is an image of invisibility, as the girl renders herself coextensive with the darkness" (Gow 2001: 162).
- 8. In this analysis I have been inspired by the work of Amazonian scholars who described the key role of the body in indigenous theories of sociality (Seeger, Da Matta, and Viveiros de Castro 1979; Viveiros de Castro 1979; Vilaça 2002, 2005).
- 9. Chapin (1983: 140) notes that "when the decision to leave the *nele*'s power intact is made, parents are obliged to take special precautions. They must protect themselves with medicines, and sometimes even decide to have the young *nele* raised in another household." De Smidt (1948: 21) heard of a case in the community of Ailikanti where a *nele* child always referred to his mother as 'aunt' and his father as 'uncle,' a strategy which was devised to shield his parents from danger.
- 10. This was sometimes translated as "epilepsy" and described as an illness that manifests sporadically during a person's life and can be transmitted through generations.
 - 11. See chapters 2 and 3 for a description of these entities.
- 12. Okopsukkun is the only village in Kuna Yala that still has a maternity house. However, women from Okopsukkun can choose to give birth there, followed by Kuna midwives, or in the health center in Ustupu, where Panamanian and Kuna midwives work together. Okopsukkun Muu neka and the health center are only a few meters from one another.
 - 13. Here the point is indeed more complex, because not all illnesses are diag-

nosed at birth. Sometimes the link with an animal may be discovered by ritual specialists later in the life of a person and then treated. This points to an interesting issue regarding the nature of the *kurkin* as the place where designs (bearing the sign of the relationship with an animal predator) are written. I discuss this point below. Here I want to note that a person's *kurkin* is the place where relationships with cosmic alterity take place first. It is the physical locus of the encounters with supernatural forces. See Kohn 2007 for an interesting description of how the Ecuadorian Runa consider the crown of dogs' skull the seat of the awareness of cosmological alterity.

- 14. I could not identify this plant, which was described as similar to a pine-apple plant that has a transparent fruit, similar to a shining 'glass,' ispe.
- 15. Community involvement in the initiation of the *nele* was still common practice in the Kuna villages of Niatup and Naraskantup in the late 1960s (Howe, pers. comm.).
- 16. It is interesting to see what Perruchon (2003: 338) says about the Shuar female shamans: "Women could, however, become shamans before marrying and having children, even if there seems to be a difference between women and men in the age of shamanic initiation."
- 17. There are also stories about eight mythic *nelekana* who were extremely powerful and knowledgeable. Each one specialized in a particular type of knowledge; one for instance ventured into the land of the dead, another learned everything about the life of birds, while another discovered how the world was composed of five continents. Eventually these *nelekana* became poisoned by their knowledge and started to tyrannize Kuna ancestors. Eventually Kuna people killed the leader of these *nelekana*, Tiekun, with the help of the young *nele* Kwani. Other versions of the "great *nelekana*" stories have been collected by Nordenskiöld (1938: 278–322), Chapin (1989: 128–166), and Wakua, Green, and Peláez (1996: 87–99).
- 18. Gallup Diaz (2001) argues that Kuna political leaders in the postconquest period emerged as new figures to deal with Europeans, while *nelekana* were the traditional authoritative figures still able to make the life of Spanish missionaries difficult. In her study of precolonial Panamá, Helms (1979), influenced by the anthropology of Pacific societies, argues for the association of rank status with supernatural powers. While speculations about the status of ancient Kuna *nelekana* is not among my interests here, I wish to point out that the praxis of past *nelekana* seems more familiar to contemporary Amazonian shamans than that of present *nelekana* (see chapter 4, note 18).
- 19. The role of women in curing processes is indeed more complex and still obscure to me. Once I heard a young woman saying that she knew curing songs but did not sing them because she was shy, adding that perhaps she would do that when she got older.
- 20. Fausto (2001: 341) says that the Parakanã conceive women as possessing a more powerful knowledge than men, by virtue of their smell of blood.

- 21. *Tule takket*, 'to see people,' refers to the capacity of *nele* to see within a person's body, discovering the causes of an illness.
- 22. It is interesting to compare this with what Gow (2000: 57) suggests about Piro female shamans: "Women also become shamans, but they do not, to my knowledge, engage in long shamanic apprenticeships. While this was never made explicit to me, I have the impression that women attain their access to shamanry through miscarried foetuses and children who died in infancy."
- 23. It is of interest here to compare the rites of passage celebrated by the Gimi from Papua New Guinea (Gillison 1997), where men have to steal knowledge from women in order to become adults. Men have to overcome the fact that women always see them by virtue of the fact that they saw them when they were born. Men thus play flutes during their initiation and keep the flutes strictly out of women's sight. By becoming invisible to women, men thus acquire the capacity to see, their new male knowledge. On a different note, I also find appealing the analogy with what in psychophysics are called multistable objects. These are visual illusions in which a given representation can be seen in two ways, but the two perspectives are mutually exclusive, such as in the case of the Necker cube. The kurkin of nele enables either the mother or the son to see cosmic transformations, provided that one of them is not able to see them.
- 24. The Piaroa oppose the heat of the sun, associated with madness, to the coolness of the moon, associated with positive shamanic power (Overing 1985a).

- 1. In the case where both parents are dead (I actually heard of just one case during my fieldwork between 2003 and 2004), this is even more evident; but also in the case where they are alive, as in Inaekikiña's case, the relationship that the child has with his parents is marked by less intimacy than with other children.
- 2. The concept of nika has not been described so far in this work. When I asked about its meaning, I was told that it means fuerza (the Spanish word for "strength"). I was also told that men and women take plant medicines to increase their nika regularly during their life. It is intended to recuperate and improve their energies and their strength, which sometimes, for various reasons, might diminish. A good description of nika is found in Nordenskiöld: "Brave' means, in Cuna, kántikit, but is not the same as niga; however one must have niga in order to be brave. When a person is timid in a serious situation one says niga suli, he does not have niga. The same thing applies to the one who is shy about appearing and speaking before a large gathering. When a child grows, its niga also grows. Before the child has enough niga it cannot go alone to the forest. If a person has much niga it is a protection against attack by wild animals. All animals also have niga and if a wild animal has more niga than a person whom it meets, the animal makes an attack.... [O]ne never says that plants have

niga. Nor do stones have niga. According to what an old medicine man in Ailligandi has explained to Pérez, niga is even a protection against certain dangerous dreams, in other words, against certain evil spirits. Through certain medicines one can even develop one's niga. A person's niga cannot, like his purpa, be abducted" (1938: 361). It is interesting to compare the visual representation of nika made by Pérez, designed as a halo around the head (361), with that of the "crown" on the head of the Jívaro shaman under the influence of ayahuasca (Harner 1972: fig. 24).

- 3. On one occasion Prisilla Diaz told me, "During dreams I am taught things. This evil thing lies in the body, that other evil thing lies in the body. It's like that. That evil thing is called that. That [other] evil thing is called that. Therefore I can see what actually happens. [I can see] what evil thing is eating you. In this way things are shown to me." She was explaining to me the way in which she learned to see how illnesses appear within the human body. She also told me that to learn this she was conducted into the underworld by *nuchukana* and shown the places where animals live.
- 4. Another interesting perspective comes from Viveiros de Castro's (2009) analysis of how the Yanomami experience the 'spirits,' xapiripë, as not detached from the visibility and materiality of human bodies. He translates this experience in terms of "different vibrations and intensive and continuous modulations."
- 5. Severi (1981b: 91) describes the ritual chant performed for the curing of madness as an action "that enables to restore the limit, in each occasion of disorder, between the space of humans and that of animals and trees."
- 6. I find here an interesting similarity with Taylor's analysis of the Achuar's conceptions of illness and power. Death for the Achuar is an aggravation of illness and not a distinct state, while the ritual of *arutam*, through which people seek visions of the dead, is a quest for power and makes the person invulnerable. Both illness/death and self-enhancement consist in the suspension of communication by the person with other human beings. But while healing is "a return to the self," the enhancement of the self, attained through meeting an *arutam* vision, consists in an "interaction with an entity which is structurally just as 'outside' society as are the foreigners encountered by the shaman" (Taylor 1996: 209).
- 7. The plant here referred to with the Kuna name *take* is *Cnidoscolus urens*. It is a tropical stinging bush that is used by the Kuna for curing rheumatism, stomachache, and, by men, for keeping children away from the gathering house during night reunions.
- 8. Aku is a stick in the shape of a small paddle used in the past for weaving hammocks.
- 9. This bears a striking similarity to the relationship between a *nele* and his grandmother and suggests seeing the eight siblings as prototypes of contemporary *nelekana*.
 - 10. As Lagrou (1996: 223–224) noted, the Cashinahua associates the uterus

with the cloth used to carry babies, cushma. As illustrated in chapter 3, the process of the formation of babies, the shaping of their bodies, is expressed with the same verb used for weaving hammocks, sopet. Weaving hammocks (no longer done today) and making babies are women's praxis. The body of Magiryai is therefore put in a hammock woven by Olowai-ili in order to re-form her body.

- 11. See Howe 2002 [1986]: 35-43 for an edited transcription of a Kuna chant describing the river of the balsa tree, its chief, Olokunipippilele, and its followers.
- 12. Tat Ipe is the other way in which Ipelele is referred to in myths. *Ipe* means "master," "owner," "stone"; *tata* means "grandfather." *Tata* is also the Kuna name for the sun. For example, *tat kae* means "the sun shines." On the other hand, Ipelele derives from *ipe* and *lele*. *Lele*, or *ler*, is related to *nele*, 'seer.' It is a suffix for the names of many mythic characters. Olokunipippiler, the master of balsa tree, *olo*, 'gold,' *kuni* (meaning not known), *pippi*, 'small,' *lele*, 'seer.'
- 13. However, we could also say that Makiryai's mother-in-law is her own mother, by virtue of the fact that she conceived her children through incestuous relations with her twin brother.
- 14. The relationship with affinity is a complex issue in present-day Kuna life, characterized by nucleated and densely inhabited villages where distance between non-kinspeople has literally to be created (Margiotti 2010). It is possible, although still hypothetical, that the relationship that the Kuna have with animals in shamanism, curing, and hunting is the metaphysical transposition of the relationship they had in the past with enemies and others, such as other Kuna groups and the Emberá (cf. Wassén 1955). Fausto noted for the Parakanã that "the representation of an internal sterility is subjected to the opening toward the outside in the sphere of shamanism and/or warfare, where predatory relationships between beings of a different kind reign" (2001: 320–322; my translation).
- 15. Kuna people told me that when a person dies in unknown circumstances and the body is not found, for example, when someone drowns, he or she becomes a kirmar, 'ghost,' haunting the living. These deaths are usually ultimately imputed to an animal, normally a crocodile, which eats the victim and thereby causes him or her to become a predator until he or she finds a partner among animal entities, thus retiring to live with them and stop bothering humans. These deaths escape normal mortuary rituals; instead the process focuses on the corpse as a way to secure (for both the deceased and the living) a safe postmortem life for the soul.
- 16. See also Villas Boas and Villas Boas 1970: 57–88 for two similar versions by the Tupi-speaking Kamaiurá and the Carib-speaking Kuikúru, both from the Upper Xingu region.
- 17. Variations of this myth, known as "The wooden bride," are found in other areas of the Amazon basin (Lévi-Strauss 1973: 215-224).
- 18. Here I find an interesting resemblance to Gow's interpretation of Piro shamanism. For Piro people, he says, becoming a shaman is motivated by the

inconsolable pain and sense of solitude felt by a man when he loses a child (2000: 56-59). In contrast, for Kuna people it is the grief over the death of one's mother, or the loneliness caused by the distance from her, that moves the *nele* to follow the road of knowledge.

- 19. For the analysis of a similar case among the Piro, see Gow 2001: 107–110.
- 20. Nele sunnati, which I translate as "real nele," is the nele who has completed his initiation and has full powers, thus implying a judgment of "intensity" and "degree" of powers rather than "truthfulness." Kuna people told me that real nelekana were those of the past. This could be interpreted as their being closer to the mythic prototypes of nele as portrayed in the figures of Ipelele and his siblings. The analysis of Viveiros de Castro (1977) on the category of archetype for the Yawalapíti is useful for interpreting Kuna explanations of past and present shamanic praxis (Fortis 2011).
- 21. The theme of mortality in Piro mythology is dealt with in the story "Tsla swallowed by a Giant Catfish" (Gow 2001: 86–87). "The 'land of death' from which Tsla and his brothers flee on hearing the bird call is the lived Piro world" (93).
- 22. The only jaguar spared by Tsla and the Muchkajine is Yompichgojru, the mother of the jaguars. However, "she was pregnant, and her young one was male. From them came the jaguars we have today. If Tsla had killed his grandmother, there would be no jaguars about now" (Gow 2001: 105).
- 23. It is interesting to note that the difference between humans and animals is also present in mythic time, before their separation. Muu Kwelopunayai's animal grandchildren smell pineapple when Magiryai hides in their home. Humans smell like pineapple to animals, meaning that they are food for them. Yakonero's jaguar brothers-in-law smell "human meat" and lick their lips. What is not present in mythic times is the awareness of this difference by humans, who are thus victims of animals' predations.

- 1. Today marriage among the Kuna is celebrated by putting the bride and the groom in a hammock together, which is then swung by children and people attending the ceremony. Beneath the hammock firewood is lit, symbolizing the collective work of a man and a woman in gathering and cooking food, or, according to another version, so that "the children that they will have will not be born blind" (Prestan Simón 1975: 93).
- 2. Akkwanusa are stones used for medicine; they can also be the auxiliary spirits of nelekana: akkwa, 'stone,' nusa, 'mouse,' 'rat.' Chapin defines akkwanusa as "a polished agate found in the rivers and used as cooling medicine. It is the principal figure in 'the way of nusa' (nusa ikala), which is used to recover abducted purpakana and refresh them" (1983: 556).
 - 3. In Viveiros de Castro's description of the Araweté conception of creation

in mythic time we find interesting similarities with the Kuna myth presented here: "Created animals used to be humans long ago. During a great maize beer festival, $\tilde{N}\tilde{a}$ - $Ma\ddot{i}$ ('Jaguar-God,' brother of $Miko\ ra'i$, 'Opossum's son'), seeking revenge for the death of his mother at the claws of the monstrous jaguar $\tilde{N}\tilde{a}$ $now\ddot{i}$ ' $h\tilde{a}$, transformed all the human guests into the animals of today: harpy eagles, vultures, jaguars, giant river otters, howler monkeys, capuchin monkeys, saki monkeys, agoutis, collared peccaries, tapirs, curassows, toucans, deer, guans, pacas, and anteaters. $\tilde{N}\tilde{a}$ - $Ma\ddot{i}$ transformed or 'created' them with the help of his array (shaman rattle) and tobacco. Then he transformed cultural objects of vegetal origin into various fishes: the serving vessel made of cockerite palm spathes turned into the trair \tilde{a} 0; the tupe mat turned into the matrinx \tilde{a} 3; the fire fan, pestle and so on turned into other species of fish. $Miko\ ra'i$, for his part, transformed the smoke of a bonfire into mosquito and other insects pests" (1992: 72).

- 4. When I spoke with a Kuna man at the end of my fieldwork, he told me something that initially surprised me but now makes more sense. "If you really want to learn our language and our culture well, you have to marry a Kuna woman," he said. Recognizing my serious attempt to learn about his way of life, he was telling me that if I wanted to succeed I should do something more than just ask questions and observe. Now I find his position more realistic and meaningful and an incisive statement about the limits of anthropological research.
- 5. The api sua also leads the collective curing ceremony called apsoket, 'to converse,' performed in cases of epidemic or when the soul of a dead person haunts the village (cf. Howe 1976a). There are many similarities between opakket and apsoket, and they basically follow the same ritual structure. Though I could not observe either of the two ceremonies, I heard many descriptions of them. The first leads to the marriage between a nele and a daughter of a chief of animals; the second aims to send the animal entities that attacked the village back under the earth, thus reenacting the primordial separation between humans and animals.
- 6. The Murui-Muinane in the Colombian Amazon used to carve wooden statues representing human couples. The woman was put at the bottom of the house and the man at the entrance. They had two types of statues called *janare* and *janane*. The *janare* acquire the personality of the owner of the house, who with the help of the statues will remain awake, protecting the household from sorcerers. The *janane* statues are created in numbers of four, two representing the couple of mythic heroes, the other two the owner of the house and his wife. These statues are responsible for advising the owner when the house is attacked by the *janane* spirits in dreams (Yepez 1982: 56–62).
- 7. Sianar, 'brazier,' derives from sia, 'cacao,' and narret, 'to smoke.' "Smoking with cacao" is exactly the main use for a sianar on ritual occasions. However, sianar may be used by elder women for more mundane tasks, such as going to a neighbor's house at dawn to ask for some 'embers,' sokun, to relight the fire.
- 8. War suit, literally, 'long tobacco,' is used in all Kuna curing ceremonies, in girl-naming rituals, and in the nele's initiation ceremony. It is always smoked

by another person rather than the ritual specialist, and the smoke is intended to reinforce both the specialist and his auxiliary spirits. This is the only way in which locally produced tobacco is consumed. The cigar, made with roughly rolled tobacco leaves, is about 30 cm long and closed at the end with a string. People in Okopsukkun do not cultivate tobacco anymore, so they buy war suit made by the Kuna living in the inland Bayano region.

- 9. The difference between unfermented and fermented *inna* in everyday Kuna life is that the first is made with dry maize powder chewed by women, mixed with water, boiled and drunk before it ferments, while the second is made with sugarcane juice and dry ground maize, boiled and left to ferment in clay pots for a few weeks. The first is refreshing and drunk on an everyday basis, offered to visitors to the house, and taken by men to their gardens. The second is alcoholic and is consumed during puberty ceremonies only. See Viveiros de Castro 1992: 119–129 for a similar distinction among the Araweté.
- 10. This moment reminds me of the description of the pre-battle ritual conducted by the Parakanã, in which the shaman could see the enemies without being seen by them (Fausto 2001: 277–285). This points to the intensification of shamanic vision through the smoke of tobacco, which increases the *nele*'s vision and gives him the capacity to see both in dreams and in waking life while performing his diagnosis by smoking tobacco (cf. Wilbert 1987: 162–171).
- 11. The possibility of being deceived by fake auxiliary spirits appears also in Crocker's description of the shamanic possession among the Bororo: "Only a wise and experienced shaman can distinguish neatly among all the horde of *bope* that come crowding in, drawn by the odour of tobacco and cooked food, and tell which among them is really his familiar" (1985: 222).
- 12. Rotalio says, "Just my eyes show up." Howe was told that in the Kuna village of Naraskantup a woman nele was carried by nuchukana to visit different kalukana all wrapped up in clothes. At each kalu the nuchukana would open the clothes just enough for her to see ponikana without them seeing her (pers. comm.). This reminds me of Harner's description of the spirit helper of the Shuar bewitching shamans: "The curing shaman, under the influence of natemä, sees the pasuk of the bewitcher in human form and size, but 'covered with iron except for its eyes.' The curing shaman can kill this pasuk only by shooting a tsentsak [magic dart] into its eyes, the sole vulnerable area in the pasuk's armor" (1972: 159).
- 13. In the the long chant apsoket ikar, performed in this ceremony, the api sua demonstrates his skills of remembering with precision the names of many kalukana and of their inhabitants. This is meant to guide nuchukana to fight back evil entities, while a nele observes in his sleep the mystical battle. There is a strong resemblance between this ceremony and the initiation ceremony of the nele (see note 5 above). In both, the knowledge of the api sua serves as a guide for the nele and the nuchukana in the underworld. Through his singing he directs them into the invisible dimension of the cosmos, while they perform the actual battle against pathogenic spirits. Thus, I suggest, nuchukana and nele, respectively the

hand and the eyes of the api sua, may be regarded as his tarpakana, his extension in the underworld.

- 14. Piro people talk about olden day shamans as jaguar shamans, who lived alone and used to transform into jaguars, to kill animals and practice sorcery (Gow 2001: 123–124).
- 15. My Kuna informants varied in their opinions on this issue. Some told me that the *nele* really encounters *ponikana* when he has undergone initiation four times. Others argued that each time the *nele* meets a different *poni*, and therefore the more ceremonies he undergoes, the more auxiliary spirits he acquires and the more powerful he becomes. This latter case would flatten the differences between male and female *nelekana* highlighted in chapter 5.
- 16. See Margiotti 2010: 102-138 for an analysis of *inna suit* that focuses on the variations in the patterning of relationships between people and between humans and *ponikana* during the ritual.
- 17. Similarly, I heard that during the preparation of fermented chicha, the *inna sopet*—in Spanish *el quimico de la chicha*, "he who distills chicha"—might be attacked by animal entities if the parents of the girl do not abstain from sex during the fermentation of the chicha.
- 18. However, Howe (1985) argues that the exchange between older and younger generations within Kuna households is also a means of control exercised by the senior generation.
- 19. It is interesting to note that a Piaroa shaman would not speak about his relationship with his auxiliary spirits, saying that it would be like "showing his penis" (Overing, pers. comm.).
- 20. Kwamuty, or Mavutsinim (Viveiros de Castro 1979: 42) is the culture hero, who is called Kwatingi in Kalapalo mythology (Basso 1987a).
- 21. Kuarup, kwarup, and kwarip are the different names by which the ceremonial decorated wooden logs are called by the Tupi-speaking Xinguanos.

- 1. See chapter 3 for a description of Leopoldo Smith's carving skills.
- 2. This is the same type of cigar used in the initiation ritual of *nelekana*, in collective healing ceremonies, and when fermented chicha is prepared before puberty ceremonies.
- 3. For a transcription and translation in English of a version of *kapur ikar*, see Chapin 1983: 483–511.
 - 4. See Beatriz Alba's description of her own nuchukana in chapter 3.
- 5. This would suggest a parallelism between the dense layout and the "saturation of daily life" of Kuna villages (Margiotti 2010) and the disposition of *nuchukana* within their boxes.
- 6. Note that the Piro, also speaking an Arawak language, give the word *yaglu* (cf. Yawalapíti *yakulá*) the meaning of "image." This for them refers to such things as figurative drawings, dolls, and photographs (Gow 1989).

- 7. My analysis of the relationship between *sopalet* and *purpa* is indebted to Viveiros de Castro's analysis of the Yawalapíti concept of *pitalatisi*, which he translates as "form," which entails a constant differentiation between symbol and referent, "which is up to a certain point submitted to the scheme archetypeactualization that marks the whole culture of the group" (1977: 122 n. 1).
- 8. Among the Tlingit and the Tsimshiam of the Northwest Coast of North America are told different versions of a story about a man whose wife dies. In a Tlingit version the widower asks a skilled wood-carver to carve his wife's face in wood. "The carver got hold of a piece of cedar and set to work. When his carving was finished, he dressed it in her clothes and called the husband. Overjoyed, the husband took the statue and asked the carver how much he owed him." The story concludes with the man treating the statue as his dead wife until one day he hears a crack and sees that the statue has started splitting in two. Underneath it a new tree has started growing (Lévi-Strauss 1997: 182).
- 9. See also Heckenberger 2007 for an analysis of the association between ancestors, dead chiefs and *kuarup* logs in Kuikuro mortuary feasts (*egits*ï).
- 10. In the conclusive phase of the mortuary ritual the Kalapalo dispose of the posts. Basso (1973: 147) writes, "Late that afternoon the posts representing dead *anetaw* are pulled up, thus ending their ceremonial significance. The *aougufi* singers use them as seats, until toward dusk the young boys of the village roll them into the nearest body of water, usually the bathing area."
- 11. See Viveiros de Castro 1992: 264–269 for a discussion of the "animal soul" component of human beings among the Tupi-Guarani.
- 12. Public ceremonies are held in the gathering house, during which the master gives his disciple the colored necklace and the staff symbolizing that he has graduated in his discipline.

CONCLUSION

- 1. The study of art practices as experience-informing categories was inaugurated by Munn (1973) in her groundbreaking study of Australian Walbiri iconography. Gow (1999) analyzed the making of designs by Peruvian Piro women using a similar conceptual framework.
- 2. Kuna women do not distinguish between geometric and figurative *mola* designs. The designs are instead distinguished according to the layering technique by which they are created, involving more or fewer layers of fabric and creating increasingly complex designs. See Salvador 1978, 1997 for a description of these different techniques.
- 3. See Lagrou 2007: 193–201 for an analysis of a related myth of the origin of designs among the Brazilian Cashinahua.
- 4. One ethnographic example may provide an exception to this apparently widespread system, that of the Asuriní of the Upper Xingu (central Brazil). Following Müller's (1990) ethnography, the basic pattern from which the Asuriní create all designs would be the "human figure," tayngava. This may contradict the

opposition between geometric designs and figurative images formulated above, indeed posing new interesting problems for the analysis of Amerindian art.

- 5. What I call here false dualism pays homage, although rather clumsily, to the original formulation of Lévi-Strauss, who spoke of the "triadic nature of dualism" in his essay, "Do Dual Organizations Exist?" (1972 [1958]).
- 6. Riviére (1994) aptly pointed out the connection between hardness, especially associated with the wood of particular trees common in South American rainforests, and the internal immortal component of the person, the soul. This would further suggest the immortal nature of *nuchukana* as images of interiority.
- 7. The lack of kinship between *nuchukana* is perhaps one of the reasons Kuna people associate them with white people. I am grateful to Juan Pablo Sarmiento for bringing this point to my attention.
- 8. I say this based on early-twentieth-century Kuna woodcarving from Nordenskiöld (1929; 1938), as well as museum collections, such as that of the American Museum of Natural History (New York) and the Museum of World Culture–Världskultur Museet (Göteborg), to name but a few.

GLOSSARY

Anmor: MZ (mother's sister); FZ (father's sister); extendable to any collateral senior kin

Api sua: ritual chanter. Knower of healing chants and in particular of the long complex chants of the collective village-wide healing ritual nek-apsoket.

Asu: nose; prow of a canoe

Ina: medicine. Usually prepared with forest plants and with animal parts.

Ina tuleti: medicine man

Inmar: thing

Ispe: mirror; glass; spectacles

Ka: leaf

Kalu: village inhabited by animal entities, demons, or primordial entities

Kana: master; stool; pond where animals gather to drink

Kantule (kantur): singer in girl naming ceremonies

Kaptakket: to dream

Kia takkaler: killer. An ill person who is deemed able to kill other people in dreams.

Kilu: FB (father's brother); MB (mother's brother); extendable to any collateral senior kin or visitor from other villages

Kurkin: amniotic sac; caul; hat; intelligence; brain

Kwa: core. The internal part of something, usually the hard core of tree trunks.

Kwake: heart

Machi (macheret): man; son

Merki: stranger; white man. Usually referring to North Americans or Europeans.

Mola: cloth; dress. Refers to women's and men's clothing in general or to specific items, such as a woman's blouse.

Muu: MM (mother's mother); FM (father's mother); extendable to any elder woman

Namakket: to sing Nana: M (mother)

Narmakket: to draw designs; to write

Neka: house

Nek-apsoket: collective healing ritual aimed at freeing the village from pathogenic entities causing epidemics

Nele: seer Nono: head

Nuchu: carved wooden figure used in healing rituals and as protector spirit of the household

Nueti: well; good

Oyoket: to show; to demonstrate

Papa: F (father)

Piñe (opine): to transform (tr.)
Pinsaet: to think; to call to mind

Poni: evil entity

Purpa: soul; image; double; sexual substance

Sana: flesh; body Sappi: tree Sappulu: forest

Sopet: to give shape; to carve; to weave; to mold

Sor: buttocks; stern of a canoe

Suar: stick

Sunmakket: to speak

Takket: to see Tala: sight

Tarpa: auxiliary spirit

Tata: FF (father's father); MF (mother's father); extendable to any elder man

Temar: sea
Tii: water
Tiiwar: river
Tupu: island
Ua: fish

Waka: stranger; usually referring to Panamanians and Colombians

Wakar: face War: tobacco

Ulu: canoe

Winni: beadwork. The multicolor designed beadwork coiled around women's forearms and calves or the single-color bead necklace worn by ritual specialists.

Yala (yar): mountain Yer tayleke: beautiful Yer ittoke: happy; content

REFERENCES

- Agostinho, P. 1974. Kwarip: Mito e ritual no Alto Xingu. São Paulo: Editora Pedagógica e Universitaria/EDUSP.
- Århem, K. 1996. "The Cosmic Food Web: Human-Nature Relatedness in the Northwest Amazon." In P. Descola and G. Pálsson (eds.), *Nature and Society:* Anthropological Perspectives, pp. 185–204. London: Routledge.
- Barcelos Neto, A. 2002. A arte dos sonhos: Uma iconografia ameríndia. Lisboa: Museu Nacional de Etnologia/Assírio & Alvim.
- —. 2004. "As máscaras rituais do Alto Xingu um século depois de Karl von den Steinen." Bulletin de la Société Suisse des Américanistes 68: 51–71.
- ——. 2008. Apapaatai: Rituais de máscaras no Alto Xingu. São Paulo: EDUSP.
- Basso, E. 1973. The Kalapalo Indians of Central Brazil. Prospect Heights, IL: Waveland Press.
- ——. 1985. A Musical View of the Universe: Kalapalo Myth and Ritual Performances. Philadelphia: University of Pennsylvania Press.
- ——. 1987a. In Favor of Deceit: A Study of Tricksters in an Amazonian Society. Tucson: University of Arizona Press.
- —. 1987b. "The Implication of a Progressive Theory of Dreaming." In B. Tedlock (ed.), *Dreaming: Anthropological and Psychological Interpretations*, pp. 86–104. Cambridge: Cambridge University Press.
- Belaunde, L. E. 2000. "The Convivial Self and the Fear of Anger amongst the Airo-Pai of Amazonian Peru." In J. Overing and A. Passes (eds.), *The Anthropology of Love and Anger: The Aesthetics of Conviviality in Native Amazonia*, pp. 209–220. London: Routledge.
- —. 2001. Viviendo bien: Género y fertilidad entre los Airo-Pai de la Amazonía peruana. Lima: CAAAP.
- Calvo Buezas, T. 1990. Indios Cunas: La lucha por la tierra y la identidad. Madrid: Universidad Libertarias.
- Carneiro da Cunha, M. 1981. "Eschatology among the Krahó: Reflection upon Society, Free Field of Fabulation." In S. Humphreys and H. King (eds.), Mortality and Immortality: The Anthropology and Archaeology of Death, pp. 161–174. London: Academic Press.
- Chapin, M. 1970. Pap Ikala: Historias de la tradición Cuna. Panamá: Universidad de Panamá, Centro de Investigaciones Antropológicas.
- ——. 1976. "Muu Ikala: Cuna Birth Ceremony." In P. Young and J. Howe (eds.), *Ritual and Symbol in Native Central America*, pp. 57–66. University of Oregon Anthropological Papers No. 9.
- ——. 1983. "Curing among the San Blas Kuna of Panama." Ph.D. diss., University of Arizona.

- ----. 1989. Pab Igala: Historias de la tradición Kuna. Quito: Abya-Yala.
- ——. 1997. "'The World of Spirit, Disease, and Curing." In M. L.Salvador (ed.), The Art of Being Kuna: Layers of Meaning among the Kuna of Panama, pp. 219— 244. Los Angeles: UCLA Fowler Museum of Cultural History.
- Colpron, A. M. 2005. "Monopólio masculino do xamanismo amazônico: O contra-exemplo das mulheres Xamã Shipibo-Conibo." *Mana* 11(1): 95–128.
- Constenla Umaña, A. 1991. Las lenguas del area intermedia: Introducción a su studio areal. San José: Editorial de la Universidad de Costa Rica.
- Crocker, C. 1985. Vital Souls: Bororo Cosmology, Natural Symbolism, and Shamanism. Tucson: University of Arizona Press.
- De Smidt, L. S. 1948. Among the San Blas Indians of Panama: Giving a Description of Their Manners, Customs, and Beliefs. New York: Troy.
- Descola, P. 1992. "Societies of Nature and the Nature of Society." In A. Kuper (ed.), Conceptualizing Society, pp. 107-126. London: Routledge.
- ——. 1994. In the Society of Nature: A Native Ecology in Amazonia. Cambridge: Cambridge University Press.
- Duke, J. 1970. "Ethnobotanical Observations on the Chocó Indians." *Economic Botany* 24(3): 344-366.
- Erice, Jesus. 1980. *Gramatica de la lengua kuna*. Panama: Ministerio de Educación.

 ——. 1985. *Diccionario de la lengua kuna*. Panama: Ministerio de Educación.
- Erikson, P. 1989. "Les Matis de la tête aux pieds et du nez aux fesses." In M. L. Beffa and R. Hamayon (eds.), *Les figures du corps*, pp. 287–295. Paris: Laboratoire d'Ethnologie et de Sociologie Comparative de l'Université de Paris X-Nanterre.
- —. 2007. "Faces from the Past: Just How 'Ancestral' Are Matis 'Ancestor Spirit' Masks?" In C. Fausto and M. Heckenberger (eds.), *Time and Memory in Indigenous Amazonia: Anthropological Perspectives*, pp. 219–242. Gainesville: University Press of Florida.
- Ewart, E. 2003. "Lines and Circles: Images of Time in a Panará Village." *Journal of the Royal Anthropological Institute*, n.s., 9: 261–279.
- ——. 2008. "Seeing, Hearing and Speaking: Morality and Sense among the Panará in Central Brazil." *Ethnos* 73: 505–522.
- Fausto, C. 2001. *Inimigos fiéis: História, guerra e xamanismo na Amazônia*. São Paulo: Editora da Universidade de São Paulo.
- Fortis, P. 2002. "La 'mola' dei Cuna di Panamá come linguaggio figurative." Undergraduate thesis, Università di Siena.
- ——. 2009. "Nuchukana: Entalhe em Madeira entre os Kuna do Panamá." Tellus 15: 279–289.
- ——. 2010. "The Birth of Design: A Kuna Theory of Body and Personhood." Journal of the Royal Anthropological Institute 16 (3): 480–495.
- -----. 2011. "Nuchu and Kwarip: Images of Past in Central and South America." In P. Fortis and I. Praet, eds., The Archaeological Encounter: Anthropologi-

- cal Perspectives, pp. 204–233. St. Andrews: University of St. Andrews, Centre for Amerindian, Latin American, and Caribbean Studies.
- —. 2012. "Images of Person in an Amerindian Society: An Ethnographic Account of Kuna Woodcarving." Journal de la Société des Américanistes. 98(1): 7–37.
- Fortis, P., and I. Praet. 2011. *The Archaeological Encounter: Anthropological Perspectives*. St. Andrews: University of St. Andrews, Centre for Amerindian, Latin American, and Caribbean Studies.
- Gallup Diaz, I. 2001. The Door of the Sea and Key to the Universe. New York: Columbia University Press.
- Gebhart-Sayer, A. 1984. The Cosmos Encoiled: Indian Art of the Peruvian Amazon. New York: Center for Inter-American Relations.
- —. 1986. "Una terapia estética: Los diseños visionarios del Ayahuasca entre los Shipibo-Conibo." *América Indígena* 96: 189–218.
- Gell, A. 1993. Wrapping in Images: Tattooing in Polynesia. Oxford: Clarendon Press.
- —. 1998. Art and Agency: An Anthropological Theory. Oxford: Clarendon Press.
- Gillison, G. 1997. "To See or Not to See: Looking as an Object of Exchange in the New Guinea Highlands." In M. Banks and H. Morphy (eds.), *Rethinking Visual Anthropology*. New Haven: Yale University Press.
- Goldman, M. 2009. "An Afro-Brazilian Theory of the Creative Process: An Essay in Anthropological Symmetrization." *Social Analysis* 53(2): 108–129.
- Gombrich, E. H. 1979. The Sense of Order: A Study in the Psychology of Decorative Art. Oxford: Phaidon Press.
- Gómez-Pompa, A., J. S. Flores, and M. A. Fernández. 1990. "The Sacred Cacao Groves of the Maya." *Latin America Antiquity* 1(3): 247–257.
- Goody, J. 1997. Representations and Contradictions: Ambivalence towards Images, Theatre, Fiction, Relics, and Sexuality. Oxford: Blackwell.
- Gow, P. 1987. "La vida monstruosa de las plantas." *Amazonía Peruana* 14: 115–122.
- —. 1991. Of Mixed Blood: Kinship and History in Peruvian Amazonia. Oxford: Oxford University Press.
- —. 1994. "River People: Shamanism and History in Western Amazonia." In N. Thomas and C. Humphrey (eds.), *Shamanism*, *History, and the State*, pp. 90–113. Ann Arbor: University of Michigan Press.
- —. 1996. "Aesthetics Is a Cross-Cultural Category." In T. Ingold (ed.), Key Debates in Anthropology, pp. 229–275. London: Routledge.
- —. 1999. "Piro Designs: Painting as Meaningful Action in an Amazonian Lived World." *Journal of the Royal Anthropological Institute*, n.s., 5: 229–246.
- ----. 2000. "Helpless. The Affective Preconditions of Piro Social Life." In

- J. Overing and A. Passes (eds.), *The Anthropology of Love and Anger: The Aesthetics of Conviviality in Native Amazonia*, pp. 46–63. London: Routledge.
- —. 2001. An Amazonian Myth and Its History. Oxford: Oxford University Press.
- ——. 2005. "The Dynamics of Fear in the Piro Lived World." Unpublished paper.
- ——. 2012. "The Piro Canoe. A Preliminary Ethnographic Account." *Journal de la Société des Américanistes* 98(1).
- Gow, P., and M. Margiotti. 2012. "Is There Fortune in Greater Amazonia?" Social Analysis.
- Guss, D. M. 1989. To Weave and Sing: Art, Symbol, and Narrative in the South American Rain Forest. Berkeley: University of California Press.
- Hanbury-Tenison, A. R., and P. J. K. Burton. 1973. "Should the Darien Gap Be Closed?" *Geographical Journal* 139(1): 43-52.
- Harner, M. 1972. The Jivaro: People of the Sacred Waterfalls. Berkeley: University of California Press.
- Heckenberger, M. 2007. "Xinguano Heroes, Ancestors, and Others: Materializing the Past in Chiefly Bodies, Ritual Space, and Landscape." In C. Fausto and M. Heckenberger (eds.), *Time and Memory in Indigenous Amazonia: Anthropological Perspectives*, pp. 284-311. Gainesville: University Press of Florida.
- Helms, M. 1979. Ancient Panama: Chiefs in Search of Power. Austin: University of Texas Press.
- ——. 1981. Cuna Molas and Cocle Art Forms: Reflections on Panamanian Design Styles and Symbols. Working Papers in Traditional Arts 7. Philadelphia: Institute for the Study of Human Issues.
- Henare, A., M. Holbraad, and S. Wastell. 2007. Thinking through Things: Theorising Artefacts Ethnographically. London: Routledge.
- Herrera, L., and M. C. de Schrimpff. 1974. "Mitología Cuna: Los Kalu. Según Alfonso Diaz Granados." *Revista Colombiana de Antropología* 42: 203–247.
- Hirschfeld, L. A. 1976. "A Structural Analysis of the Cuna Arts." In P. Young and J. Howe (eds.), *Ritual and Symbol in Native Central America*, pp. 43-56. University of Oregon Anthropological Papers No. 9.
- ——. (1977) "Art in Cunaland: Ideology and Cultural Adaptation." *Man*, n.s., 12: 104–123.
- Holmer, N. M. 1947. Critical and Comparative Grammar of the Cuna Language. Göteborg: Etnologiska Studier.
- Holmer, N. M., and H. Wassén. 1947. Mu-Igala or the Way of Muu, a Medicine Song from the Cunas of Panama. Göteborg: Etnografiska Museet.
- Howe, J. 1976a. "Smoking Out the Spirits: A Cuna Exorcism." In P. Young and J. Howe (eds.), *Ritual and Symbol in Native Central America*, pp. 67–76. University of Oregon Anthropological Papers 9.
- —. 1976b. "Communal Land Tenure and the Origin of Descent Groups among the San Blas Cuna." In M. Helms and F. Loveland (eds.), Frontier Adaptations in Lower Central America, pp. 151–163. Philadelphia: ISHI.

- . 1977. "Carrying the Village: Cuna Political Metaphors." In D. Sapir and C. Crocker (eds.), *The Social Use of Metaphor*, pp. 132–163. Philadelphia: University of Pennsylvania Press.
- —. 1985. "Marriage and Domestic Organization among the San Blas Cuna." In W. D'Arcy and M. Correa (eds.), The Botany and Natural History of Panamá, pp. 317–331. St. Louis: Missouri Botanical Garden.
- —. 1997. "The Kuna and the World: Five Centuries of Struggle." In M. L. Salvador (ed.), *The Art of Being Kuna: Layers of Meaning among the Kuna of Panama*, pp. 85–102. Los Angeles: UCLA Fowler Museum of Cultural History.
- ——. 1998. A People Who Would not Kneel: Panama, the United States, and the San Blas Kuna. Washington, DC: Smithsonian Institution Press.
- ——. 2002 [1986]. The Kuna Gathering: Contemporary Village Politics in Panama. Tucson, AZ: Fenestra Books.
- —. 2009. Chiefs, Scribes and Ethnographers: Kuna Culture from Inside and Out. Austin: University of Texas Press.
- Howe, J. and Sherzer, J. 1975. "Take and Tell: A Practical Classification from the San Blas Cuna." *American Ethnologist* 2(3): 435–460.
- Howe, J., J. Sherzer, and M. Chapin. 1980. Cantos y oraciones del Congreso Cuna. Panamá: Editorial Universitaria.
- Isacsson, S. E. 1993. Transformations of Eternity: On Man and Cosmos in Emberá Thought. Göteborg: University of Göteborg.
- Jeambrun, P. 1998. "L'Albinisme oculocutané: Mises au point clinique, historique et anthropologique." *Archives Pédiatrie* 5: 896–907.
- Kane, S. C. 1994. The Phantom Gringo Boat: Shamanic Discourse and Development in Panama. Washington, DC: Smithsonian Institution Press.
- Kohn, E. 2007. "How Dogs Dream: Amazonian Natures and the Politics of Transspecies Engagement." *American Ethnologist* 34: 3-24.
- Kracke, W. 1989. "O poder do sonho no xamanismo Tupi (Parintintin)." Série Antropologia 79. Brasília: Universidade de Brasília, Instituto de Ciências Humanas.
- Kramer, F. W. 1970. Literature among the Cuna Indians. Göteborg: Etnologiska Studier.
- Kroeber, A. 1949. "Esthetic and Recreational Activities." In J. H. Steward (ed.), Handbook of South American Indians. Vol. 5: The Comparative Ethnology of South American Indians, pp. 411-492. Washington, DC: Smithsonian Institution, Bureau of American Ethnology.
- Lagrou, E. M. 1996. "Xamanismo e representação entre os Kaxinawá." In J. M. Langdon (ed.), Xamanismo no Brasil: Novas perspectivas. Florianópolis: Editora da UFSC.
- —. 1998. "Cashinahua Cosmovision: A Perspectival Approach to Identity and Alterity." Ph.D. diss., University of St. Andrews.

- ——. 2000. "Homesickness and the Cashinahua Self: A Reflection on the Embodied Condition of Relatedness." In J. Overing and A. Passes (eds.). The Anthropology of Love and Anger: The Aesthetics of Conviviality in Native Amazonia, pp. 152–169. London: Routledge.
- —. 2002. "O que nos diz a arte Kaxinawa sobre a relação entre identitade e alteridade." *Mana* 8(1): 29–61.
- ——. 2007. A fluidez da forma: Arte, alteridade e agência em uma sociedade amazônica. Rio de Janeiro: Topbooks.
- Lévi-Strauss, C. 1966. The Savage Mind. London: Weidenfeld and Nicholson.
- ----. 1972 [1958]. Structural Anthropology. London: Penguin.
- —. 1973. From Honey to Ashes: Introduction to a Science of Mythology. Vol. 2. London: Jonathan Cape.
- ----. 1989 [1955]. Tristes tropiques. London: Jonathan Cape.
- ----. 1995. The Story of Lynx. Chicago: University of Chicago Press.
- ——. 1997. Look, Listen, Read. New York: Basic Books.
- Lima, T. S. 1996. "O dois e seu múltiplo: Reflexões sobre o perspectivismo em uma cosmologia Tupi." *Mana* 2(2): 21–47.
- Londoño-Sulkin, C. 2000. "Though It Comes as Evil, I Embrace It as Good: Social Sensibilities and the Tranformation of Malignant Agency among the Muinane." In J. Overing and A. Passes (eds.), The Anthropology of Love and Anger: The Aesthetics of Conviviality in Native Amazonia, pp. 170–186. London: Routledge.
- Losonczy, A.-M. 1990. "La maîtrise du multiple: Corps et espace dans le chamanisme embera du Choco (Colombie)." L'Homme 30: 75–100.
- McCallum, C. 2001. Gender and Sociality in Amazonia: How Real People Are Made. Oxford: Berg.
- Margiotti, M. 1999. "Gli indigeni, il Panama, gli USA e il canale: Strategie di convivenza e mediazione degli interessi." *Latinoamerica* 71: 31–45.
- ——. 2010. "Kinship and the Saturation of Life among the Kuna of Panamá." Ph.D. diss., University of St. Andrews.
- —. n.d. "Clothing Sociality: Materiality and the Everyday among the Kuna of Panama." MS.
- Martínez Mauri, M. 2007. "De Tule Nega a Kuna Yala: Mediación, territorio y ecología en Panamá, 1903–2004." Ph.D. diss., Universidad Autónoma de Barcelona.
- Munn, N. 1973. Walbiri Iconography: Graphic Representation and Cultural Symbolism in a Central Australian Society. Ithaca: Cornell University Press.
- . 1986. The Fame of Gawa: A Symbolic Study of Value Transformation in a Massim (Papua New Guinea) Society. Cambridge: Cambridge University Press.
- Nordenskiöld, E. 1929. "Les rapports entre l'art, la religion et la magie chez les Indiens Cuna et Choco." *Journal de la Société des Américanistes* 21: 141–158.

- —. 1938. An Historical and Ethnological Survey of the Cuna Indians. Göteborg: Etnografiska Museet.
- Orán, R. B., and A. Wagua. 2011. Gayamar Sabga: Diccionario escolar gunagaya-español. Panama: Equipo Ebi Guna.
- Overing, J. 1985a. "There Is No End of Evil: The Guilty Innocents and Their Fallible God." In D. Parkin (ed.), *The Anthropology of Evil*, pp. 244–278. Oxford: Basil Blackwell.
- —. 1985b. "Today I Shall Call Him 'Mummy': Multiple Worlds and Classificatory Confusion." In J. Overing (ed.), Reason and Morality, pp. 152–179. London: Tavistock.
- -----. 1986. "Images of Cannibalism, Death and Domination in a 'Non-Violent' Society." *Journal de la Société des Américanistes* 72: 133–156.
- —. 1989. "The Aesthetics of Production: The Sense of Community among the Cubeo and Piaroa." *Dialectical Anthropology* 14: 159–179.
- —. 1996. "Who Is the Mightiest of Them All? Jaguar and Conquistador in Piaroa Images of Alterity and Identity." In A. J. Arnold (ed.), *Monsters, Tricksters, and Sacred Cows: Animal Tales and American Identities*, pp. 50–79. Charlottesville: University of Virginia Press.
- —. 1999. "Elogio do cotidiano: A confiança e a arte da vida social em uma comunidade amazonica." *Mana* 5(1): 81–107.
- —. 2000. "The Efficacy of Laughter: The Ludic Side of Magic within Amazonian Sociality." In J. Overing and A. Passes (eds.), The Anthropology of Love and Anger: The Aesthetics of Conviviality in Native Amazonia, pp. 64–81. London: Routledge.
- ——. 2003. "In Praise of the Everyday: Trust and the Art of Social Life in an Amazonian Community." *Ethnos* 68(3): 293–316.
- Overing, J., and A. Passes (eds.). 2000. The Anthropology of Love and Anger: The Aesthetics of Conviviality in Native Amazonia. London: Routledge.
- Overing Kaplan, J. 1975. The Piaroa. Oxford: Clarendon Press.
- —. 1984. "Dualism as an Expression of Differences and Danger: Marriage Exchange and Reciprocity among the Piaroa of Venezuela." In K. M. Kensinger (ed.), *Marriage Practices in Lowland South America*, pp. 127–155. Urbana: University of Illinois Press.
- Perrin, M. 1998. Tableaux Kuna: Les molas, un art d'Amerique. Paris: Arthaud.
- Perruchon, M. 2003. I Am Tsunki: Gender and Shamanism among the Shuar of Western Amazonia. Uppsala: Uppsala University Library.
- Prestan Simón, A. 1975. El uso de la chicha y la sociedad Kuna. México, DF: Instituto Indigenista Interamericano.
- Price, K. 2005. "Kuna' or 'Guna': The Linguistic, Social, and Political Implications of Developing a Standard Orthography." Master's thesis, University of Texas at Austin.
- Reichel-Dolmatoff, G. 1961. "Anthropomorphic Figurines from Colombia, Their Magic and Art." In S. Lothrop (ed.), *Essays in Pre-Columbian Art and Archaeology*, pp. 229–41. Cambridge, MA: Harvard University Press.

- 1978. Beyond the Milky Way: Hallucinatory Imagery of the Tukano Indians. Los Angeles: UCLA Latin American Center Publications.
- Rival, L. 1998. "Androgynous Parents and Guest Children: The Huaorani Couvade." Journal of the Royal Antrhopological Institute, n.s., 4(4): 619-642.
- -. 2006. "Amazonian Historical Ecologies." Journal of the Royal Anthropological Institute, n.s., S79-S94.
- Rivière, P. 1974. "The Couvade: A Problem Reborn." Man, n.s., 9(3): 423-435.
- ----. 1994. "Wysinwyg in Amazonia." Journal of the Anthropological Society of Oxford, 25(3): 255-262.
- Rosengren, D. 2006. "Transdimensional Relations: On Human-Spirit Interaction in the Amazon." Journal of the Royal Anthropological Institute, n.s., 12: 803-816.
- Salcedo, G. and J. Howe. 1978. "The Story of the Great Salt Tree." Kuna Collection, Archive of the Indigenous Languages of Latin America. www.ailla
- Salcedo Requejo, J. 1908 [1640]. "Relación histórica y geográfica de la provincia de Panamá." In Relaciones históricas y geográficas de América Central. Madrid: Libreria General de Victoriano Suárez.
- Salvador, M. L. 1978. Yer Dailege! Kuna Women's Art. Albuquerque, NM: Maxwell Museum of Anthropology.
- 1997. The Art of Being Kuna: Layers of Meaning among the Kuna of Panama. Los Angeles: UCLA Fowler Museum of Cultural History.
- Santos-Granero, F. 1991. The Power of Love: The Moral Use of Knowledge amongst the Amuesha of Central Peru. London: Athlone Press.
- —. 2004. "The Enemy Within: Child Sorcery, Revolution, and the Evils of Modernization in Eastern Peru." In N. Whitehead and R. Wright (eds.), In Darkness and Secrecy: The Anthropology of Assault Sorcery and Witchcraft in Amazonia, pp. 272-305. Durham, NC: Duke University Press.
- Seeger, A. 1975. "The Meaning of Body Ornaments: A Suya Example." Ethnology 14: 211-224.
- Seeger, A., R. Da Matta, and E. Viveiros de Castro. 1979. "A construção da pessoa nas sociedades indígenas brasileiras." Boletim do Museu Nacional, n.s., 32: 2-19.
- Severi, C. 1981a. "Le anime Cuna." La Ricerca Folklorica 4: 69-75.
- —. 1981b. "Image d'étranger." *Res* 1: 88–94.
- ----. 1982. "Le chemin des métamorphoses: Un chant chamanique Cuna." Res 3: 33-67.
- . 1983. "Los pueblos del camino de la locura." Amerindia 8: 129–179.
 . 1987. "The Invisible Path: Ritual Representation of Suffering in Cuna Traditional Thought." Res 14: 67-86.
- ----. 1993. La memoria rituale: Follia e immagine del bianco in una tradizione sciamanica amerindiana. Firenze: La Nuova Italia.
- ----. 1997. "Kuna Picture-Writing: A Study in Iconography and Memory." In M. L. Salvador (ed.), The Art of Being Kuna: Layers of Meaning among the

- Kuna of Panama, pp. 245-270. Los Angeles: UCLA Fowler Museum of Cultural History.
- —. 2000b. "Proiezione e credenza: Nuove riflessioni sull'efficacia simbolica." Etnosistemi: Percorsi e Dinamiche Culturali 7: 75-85.
- Sherzer, D., and J. Sherzer. 1976. "Mormaknamaloe: The Cuna Mola." In P. Young and J. Howe (eds.), *Ritual and Symbol in Native Central America*, pp. 21–42. University of Oregon Anthropological Papers 9.
- Sherzer, J. 1990. Verbal Art in San Blas: Kuna Culture through Its Discourse. Cambridge: Cambridge University Press.
- ——. 2001 [1983]. Kuna Ways of Speaking: An Ethnographic Perspective. Tucson, AZ: Hats Off Books.
- ——. 1997. "Kuna Language and Literature." In M. L. Salvador (ed.), The Art of Being Kuna: Layers of Meaning among the Kuna of Panama, pp. 103–134. Los Angeles: UCLA Fowler Museum of Cultural History.
- —. 2003. Stories, Myths, Chants, and Songs of the Kuna Indians. Austin: University of Texas Press.
- Squillacciotti, M. 1998. I Cuna di Panama: Identità di popolo tra storia ed antropologia. Rome: L'Harmattan Italia.
- Stier, F. R. 1979. "The Effect of Demographic Change on Agriculture in San Blas, Panama." Ph.D. diss., University of Arizona.
- Stout, D. B. 1947. San Blas Cuna Acculturation: An Introduction. New York: Viking Fund Publications in Anthropology.
- Taussig, M. 1993. Mimesis and Alterity: A Particular History of the Senses. New York: Routledge.
- Taylor, A.-C. 1993. "Remembering to Forget: Identity, Mourning, and Memory among the Jivaro." *Man*, n.s., 28: 653-678.
- —. 1996. "The Soul's Body and Its States: An Amazonian Perspective on the Nature of Being Human." *Journal of the Royal Anthropological Institute* 2: 201–215.
- —. 1998. "Corps immortels, devoir d'oubli: Formes humaines et trajectoires de vie chez les Achuar." In M. Godelier and M. Panoff (eds.), *La production du corps: Approches anthropologiques et historiques*, pp. 317–338. Amsterdam: Éditions des Archives Contemporaines.
- —. 2002. "The Face of Indian Souls: A Problem of Conversion." In B. Latour and P. Weibel (eds.), *Iconoclash: Beyond the Image Wars in Science, Religion, and Art*, pp. 462–464. Cambridge, MA: MIT Press.
- ——. 2003. "Les masques de la mémoire: Essai sur la fonction des peintures corporelles Jivaro." L'Homme 165: 223–248.
- —. 2007. "Sick of History: Contrasting Regimes of Historicity in the Upper Amazon." In C. Fausto and M. Heckenberger (eds.), Times and Memory in Indigenous Amazonia: Anthropological Perspectives, pp. 133–168. Gainesville: University Press of Florida.

- Taylor, A.-C., and E. Viveiros De Castro. 2006. "Un corps fait de regards." In S. Breton (ed.), *Qu'est-ce qu'un corps?*, pp. 148–199. Paris: Musée du Quai Branly/Flammarion.
- Teixeira-Pinto, M. 2004. "Being Alone amid Others: Sorcery and Morality among the Arara, Carib, Brasil." In N. Whitehead and R. Wright (eds.), In Darkness and Secrecy: The Anthropology of Assault Sorcery and Witchcraft in Amazonia, pp. 215–243. Durham, NC: Duke University Press.
- Tice, K. E. 1995. Kuna Crafts, Gender, and the Global Economy. Austin: University of Texas Press.
- Toren, C. 2002. "Anthropology as the Whole Science of What It Is to Be Human." In R. Fox and B. King (eds.), *Anthropology Beyond Culture*, pp. 105–124. London: Berg.
- —. 2007. "How Do We Know What Is True?" In R. Astuti, J. Parry, and C. Stafford (eds.), *Questions of Anthropology*, 307-336. Oxford and New York: Berg.
- Ventocilla, Jorge. 1991. "Caceria y subsistencia en Cangandi, una comunidad de los indigenas Kunas (Comarca de San Blas, Panama)." M.A. thesis, Universidad Nacional de Panamá.
- Ventocilla, J., H. Herrera, and V. Núñez. 1995. Plants and Animals in the Life of the Kuna. Austin: University of Texas Press.
- Vilaça, A. 2002. "Making Kin out of Others in Amazonia." *Journal of the Royal Anthropological Institute*, n.s., 8: 347–365.
- -----. 2005. "Chronically Unstable Bodies: Reflections on Amazonian Corporalities." *Journal of the Royal Anthropological Institute*, n.s., 11: 445–464.
- Villas Boas, O., and C. Villas Boas. 1970. Xingu: The Indians, Their Myths. London: Souvenir Press.
- Viveiros de Castro, E. 1977. "Individuo e sociedade no Alto Xingu: Os Yawalapíti." M.A. thesis, Museo Nacional, Rio de Janeiro.
- ——. 1978. "Alguns aspectos do pensamento Yawalapíti (Alto Xingu): Classificações e transformações." *Boletim do Museu Nacional*, n.s., 26: 1–41.
- —. 1979. "A fabricação do corpo na sociedade xinguana." Boletim do Museu Nacional, n.s., 32: 40–49.
- —. 1992. From the Enemy's Point of View: Humanity and Divinity in an Amazonian Society. Chicago: University of Chicago Press.
- -----. 1998. "Cosmological Deixis and Amerindian Perspectivism." Journal of the Royal Anthropological Institute, n.s., 4: 469–488.
- -----. 2001." "Gut Feelings about Amazonia: Potential Affinity and the Construction of Sociality." In L. Rival and N. Whitehead (eds.), Beyond the Visible and the Material: The Amerindianization of Sy in the Work of Peter Rivière, pp. 19–44. Oxford: Oxford University Press.
- -----. 2002. A incostância da alma selvagem. São Paulo: Cosac & Naify.
- ——. 2004. "Exchanging Perspectives: The Transformation of Objects into Subjects in Amerindian Ontologies." *Common Knowledge* 10: 463–484.

- . 2009. "La forêt dês miroirs: Quelques notes sur l'ontologie dês esprits amazoniens." In F. Laugrand and J. Oosten (eds.), La nature dês esprits dans lês cosmologies autochtones, pp. 45-74. Laval: Presses de l'Université de Laval.
- Wagua, A. 2000. En defensa de la vida y su armonía. Panamá: Instituto de Investigaciones Koskun Kalu, Congreso General de la Cultura Kuna.
- Wakua, A., A. Green, and J. Peláez. 1996. La historia de mis abuelos: Textos del Pueblo Tule, Panamá—Colombia. Antioquia: Asociación de Cabildos Indígenas de Antioquia.
- Wassén, Henry S. 1934. "Mitos y cuentos de los indios Cunas." Journal de la Société des Americanistes 26.
- ——. 1937. "Some Cuna Indian Animal Stories, with Original Texts." Etnologiska Studier 4.
- ——. 1938. "Original Documents from the Cuna Indians of San Blas, Panama." Etnologiska Studier 6.
- . 1955. "Etnohistoria chocoana y cinco quentos waunana apuntados en 1955." Etnologiska Studier 26: 9–78.
- Whitehead, N., and R. Wright (eds.). 2004. In Darkness and Secrecy: The Anthropology of Assault Sorcery and Witchcraft in Amazonia. Durham, NC: Duke University Press.
- Wilbert, J. 1987. Tobacco and Shamanism in South America. New Haven: Yale University Press.
- Yépez, B. 1982. La estatuaria Murui-Muinane: Simbolismo de la gente 'Huitoto' de la Amazonia colombiana. Bogotá: Fundación de Investigaciones Arqueológicas Nacionales.
- Young, P., and J. Howe (eds.). 1976. *Ritual and Symbol in Native Central America*. University of Oregon Anthropological Papers No. 9.

INDEX

achiote, 145, 147, 153; makep, 16, 36, 76 aesthetics, 5, 10, 93, 204 agency, 13, 16, 24, 37, 42, 55, 61, 63, 64, 66, 115, 117, 162, 166-167, 172, 175, 198 Agostinho, Pedro, 171, 184 agouti, 34, 50, 52, 53, 54, 55 agriculture. See gardens alterity, 9, 12, 13, 16, 37-38, 49, 88, 99-100, 102, 106, 114, 119, 121, 129, 133, 139, 144, 152, 187, 188, 202-203 amniotic sac, 17, 92, 94, 96, 98, 119 ancestors, 27, 34, 42, 53, 55, 61, 64, 79, animals, 16, 19, 23, 35, 37, 40, 49-50, 52, 53-59, 63, 150, 155, 171-172; agency of, 55, 61, 63; ancestors, 61; animal-people, 35, 43, 50, 55, 118, 140-142, 144, 150, 155, 162; classifying, 44, 51-52, 54-56, 60-63; entities, 32, 33, 38, 40, 51, 56, 59, 82-83, 89-90, 100, 105-106, 110-111, 114, 119-121, 124, 128, 133-138, 152-153, 157, 160, 163-164, 166, 187, 200; predation, 41, 57, 61, 97, 120, 139, 142-143, 148; species, 8, 41-42, 53, 63, 160 ant, 34, 50 anteater, 34, 41, 50, 59, 61, 82, 83; giant anteater, 34, 53, 60, 81; silky anteater, 34, 53, 59, 60, 107 anthropomorphic, 1, 3, 175 art, 1, 3, 13, 194; and death, 9, 138, 182, 185, 203; decorative, 6, 7, 195; as experiential category, 1, 2, 193;

figurative, 6, 7, 8, 186, 195; geometric, 7, 195; visual, 1, 5, 9-10, 193, 198; way of knowing, 1 baby, 96, 98, 100, 103, 111, 116, 118-119, 120, 131, 187-188, 201. See also kurkin; nele; personhood basket weaving, 10, 65, 68, 82-83, Basso, Ellen, 112, 116, 184 beadwork (winni), 10, 101, 119-120, 194 beautiful (yer tayleke), 11, 57, 87, 97, 102, 106, 119, 148, 194; nose, 87. See also mola (woman's blouse); visible Belaunde, Luisa, 94 birds, 38, 137, 139; shamans, 141, 145-147 birth, 13, 17, 86-87, 90-91, 124, 155, 166-167, 182, 201; myths, 144-146; nele, 94, 95-96, 99-100, 111, 131, 136, 147. Compare death. See also amniotic sac; designs; kurkin; octu-

plet heroes blue taro (tarkwa), 25, 26, 65 Boas, Franz, 6, 7 body (sana), 10, 17, 69, 94, 184, 194, 197. See also substance (sanalet)

Caduveo, 7, 101, 197, 200, 201
Carneiro da Cunha, Manuela, 183
carving, 1, 2, 5, 6, 9, 13, 68, 83–84, 85, 87, 175, 182, 190; canoe, 69–70, 80, 82, 91; carver, 185, 191, 196; sopet (to give shape), 68, 83, 102, 186. See also birth; death; nuchu; statue

chant (ikar), 43, 71, 83, 116, 146; apsoket, 17, 32, 161; nia ikar, 12, 52; Pap ikar, 42, 43, 45. See also knowledge Chapin, Mac, 12, 91, 140, 205 chiefs (sayla), 43, 55-56, 57, 61, 74, 87-88, 90, 157, 161, 164, 167, 216n35 children, 94, 97, 105, 111, 120, 135, 142-143, 147-148, 162, 167, 174, 183, 190, 200. See also baby; personhood cosmology, 23, 38, 48, 52, 55, 69, 89, 144 couvade, 118. Compare birth Crocker, Christopher, 62 crocodiles, 56-57, 58, 59, 61, 90 culture heroes, 42-43, 161, 171. See also octuplet heroes cure, 2, 9, 16, 17, 40, 41, 42, 52, 61, 94, 113, 144, 157, 168, 180. See also chant; nele; ritual specialist;

death, 1, 2, 8, 147-149, 155, 166-167, 202-203. Compare birth demons, 29, 32, 38, 51, 104-105, 136, 160-161 Descola, Philippe, 2, 36, 53, 64-65, designs, 3, 5, 7-8, 9, 10, 94, 98, 138, 187-188, 189-190, 194, 195, 201; amniotic, 17, 93, 96-99, 198; as category of praxis, 10, 98, 99, 102; as existential category, 5; invisible, 99, 100, 102; narmakkalet, 6, 11. Compare image. See also amniotic sac; birth; kurkin; mola (woman's blouse) dreams, 93, 94, 95, 97, 103, 110, 112-116, 129, 136; nightmares, 93, 94,

shamans

Emberá, 11, 69-70, 137, 206 enclosure (surpa), 32, 157, 158

103, 106, 129

epidemic, 32, 38, 88, 89, 160. See also chant

Erice, Jesus, xiii

Erikson, Philippe, 199

evil entity (poni), 33, 47–48, 62, 137–138, 171

Ewart, Elizabeth, 203

external, 3, 5, 9, 11, 98, 138. Compare internal

father, 31, 43-44, 50, 51, 63, 71, 75, 118-119, 128, 167

Fausto, Carlos, 53, 111
fear, 27, 93-94, 95, 99-100, 106, 149
fertility, 68, 111, 182, 202
fetus, 56, 68, 74, 84, 96, 110, 112-113, 117, 119, 121, 125, 127-128, 135, 137, 187. See also amniotic sac; baby; birth; kurkin

fish, 26 food, 25–26, 28, 66 forest (sappulu), 10, 13, 18, 19, 23, 24, 27, 32, 37, 38, 40, 41, 42, 56; classifying, 29, 33, 55, 65; and personhood, 26. See also medicine; plant; tree. Compare island (tupu)

Fortis, Paolo, 4, 8, 10, 57, 68, 98, 102, 157, 198, 202

gardens (nainu), 20-21, 30-33, 37-38, 64, 168
gathering house (onmakket neka), 19, 28, 42
gaze, 11, 114, 119
Gebhart-Sayer, Angelika, 8
Gell, Alfred, 9, 11, 198, 201
gender, 5, 10, 127, 183. See also female; shamanism
genipap, 35, 78, 116, 117, 120, 140
Gow, Peter, 7, 94, 101, 102, 145, 146, 197
grandfather, 16, 68, 71, 72, 79, 115,

136. See also carving

grandmother, 16, 49, 68, 96, 108, 115, 120, 127, 130, 136, 142, 177, 178 Great Father (Pap Tummat), 41, 42, 45, 56, 84, 89, 90, 92, 196, 205 Great Mother (Nan Tummat), 42, 46, 49, 90, 91, 196, 205 Guss, David, 8, 64

Harner, Michael, 108, 115 Holmer, Nils, xiii, 14 Howe, James, 17, 30, 33, 43, 56, 167 hunt, 25, 42, 53, 55–56, 59, 115; hunter, 32, 38

illness and disease, 1, 2, 17, 41, 52, 59, 138, 177. See also cure; evil entity (poni); personhood image, 3, 5, 7-8, 9, 10, 173, 181, 183, 184-185, 194, 204-207; as category of praxis, 10; as existential category, 5; non-iconic, 8; purpa (soul), 6, 12, 181, 199, 202, 203; sopalet, 6, 175, 181, 186-187. Compare carving; designs immortal, 9, 10, 174, 203 incest, 50, 140, 147 internal, 3, 5, 9, 11, 98, 107, 138, 189-190, 198-199. Compare external invisible, 2, 3, 16, 99, 100, 119-120, 138, 194, 196, 199. See also nele. Compare visible island (tupu), 23, 24, 27, 37

jaguar, 50, 52, 57, 58, 59, 61, 97, 148, 203; sky jaguar, 52, 57, 59

Kalapalo, 139, 144, 150, 171

Kane, Stephanie, 69

killer (kia takkaler), 53, 82, 127. See also madness

kinship, 41, 143; marriage, 51, 143, 152–153, 165, 172; nuchukana, 190–191; shamanic marriage, 124,

127, 134, 136, 148–150, 157, 163, 164–171 knowledge, 38, 43, 45, 68–69, 155. See also chant Kroeber, Alfred, 6–7 kurkin, 80, 99, 120, 121, 123, 127, 129, 130, 189; brain, 80, 97–98; caul, 92; design, 187–188; hat, 96, 98, 119, 127; intelligence, 84. See also amniotic sac; designs; fetus

learning, 43, 47, 81–82, 83, 127, 129, 137, 162, 182; as ability to see, 82, 83, 99. See also nele

Lévi-Strauss, Claude 6, 7, 101, 197, 200–201

life cycle, 93, 164

Londoño-Sulkin, Carlos, 41

Losonczy, Anne-Marie, 206

love, 49, 95, 117, 149, 155, 163. See also memory

Lagrou, Els, 7, 8, 83

madness, 12, 51; mad person, 52, 82. See also killer maize, 31, 34, 36, 37, 65 manioc, 25, 26, 31, 34, 36, 37, 65 Margiotti, Margherita, 45, 120, 124, 126, 128, 147, 168, 204 Martínez Mauri, Monica, 55 master (kana), 43, 45, 153, 168, 180 McCallum, Cecilia, 166 mediation, 134, 144, 150 medicine (ina), 26, 35, 38, 48, 72, 76, 79, 81, 90, 116-117, 120, 125, 130; medicine man (ina tuleti), 17, 45, 73, 114, 188-189 memory (pinsaet), 12, 49, 66, 117, 134, 148, 155, 163, 190. See also love mimesis, 12, 205 mola, molokana (woman's blouse), 3, 10, 11, 82, 101, 102, 119, 194-196 moon, 62, 139, 145, 150, 182, 203. See also sun

mortal, 2, 9, 139, 148, 155, 185, 203.

Compare immortal

mother, 108, 110, 113, 116, 118, 119,
125, 128, 131, 133, 141, 142, 144,
147, 148, 174, 205

mountain, 29

Munn, Nancy, 10, 69, 91

myths, 33, 36; Kalapalo, 144–145;

mythic beings, 43, 206; mythic
discourse, 40, 42–43, 48; mythic
past, 43; Piro, 145; tree of salt,
33–36; young men of the father,
46–48

Nakekiryai, 195 naming, 188-189 nele (seer), 16-17, 52, 53, 59, 93, 94-95, 98, 99, 100, 105, 106–108, 115, 123– 124, 126, 127, 133-136, 138, 142, 143, 147, 150, 157, 161, 162, 163, 169, 172, 191, 200. See also nuchu; shamanism; shamans Nia (devil), 12, 47-49, 51, 52, 62 nonhuman, 2, 23, 24, 38. See also animal; evil entity; spirit Nordenskiöld, Erland, 11, 12, 87, 89, nuchu, 2, 3, 4, 5, 9, 10-16, 67-68, 70, 73-74, 86, 89, 90, 91, 159, 162, 174, 175, 178, 181, 183, 187, 190-191, 196, 200, 202, 203, 206, 207. See also carving; nele

octuplet heroes, 33, 146, 173, 203 Olowai-ili, 141, 142, 153, 172 ontology, 1, 2, 5, 9, 16 Other, 11, 203, 207; otherness, 49 Overing, Joanna, 13, 37, 93, 124, 143–144, 169, 194, 202

peccary, 34; collared peccary, 36, 50, 53, 54; white-lipped peccary, 33, 50, 53, 54 personhood, 1, 2, 5, 9, 93, 137–138,

166, 175, 188-189, 200; and trees, 86-87. See also praxis; skill perspectivism, 99, 120, 129, 143, 162-163, 187, 199-200 Piro, 94, 101, 117, 139, 144, 146, 197 placenta, 96, 128, 146-147 plant, 24, 33, 42, 53, 63, 64; cultivated, 24, 33, 37, 64, 66; edible, 23, 33, 36, 37, 63, 64, 65, 76; medicinal, 17, 26, 29, 65, 75, 130 plantain, 25, 26, 31, 34, 65 praxis, 11, 68, 74, 115, 198; human, 98, 100, 102-103, 138, 188-189, 199, 201; social, 10, 41, 55, 99, 128. See also skill Prestan Simón, 165 primordial, 2, 3, 33, 52, 64, 70, 74, 148, 171, 172, 175, 181–185, 190– 191, 196, 206 Pukasui, 142, 155, 207

reciprocity, 167–169
Reichel-Dolmatoff, Gerardo, 8, 87
ritual, 9, 14, 43, 68, 88, 100, 144, 173, 183, 189; collective (nek apsoket), 17, 32; curing ritual, 88, 176; initiation (oppaket), 17, 93, 95, 122–123, 142, 157, 162–163, 169, 171, 172; puberty, 42, 164–165, 172
ritual chanter (api sua), 17, 74, 157–158, 160, 162, 180
ritual specialist, 3, 9, 16, 17, 42, 66, 100, 122, 205
Rival, Laura, 41, 118
river, 26, 37–38, 41, 42, 113
Rivière, Peter, 118, 205

Salvador, Mari Lyn, xiii, 87, 88 Santos-Granero, Fernando, 93 sea, 23, 56 seeing, 3, 11, 17, 83, 99, 112, 129 Severi, Carlo, 12, 52, 59, 114 shamanism, 1, 3, 41, 93–94, 126, 133, 150; female, 110–111, 123–124, 127

shamans, 1, 2, 16-17, 55, 99, 100, 150. See also nele (seer) Sherzer, Joel, xiii, 10, 14 sight (tala), 83, 87, 89, 90, 100, 114-115, 148. See also seeing; visible; vision singing, 74-75, 88. See also chant skill, 68, 70, 80, 82, 83. See also praxis sloth, 34, 50, 53, 59, 107 snake, 50, 52, 56-59, 96, 97 sociality, 135, 166, 181, 190 space, 27, 32, 37, 40, 41, 161 spirit, 2, 37, 41, 49, 61, 95, 104, 114, 120, 123, 199, 204 statue, 2, 3, 13, 174, 185, 193, 194, 198 stool (kana), 10, 63, 83, 92, 134 substance (sanalet), 83, 91, 138 sugarcane, 34, 83 sun, 62, 139, 145, 150, 182. See also moon supernatural, 17, 53, 55, 62, 84, 93, 95, 113, 115, 139

tapir, 34, 50, 52, 53, 54, 55 tarpa (auxiliary spirit), 133-134, 135, 136-137, 152, 169-170; component of the person, 136-139 Tat Ipe, 33-36, 153-156, 163, 164, 172-173, 203; Ipelele, 141–147, 153. See also sun Taussig, Michael, 12-13 Taylor, Anne-Christine, 149, 181, 188, 190 temporality, 37, 41-42, 64 Tice, Karin, 25, 30 tobacco, 16, 122, 129, 157–158, 172, 182 transformations, 2, 9, 11, 12, 17, 41, 51, 68, 70, 84, 97, 102, 104–106, 150,

196, 203

tree (*sappi*), 8, 28, 30–32, 37, 49, 64, 66, 76, 79, 84, 86, 97, 155, 203; and alterity, 49; classifying, 33, 37, 63, 65, 78; owner of, 182; and personhood, 64, 86–87, 155; of salt, 33, 34; used for carving canoes, 79, 90–91; used for carving *nuchu*, 74, 75, 76, 79, 91; wild, 76 twins, 145–147, 173

Ventocilla, Jorge, 56 village, 13, 18, 23, 24, 204; island village, 124; kalu (invisible village), 32, 160-161, 195 Villas Boas, Orlando, and Claudio, 148, 173, 182 violence, 50, 88 visible, 1, 11, 99, 100, 106, 131, 169, 194, 196, 199. See also beautiful. Compare invisible vision, 100, 129, 181, 205. See also gaze; sight visual, 1, 5, 7, 8, 13, 17, 84, 99, 101, 112, 129, 181, 185, 187, 193-200, 204; capacity, 2, 3, 10, 80, 206 Viveiros de Castro, Eduardo, 8-9, 62, 104, 143, 171, 173, 181, 197, 202, 203, 205, 206-207

Wagua, Aiban, xiii Wassén, Henry, 127 white people (*merki*), 12–13, 87–88

yam, 25, 65 Yawalapíti, 8–9, 62, 171–174, 180, 181, 182, 205 young men of the father (pap masmala), 44, 51, 63, 64, 76, 89, 90, 182, 190, 196